# DOPPELGANGER

## IMAGES OF THE HUMAN BEING

gestalten

Akatre
Aldo Lanzini
Alexa Meade
Alva Bernadine
Anders Krisár
Anders Lindén
Anika Lori
Anna & Bernhard Blume
Annie Collinge
Ansen Seale
Antony Gormley
Ara Jo
Aron Demetz
Ashkan Honarvar
Astrid Andersen
Blommers / Schumm
Beni Bischof
Betsy VanLangen
Bohyun Yoon
Chris Pell
Chris Scarborough
Christiane Feser
Christophe Huet
Cie. Willi Dorner
Daikichi Amano
Desiree Palmen
Dindi van der Hoek
Dmitry Grigorev
Elene Usdin
Emily Speed
Erik Wåhlström
Erwin Wurm
Estelle Hanania
Eva Eun-sil Han
Federico Cabrera
Flabbyhead
Frederique Daubal

Frederic Lebain
Ganz Toll
Gordon Magnin
Gregor Gaida
Helle Mardahl
Hugh Kretschmer
Ignacio Lozano
Jamie Isenstein
Jan von Holleben
Jonathan Baldock
Jonathan Puckey
Justine Khamara
Kate MacDowell
Kerstin zu Pan
Kevin Francis Gray
Kimiko Yoshida
Kim Joon
Kraffhics / Leemun Smith
Leif Podhajsky
Levi van Veluw
Lucy McRae
Luis Dourado
Madame Peripetie
Marcia Nolte
Matthew Stone
Matthieu Lavanchy
Maurizio Anzeri
Nadine Byrne
Nick Cave
Nick van Woert
Noil Klune
Oscar & Ewan
Paul Jackson
Phyllis Galembo
Rachel de Joode
Richard Stipl
Roger Weiss

Sibling
Simone Brewster
Sruli Recht
Stéphane Fugier
Stephen J. Shanabrook
Ted Sabarese
Tony Oursler
Urban Camouflage
Xavier Veilhan
Zoren Gold & Minori

Levi van Veluw, *Veneer I*, 2009. |→ p.18|

II

**III**

# POST-

## DIGITAL IDENTITY

(by Robert Klanten)

•

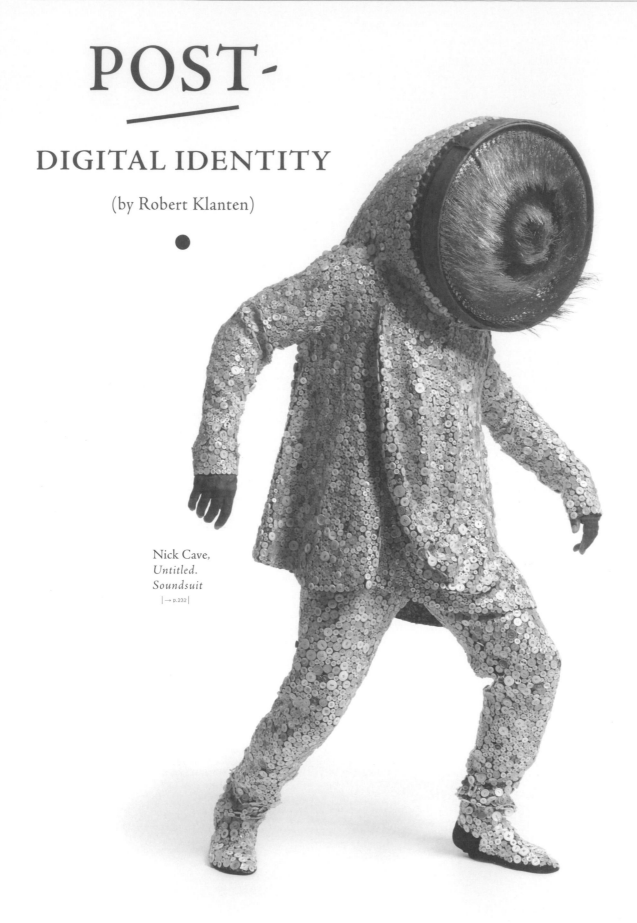

Nick Cave,
*Untitled.*
*Soundsuit*
| → p.232 |

# Who are you? Who am I?

The first attempts to depict human beings mark the beginnings of art. They have continued throughout the ages, although exploring the idea was more important in some epochs than others. Clearly there is a great demand today for investigating the form and nature of human beings.

Such investigations have always happened at times when technical upheavals were also creating or implying social consequences. Renaissance artists investigated both human mechanics and anatomy, while at the same time perfecting technical devices, such as perspective, as aids to representation.

The great social creative movements of the early twentieth century, Futurism and Constructivism, were associated with new technologies and produced radical ideas. These include the veneration of machines and war by Futurists such as F.T. Marinetti, new formal approaches for describing human form by sculptors such as Alberto Giacometti, and pioneering ideas for the application and function of media by film pioneers such as Dziga Vertov.

The Renaissance and the first half of the twentieth century saw profound technical and social changes. This is also the case today. Designers and artists are seeking to establish what can depict a human being as a human being, emotionally and formally, as an individual and as a social creature.

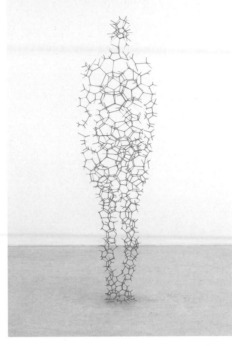

Antony Gormley, *Aperture X*

[→ p.164]

In fact, it seems that what makes us human beings—or to put it better, what we understand by being human—is changing fundamentally. Modern twentieth century man was defined by his work. The capitalist reading was that work gave people the opportunity to rise on the social scale; the Marxist reading was that work defined their class and thus their consciousness. ● In post-war America, mindless industrial activities were replaced by more complex work and services. Media such as radio and television took over the role of shaping citizens' opinions, filling people's emerging leisure time and promoting consumption through advertising.

● "LABOR IS THE WAGE OF LABOR"
(Friedrich Engels)

This modern, progressive human being, isolated within the mass, was described in a masterly fashion by writers such as Samuel Beckett, Serge Moskovici, and J. G. Ballard. In the post-modern world of the twenty-first century internet age people are coming closer to each other virtually while distancing themselves physically and personally from each other more than ever before.

A couch potato can have 1,000 Facebook friends, need never leave the house, and is independent of any random spatial or family environment, of the immediate surroundings of his physical existence.

The inner, personal cosmos of today's human beings—their self-perception, their subjective identity—is no longer based on their family context, or even their place of work, but on their interests, instincts, and what used to be called leisure.

V

The interests and instincts that we pursue and live out via the internet define our subjective experience, but then transform themselves (thanks to social networks) into consumption; and consumption becomes more a way of shaping leisure time than ever before.

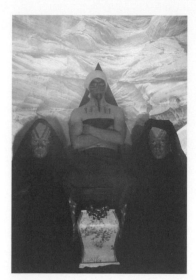

Chris Pell,
*Hoku'vale &
the Baobin
Massacre*
|→ p.212|

This is further reinforced by the fact that the internet in the Facebook era is not just a source of commodities and information, but is increasingly becoming a substitute social family. This is because even things that might be seen as low on the interest scale (such as ornamental tropical fish or early music) can and will, if seen globally, bring together a considerable group of like-minded people who can then remain in touch online.

In the internet age, unlike the Modernist era, there is also a possibility of achieving commercial success and social recognition—not by laboriously acquiring skills, but by direct acceptance within the virtual contact group. The key to success lies in digital identity, in other words, insofar as the internet is seen as a medium; it lies in the chequered world of media identity, the doppelganger of the physical human being.

The internet liberates anonymous individuals from the social constraints within which they have to function in the physical world as social beings. But the internet also liberates anonymous individuals from having to confront their group with their real human bodies. So internet identities do not have to relate to real people or groups aesthetically, formally, ethically, or morally.

Without the above-mentioned constraints, individuals are inevitably forced back to their own resources. They look for aesthetic, formal, and social anchors for a substitute identity, then find an idealized version of themselves in a self-created, artificial double—an avatar.

Many of these doppelgangers relate to idols from the media world—the world of superstars, film, and comic figures. They represent the real person in online communities. Images of doe-eyed Manga beauties represent overweight teenage girls; Trojan six-packs stand in for pimply, bourgeois boys; and disgusting pedophiles can effortlessly hide behind their Homer Simpson façades.

So the doppelgangers are not complete beings, but often reduced, abstract, and inflated artificial creatures. But also creatures who define abysses and who can often exist only under the protection of anonymity and because the World Wide Web is detached from real life. ●●

If we go along with Chris Walla, we soon realize that real life encounters are usually out of the question in real life, or at least less than advisable.

Nevertheless, and precisely for that reason, members of that group try to involve themselves with each other: the artificiality of online existence requires artificial images, new vessels, virtual clothing, and visual codes in which we can make our online existences comprehensible to ourselves and others, and dress them up, as it were.

●●
"CONFRONTED WITH OUR SIGNIFICANTLY MORE BANAL EVERYDAY LIFE, "WE'RE MEASURING OUR ACTUAL SELVES AGAINST OUR ONLINE SELVES WITH HOPEFUL RESIGNATION."
(Chris Walla)

VI

# Why can't I be you?

Many artists seek out doppelgangers in masquerade—they think up beguiling and fantastic disguises and, in this way, create artificial creatures that seem to come from other cultures. Central to this is adopting a different identity by means of disguise, playing a game.

They create elfin creatures, exotic princesses, and shamans. These identities resurrect the fantastic realism of the 1970s and especially the magic Dionysiac realism of creative artists such as Alejandro Jodorowsky.

Disguise becomes ritual, and ritual requires personality swapping. Something that was donned as a vessel becomes a cocoon within which a metamorphosis is taking place—from a caterpillar to a butterfly. Transformation and disguise are the core business of fashion and theatre.

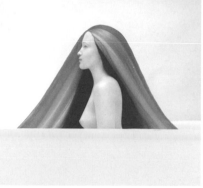

Kerstin zu Pan,
*Supervision*
| → p. 228 |

# From Leigh Bowery to Lady Gaga

In many works, the investigation moves forward by trying to establish how much or how little is needed formally to define individuals and to make them recognizable as such, and whether construction can lead to a formally convincing result.

Ultimately, digital-media individuals are not bound in their perceptions to their real physical form. Any reference to their original physical form must inevitably have the same effect as a reflex imitation of a predecessor medium by its successors.

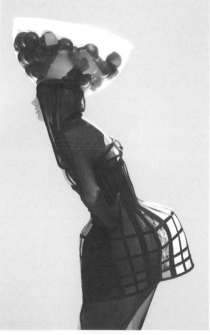

That then makes just about as much sense as websites that in the early nineties looked like printed pamphlets or e-books whose pages rustle when you turn them. This is why questions are now asked about the proportions and purposes of the human body. How can the human body be optimized as an interface for digital communication? This is a question that was discussed even in the 1990s but is now approached seriously rather than speculatively, given the ultra-rapid development of digital technology. Physical disabilities such as blindness and very serious injuries will be treatable in the foreseeable future by interfaces between flesh, implants, and chips. Everything that is being researched in order to restore a function that was previously available is also being interrogated in terms of its aesthetic possibilities.

In other words, restoring lost capabilities and optimizing existing capabilities in healthy human beings in the required way are inevitably linked.

Approaches to the amorphous human form via computer algorithms are made using wireframe models. The curves of the human body are broken down in to small vectors and segments, and this aesthetic is now also used to describe the human body formally and artistically.

Ara Jo, *A/W
Whitemare
Collection*
| → p. 179 |

But many artificial beings deconstruct human form, allot different functions to parts of the body, and play with clothing and covering. A human body does not have to be symmetrical in order to fulfill its function in the best possible way (see tennis elbow). Dysfunctional fashion, artificial implants, accessories, and asymmetrical proportions are extensions to the function-concept of fashion, shifting the concept of personal identity beyond current fashion tastes. In the late 1970s, artist Leigh Bowery's costumes were essentially the same kind of thing that Lady Gaga has made into a mainstream act, successful all over the world today (or does anyone seriously believe that her success is due to her music?).

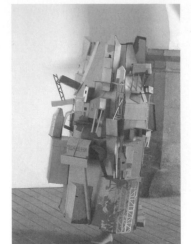

Emily Speed,
*Inhabitant*
| → p.84 |

But in addition to the above-mentioned effects on people's aesthetic and formal self-perception, the digital age has also triggered considerable changes to people's emotional and social self-perception: because of the disappearance of social constraints and people's apparent anonymity, they focus more strongly on themselves or their virtual group, and often emphasize two remarkable reflexes in the group—denial and aggression. ●●●
In his Kafkaesqe novel *The Box Man*, Japanese author Kobo Abe describes a man who decides to move into a big cardboard box one day, so that he can deliberately reject anything as strenuous as individuality.

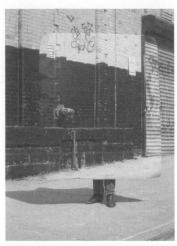

Frederic
Lebain,
*New York
Wallpaper*
| → p.61 |

Abe and his Box Man both provoke the world around them by declaring that striving for individuality is radical non-conformism. Melting into the background, being imperceptible as a person, represents both personal escape and social provocation for the Box Man. Not wishing to confront the search for identity, or the pressure to create an identity for oneself, but to withdraw, is also extremely attractive as an artistic theme.

●●●
"IT IS NOT DIFFICULT TO BECOME A BOX MAN. ALL YOU NEED TO DO IS THROW EVERYTHING AWAY— JOB, FAMILY, CREDIT CARD, EVERYTHING YOU HAVE—AND FIND A BOX. FOR EX- AMPLE, THE KIND OF BOX THAT REFRIGER- ATORS ARE DELIV- ERED IN. YOU TEAR THE BOTTOM OUT, CUT A PEEPHOLE IN THE SIDE, AND MOVE IN. TOTAL ALIEN- ATION, TOTAL FREE- DOM, TOTAL REJEC- TION OF SOCIETY. FROM THEN ON YOU ARE AN INSULT TO THE WORLD."
(*The Box Man*, Kobo Abe.)

VIII

# The Inner Troll

The digital age has also lent a new quality to the anonymity of dealing with each other in another respect. Hidden behind generic user names and protected from being accountable to fellow citizens and the state, asocial, animal behaviours come to the fore.

The relative absence of power and social norms—the loss of taboos—do not necessarily change people's nature to their own and their fellow human beings' advantage, as we know from a whole variety of social and psychological experiments. As long as average citizens are sure of not being caught, or are assured that they will get away with it unpunished, they steal from and torture their fellow human beings with an almost complete lack of inhibition.

The internet makes users subjectively anonymous: they put on masks under which the doppelgangers begin lives of their own and can sweat out the most negative elements of our human existence.

An improvised role-play is launched, and the plot evolves according to the extent that our virtual environment responds to us. What ensues are primeval animal instincts, tribalistic orgies of power, and appropriation.

Jaron Lanier calls the chauvinistic and sadistic monster concealed within most of us, when it is truly awakened, the "Inner Troll."

Thus the digital world is also the realm of the trolls—inhabited by people who, protected by their anonymity, allow themselves to be carried away to make statements and come up with insults, with hate and smear campaigns they would probably never confront their victims with in real life.

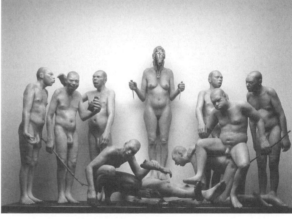

The trolls fall into a trance, form a flash lynch mob, and become intoxicated with their own power, the power of the like-minded group, the impotence of their victims, and the intimidated silence of their neutral surroundings.

Anonymity and the lack of social constraints—the feeling of being alone and helpless on the one hand and, on the other hand, expressing virtual bloodlust, violence, chauvinism, and power—are themes of the artistic approach to identity. What did human beings look like before civilization, and what will they look like after civilization. How do people and the world actually function?

Richard Stipl, *Block Sabbath II* |→ p.210|

The artists, photographers, and designers in this book use a variety of strategies in their attempts to capture the nature, form, and extended self-perception of the human being.

It is definitely not that artists, photographers and designers invent substitute identities for the internet; they are looking for what makes human beings today, driven by the reinvention of and search for identity in the digital world. Exploring what deeply concerns people emotionally and representing it pictorially is one of the most interesting things happening in art and visual culture today.

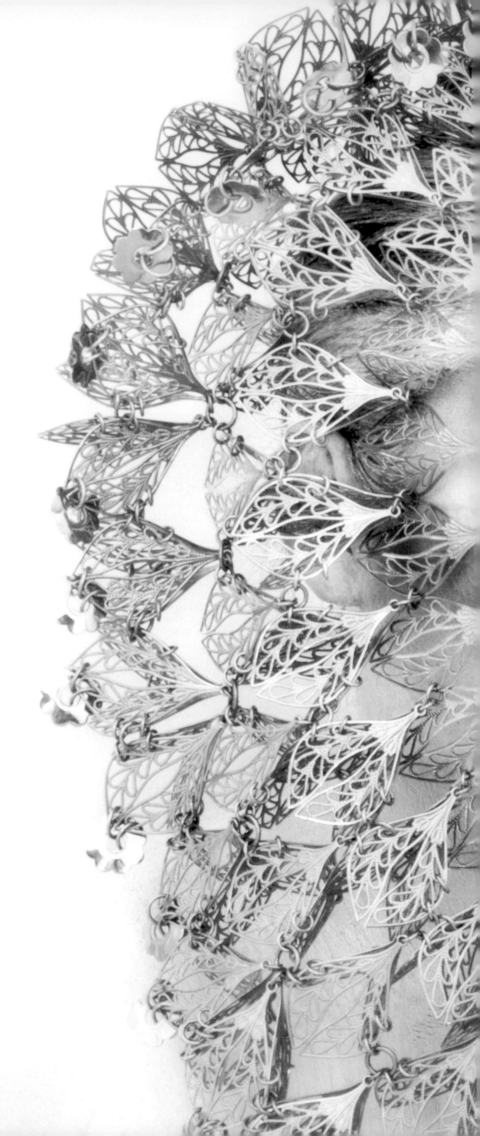

# EMBODY

(Escaping identity)

Kimiko Yoshida, 2010

*Painting (Sioux Chief Sitting Bull).*
*Courtesy Paco Rabanne's Heritage.*

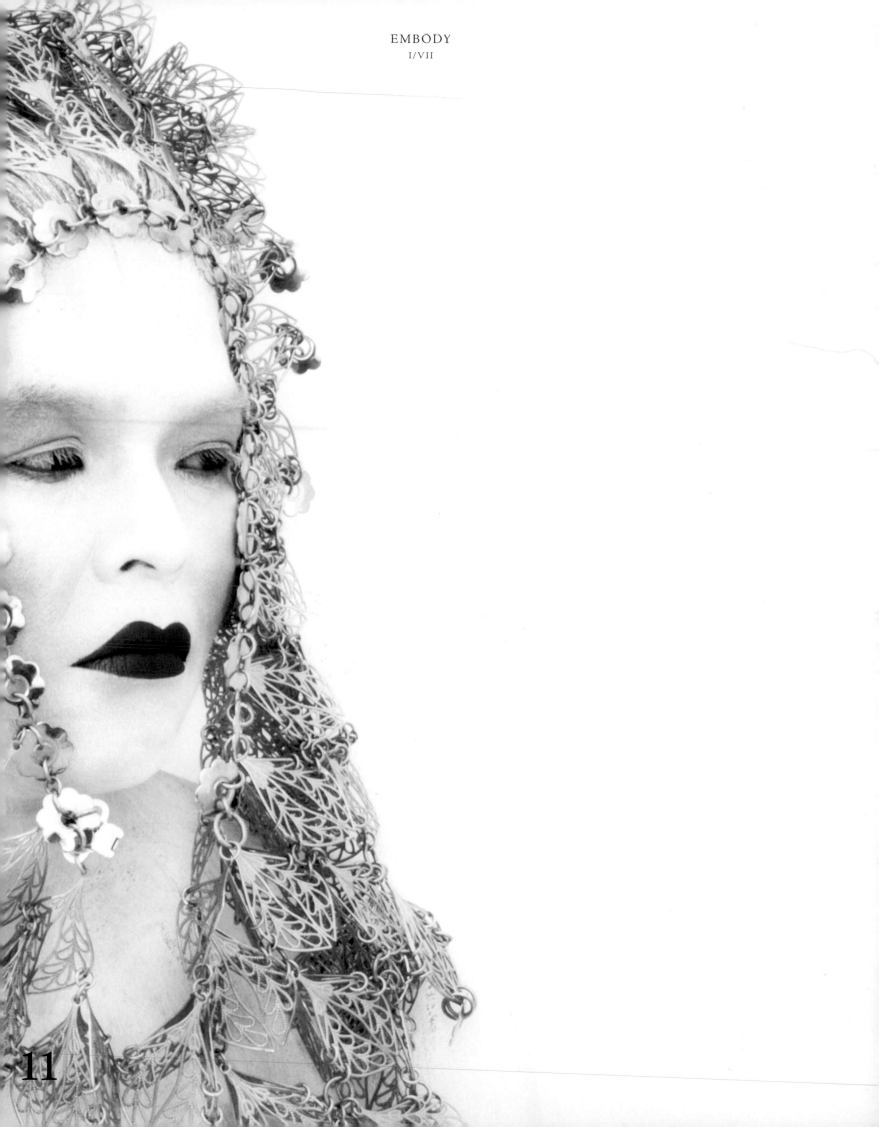

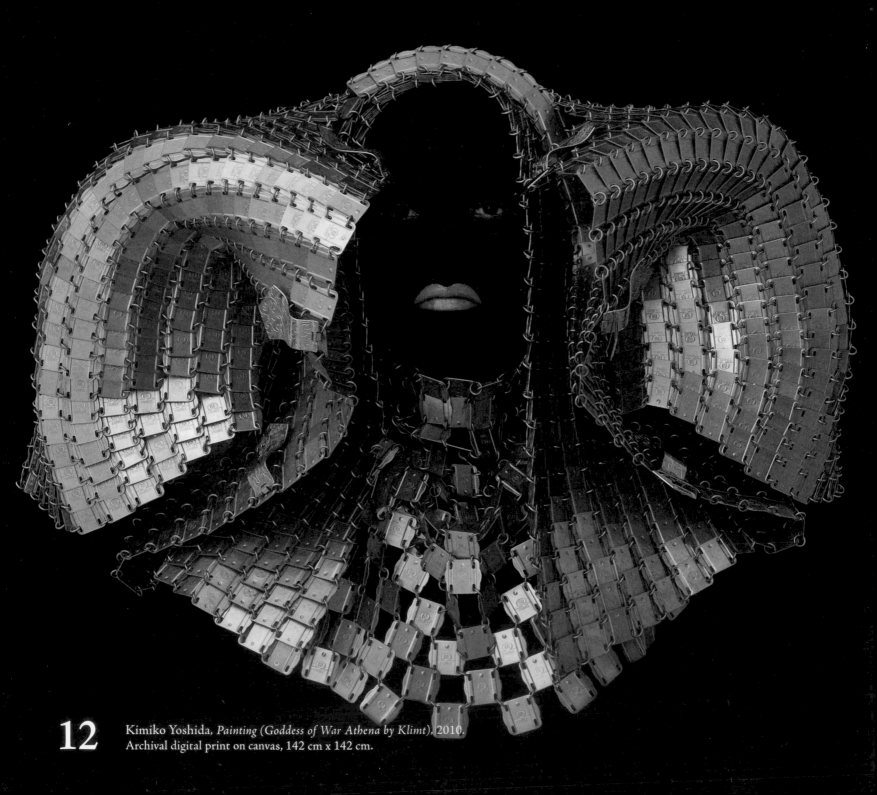

**12** Kimiko Yoshida, *Painting (Goddess of War Athena by Klimt)*, 2010.
Archival digital print on canvas, 142 cm x 142 cm.

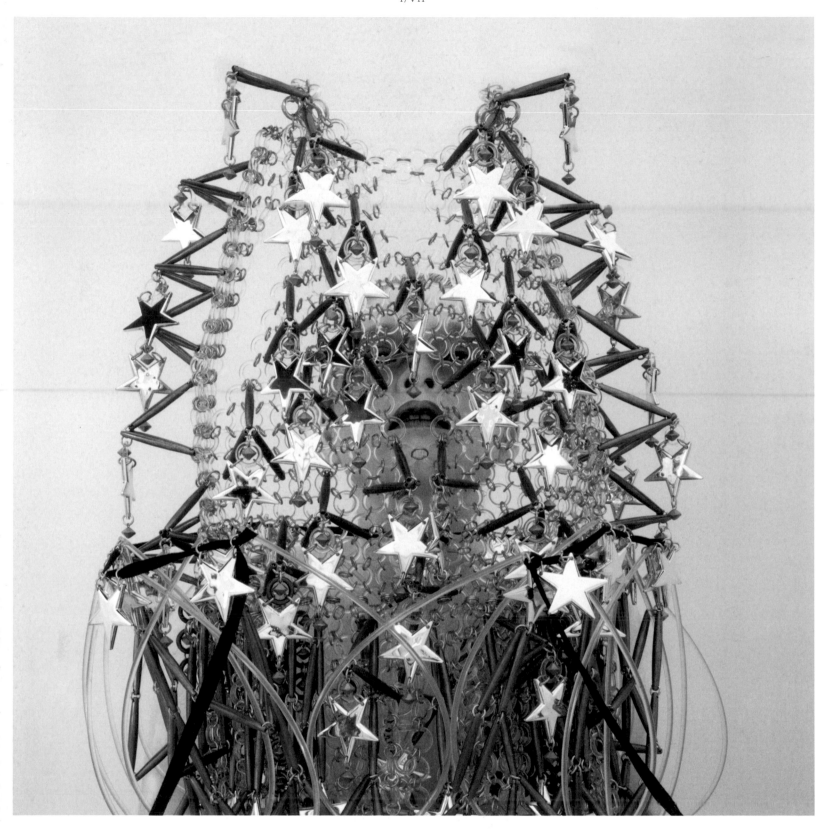

Kimiko Yoshida, *Painting (Wise King Balthazar by Gentile da Fabriano), Self-portrait*, 2010.
Archival digital print on canvas, 142 cm x 142 cm.

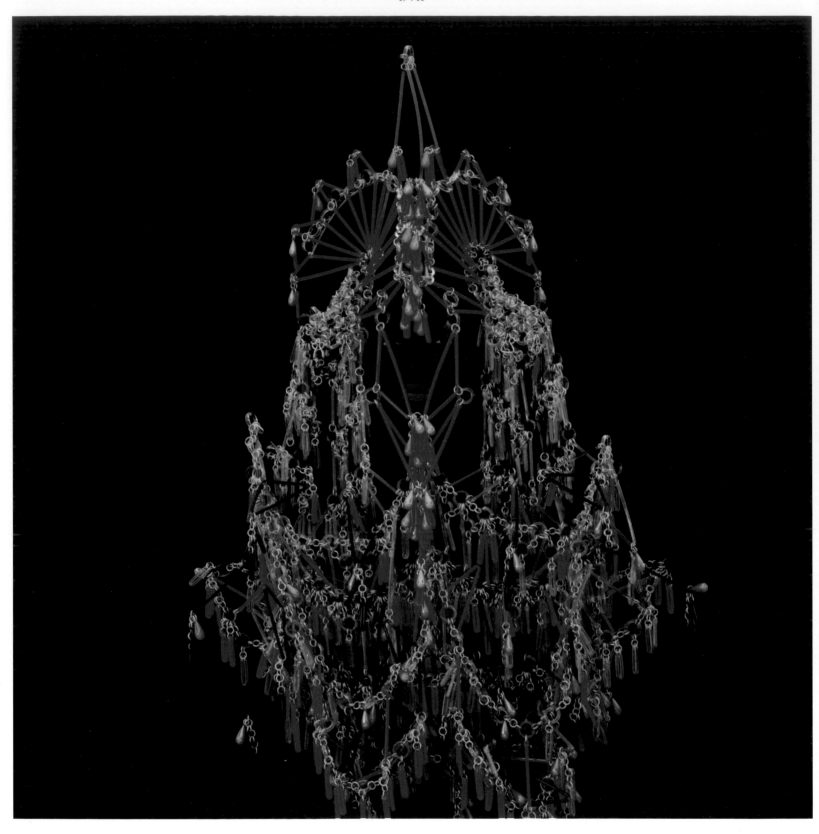

Kimiko Yoshida, *Painting (Tattoed Salome by Gustave Moreau), Self-portrait*, 2010.
Archival digital print on canvas, 142 cm x 142 cm.

**15** Kimiko Yoshida, *Painting (Condottiere Micheletto da Cotignola at the Battle of San Romano by Paolo Uccello), Self-portrait.* 2010. Archival digital print on canvas, 142 cm x 142 cm.

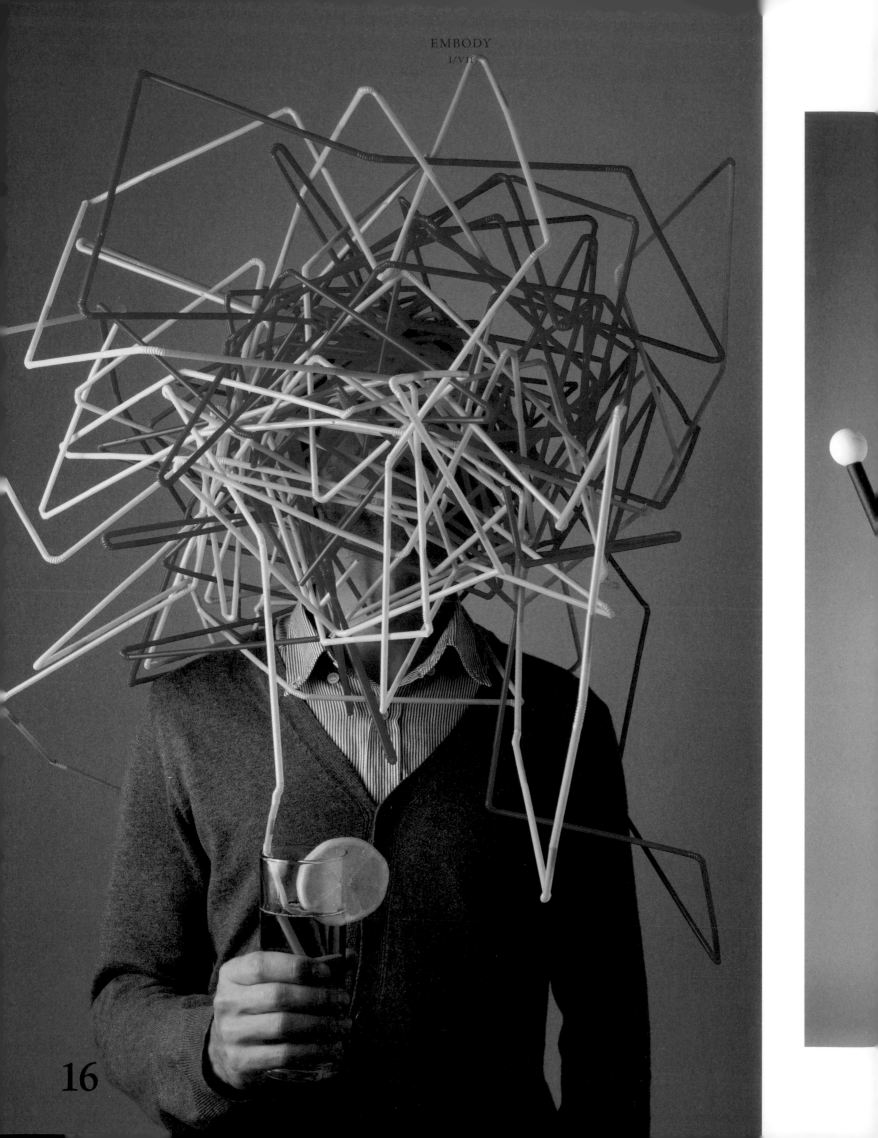

16

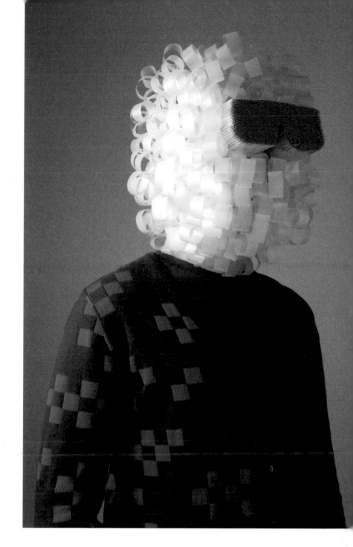

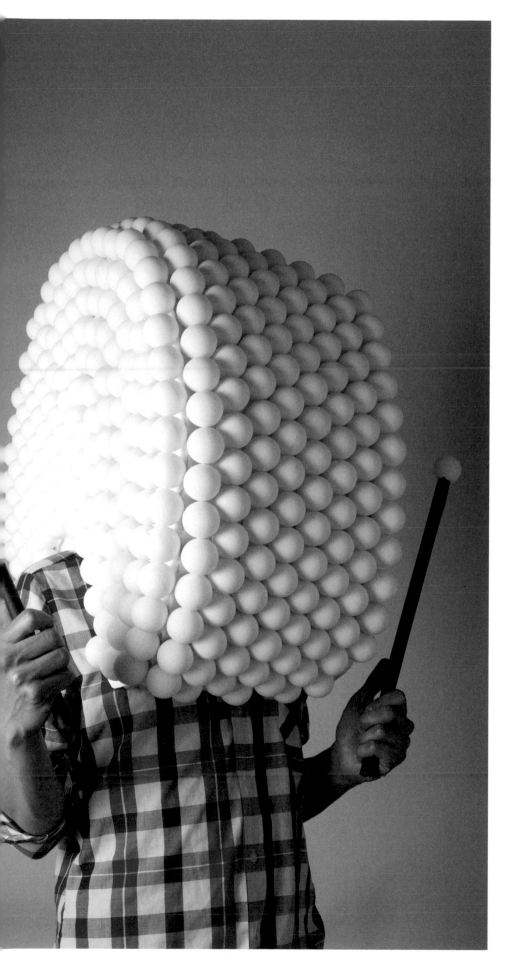

Akatre
*Mains d'Œuvres*, 2009.

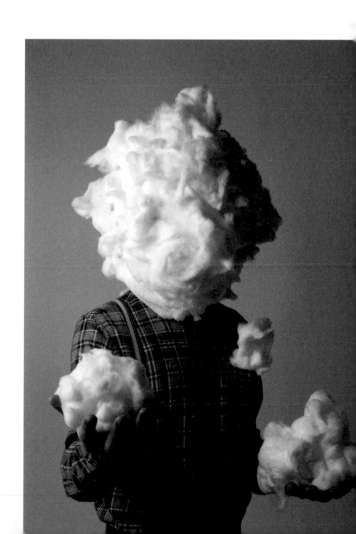

Levi van Veluw

*Landscape II, 2008.*

Levi van Veluw, *Veneer III*, 2010.

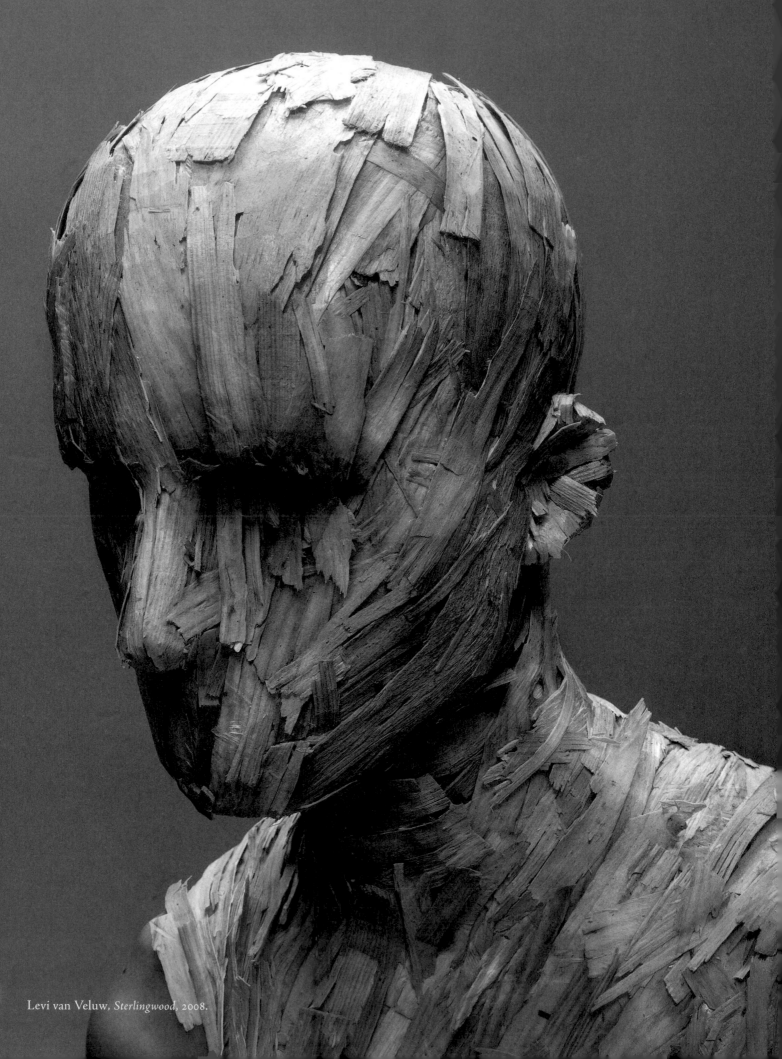

20 Levi van Veluw, *Sterlingwood*, 2008.

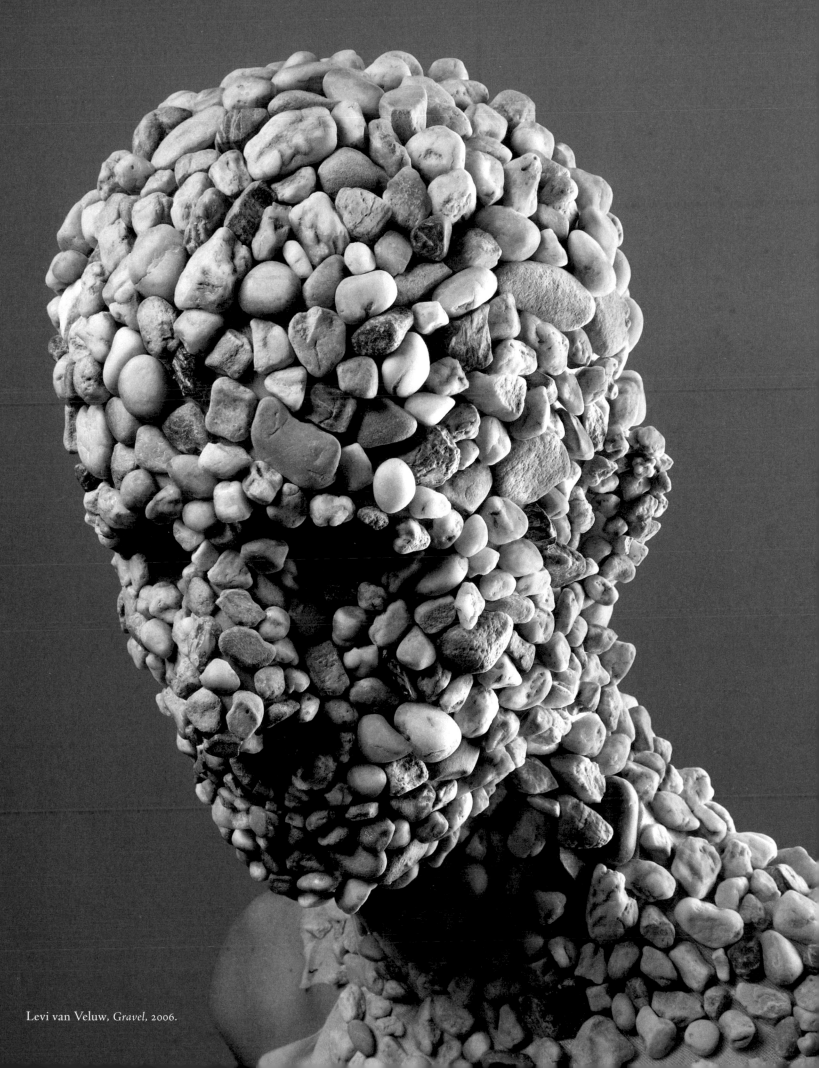

Levi van Veluw, *Gravel*, 2006.

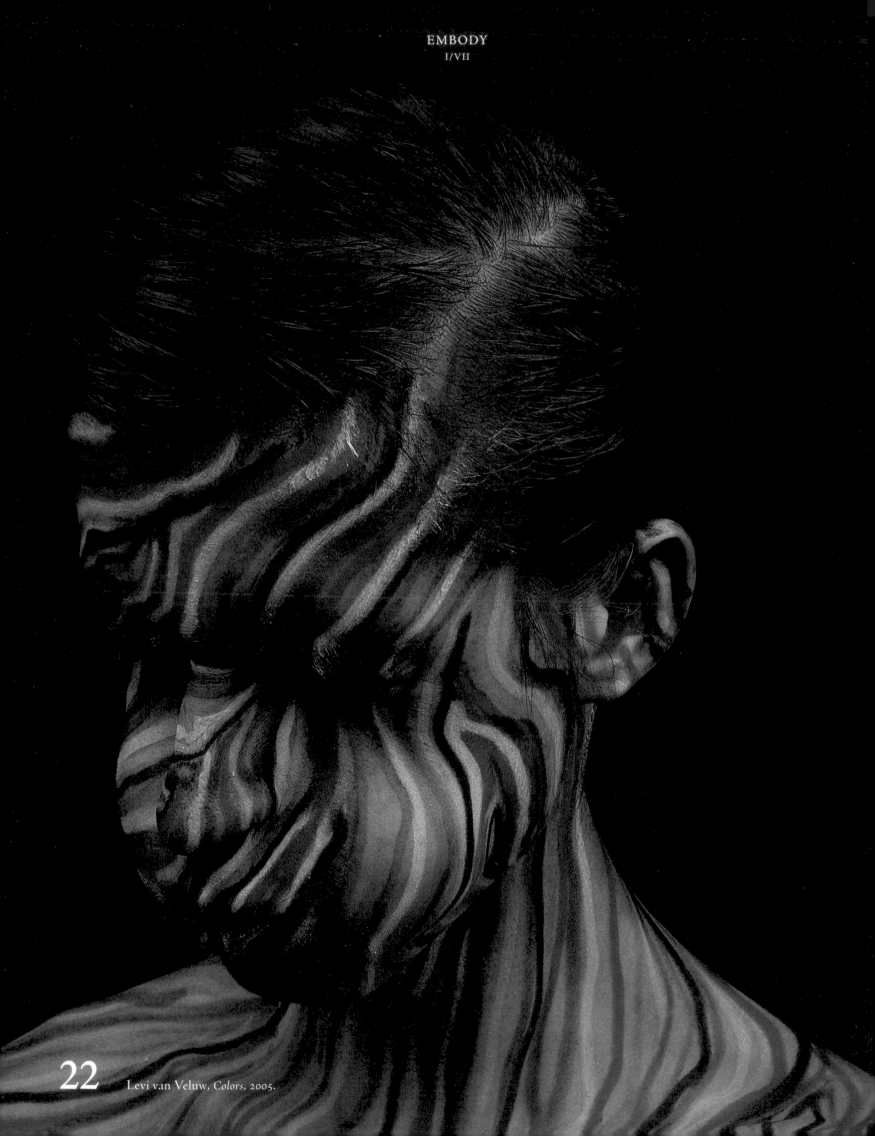

Levi van Veluw, *Colors*, 2005.

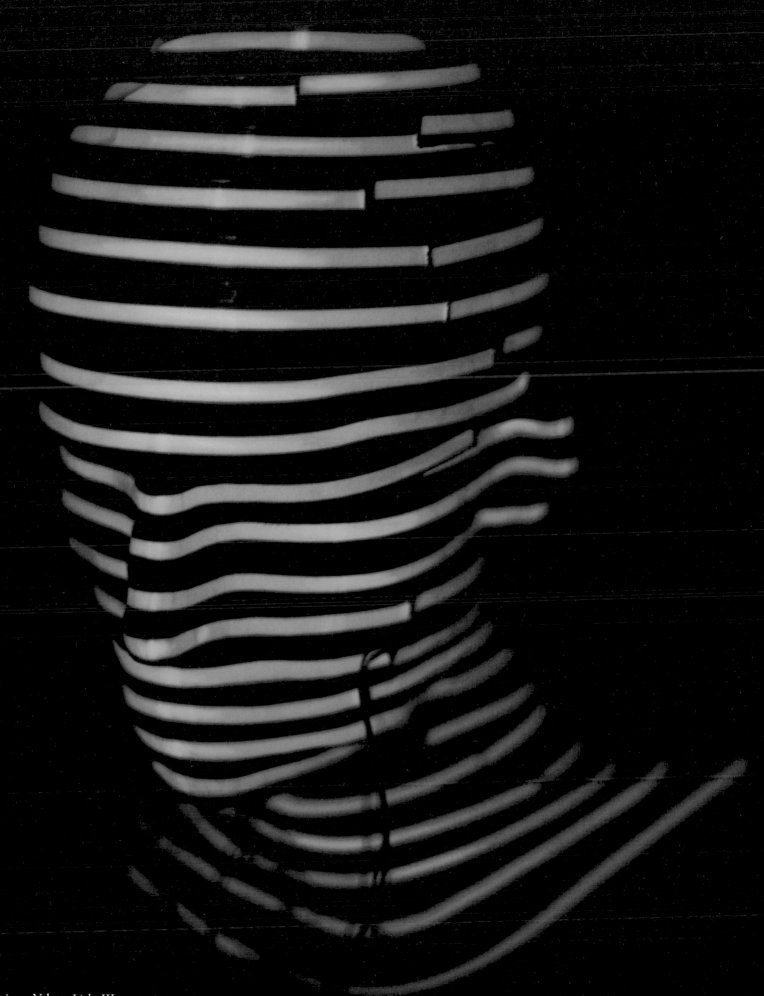

Levi van Veluw, *Light III*, 2009.

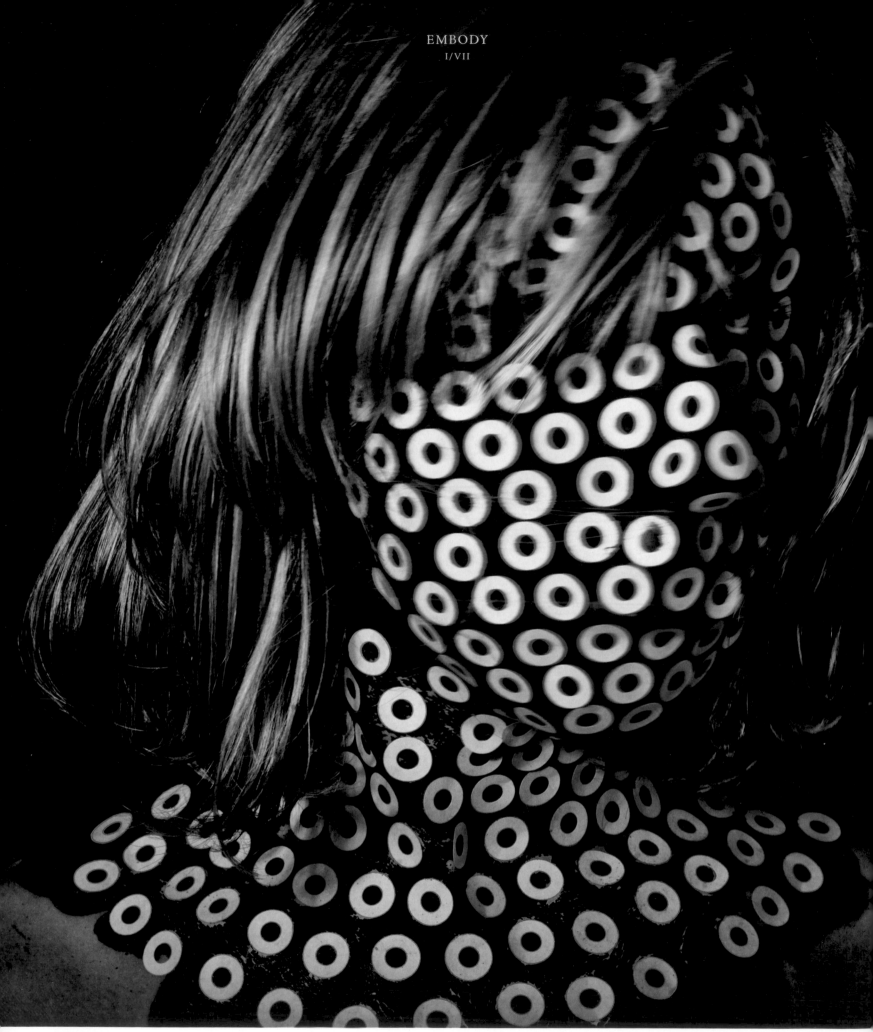

*Untitled,* 2010.

24   Betsy VanLangen

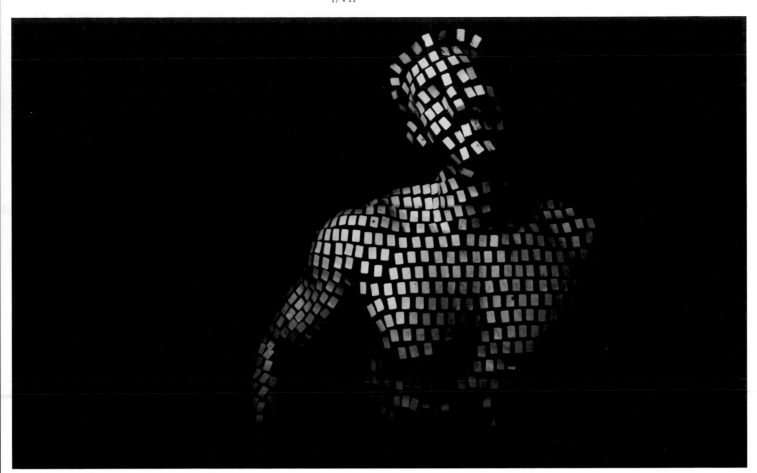

*Untitled.*

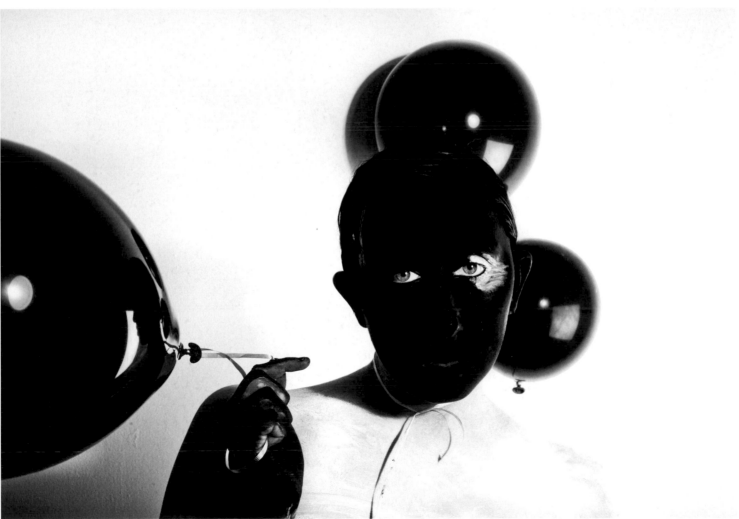

*Black Balloon.*

Daikichi Amano

*Human Nature Art, 2007.*

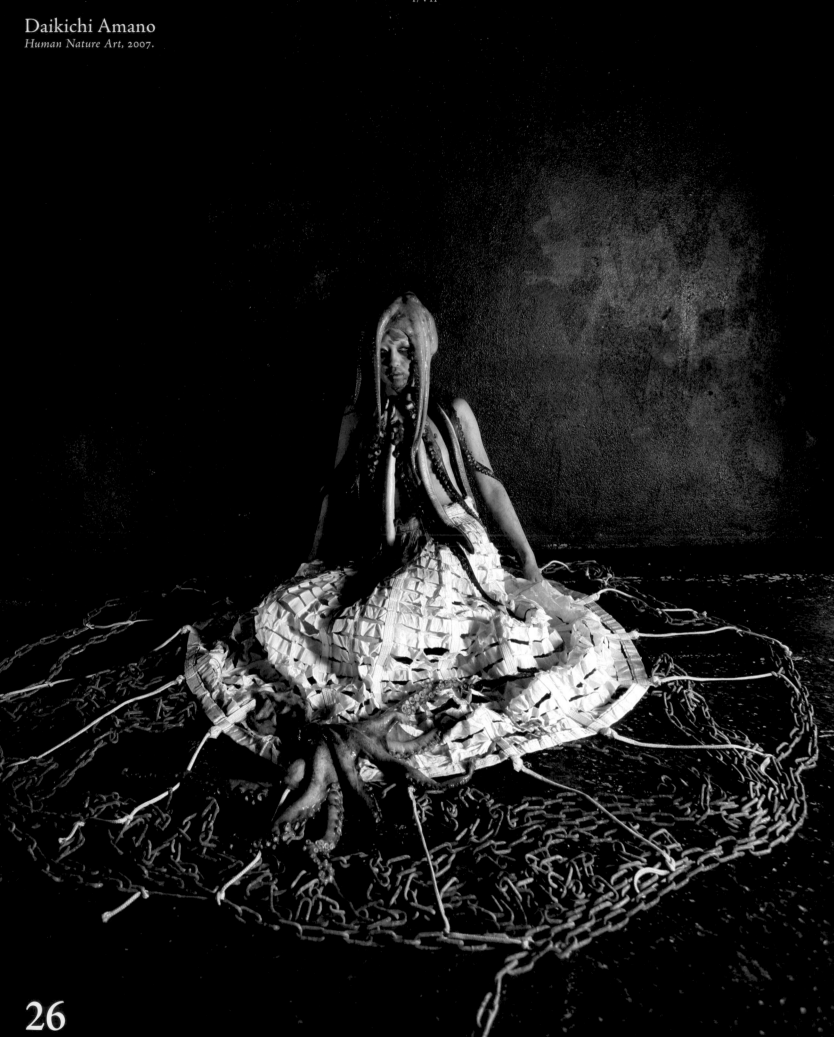

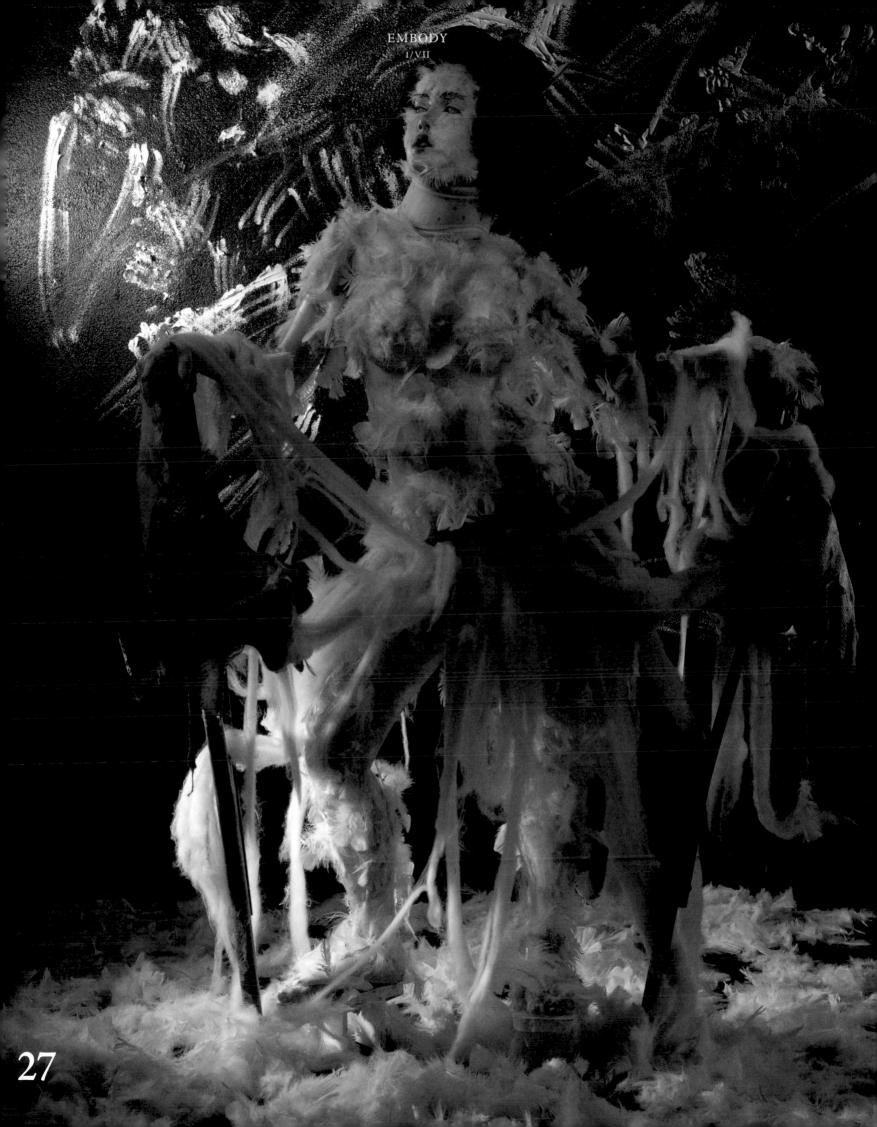

Rachel de Joode
*The Legends of Stick-On Faux Marble*
*and Eternal Grey Dreams, 2008.*

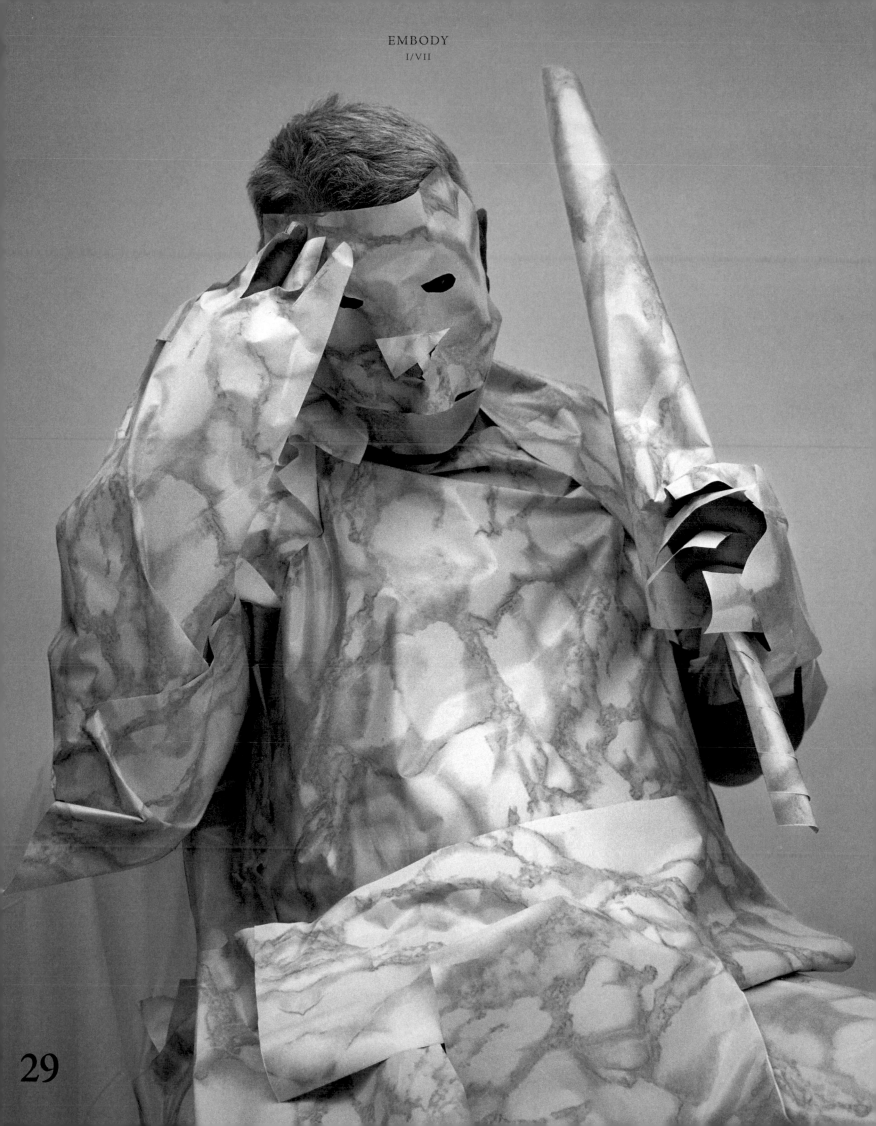

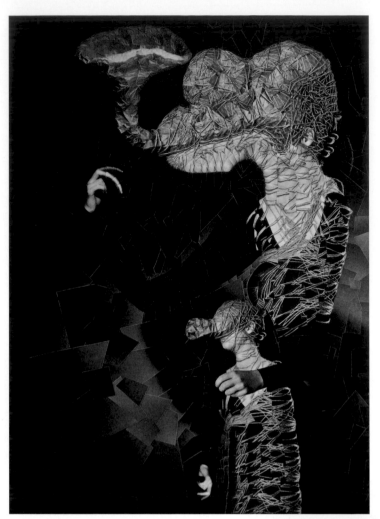

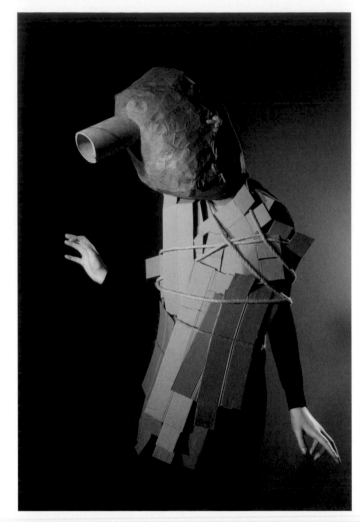

## Madame Peripetie

COOPERATION WITH LOLA DUPRÉ

*Con-de-struction (Paper Monsters)*, 2010.

And here they come—these shamanistic hybrids—half-human, half-sculpture, rising from the simplest, most conventional materials—glue, cord, and tape. Merging into some sort of mythological creature, they come together only to be captured by the camera before disassembling into numerous, disconnected elements again. Squeezed into a two-dimensional picture in the printing process, they are then re-cut and transformed into a complete, unique, yet undiscovered species. Each new creature is constructed manually by the multiplication of the same depiction that is then glued together to form a brand new composition, "evolutionizing" the old one.

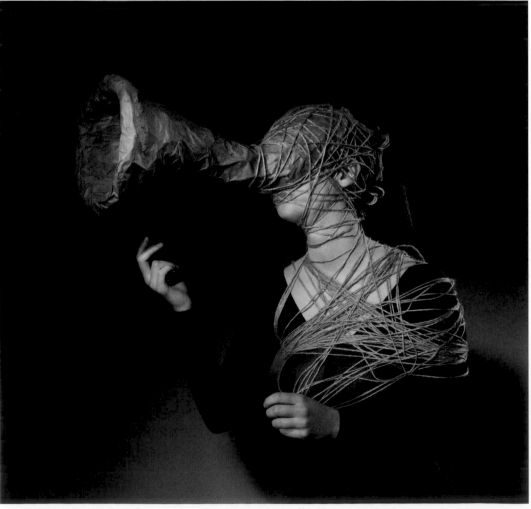

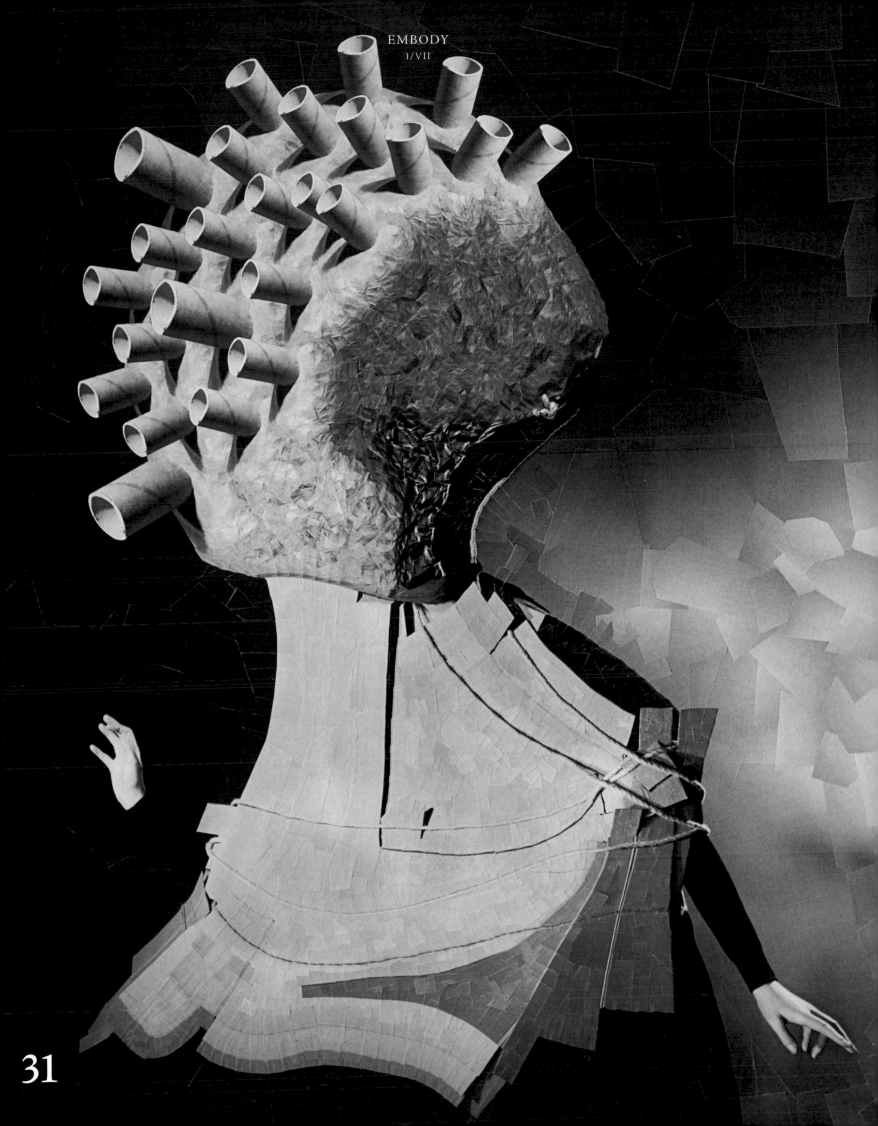

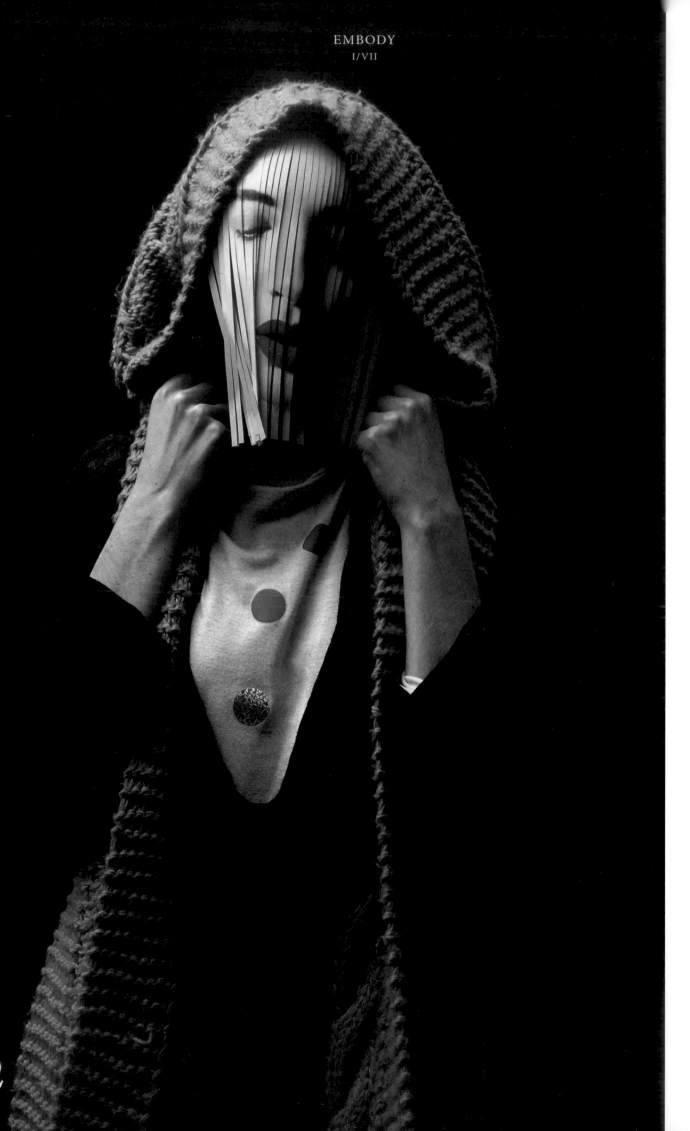

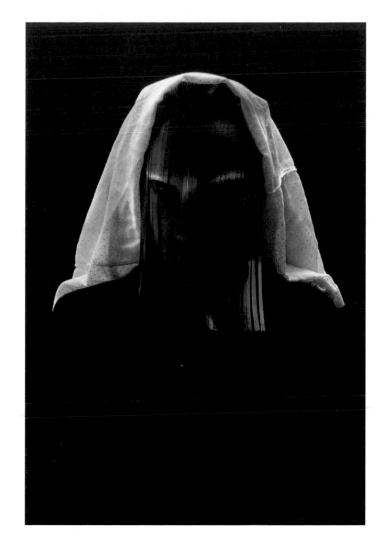

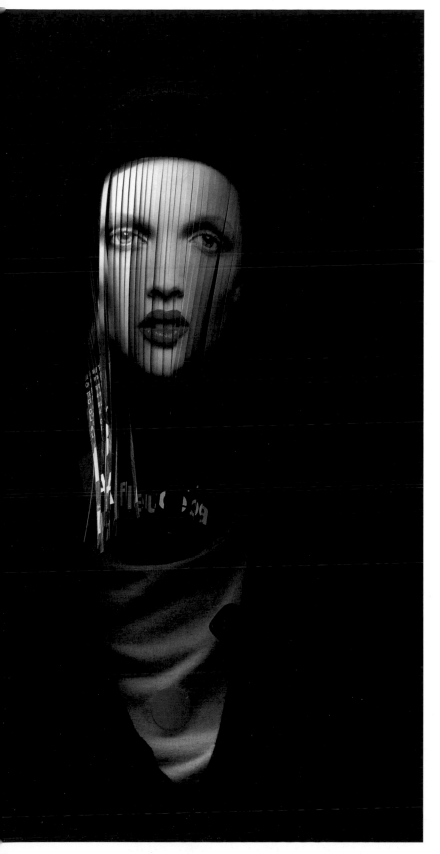

Frederique Daubal

*Hide & Seek, 2010.*

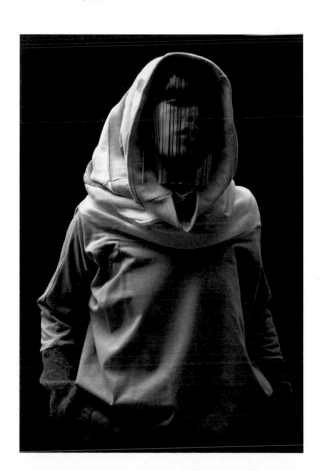

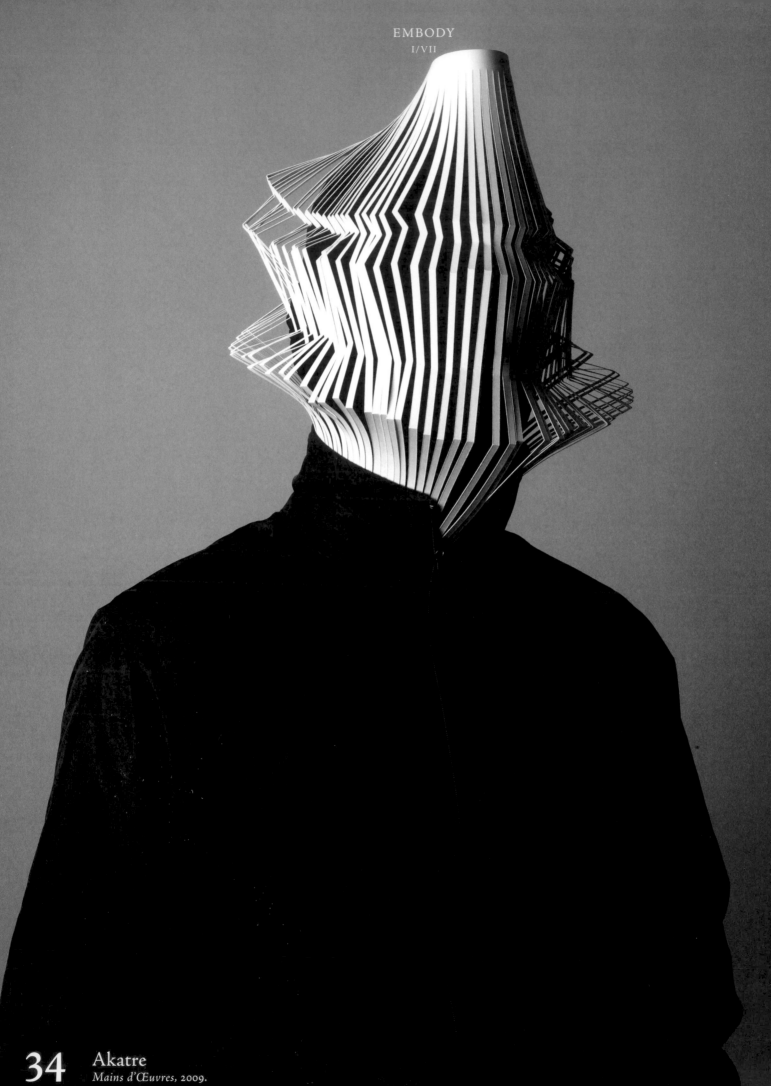

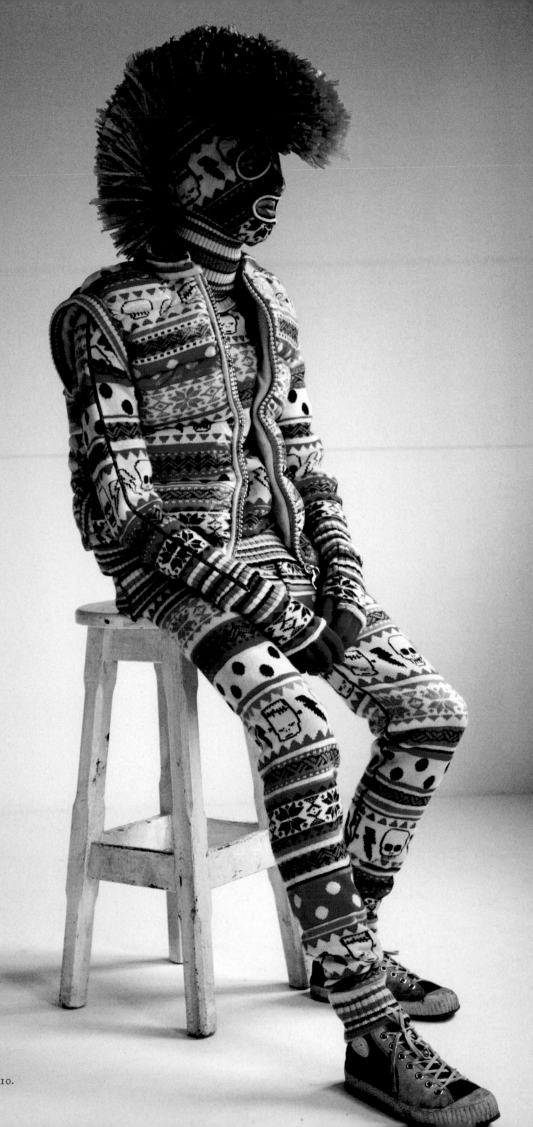

Sibling
*Scare Isle Knit Monster, 2010.*

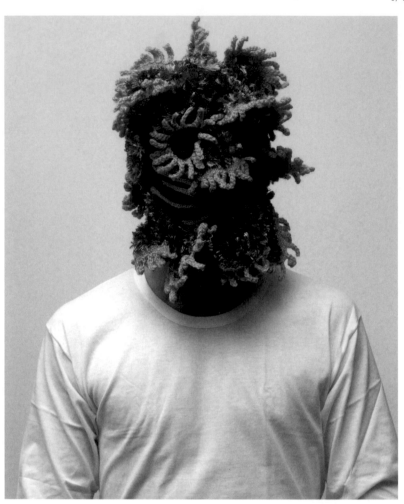

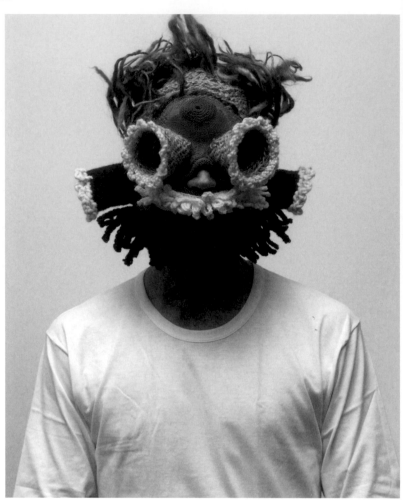

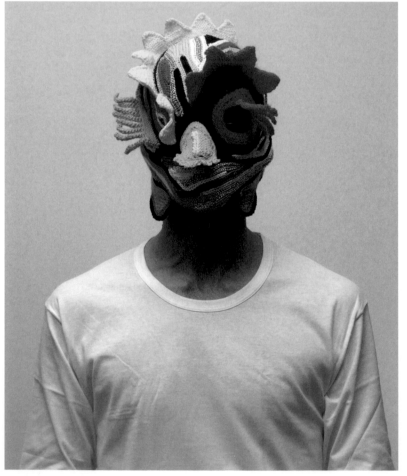

## Aldo Lanzini

Crochet for faces from the series: *The Eyes Are There Where They See, the Things Are There Where They Are Seen*, 2009.

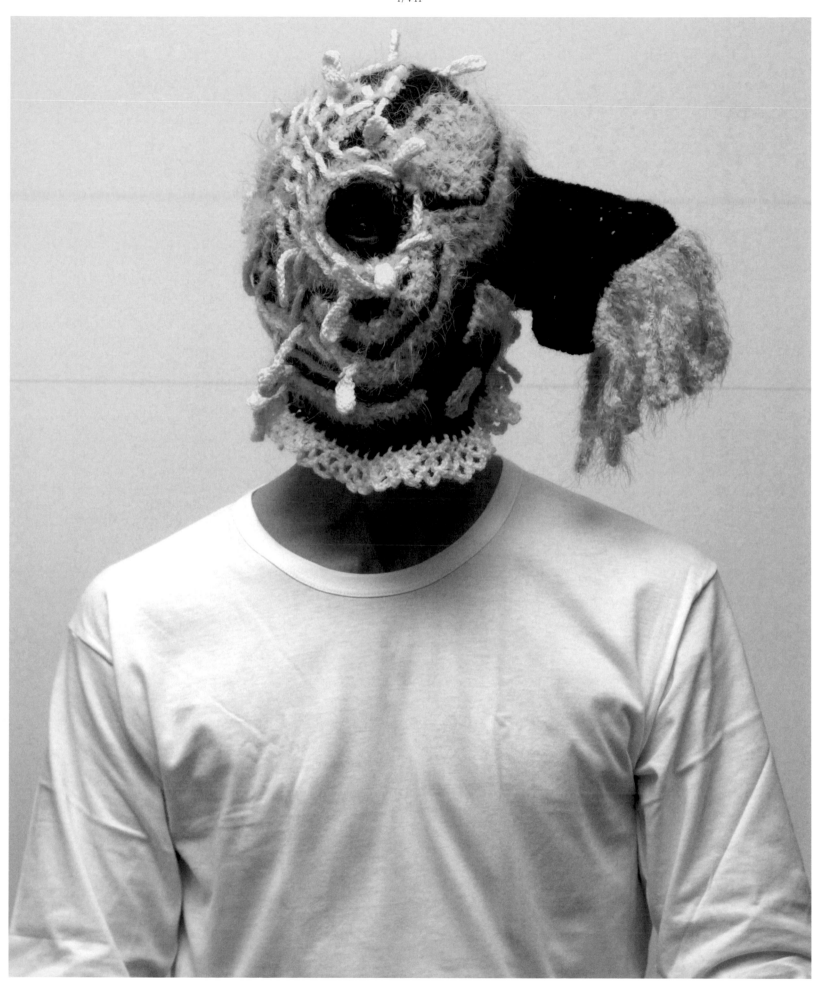

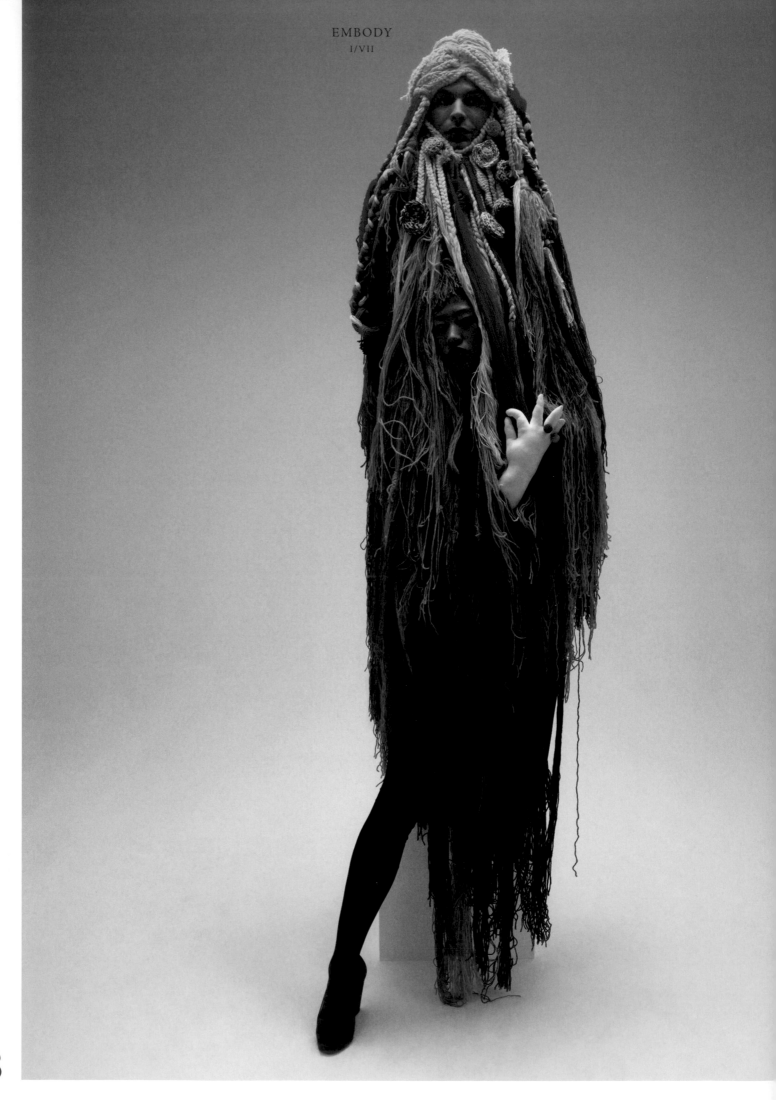

# Elene Usdin
*La barbe bleue*, 2006.

A free interpretation of the fairytale *La barbe bleue*, the story of a very bad king who scarred his wives and killed them. The women of the fairytale seem to be only broken and scarred dolls.

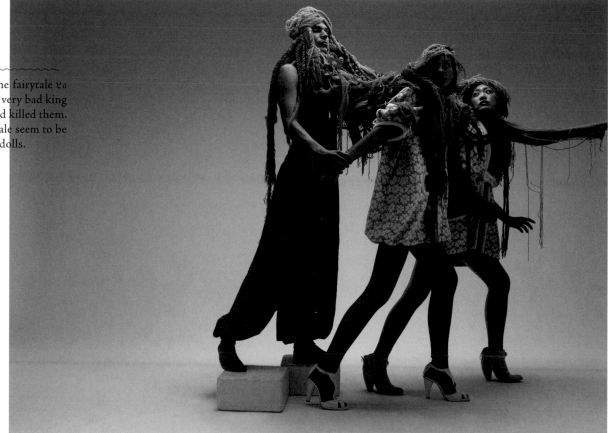

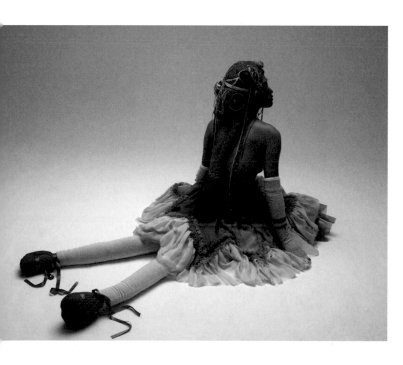

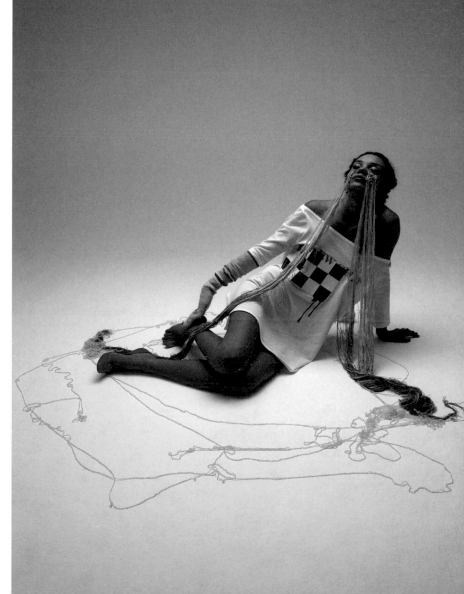

**39**

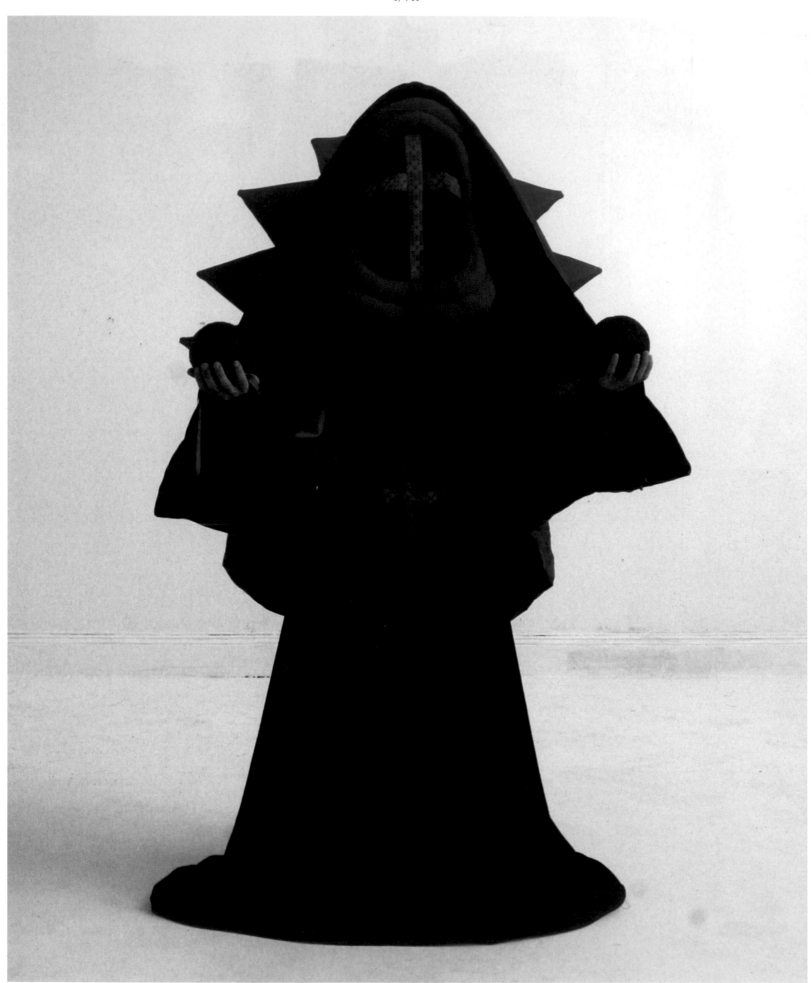

**40** Nadine Byrne
*The Nun,* 2009. Wearable textile sculpture.

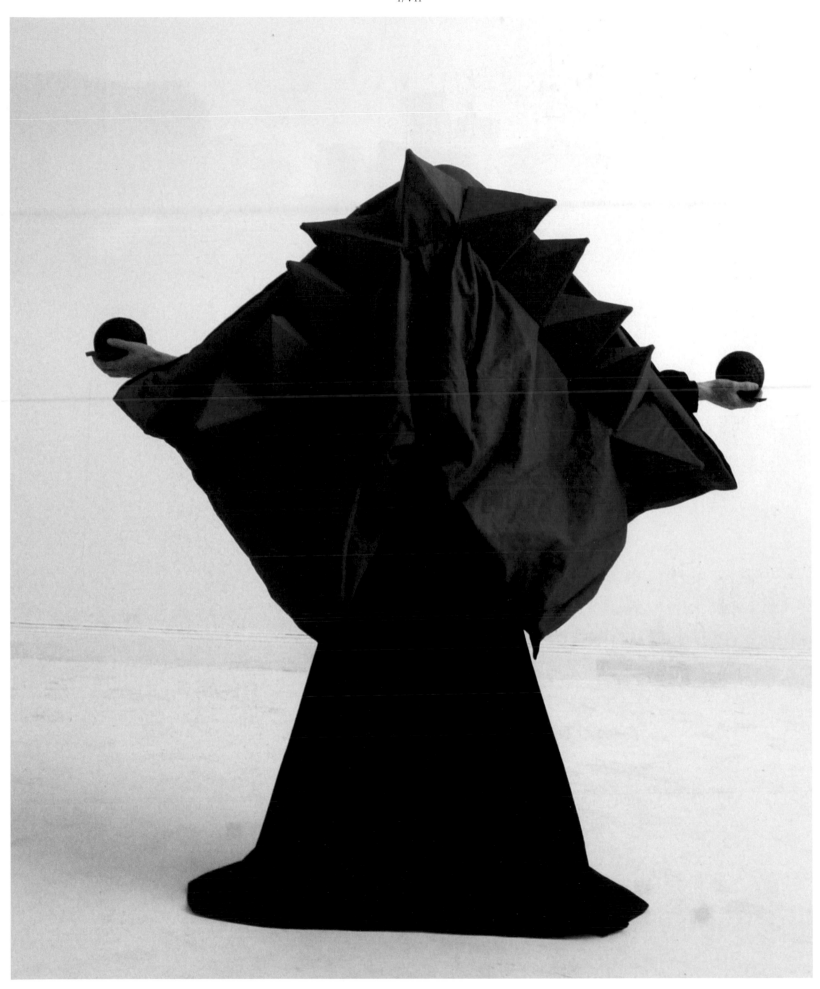

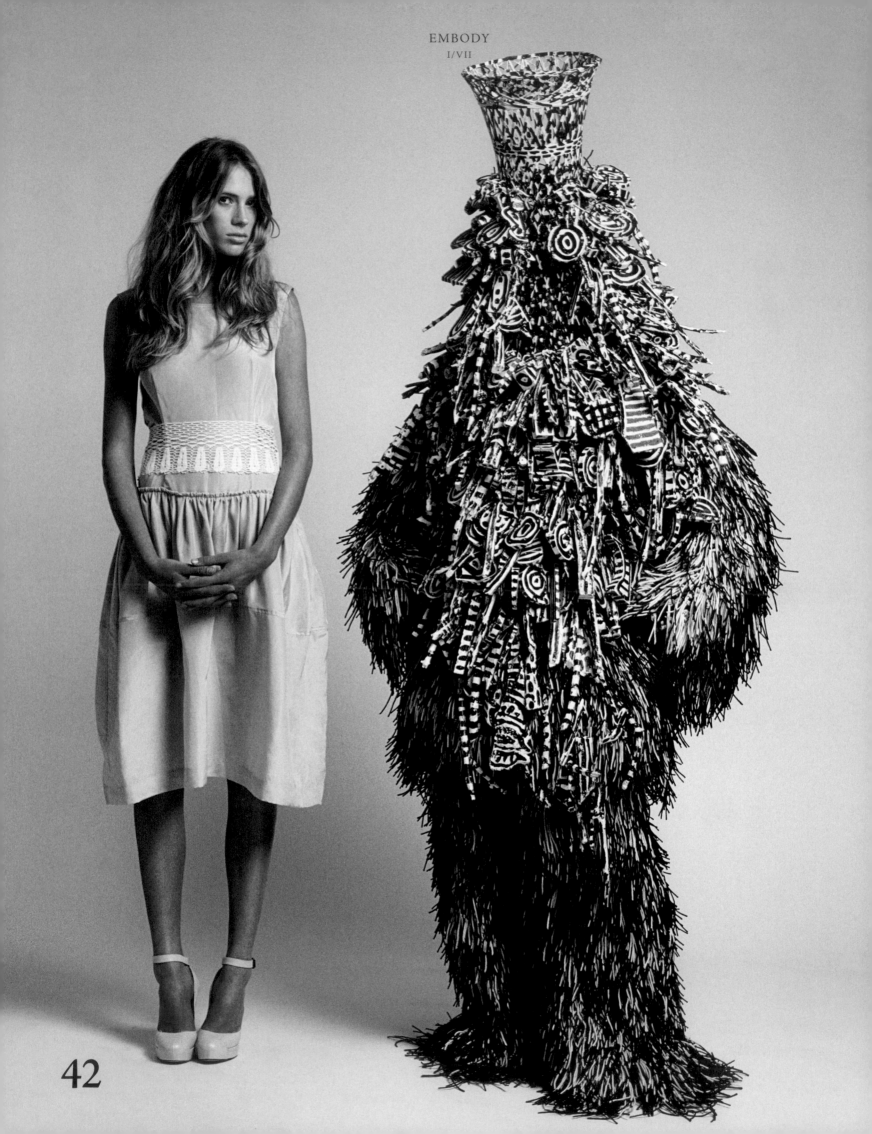

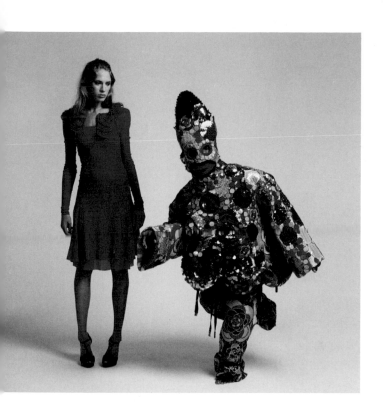

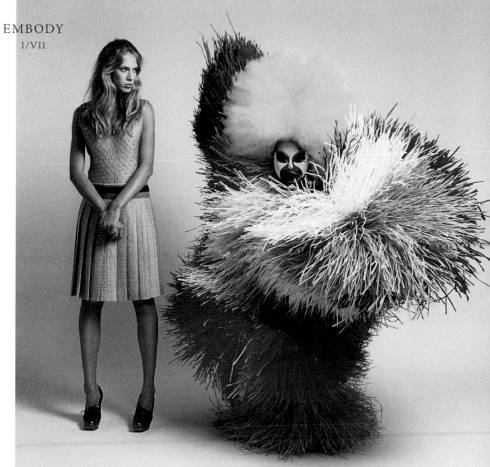

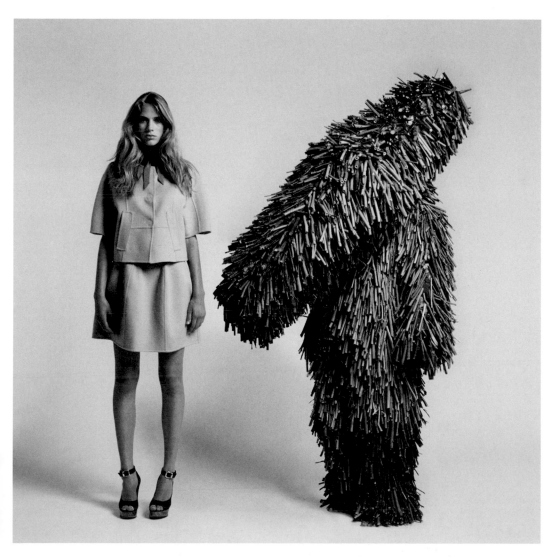

## Ted Sabarese
*Dry Clean Only,* 2007.

One in a series juxtaposing artist Nick Cave's |→ p.222| "creature couture" with fall fashion, for CITY Magazine in September 2007.

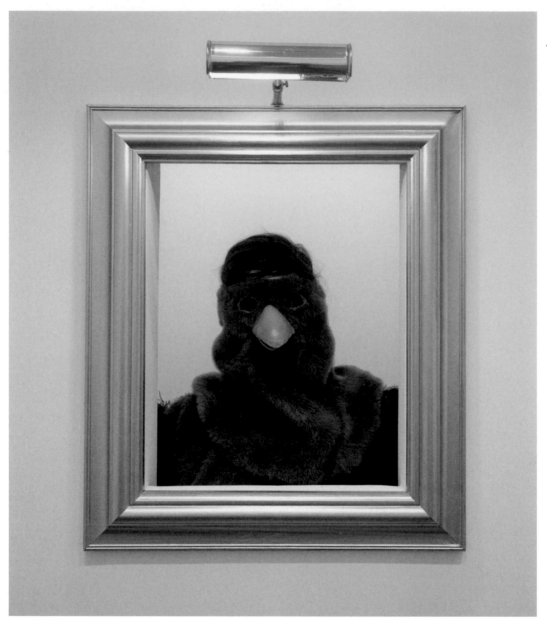

## Jamie Isenstein

*The Egress*, 2007, Hammer Museum, Los Angeles, USA.

The legendary half-bird/half-artist hybrid creature. The Egress, a creature promised but never delivered by the American showman PT Barnum, made its first appearance at the Hammer Museum, Los Angeles, CA in 2007.

## Flabbyhead

*Untitled*, 2005.
One picture, two moirés.

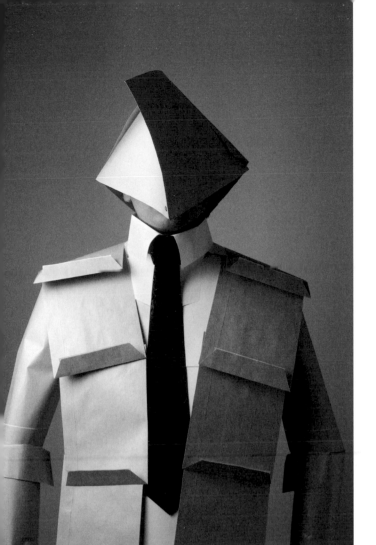

## Akatre
*Mains d'Œuvres*, 2009.

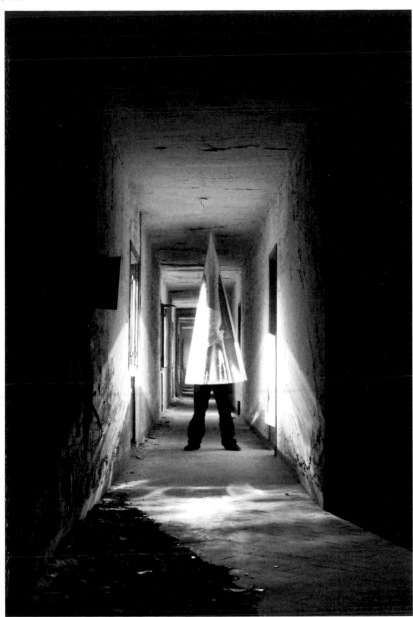

## Ganz Toll
*Der Kegel*, 2008, Parque Nacional Los Alerces, Chubut, Argentina.

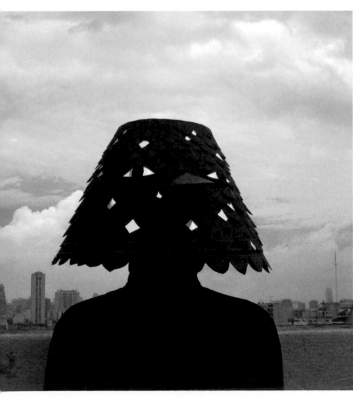

Ganz Toll, *Ave Nocturna*, 2010, Buenos Aires,
Argentina. Magazine cover made for "Carta de Publicidad."

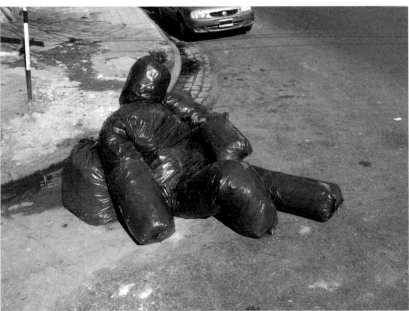

Ganz Toll, *Descartable*, 2009, Buenos Aires, Argentina.
Filled with 100% real garbage.

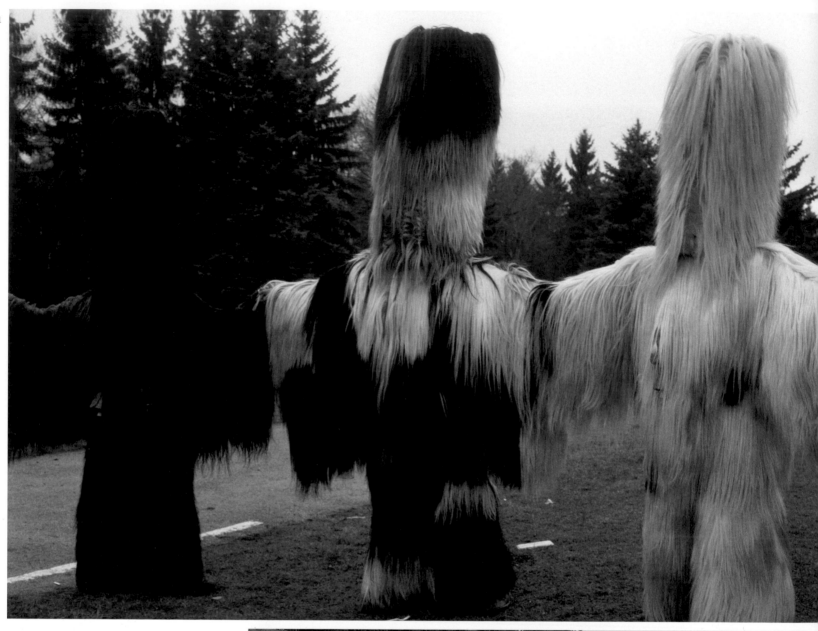

Estelle Hanania

**1**
*Parking Lot Hydra, 2009.*

**2**
*Demoniac Babble, 2007.*

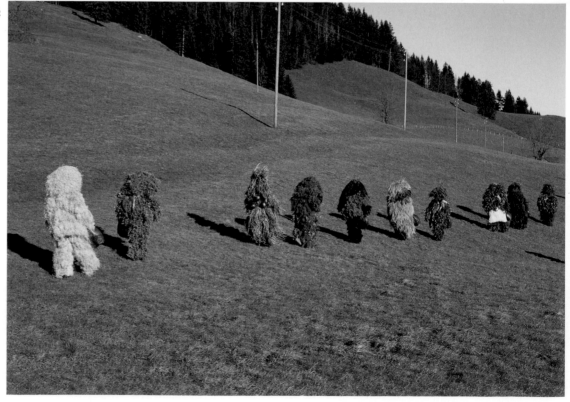

46

1

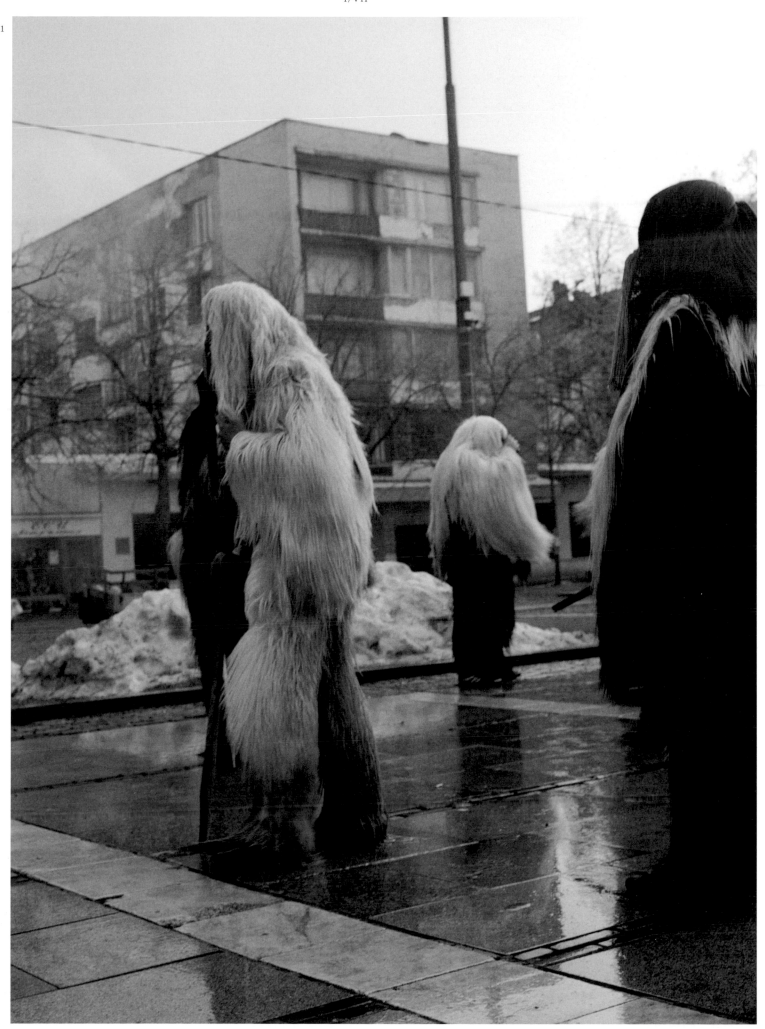

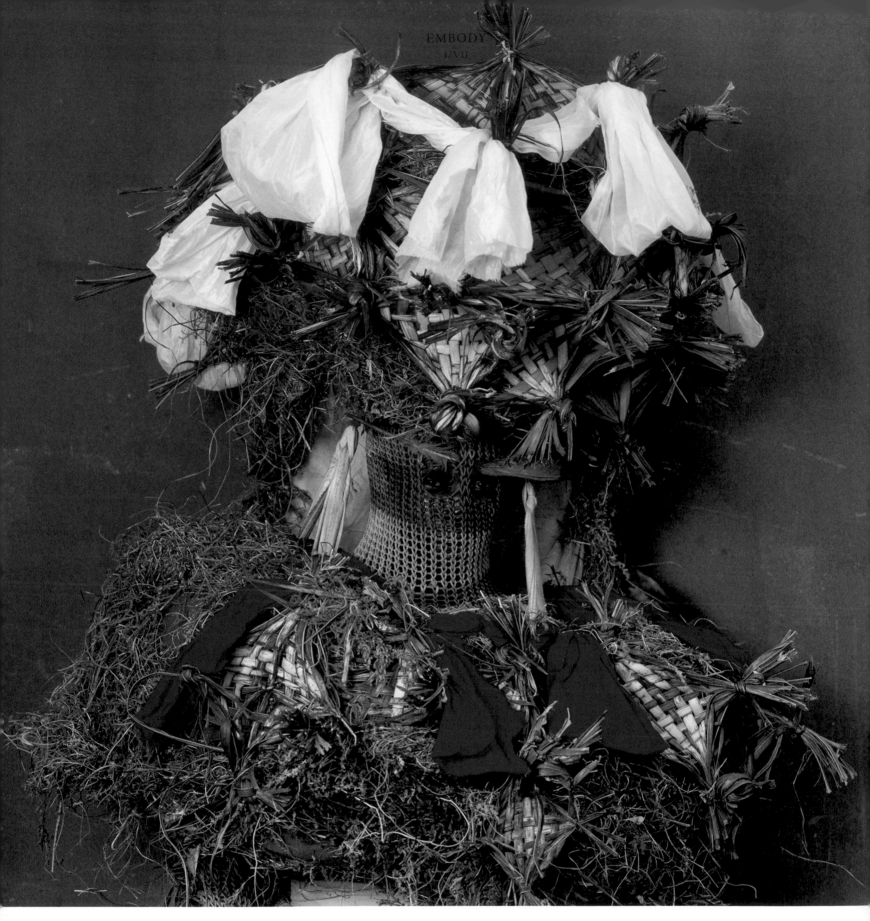

Phyllis Galembo
*Okpo Masquerade*, Calabar South, Nigeria, 2005.
Ilfochrome, 127 cm x 127 cm.

48

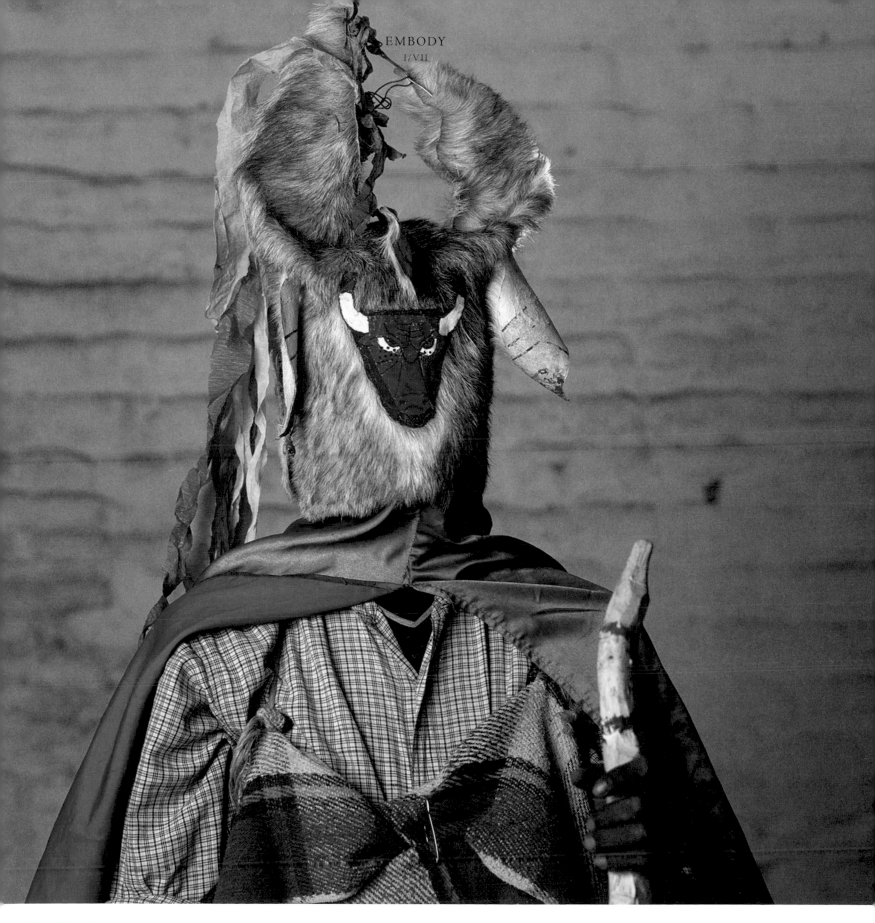

Phyllis Galembo, Los Fariseos, Mexico, 2008.

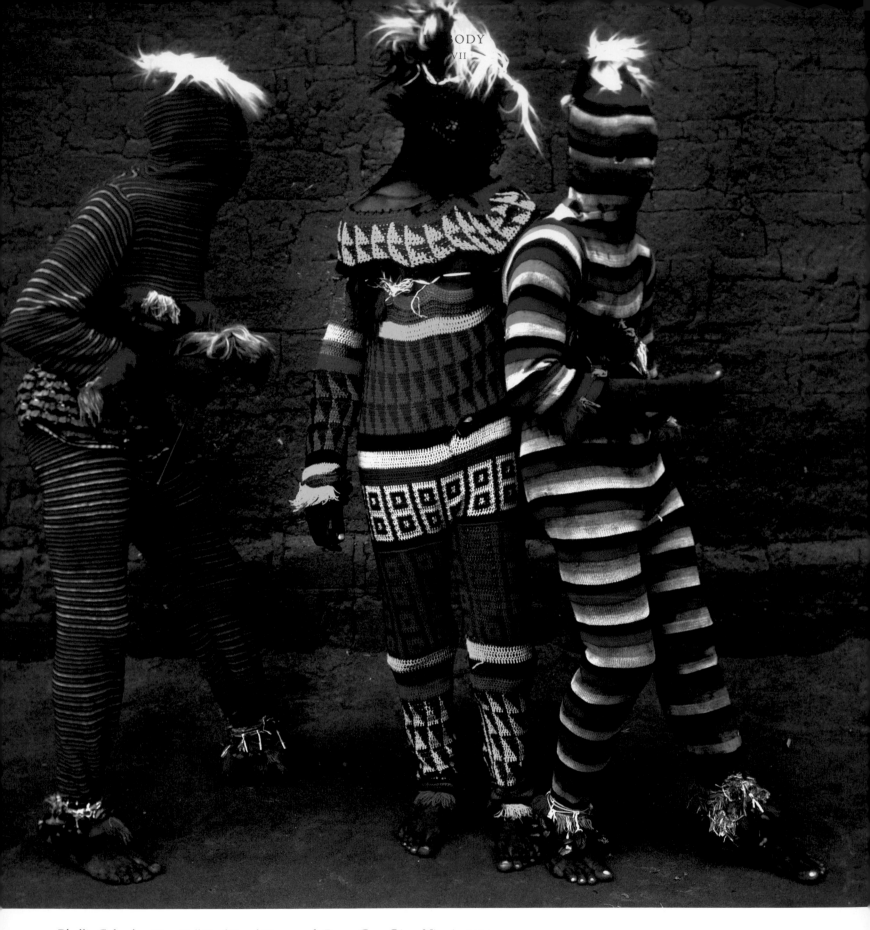

Phyllis Galembo, *Ngar Ball Traditional Masquerade Dance*, Cross River, Nigeria, 2004.
Ilfochrome, 76 cm x 76 cm.

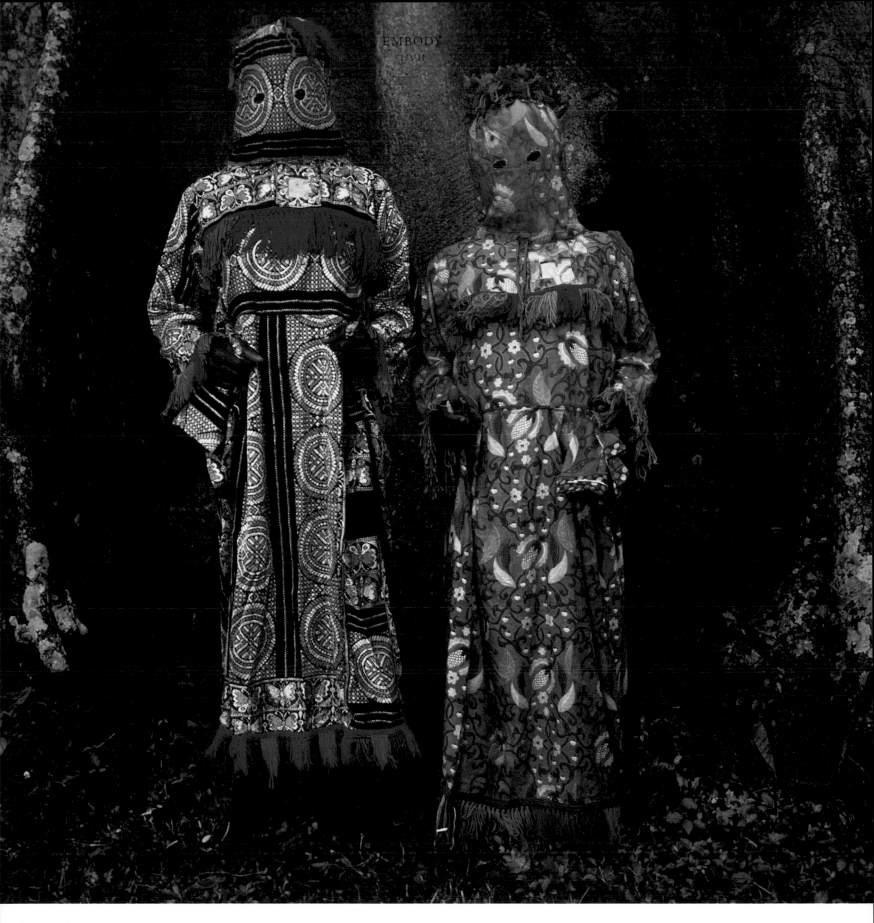

Phyllis Galembo, *Ano Dance Masquerade*, Alok Village, Cross River, Nigeria, 2004.

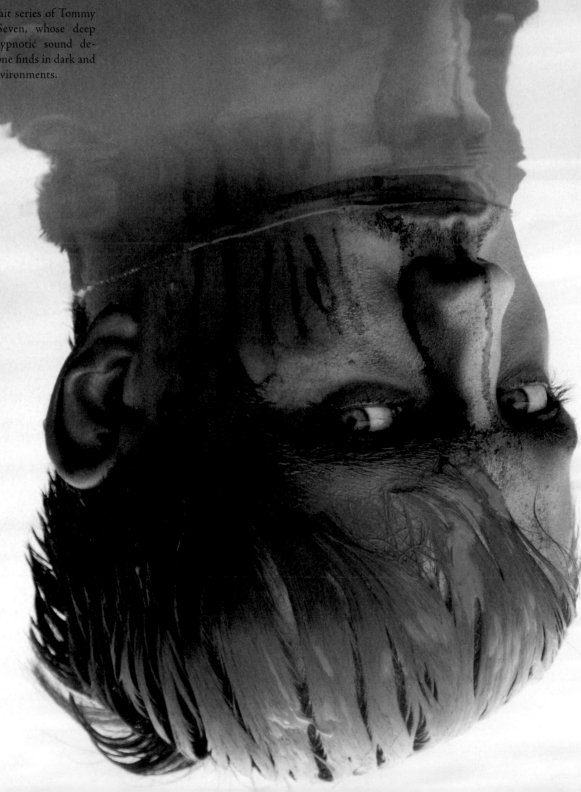

# 02

## DISSOLVE

(Wandering Ghosts)

●

Kerstin zu Pan, 2009

T47.

A portrait series of Tommy Four-Seven, whose deep and hypnotic sound designs one finds in dark and raw environments.

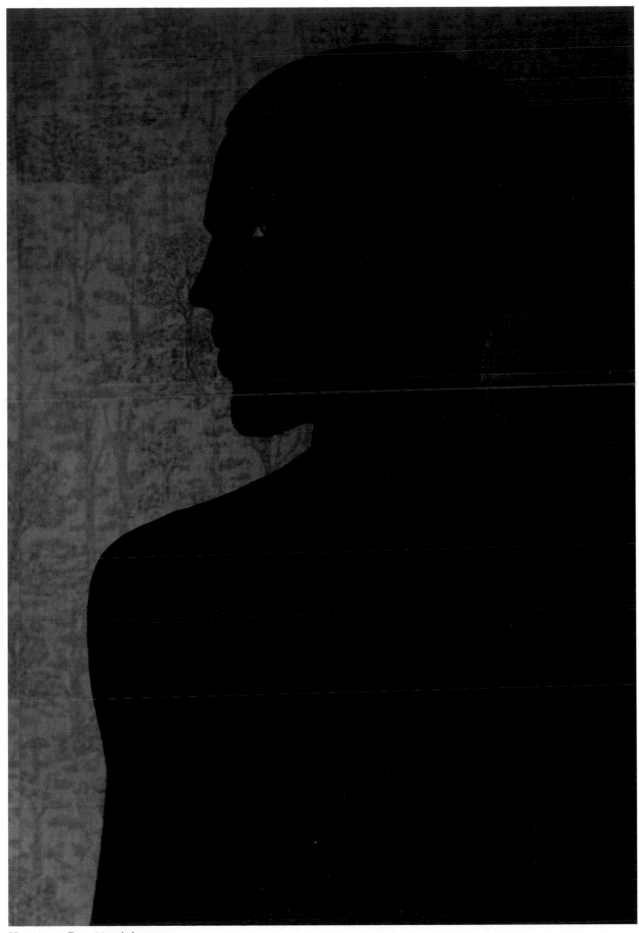

Kerstin zu Pan, *Untitled*, 2009.

Kerstin zu Pan, *Untitled*, 2009.

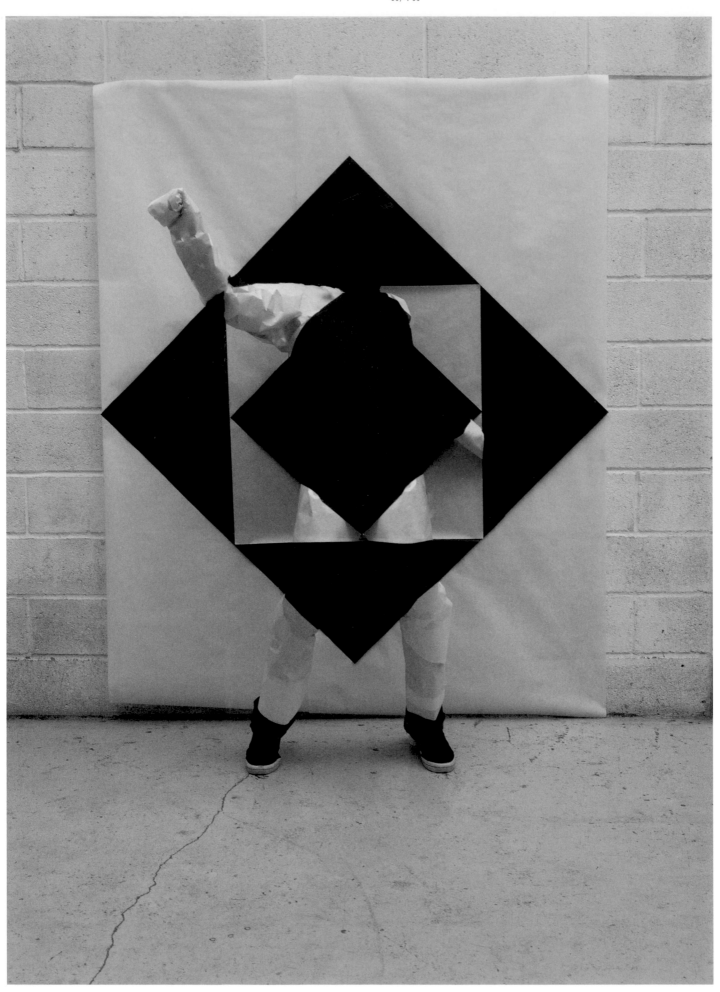

Akatre
*Mains d'Œuvres, 2009.*

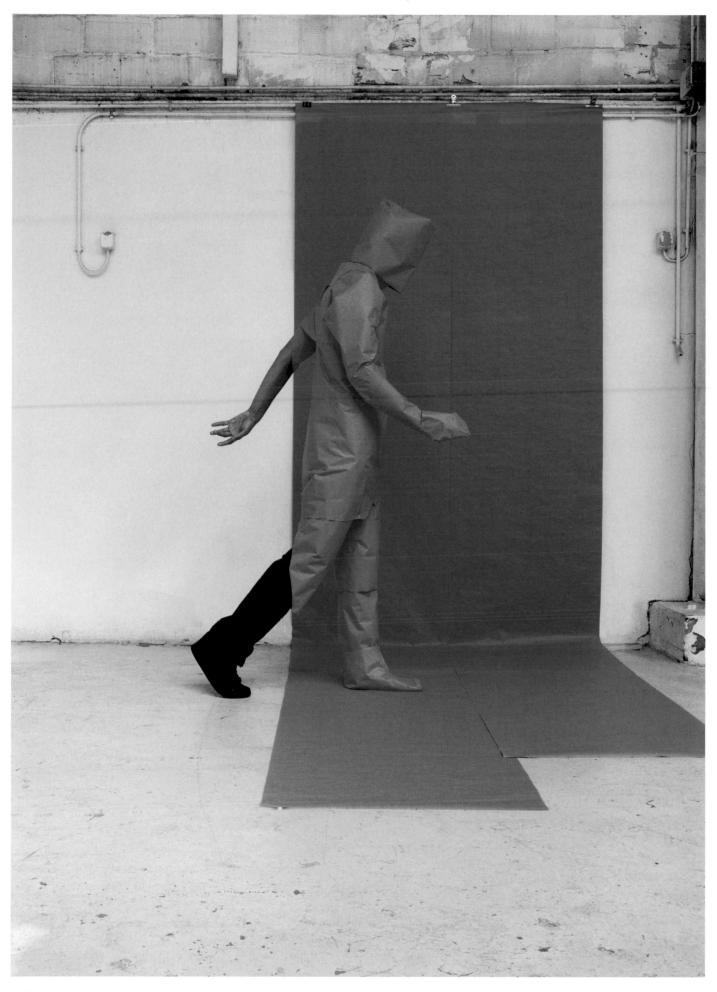

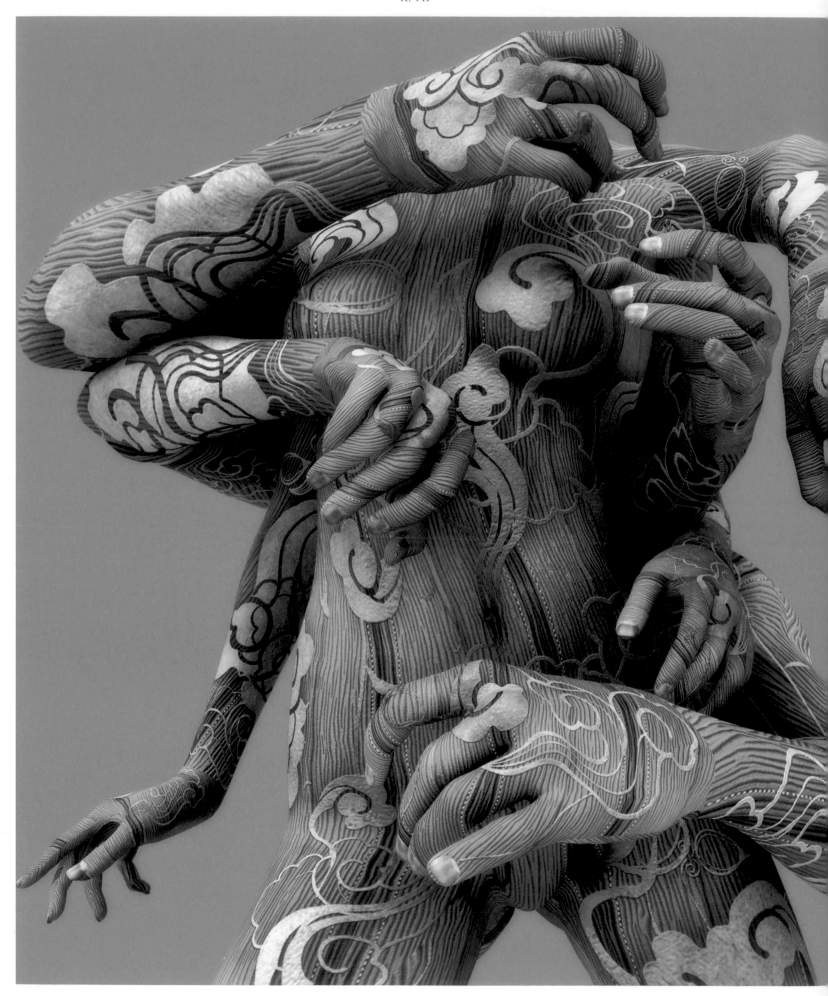

**58**    Kim Joon

*Party Louis Vuitton*, 2007. 120 cm x 120 cm. Digital print, acrylic, aluminum. Editions of 5.

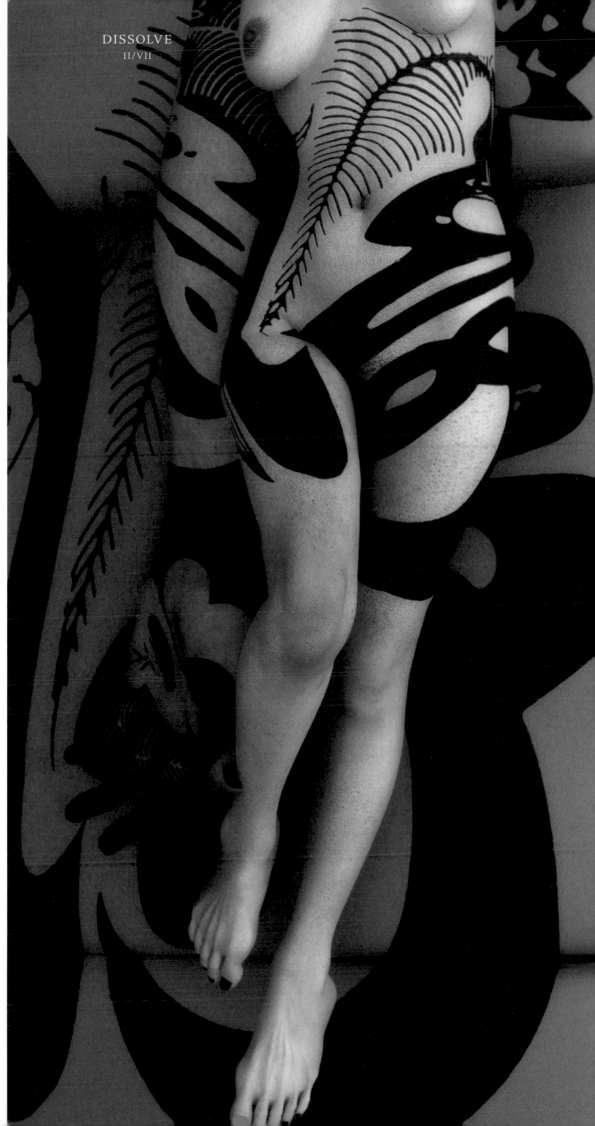

Kim Joon, *Cradle Song-Ferragamo*,
2009. 160 cm x 80 cm.
Digital print, acrylic, aluminum.
Editions of 5.

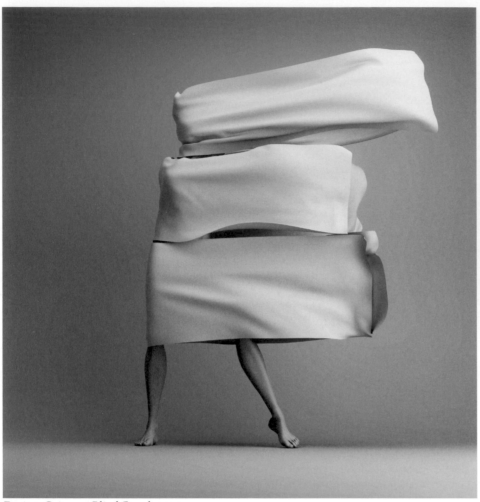

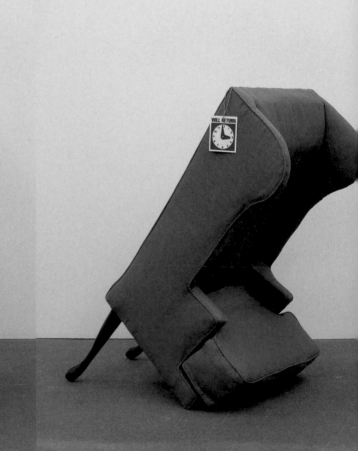

Dmitry Grigorev
*Blind Sit*, 2005.

*Dmitry Grigorev*, Blind Stand, 2005.

Jamie Isenstein
*Arm Chair*, 2006.
Wood, metal, nylon, raw
cotton, linen, hardware,
human arms, human
legs, zippered jeans.

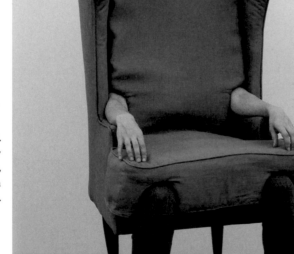

60

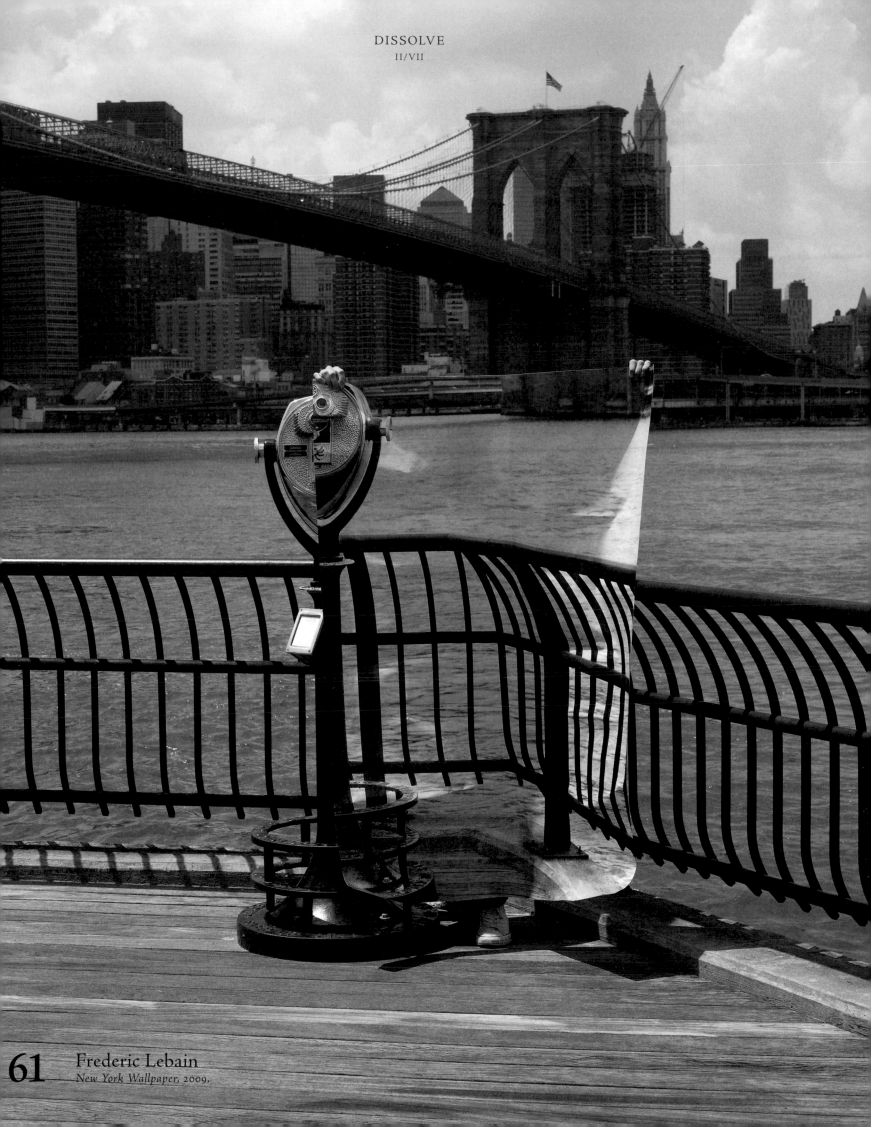

Frederic Lebain
*New York Wallpaper, 2009.*

2

## Desiree Palmen

**1** OPPOSITE PAGE
*Shield*, 2009. Museum Volkenkunde, Leiden, Netherlands, 2009. Analog color print, 147 cm x 127 cm (ed 5).

**2**
*Life is Short* (work in progress), Vienna, Austria, 2008.

**3**
*Old City Suit Tourist Camera Moslem Quarter*, Jerusalem, Israel, 2006. Analog color print, 130 cm x 41 cm (ed 5).

**4**
*Park Bench/ Couple*, Rotterdam, Netherlands 2001. Analog color print, 150 cm x 100 cm (ed 5).

3

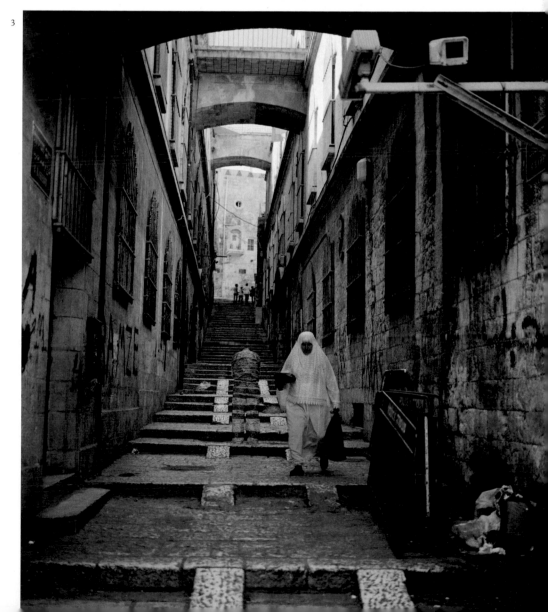

4

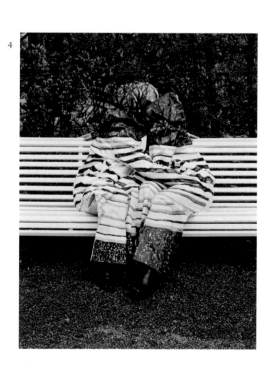

Für Ihre Projekte
bieten wir auf Bestellung:
Paneelen und
Laminate
(über 100 Dekore).

Niedrigpreise tagein – tagaus!

HEIDELBERGER
ZEMENT

MDF-Paneele

PANEELE
TRENDY DUO

Urban Camouflage
*#4 Hardware Store, 2009, Germany.*

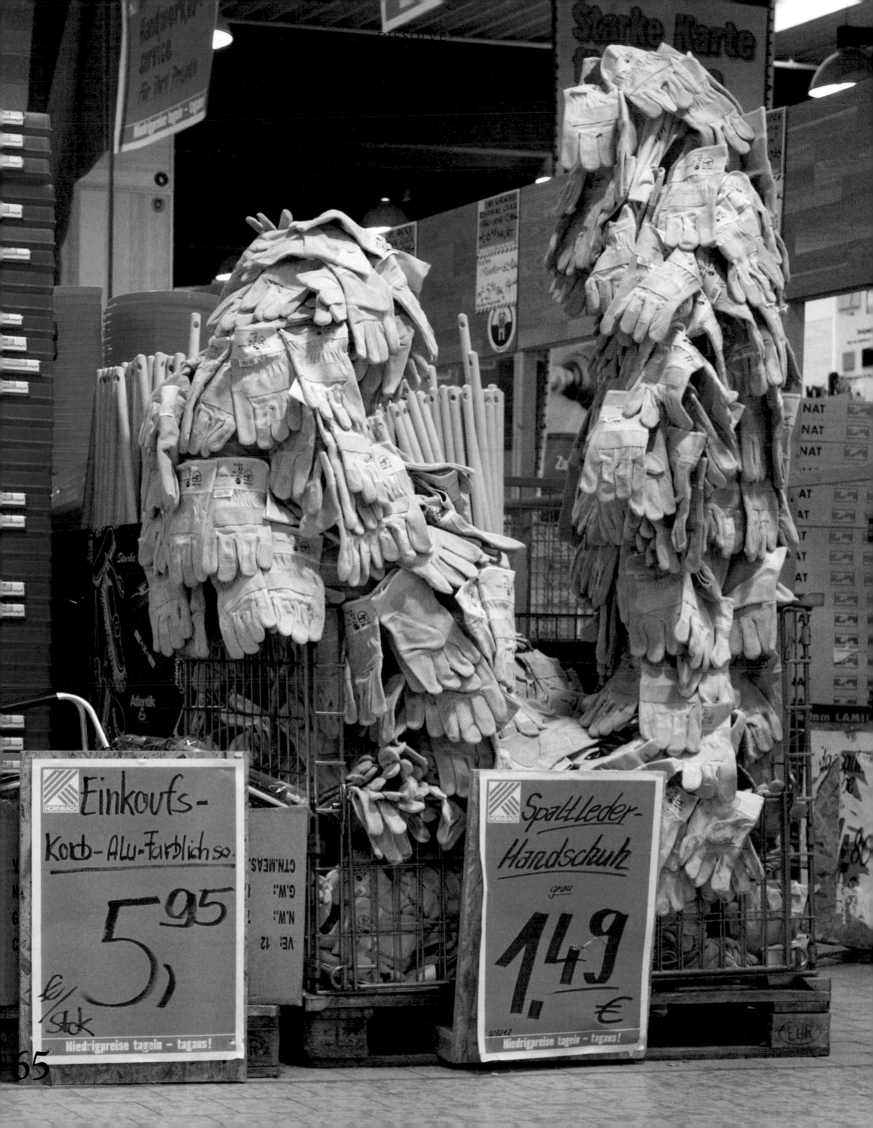

65

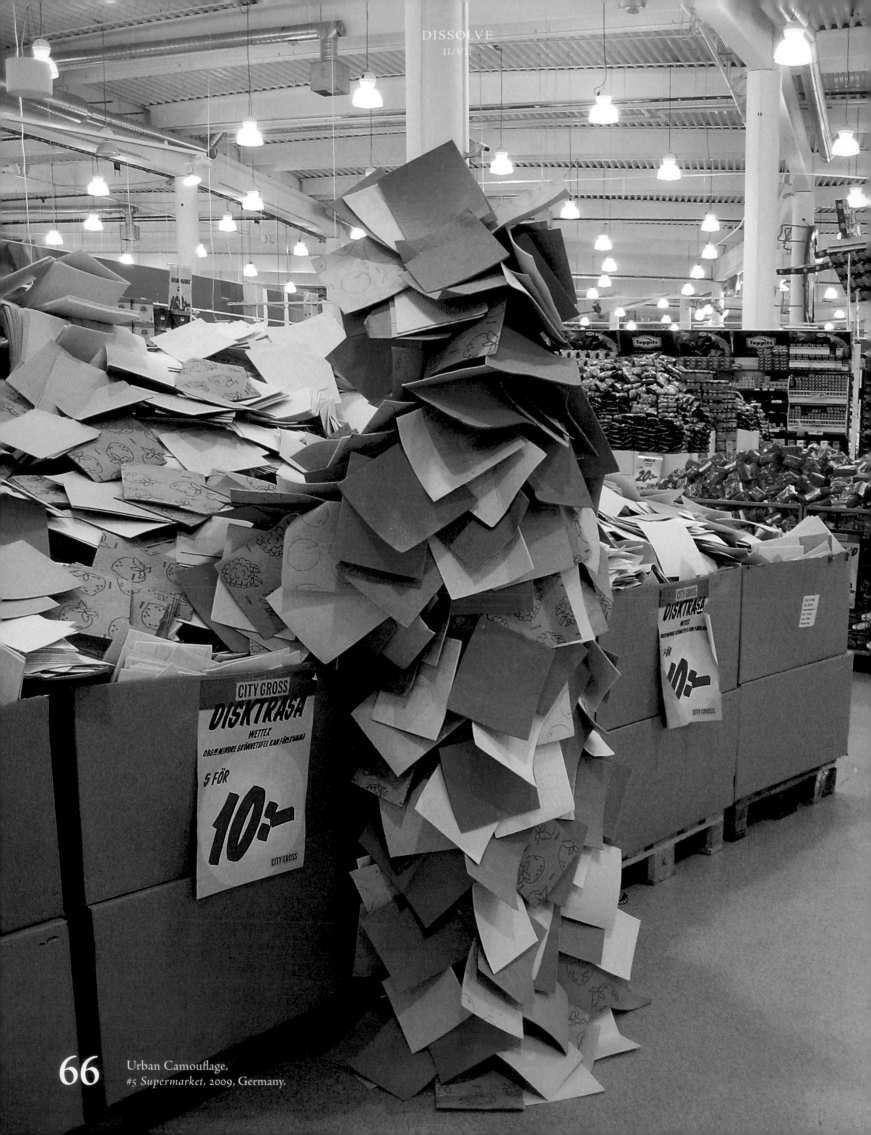

Urban Camouflage,
*#5 Supermarket*, 2009, Germany.

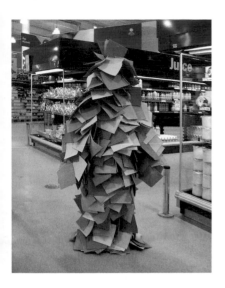

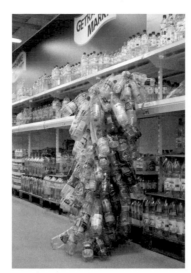

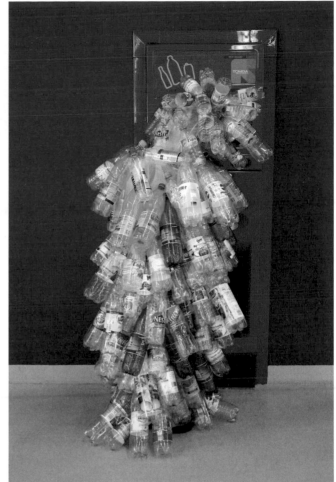

#5 *Supermarket*, 2009, Germany.

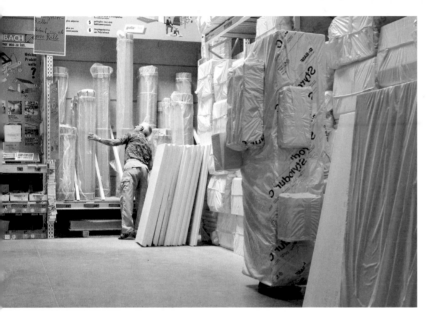

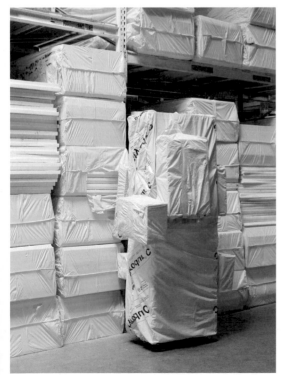

#6 *Hardware Store*, 2009, Germany.

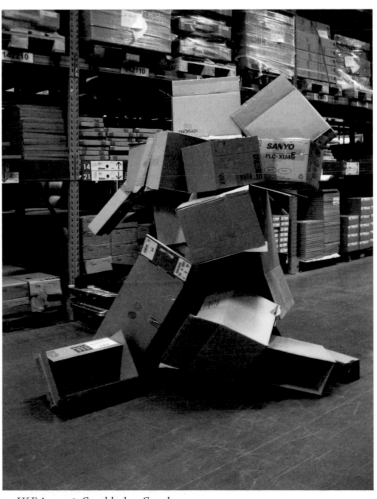

#7 *IKEA*, 2008, Stockholm, Sweden.

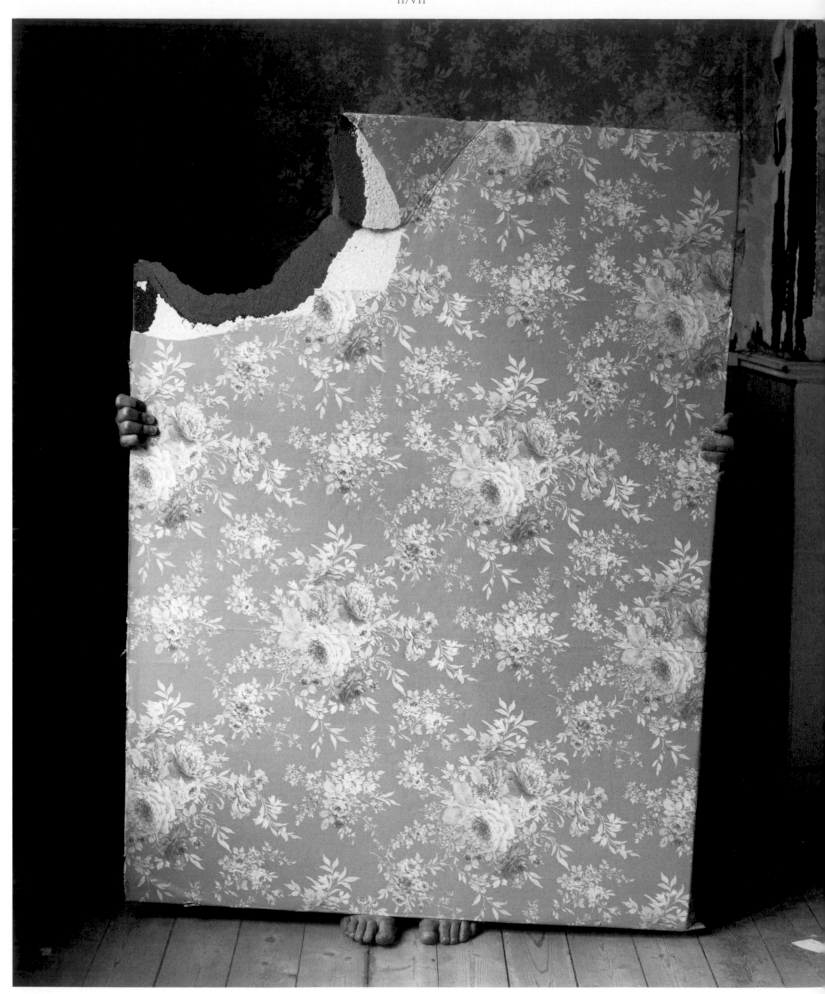

Annie Collinge
*Miranda in the Pollet, 2008.*

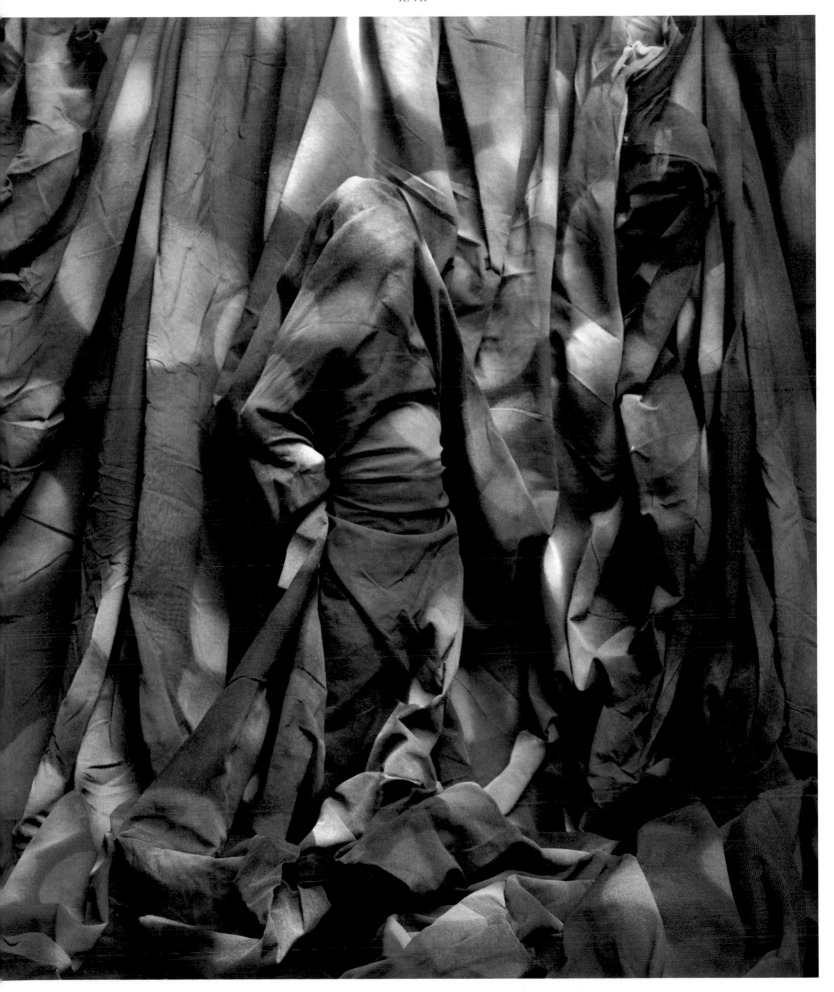

Annie Collinge, *Untitled* (work in progress), 2010.

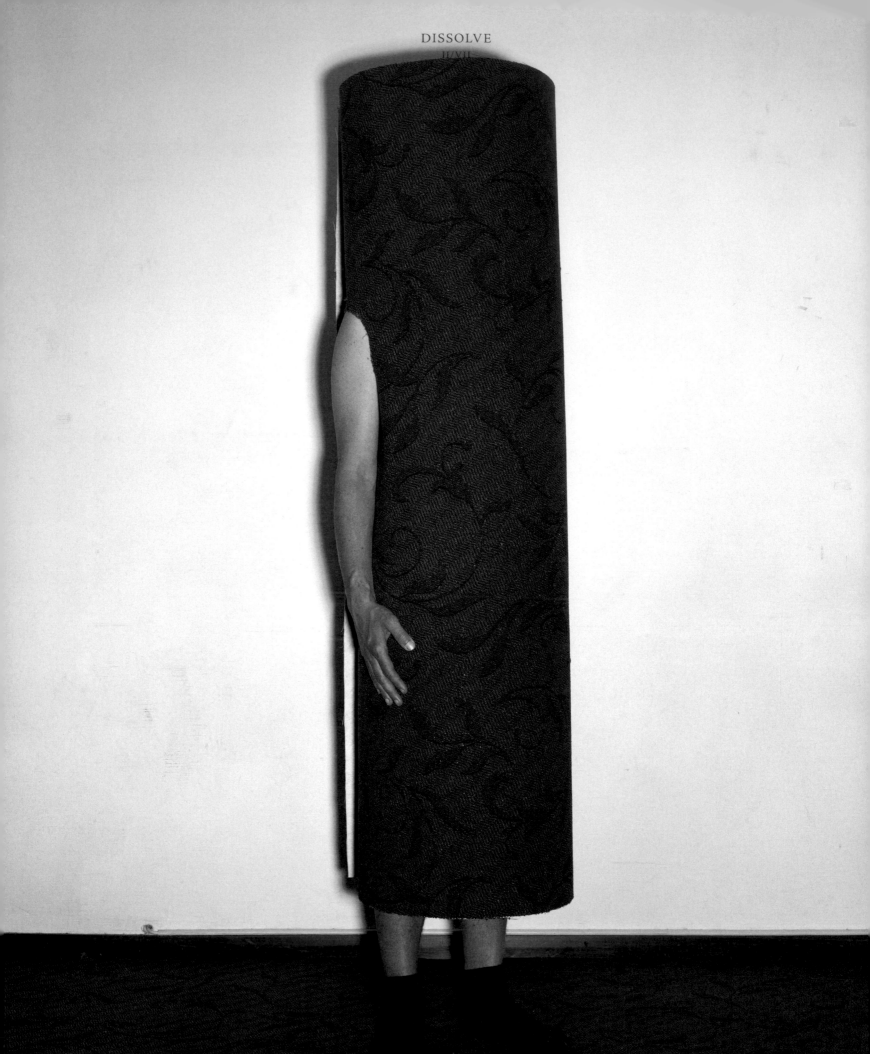

Matthieu Lavanchy
*Mr. Schuhlmann or the Man in the High Castle, 2008.*

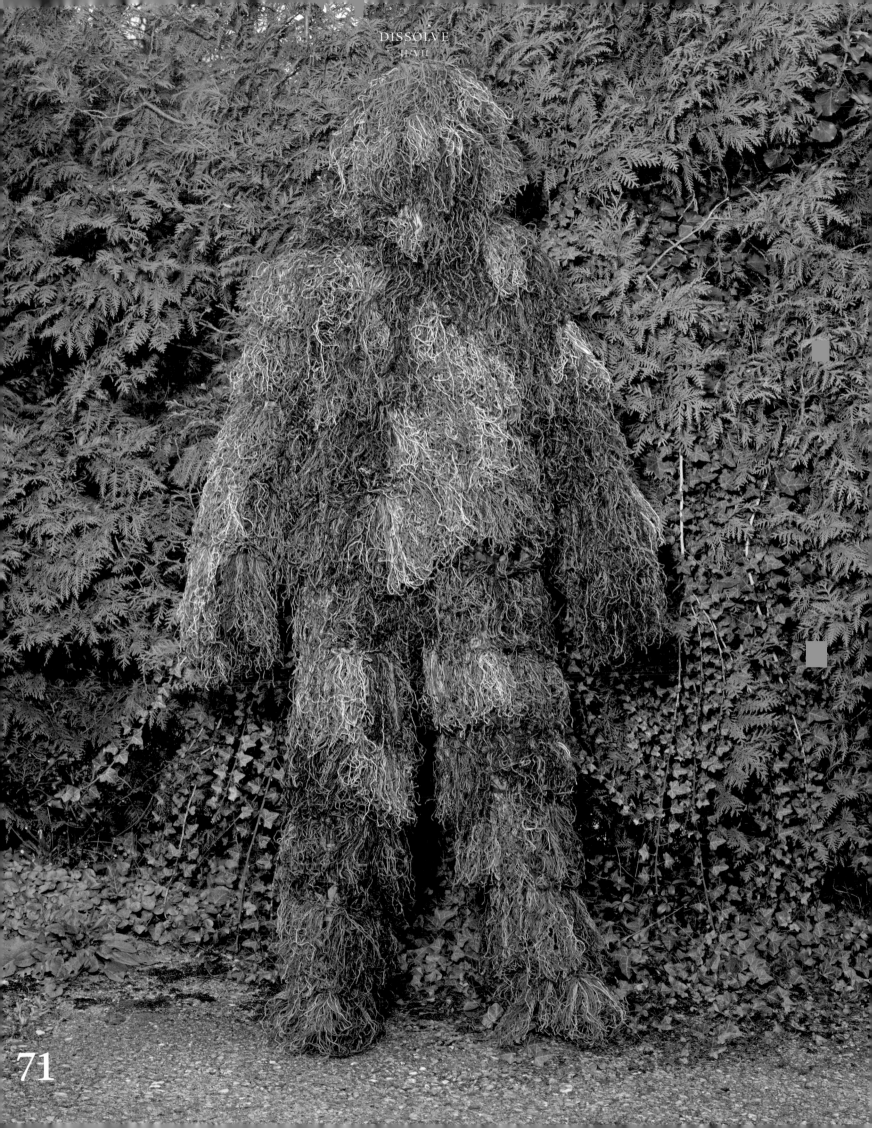

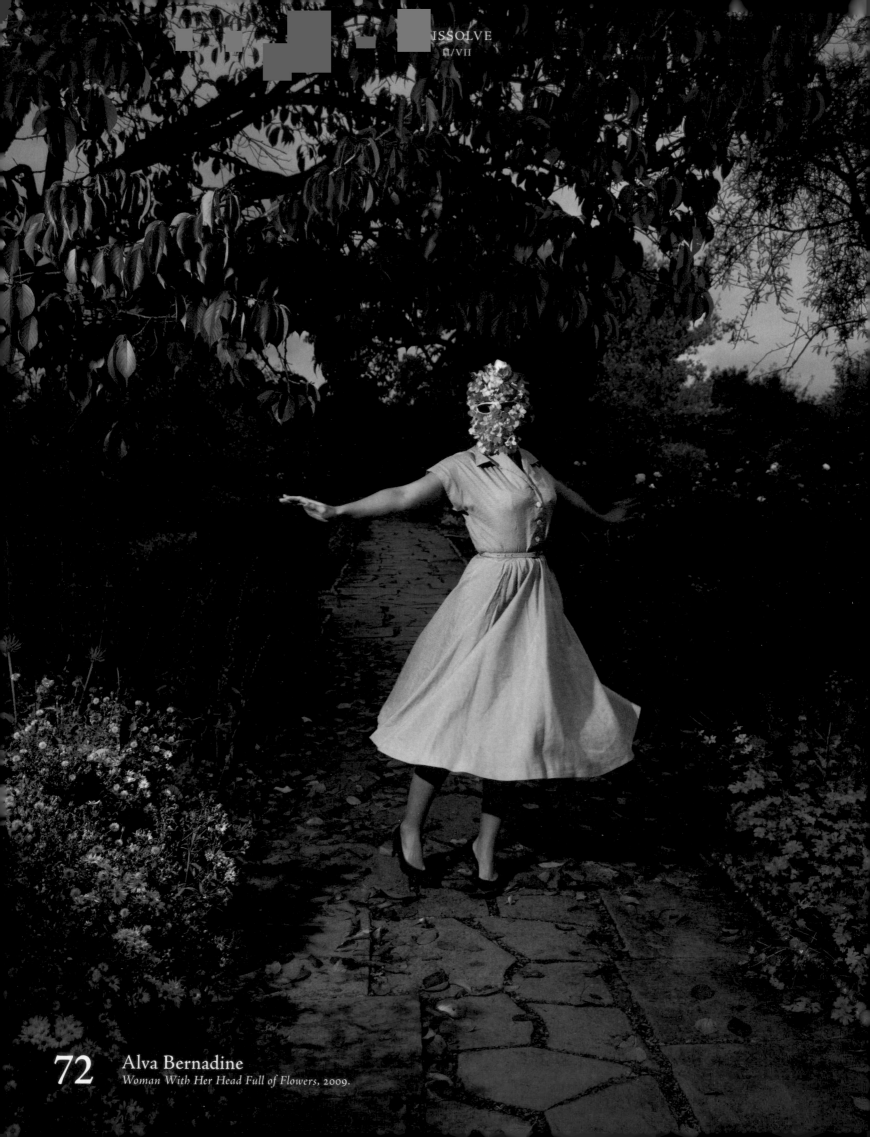

72 Alva Bernadine
*Woman With Her Head Full of Flowers*, 2009.

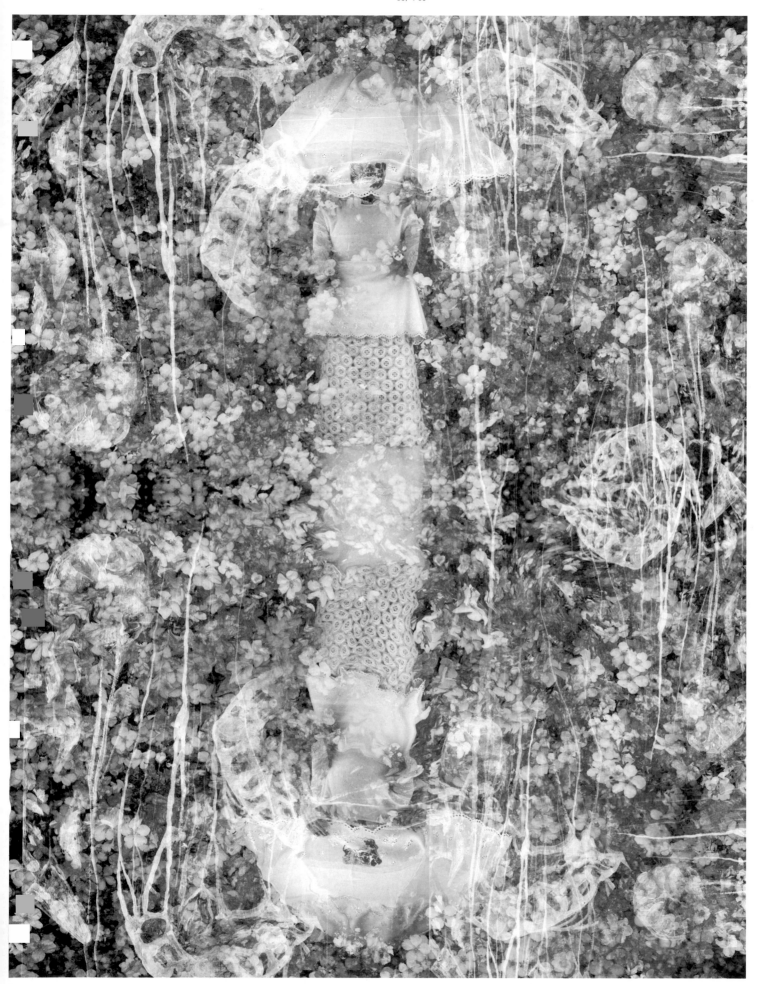

73 Dindi van der Hoek
*Carnaval les Fleurs,* 2010.

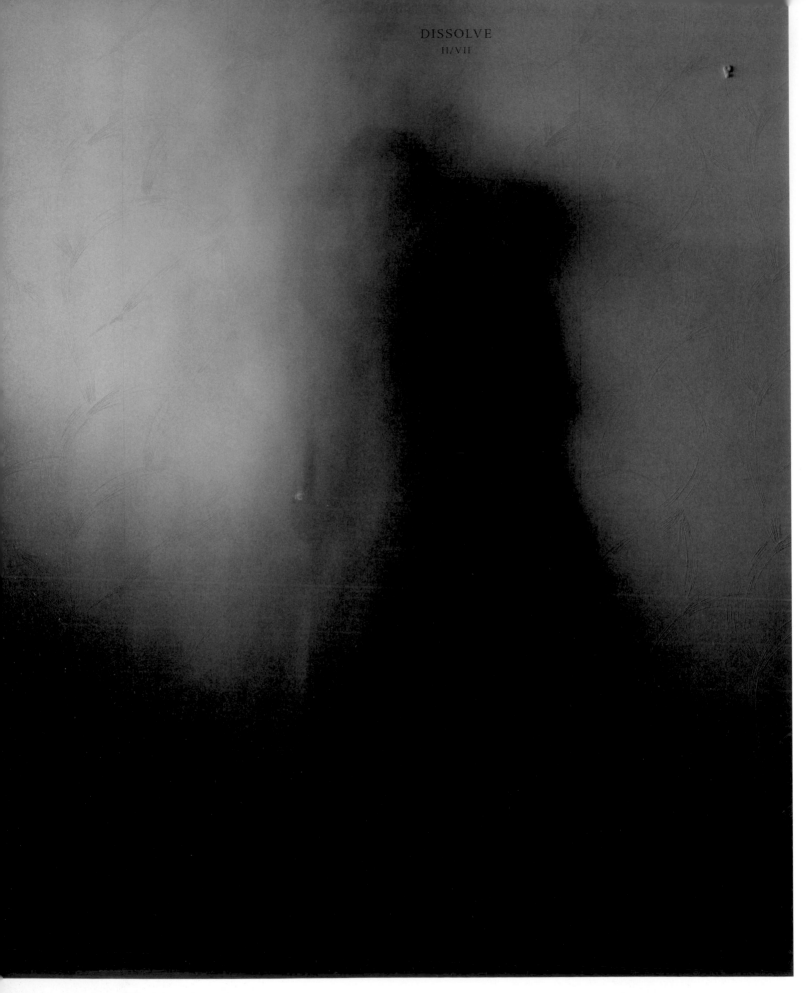

**Anders Krisár**
*Mist Mother*, 2006. Chromogenic print mounted to aluminum,
180 cm x 143 cm, edition of 3.

74

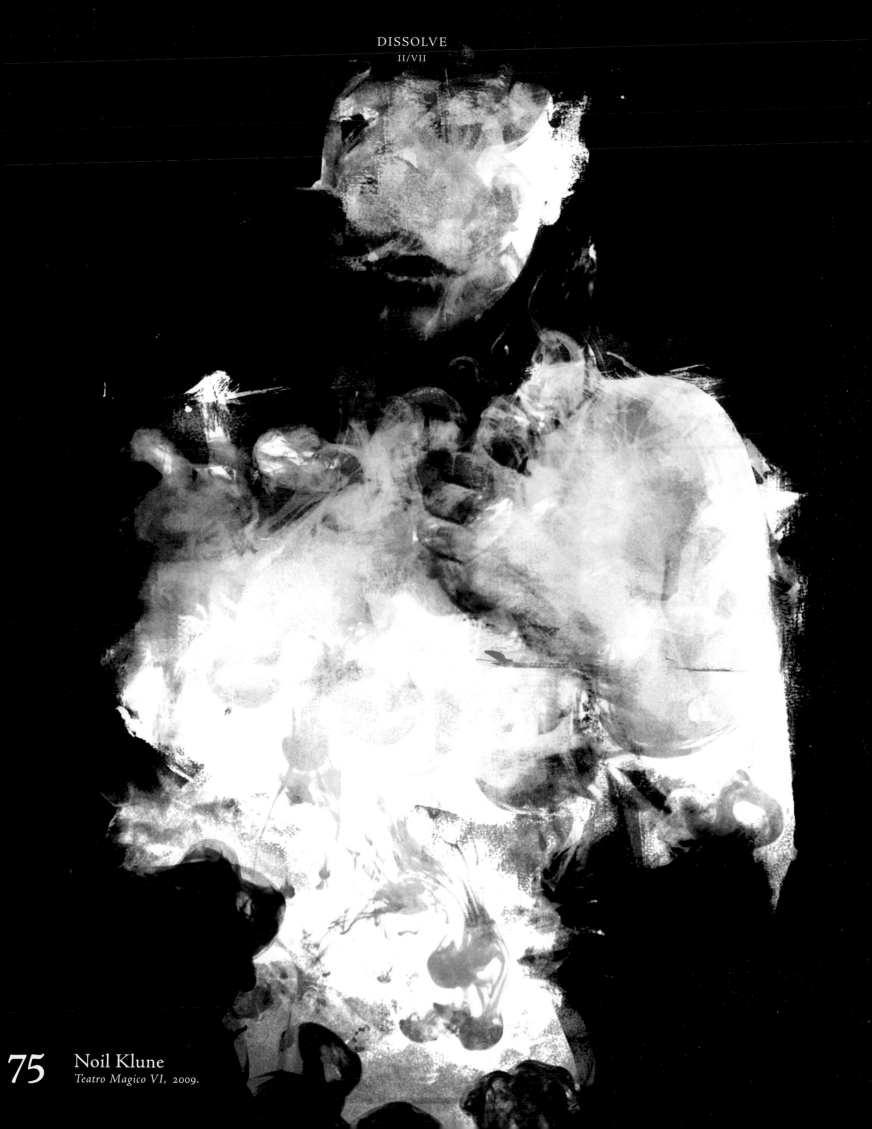

75 Noil Klune
*Teatro Magico VI*, 2009.

03
___

PERFORM

(Bodies Expressing)

●

Akatre, 2008

*Mains d'Œuvres.*

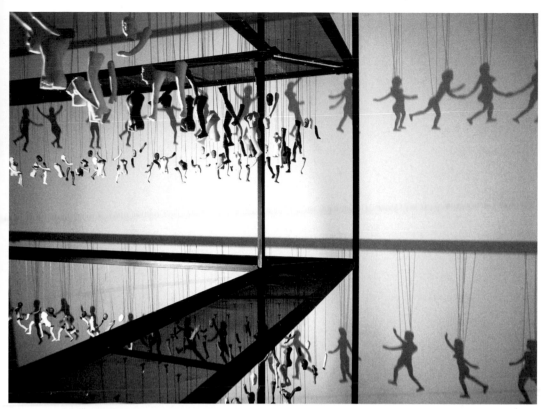

## Bohyun Yoon
*Structure of Shadow*, 2009,
*New Jersey*, USA.

There are truncated rubber figures hung like puppets, portraying the idea of a group as opposed to an individual. A light and shadow trick is a key factor in this work: it is a metaphor of the invisible power of political tricks in our society. The crowd is constructed as a shadow screen on the surrounding wall. The work is interactive: when a viewer approaches, a motion sensor shakes the light bulb so that the crowd's shadow moves around the space. The viewer's engagement plays a fundamental role in completing the work.

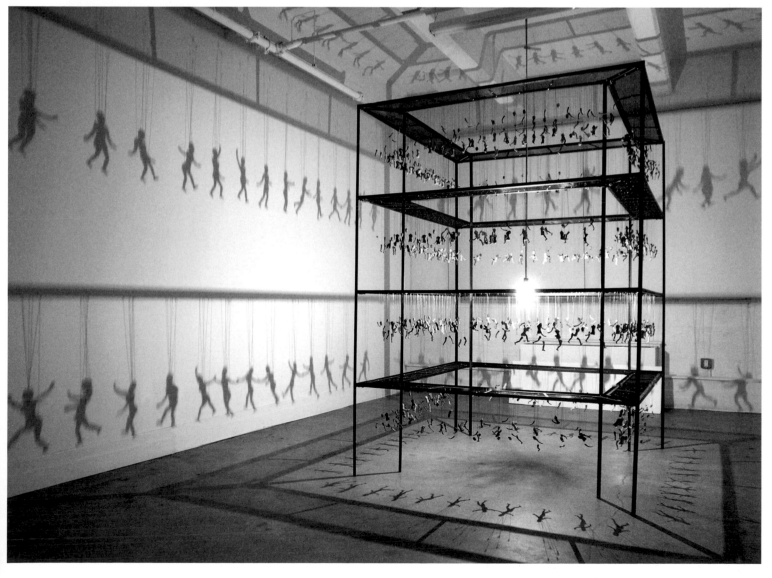

**78** Anna & Bernhard Blume
*Hommage à Oskar Schlemmer*, 2008. Inkjet on Ilford pearl roll paper, 164 cm x 116 cm.

  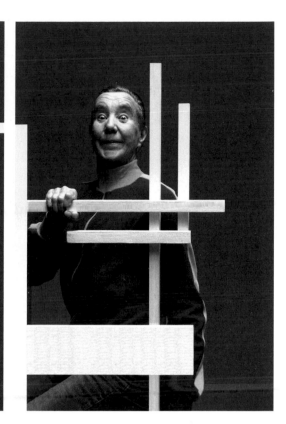

Anna & Bernhard Blume, *Hommage à Mondrian,* 2006.
C-print, three pieces, each 164 cm x 110 cm.

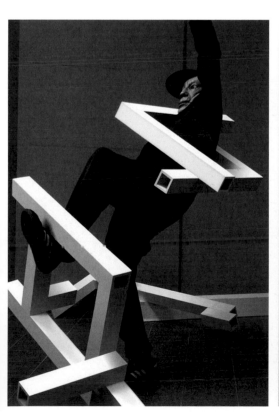 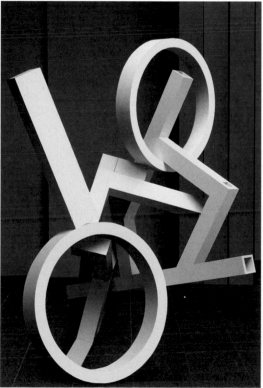 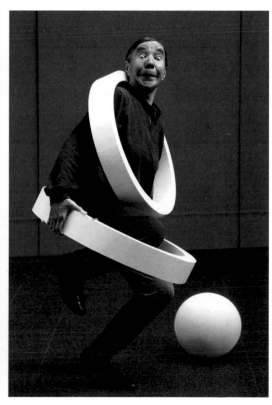

Anna & Bernhard Blume, *Trans-Skulptur,* 2008.
Inkjet on Ilford pearl roll paper, three pieces, each 214 cm x 143 cm.

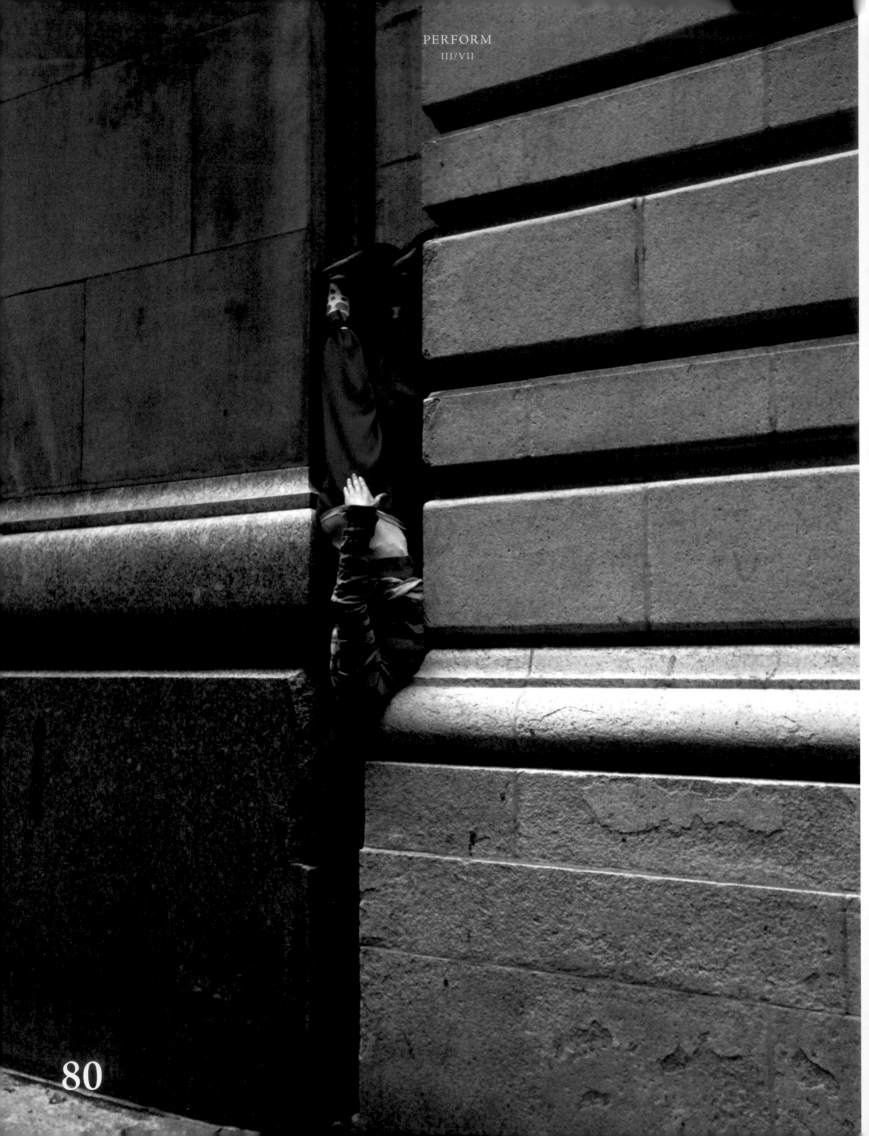

80

2

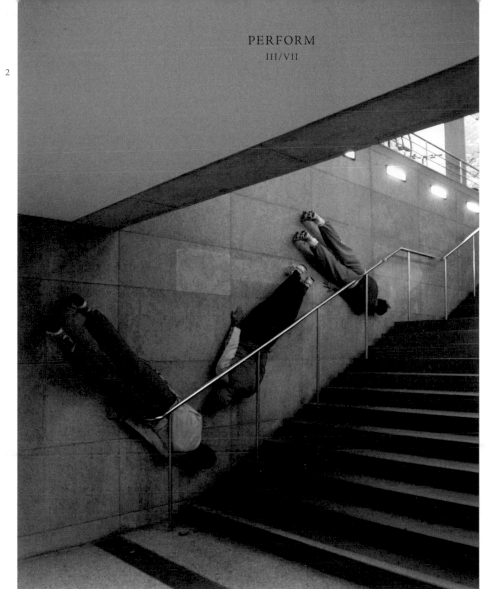

## Cie. Willi Dorner
*Bodies in Urban Spaces.*

This project explores functional urban structures and aims to uncover the possibilities of restricted movement. Passers-by and residents are prompted to reflect on their urban surroundings. 𝔅𝔬𝔡𝔦𝔢𝔰 𝔦𝔫 𝔘𝔯𝔟𝔞𝔫 𝔖𝔭𝔞𝔠𝔢𝔰 is a moving trail performed by a group of dancers. The performers lead the audience through selected parts of public and semi-public spaces. A chain of physical interventions is quickly set up, which exists only temporarily. This allows the viewer to perceive the same space in a new and different way.

### 1
New York City, USA, 2010.
Crossing the Lines festival, 𝔠𝔩𝔦𝔢𝔫𝔱: FIAF.

### 2
Berlin, Germany, 2010.
𝔠𝔩𝔦𝔢𝔫𝔱: Festival Tanz im August.

### 3
Nottingham, UK, 2007.
𝔠𝔩𝔦𝔢𝔫𝔱: Nottdance.

3

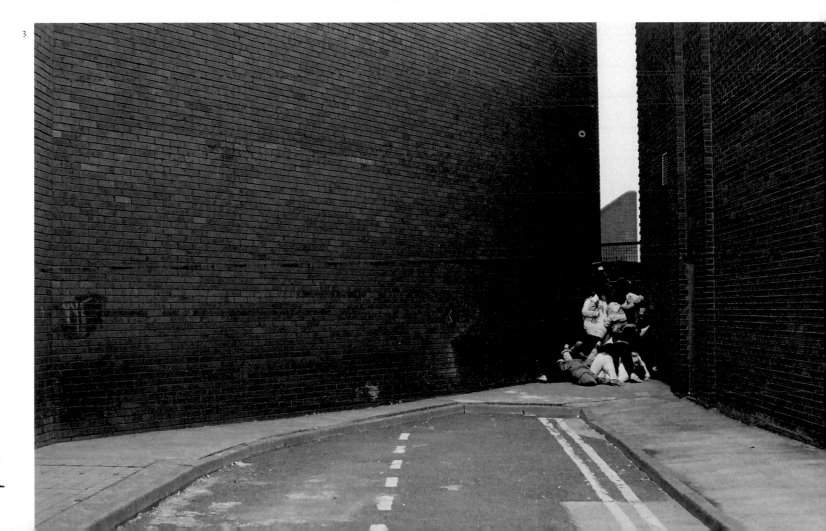

Cie. Willi Dorner, *Bodies in Urban Spaces*, London, UK 2009.
Client: Festival Dance Umbrella.

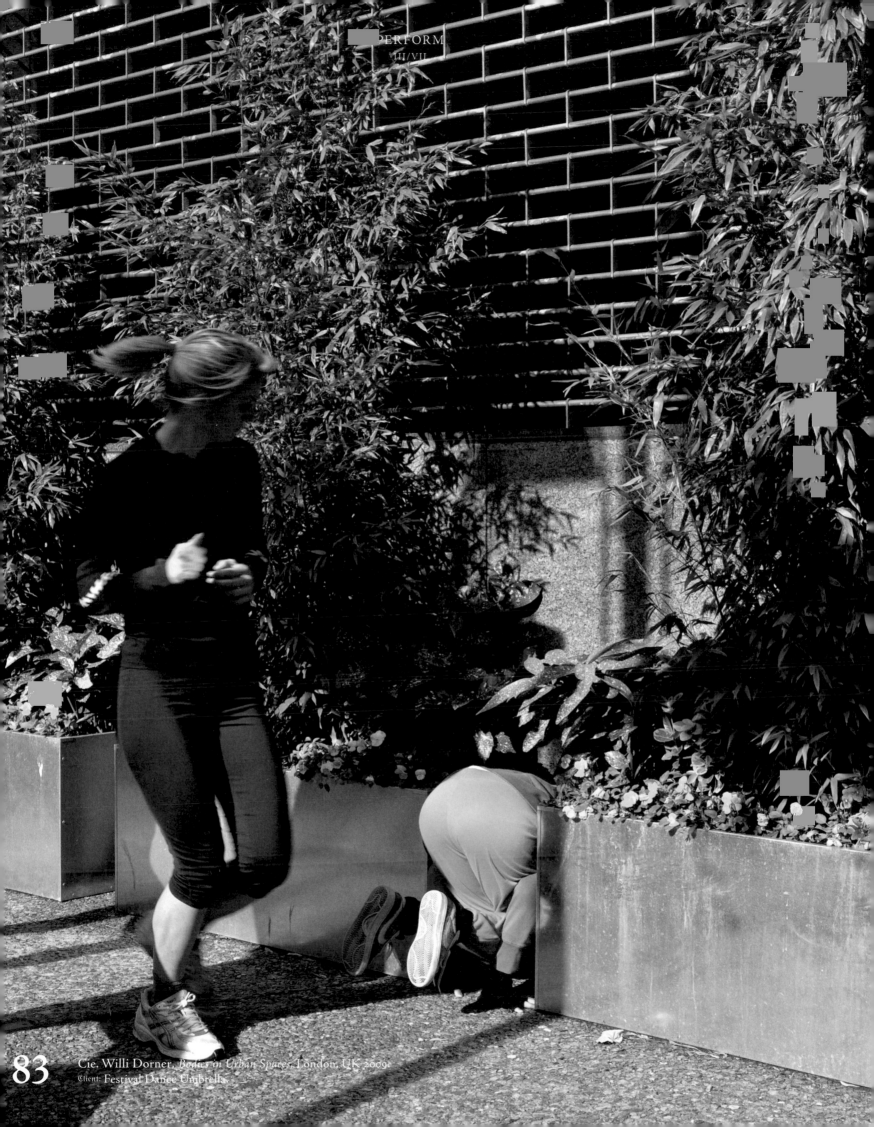

Cie. Willi Dorner, *Bodies in Urban Spaces*, London, UK 2009.
Client: Festival Dance Umbrella

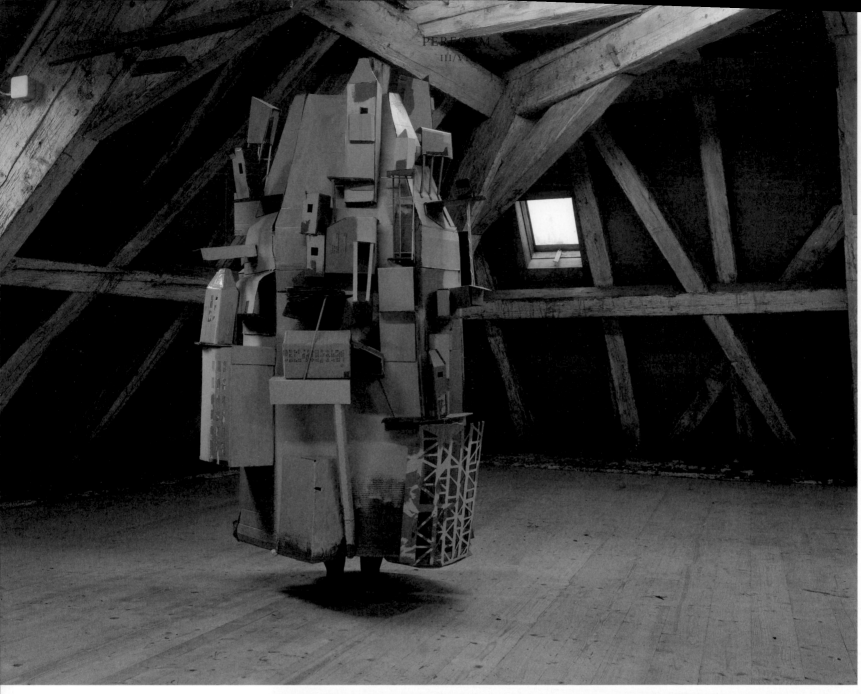

# Emily Speed
*Inhabitant*, Linz, 2009, Austria.

A representation of psychological space that is worn or inhabited. The inhabitant exists somewhere between a garment and a sculpture. It is a kind of shell or façade, in which the artist, although concealed safely inside, remains vulnerable, without the ability to see and encumbered by her own creation.

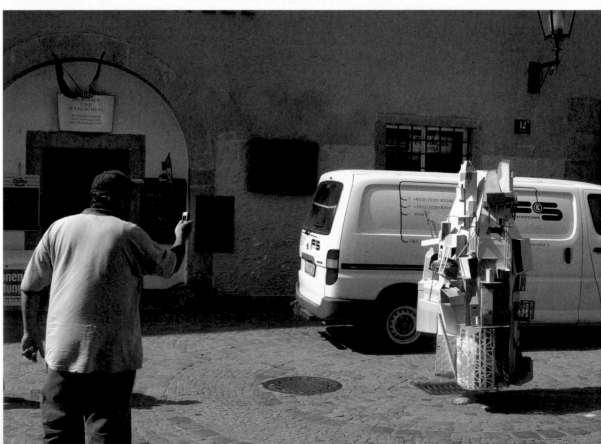

84

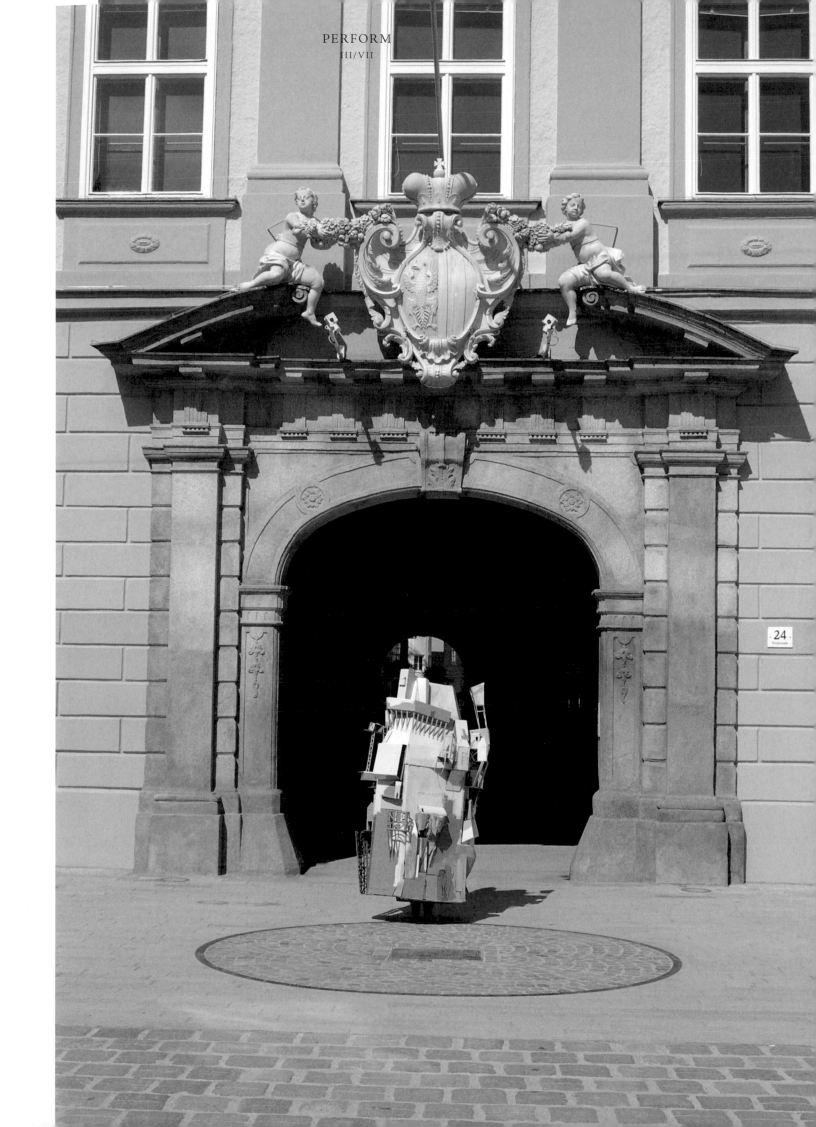

# Stephen J. Shanabrook

*Slapped in the Face Until Your Shit Turns Red*, 2009

Still from performance with cotton-candy machine, Contemporary Art Center, Nechatel, Switzerland.

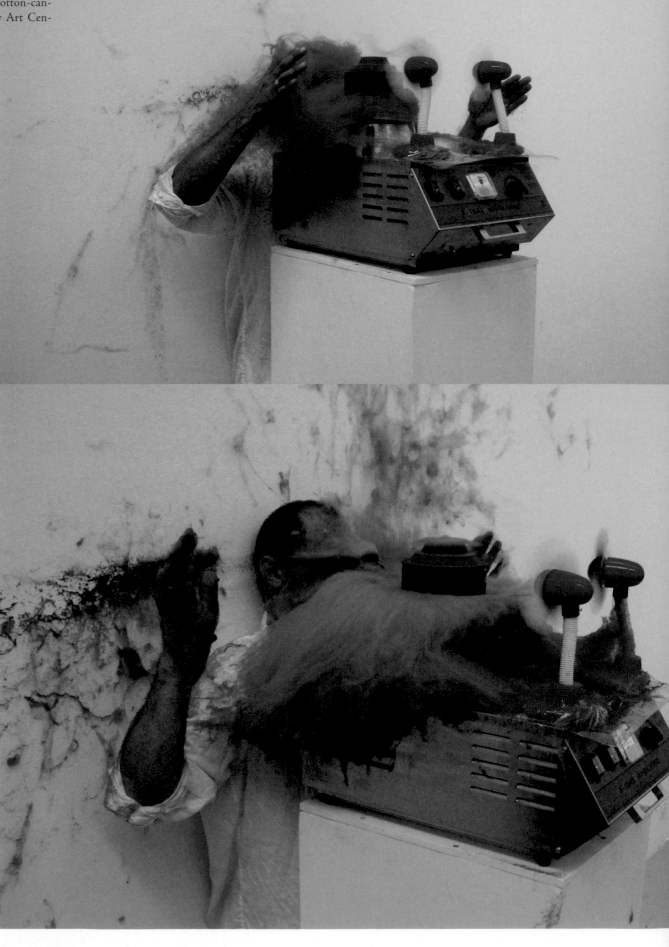

86

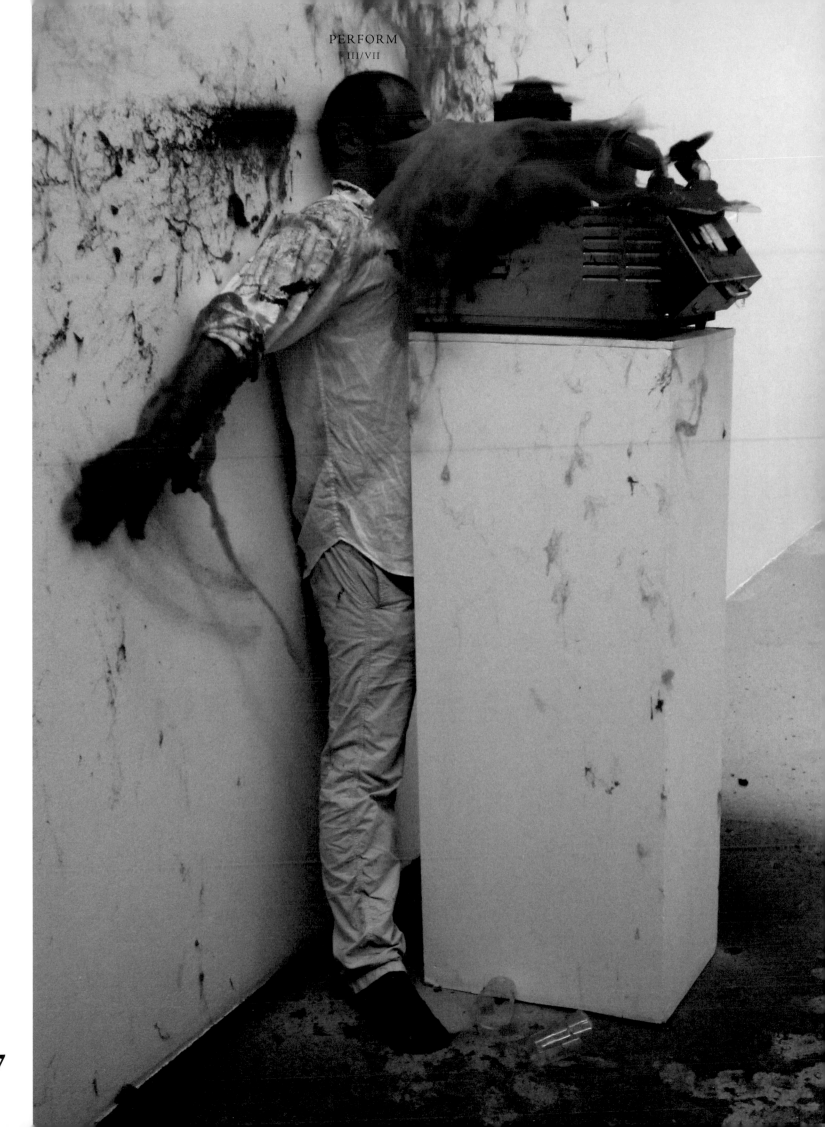

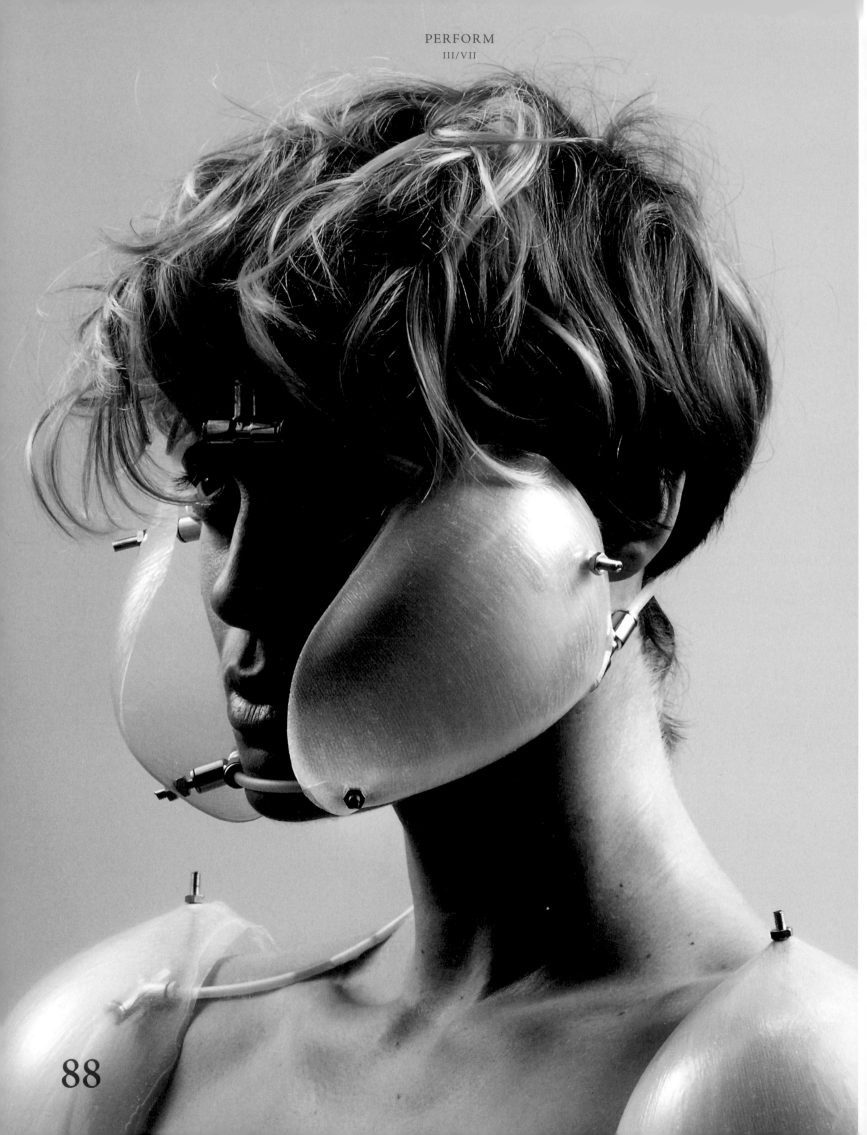

2

3

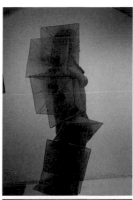

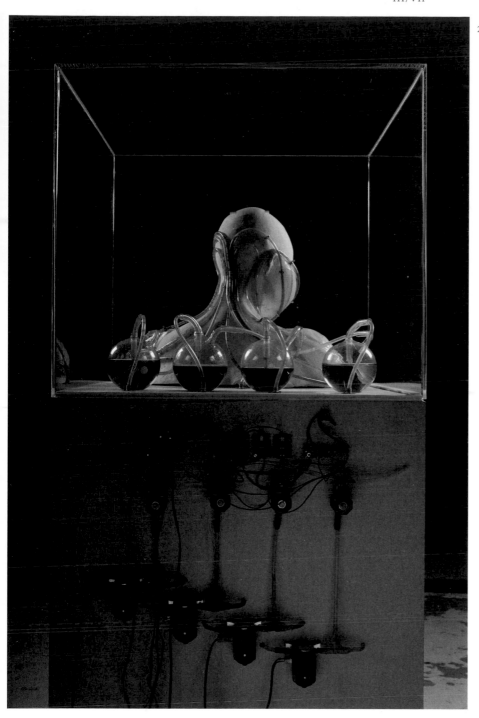

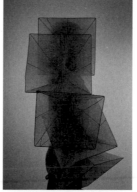
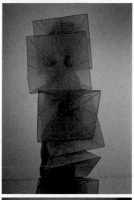

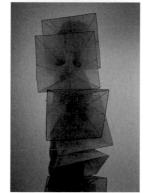
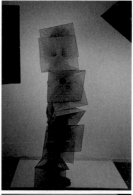

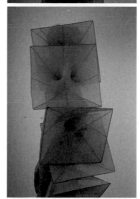
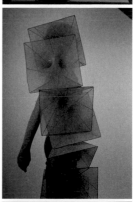

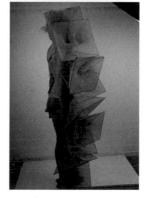
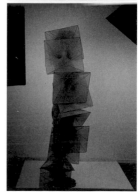

# Lucy McRae, 2010

**1** *OPPOSITE PAGE*
*Metabolic Skin.*

**2**

*Peristaltic Skin Machine.*

A collaboration with digital fabricator Mike Pelletier, 𝔓𝔢𝔯𝔦𝔰𝔱𝔞𝔩𝔱𝔦𝔠 𝔖𝔨𝔦𝔫 𝔐𝔞𝔠𝔥𝔦𝔫𝔢 is an automated machine that explores the possibility of dynamic skins wrapping a body made with liquid and air. The machine is the first sample of an on-going exploration and was selected for a Dutch exhibition, TransNatural, exploring nature and technology.

**3**

*Ghost Skin.*

Hope and Glory is a conceptual circus conceived by Simon Birch, which opened in April 2010 in Hong Kong. Lucy McRae was commissioned to develop a collection of twelve bespoke garments influenced by the hero myth that appears throughout history and across cultures, from ancient Greece to modern science fiction films.

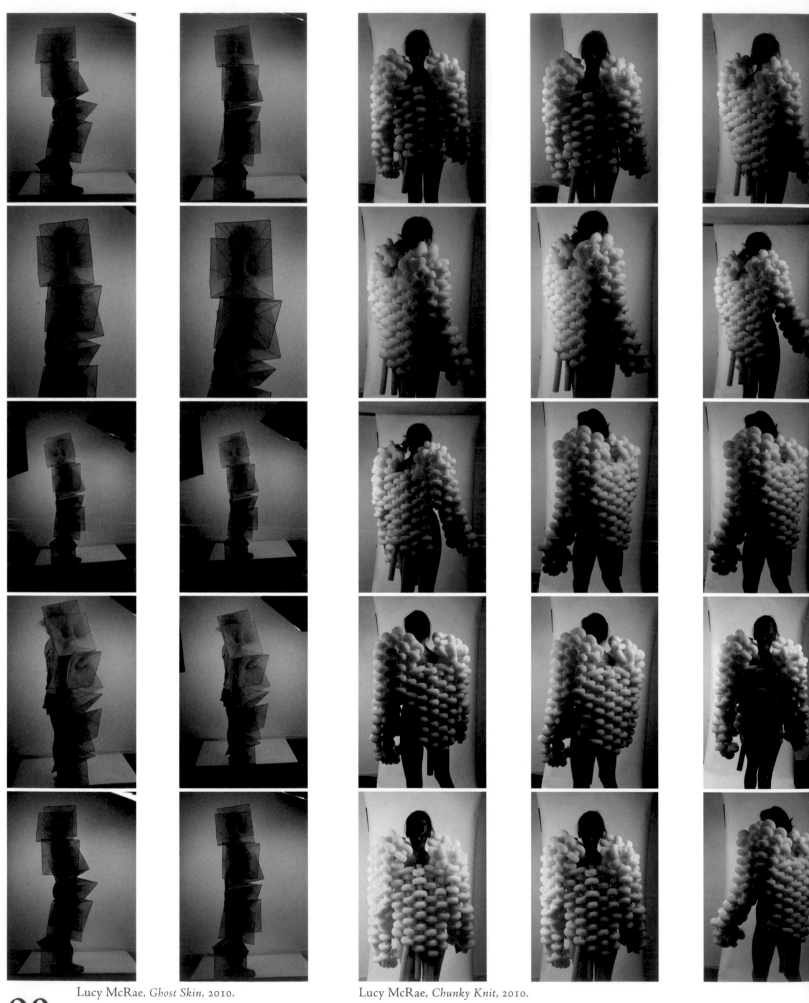

Lucy McRae, *Ghost Skin*, 2010.

Lucy McRae, *Chunky Knit*, 2010.

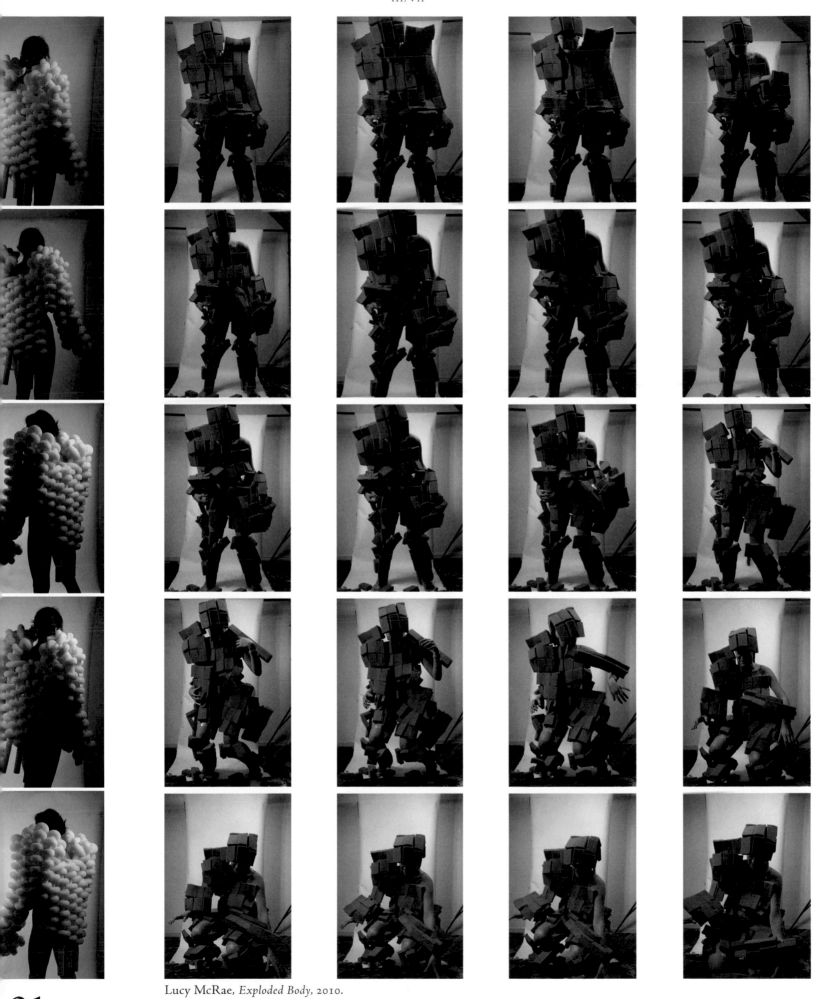

Lucy McRae, *Exploded Body*, 2010.

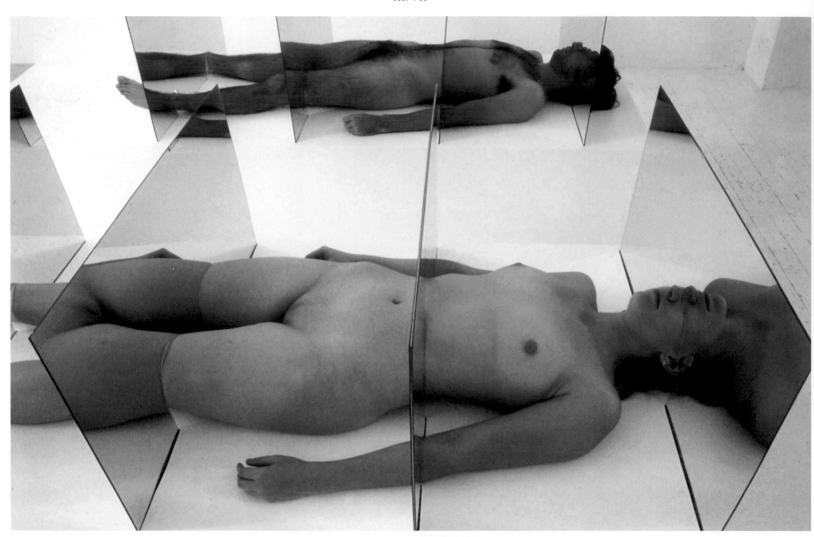

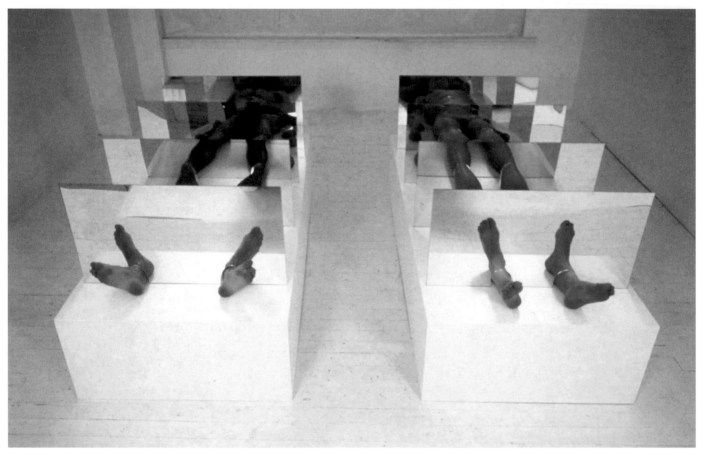

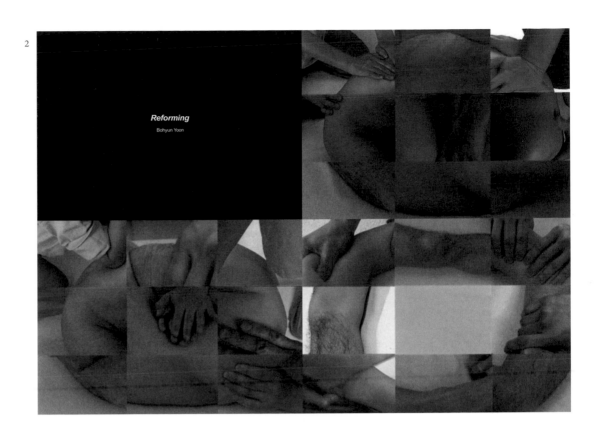

2

*Reforming*

Bohyun Yoon

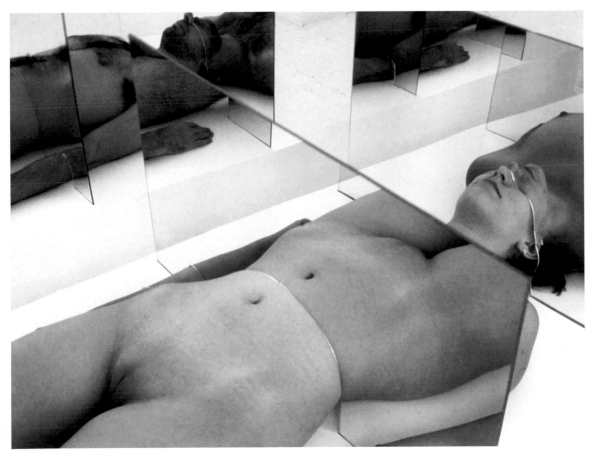

# Bohyun Yoon

## 1

*Fragmentation*, 2004.

There are unlimited numbers of reflections of truncated legs, torsos, and arms, which visually connect and create a linear pattern. This provocative image of the depersonalized body is juxtaposed with the development of modern science that enables people to alter their appearance through surgeries or cloning.

## 2

*Reforming*, 2009.

Yoon filmed body parts and edited the fragmentes to create inhuman form. Utilizing massage as a part of his art practice, he explores a new organic life form.

# Simone Brewster

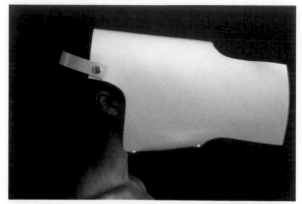

*Office Collar: Type 03, 2007.*

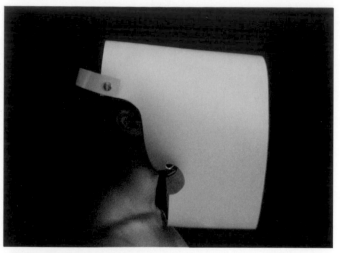

*Office Collar: Type 06, 2007.*

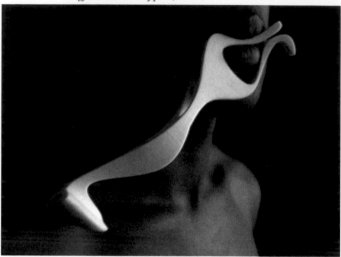

*Season of Love Cutlery: Curved Fork, 2006.*

This experimental fork comes as part of a set of cutlery that explored the relationship between the mouth, the object, and the sensual experience of eating. Exaggerated prongs which encouraged play with the lips, mouth, and tongue were explored throughout each piece.

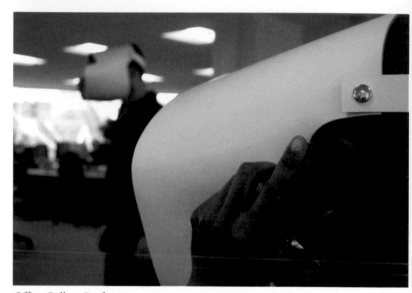

*Office Collar: Performance, 2007.*

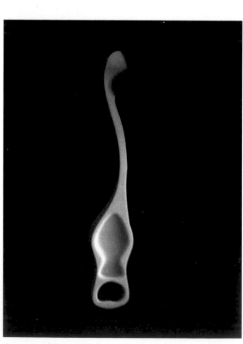

*Season of Love Cutlery: Dummy Spoon, 2006.*

*Office Collar: Installation in Use, 2007, London, UK.*

The aesthetic design of the collar came through an exploration process, for which the artist researched both past and future concepts of attire. This led her to look upon works as broad as those of 16th Century painter Johannes Vermeer—in which one can find Dutch women wearing white headscarves for their daily work—and the photographs of Edward Burtynsky's Manufactured Landscapes, in which he observes the daily working uniforms of the people of Asia.

## Sruli Recht, 2010
*Masked in Flight SR204 Mask B.*

A set of four air-purifying respirators and eye masks made from folded laser-cut, leather parchment for sleeping and breathing.

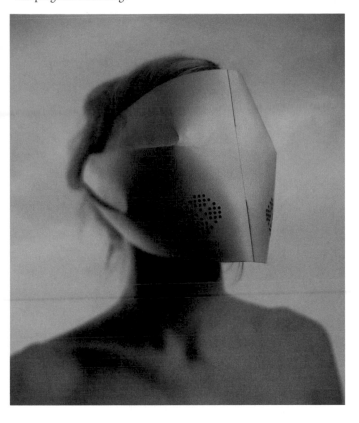

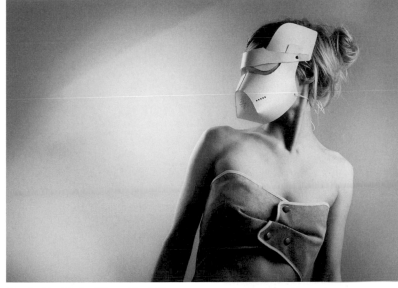

*Masked in Flight SR204 Mask D.*

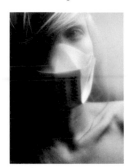

*Masked in Flight SR204 Mask A.*

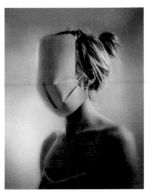

*Masked in Flight SR204 Mask C.*

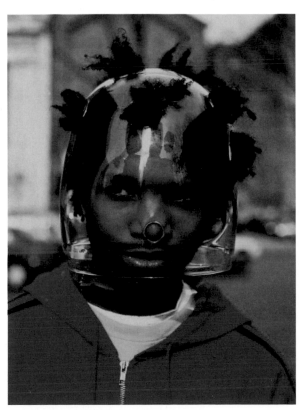

Bohyun Yoon, *Glass Lens Mask*, 2001.

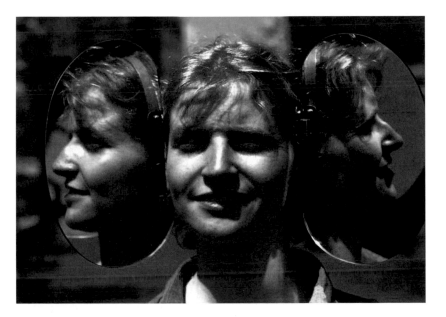

## Bohyun Yoon
*Mirror Mask*, 2002.

When Yoon first came to the U.S., he had a communication problem—English is not his native language. Observing people's faces and gestures helped his understanding, so he started to inquire and develop a project about nonverbal communication. In 𝔐irror 𝔐aſt, Yoon focused on how we are universally able to communicate with our body, regardless of race or language. This mirror shows more sides of the face, helping to communicate and exaggerate our facial expressions to one another.

# 04

## RESHAPE

(Bodies Expressing)

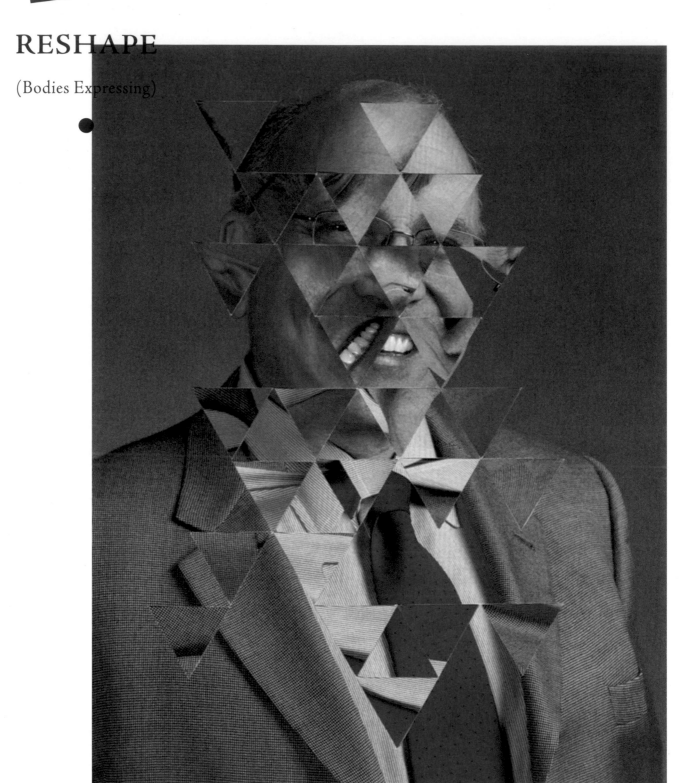

Gordon Magnin, 2008

*Untitled.* Altered found images.

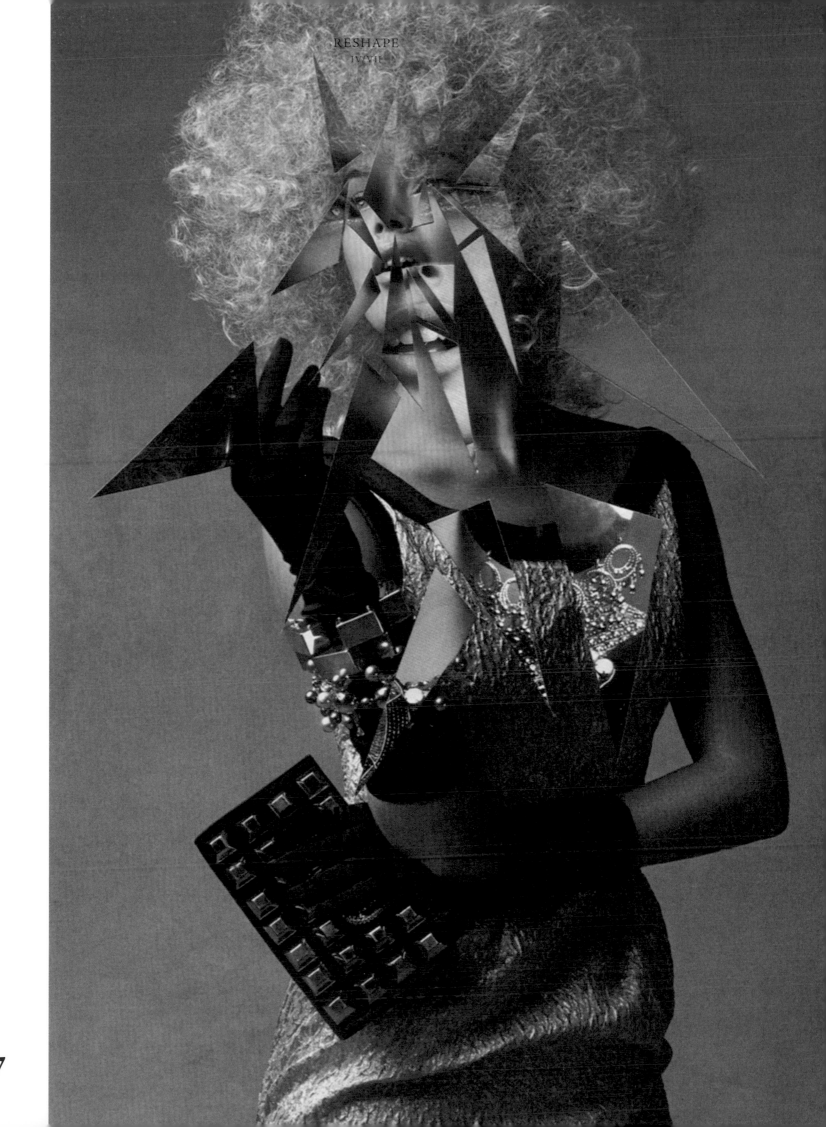

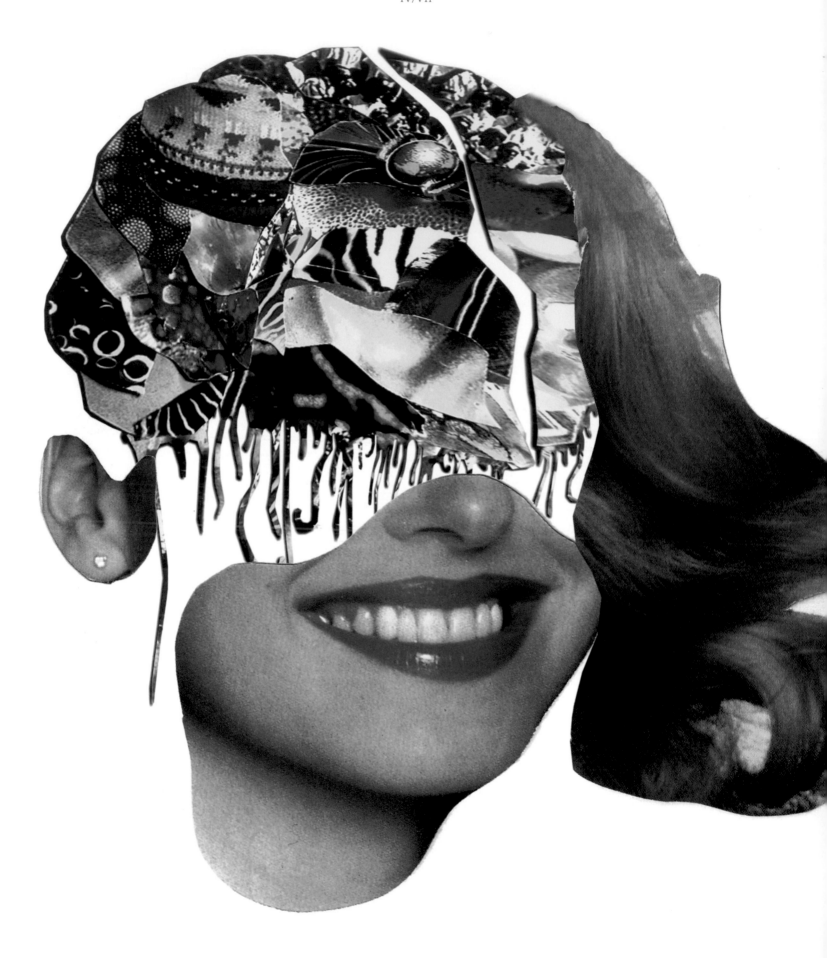

Kraffhics / Leemun Smith
*Brain Model, 2010.*

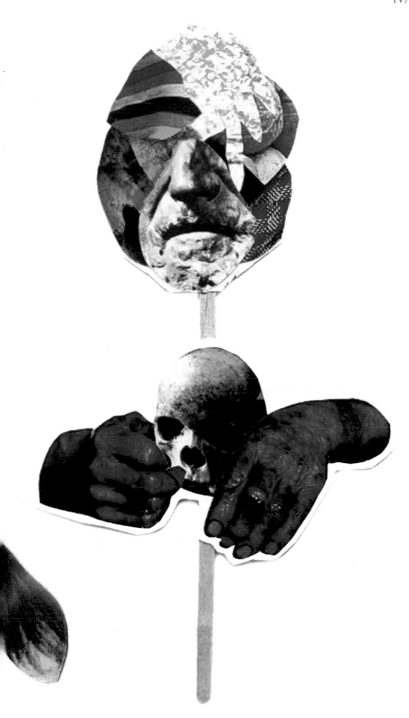

Kraffhics / Leemun Smith, *60 Years Old*, 2009.

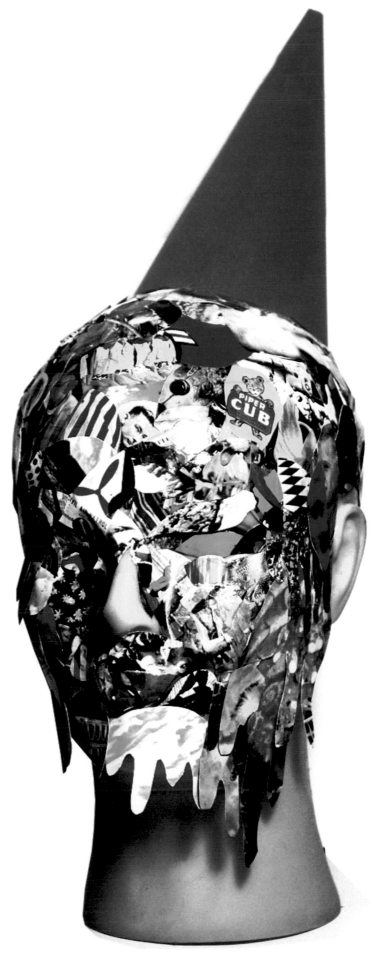

Kraffhics / Leemun Smith, *Untitled*, 2010.

99

## Ashkan Honarvar
*Persephone,* 2010, Collages.

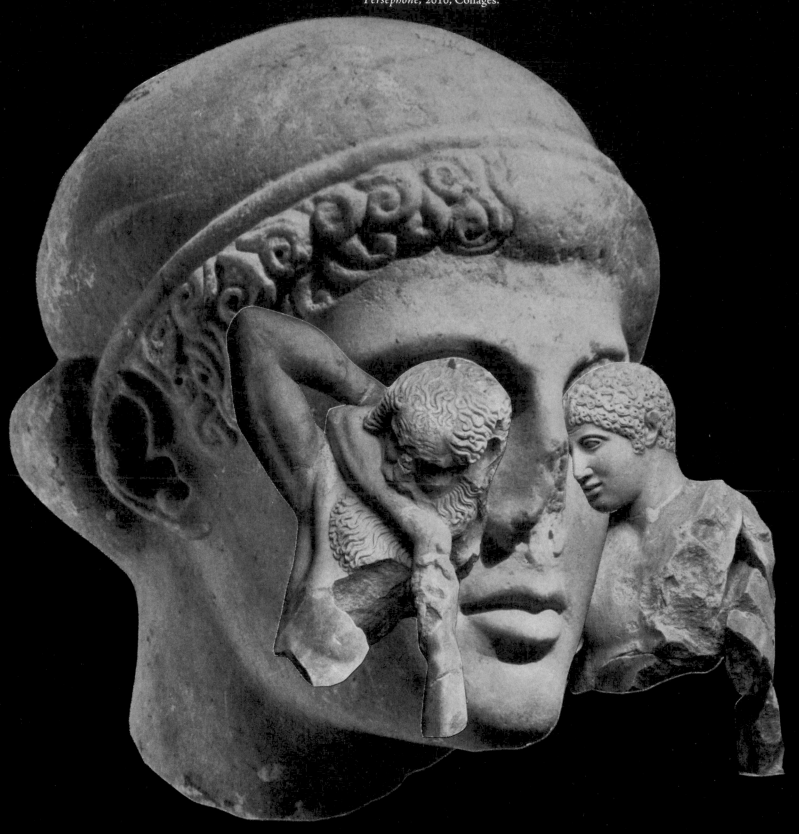

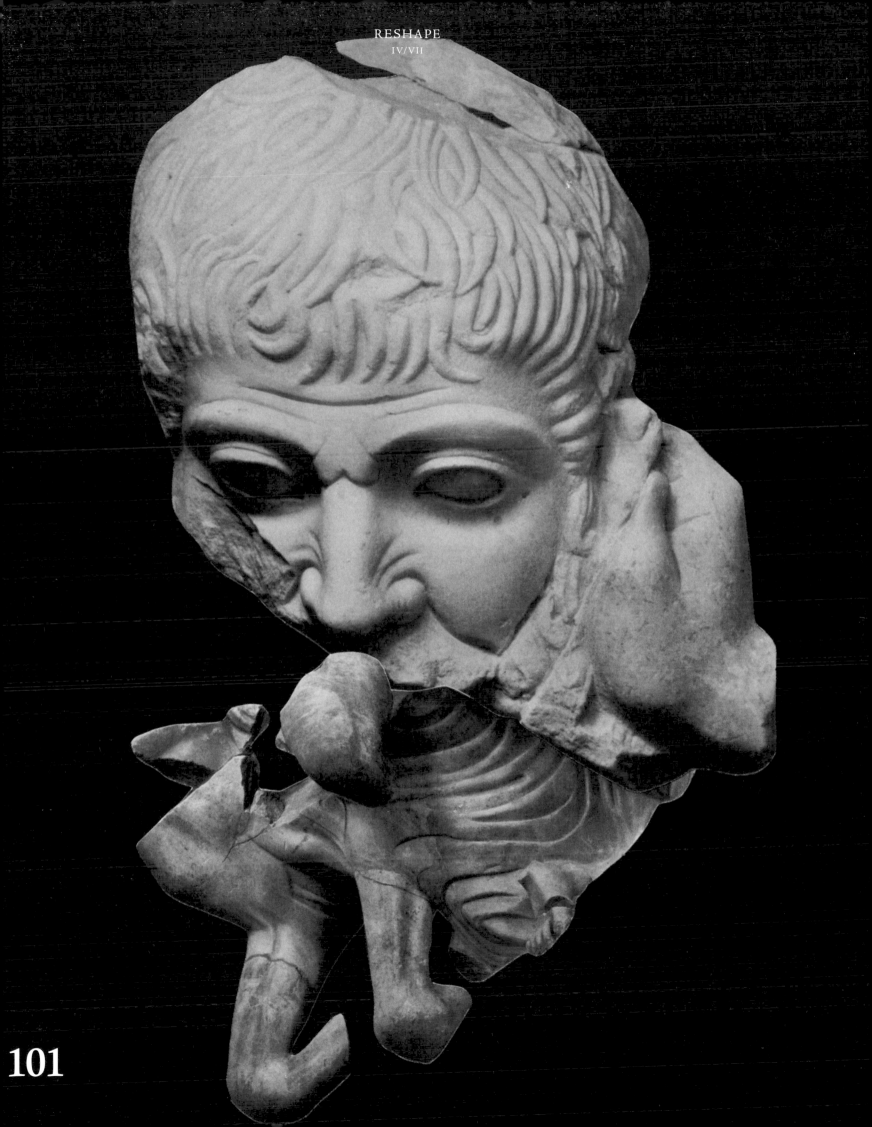

Luis Dourado
*Freddie is Dreaming, 2010.*

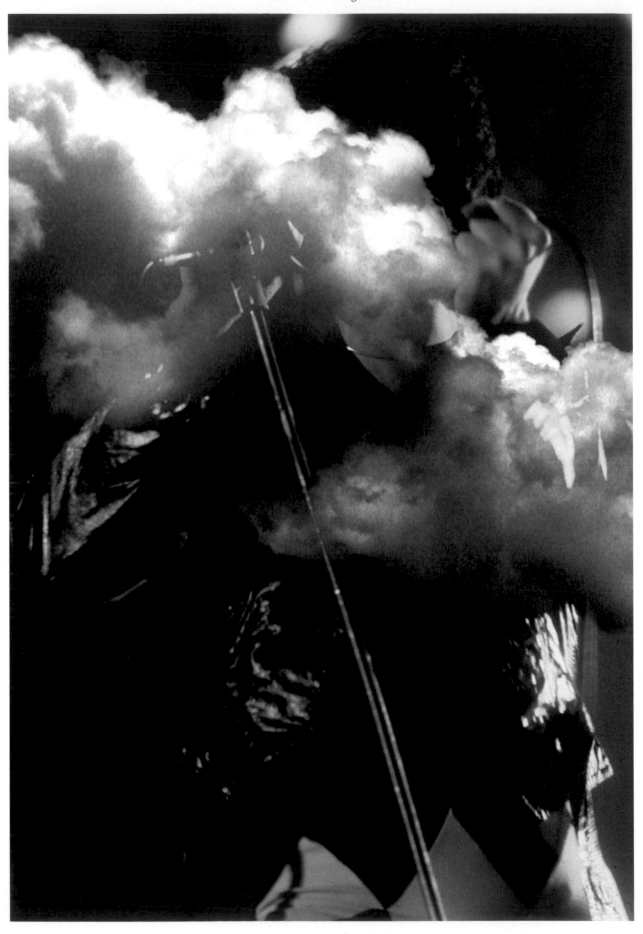

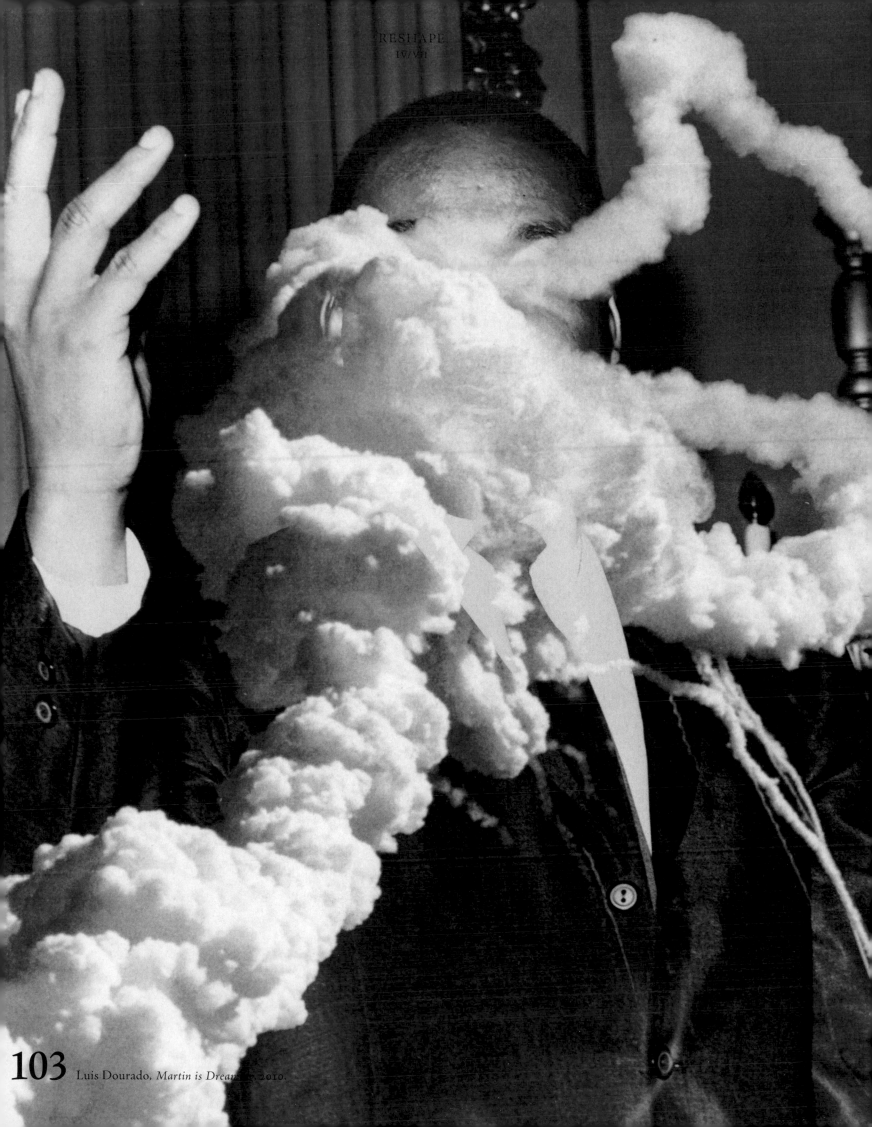

103 Luis Dourado, *Martin is Dreaming*, 2010.

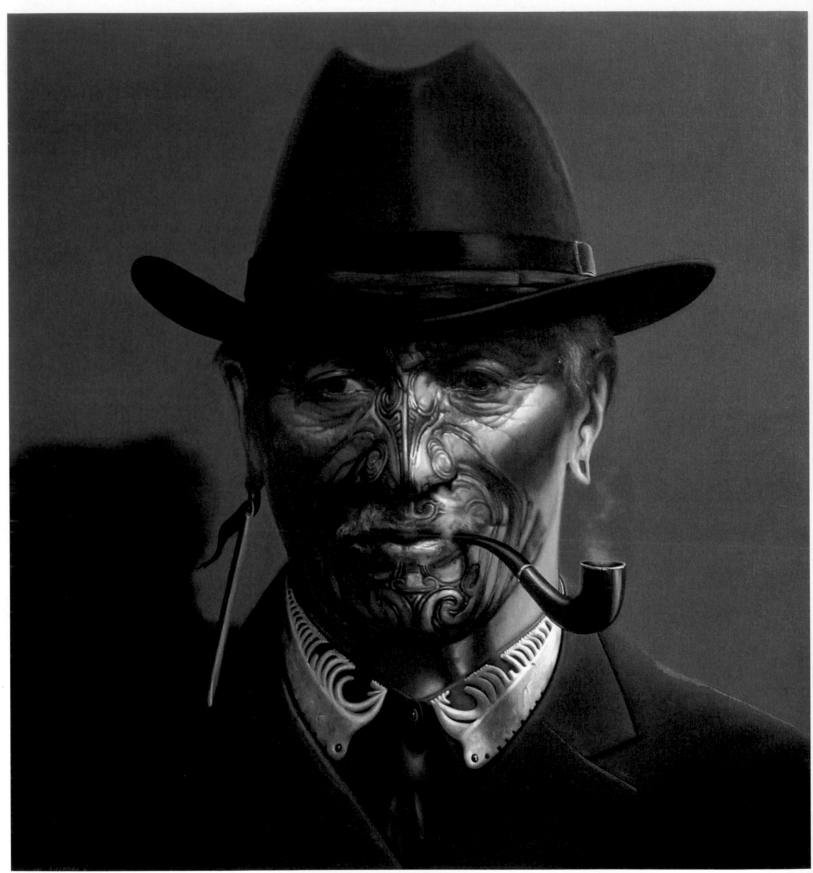

## Paul Jackson

*The Smoking Tohunga*, 2009.
Oil on linen, 100 cm x 95 cm.

These are not portraits, they are faux. These paintings are not the ruminations of polite society or historical records, but the incomprehensible meeting the im-

placable. This is the reawakening of the gaze of first contact with pakeha (non-Maori). In paintings and drawings, such as 𝔉𝔞𝔲𝔵 𝔐𝔬𝔱𝔬, 2009, 𝔚𝔬𝔩𝔣, 2008, and 𝔐𝔞𝔱𝔬, 2008, the ploughed and resolute visage of the faces presages, with the edginess of a wolf, the end of a feudal and arcane society. These paintings express morphological equivalency and distortion, contrariness, visual conceit, and juxtaposition, wrestling in the arena of difficulty and awaiting a face-off between the chosen subjects and the viewer. These

works reflect the attempt to extend an impermanent life, false hopes, and supplications to the great gods of permanence.

OPPOSITE PAGE

*The Tohunga*, 2009. Oil on linen, 132 cm x 96 cm.

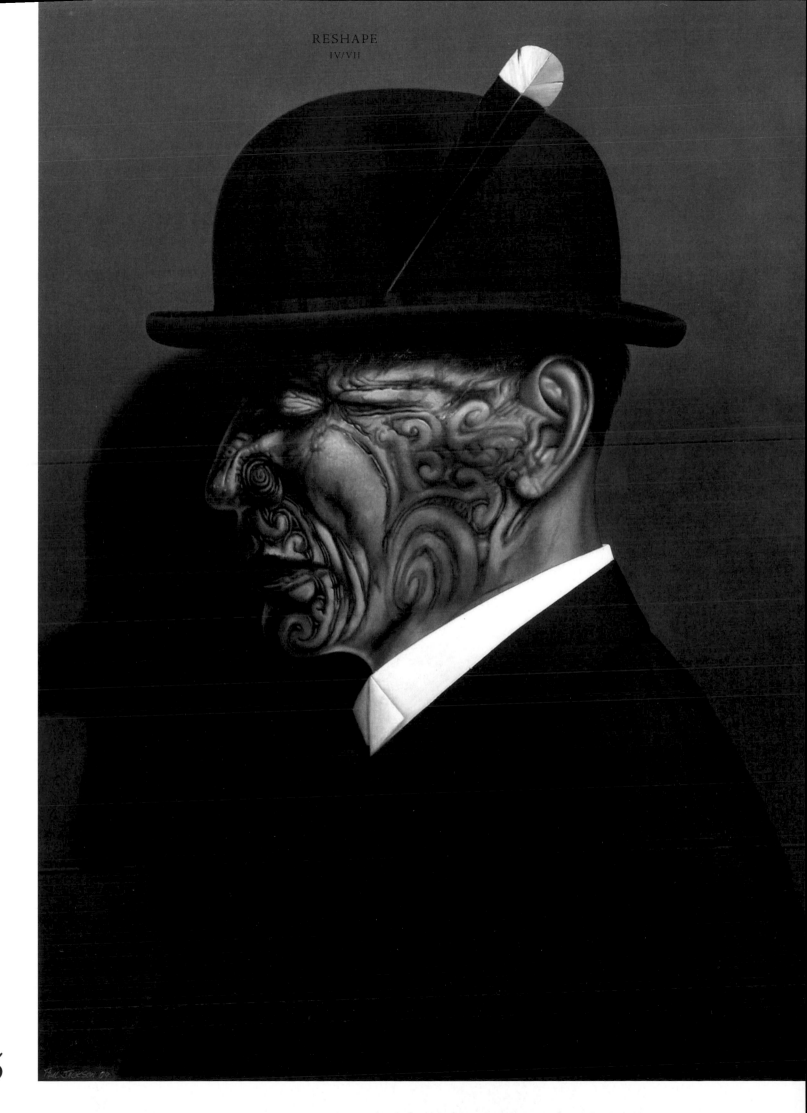

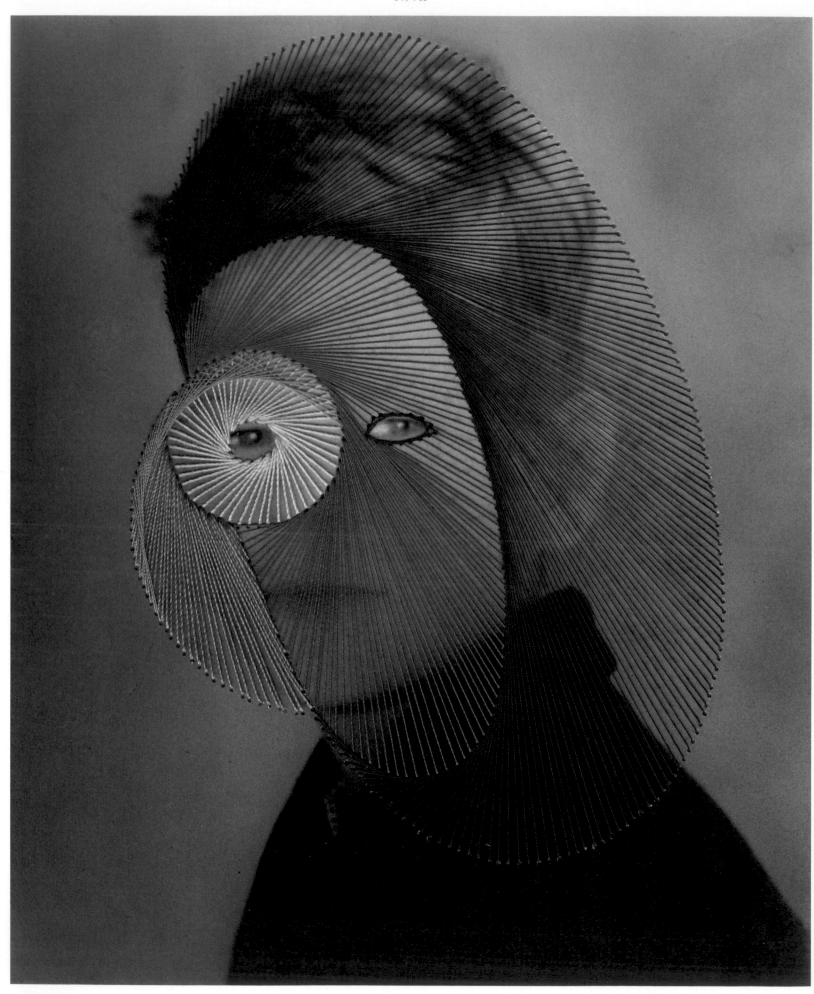

**106** Maurizio Anzeri
*Giovanni*, 2009. Embroidery on photo, 22 cm x 17 cm.

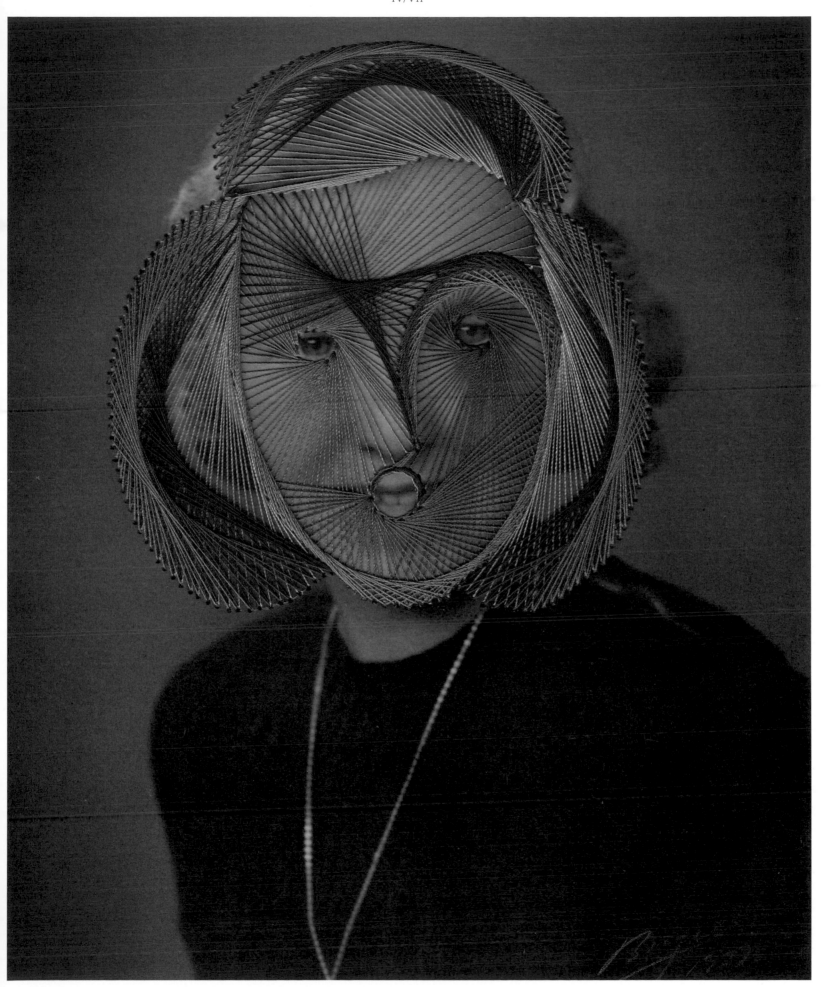

107 Maurizio Anzeri, *Brigitte*, 2009. Embroidery on photo, 20 cm x 15 cm.

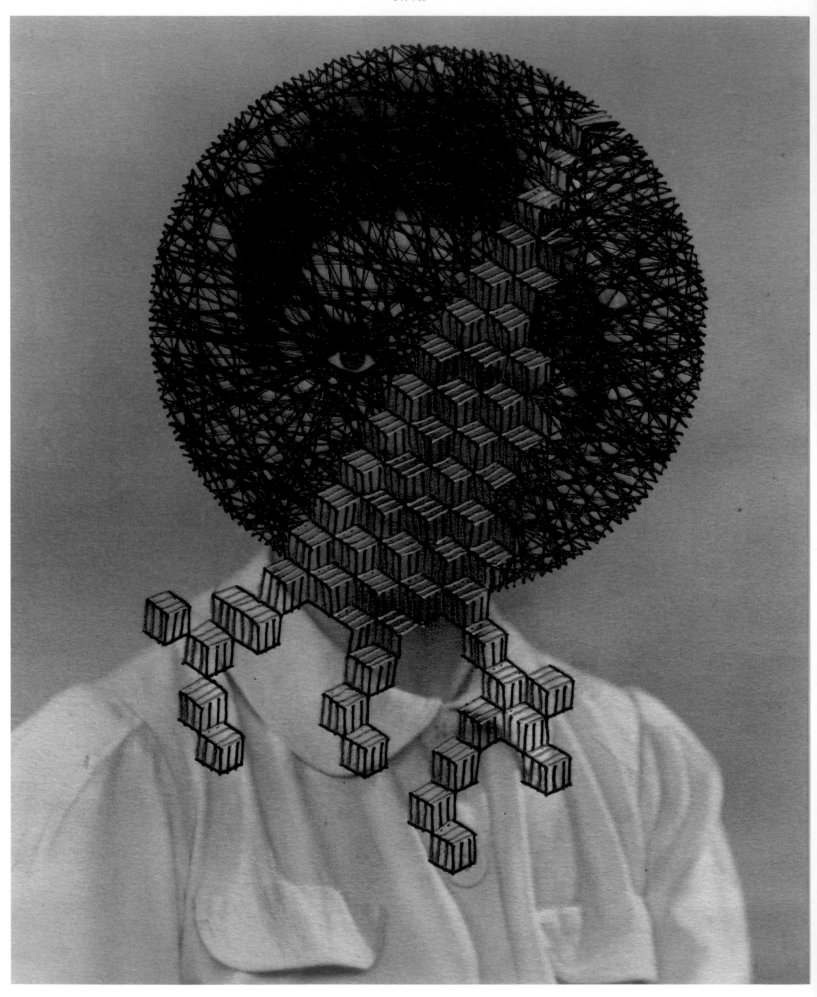

**108** Maurizio Anzeri, *Marianna*, 2010. Embroidery on photo, 24 cm x 17 cm.

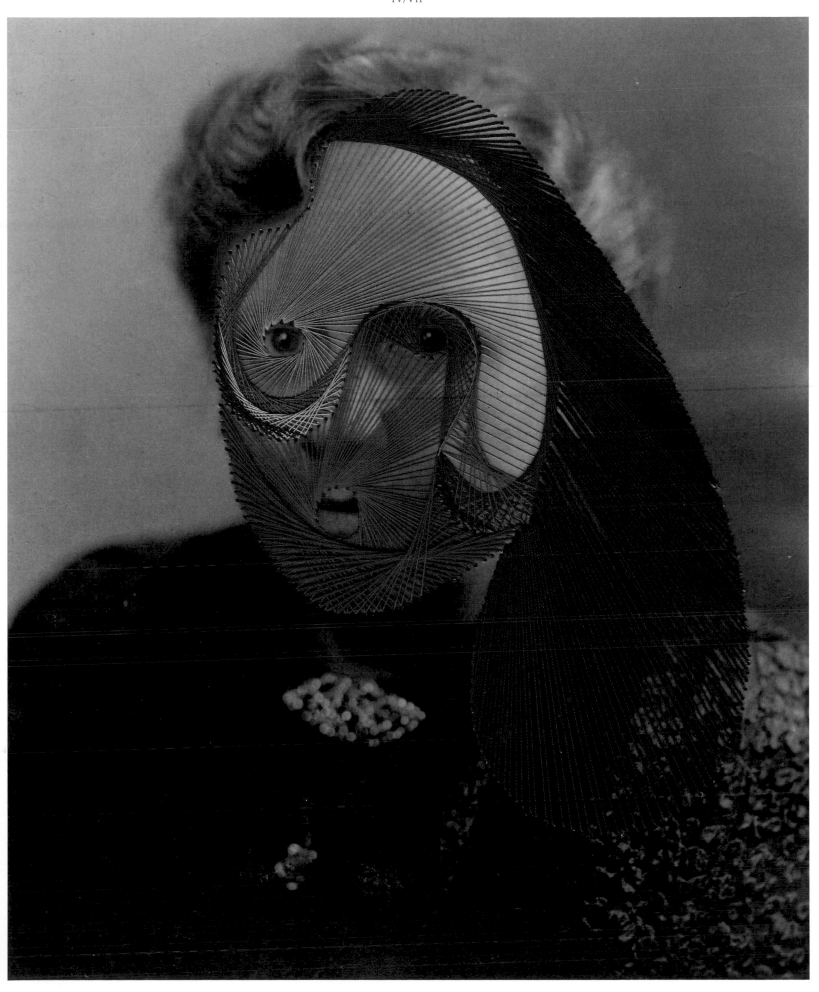

**109** Maurizio Anzeri, *Zelda*, 2009. Embroidery on photo, 24 cm x 18 cm.

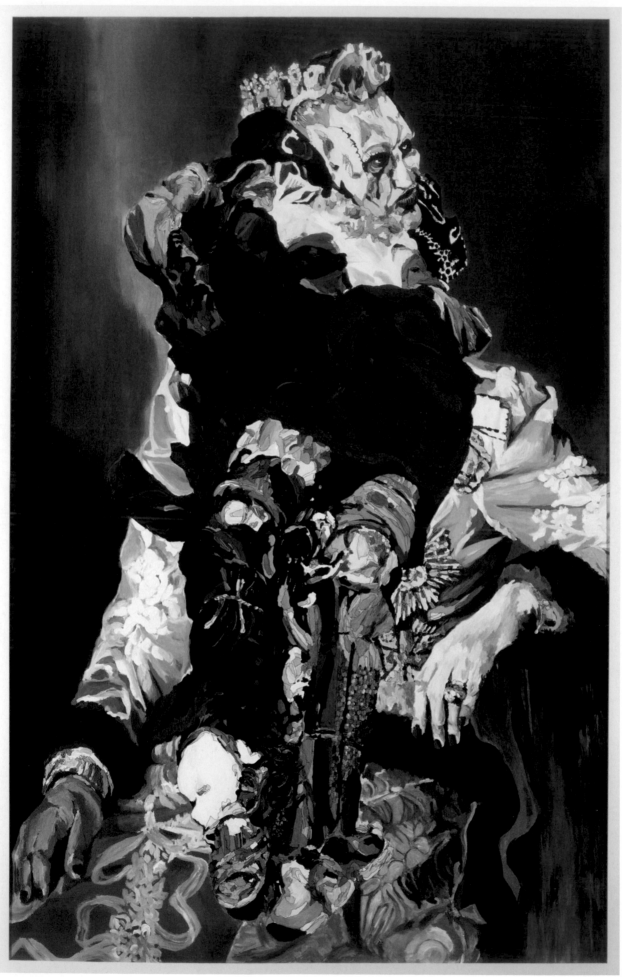

1

## Helle Mardahl

**1**
*The Homeless Queen*, 2009.
Acrylic on linen, framed,
109 cm x 69 cm.

**2**
*MC With Bird*, 2010.
Acrylic on linen, framed,
67 cm x 45 cm x 5 cm.

**3**
*His Superman*, 2010.
Acrylic on linen, framed,
138 cm x 108 cm.

**4**
*The Elephant*, 2009.
Installation, mixed media.

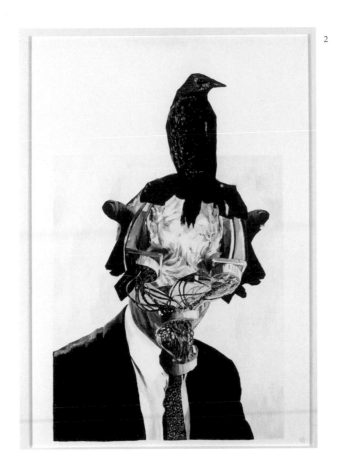

2

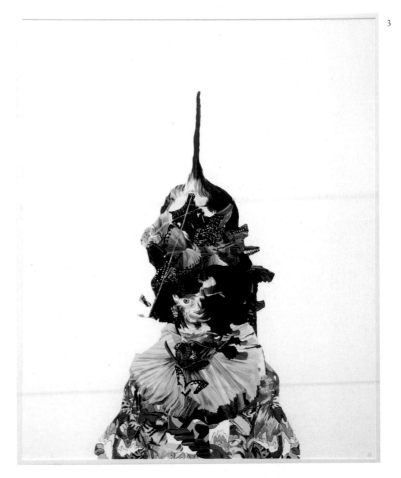

3

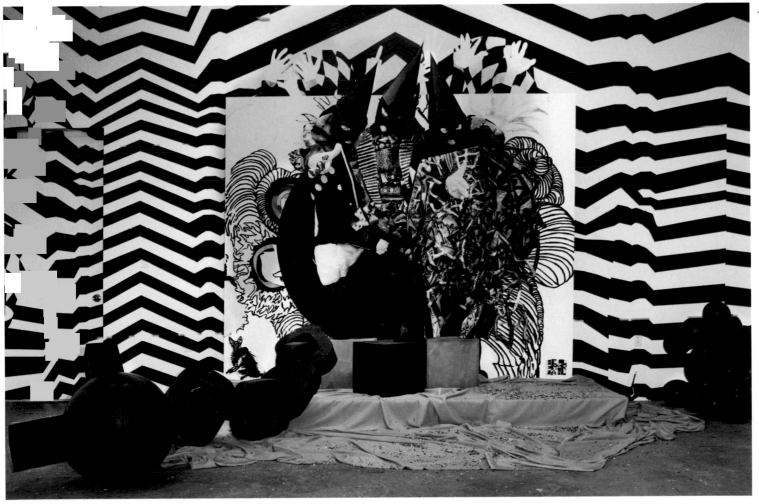

4

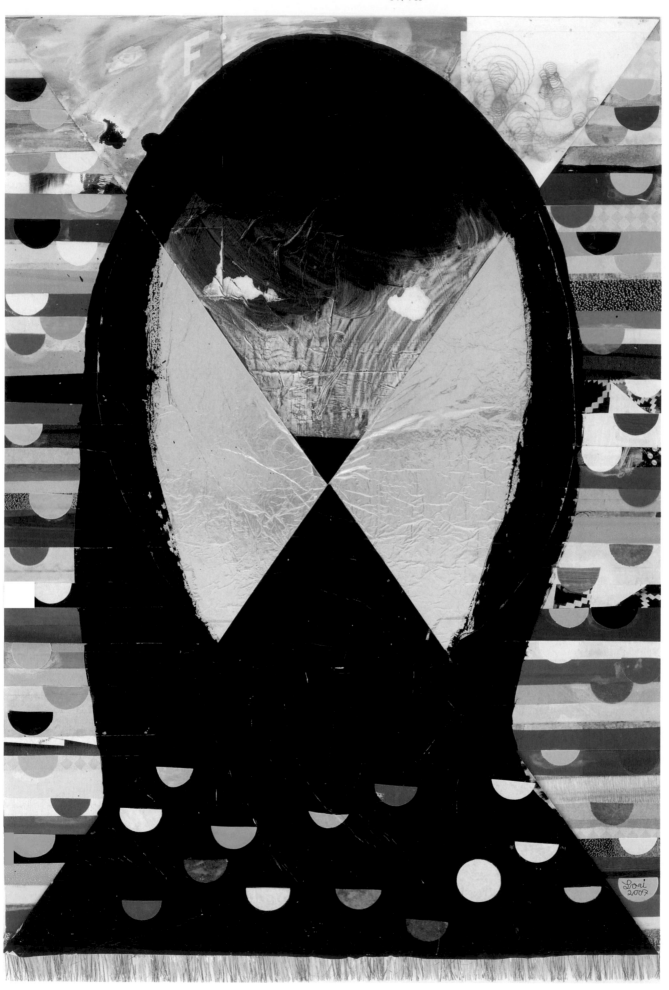

**112** Anika Lori
*Image of You,* 2007. Mixed media collage. 100 cm x 70 cm.

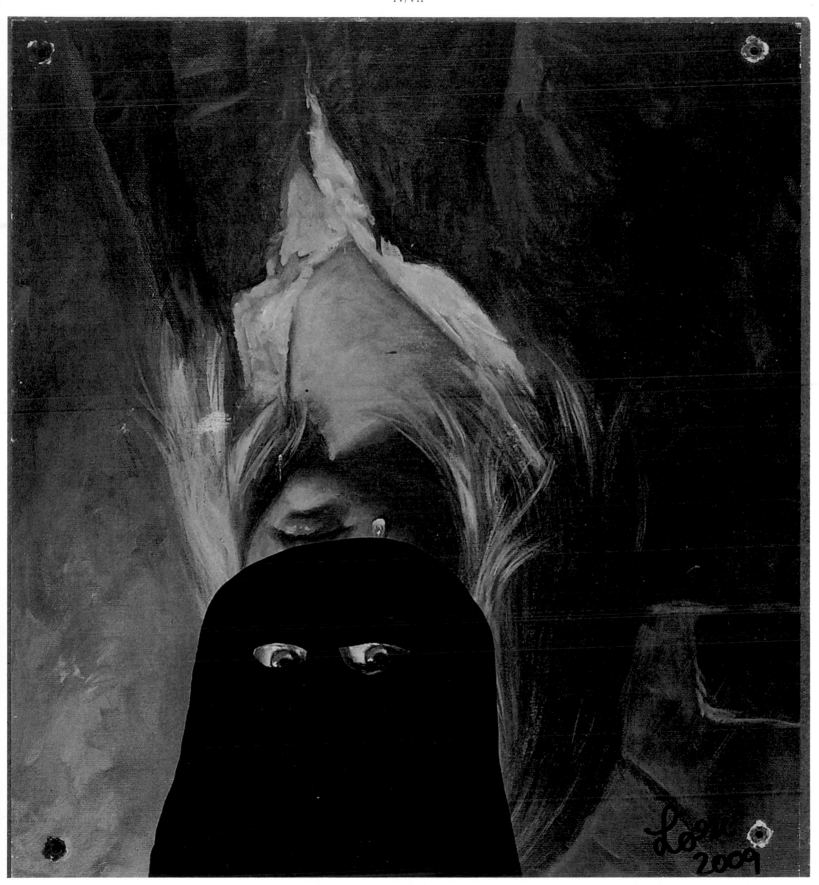

113 Anika Lori, *Do You Like My Tight Sweater? Part 4*, 2009.
Mixed media on wood. 25 cm x 23 cm.

No title, 2010.

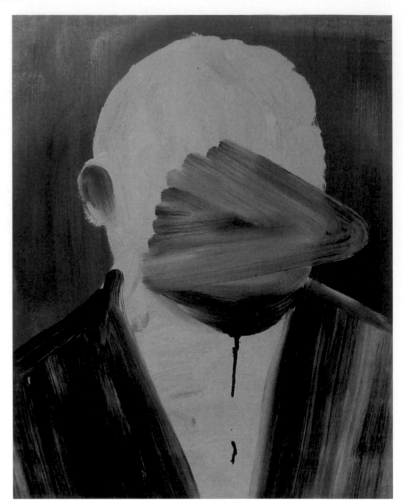

No title, 2009.

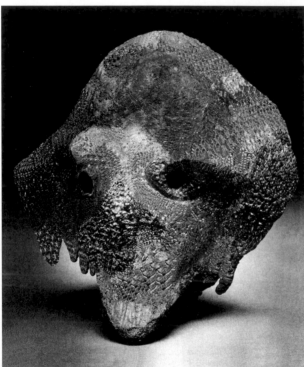

No title, 2009.

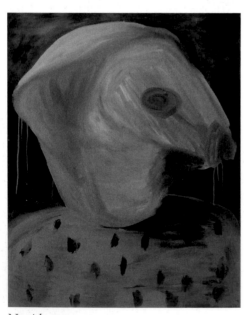

No title, 2009.

No title, 2010.
Intervention on existing photo.

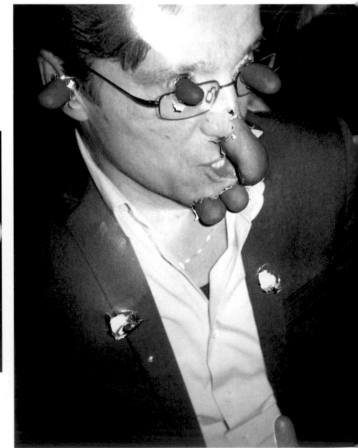

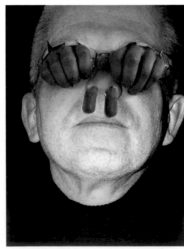

114 Beni Bischof

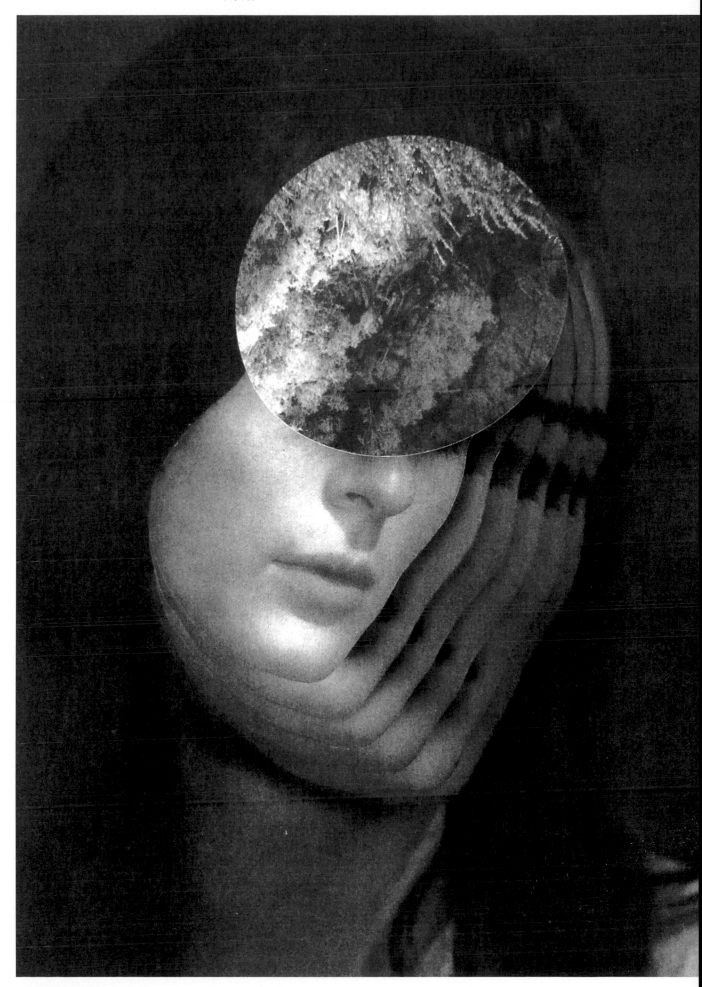

Eva Eun-sil Han
*Untitled,* 2010. Collage on paper.

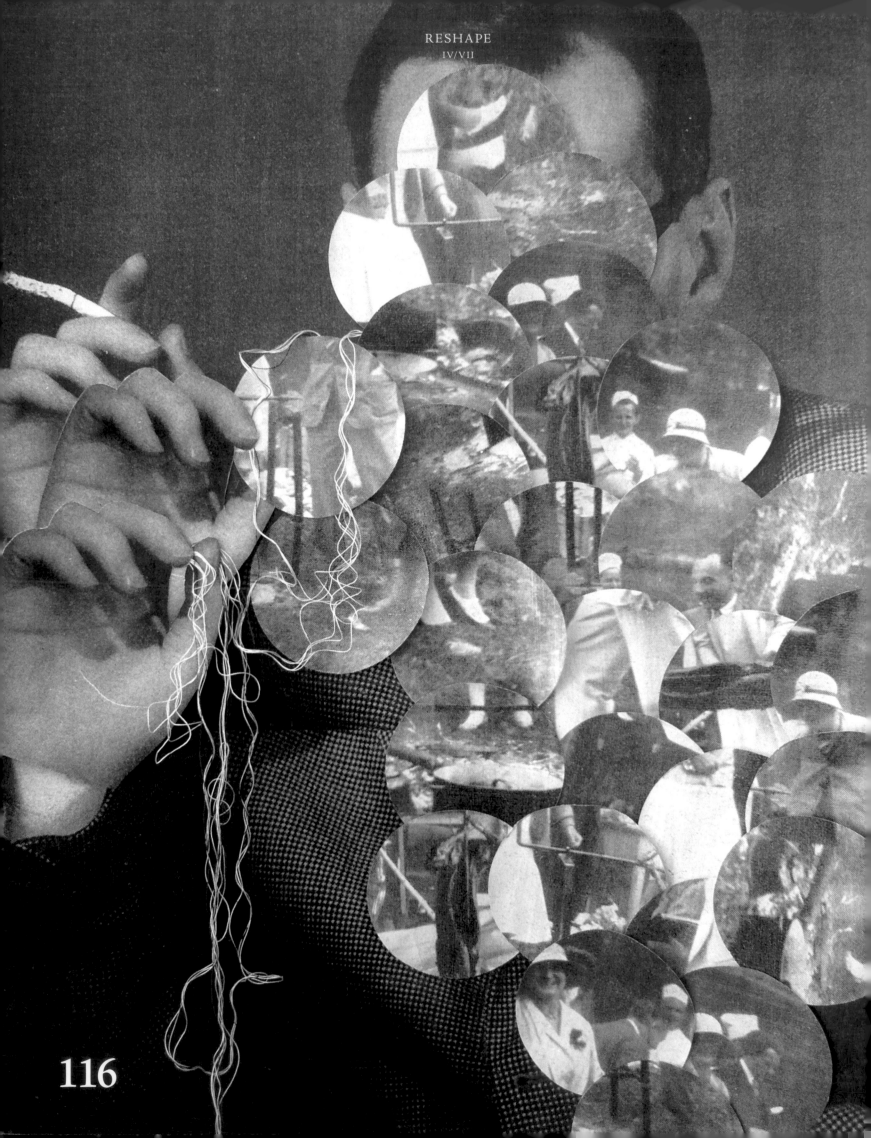

Eva Eun-sil Han, *Untitled*, 2010.
Collage on paper.

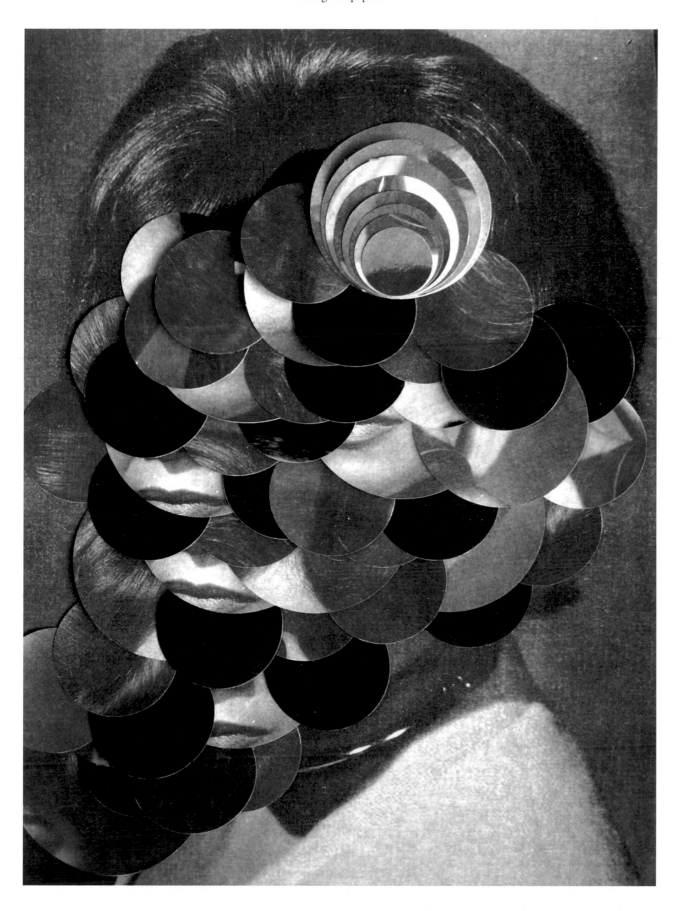

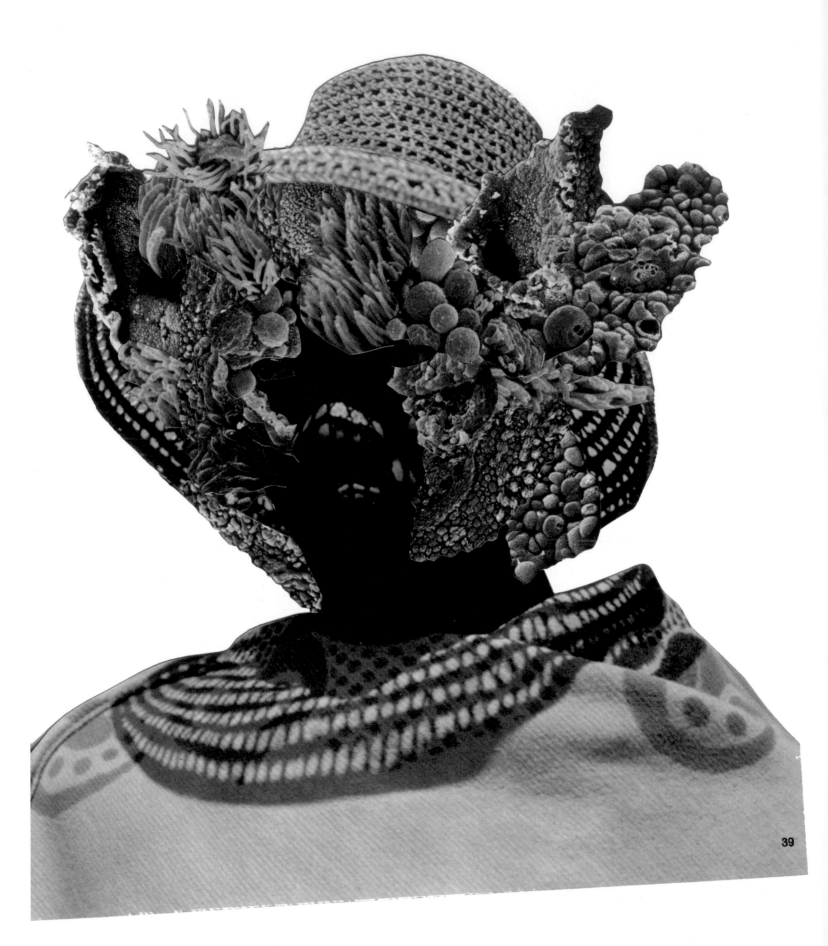

39

Ashkan Honarvar
*Ubakagi,* 2010.

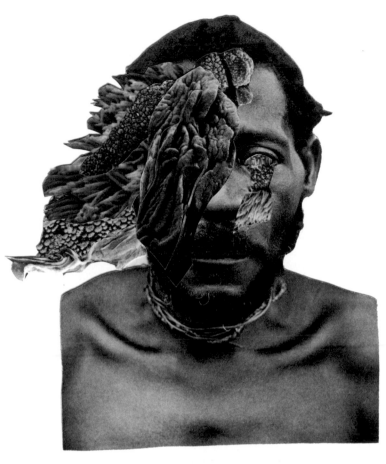

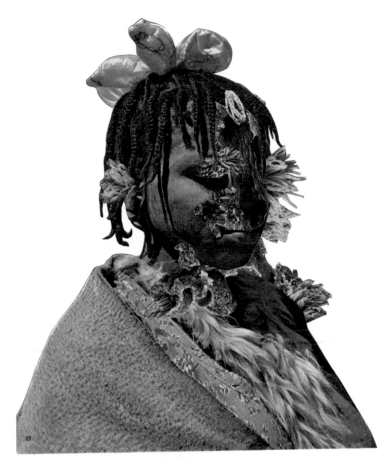

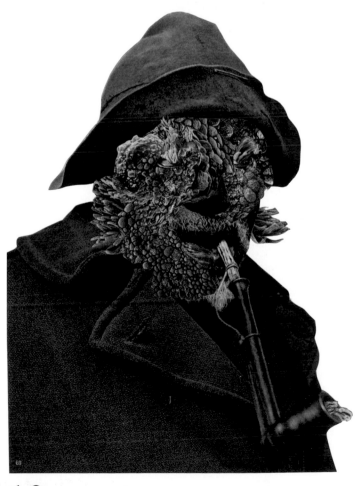

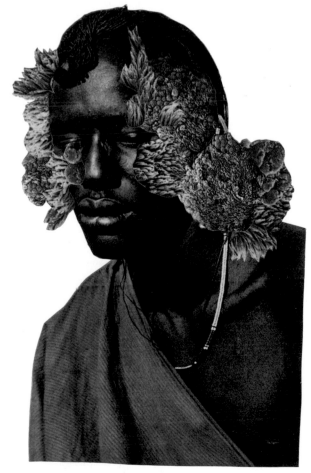

119

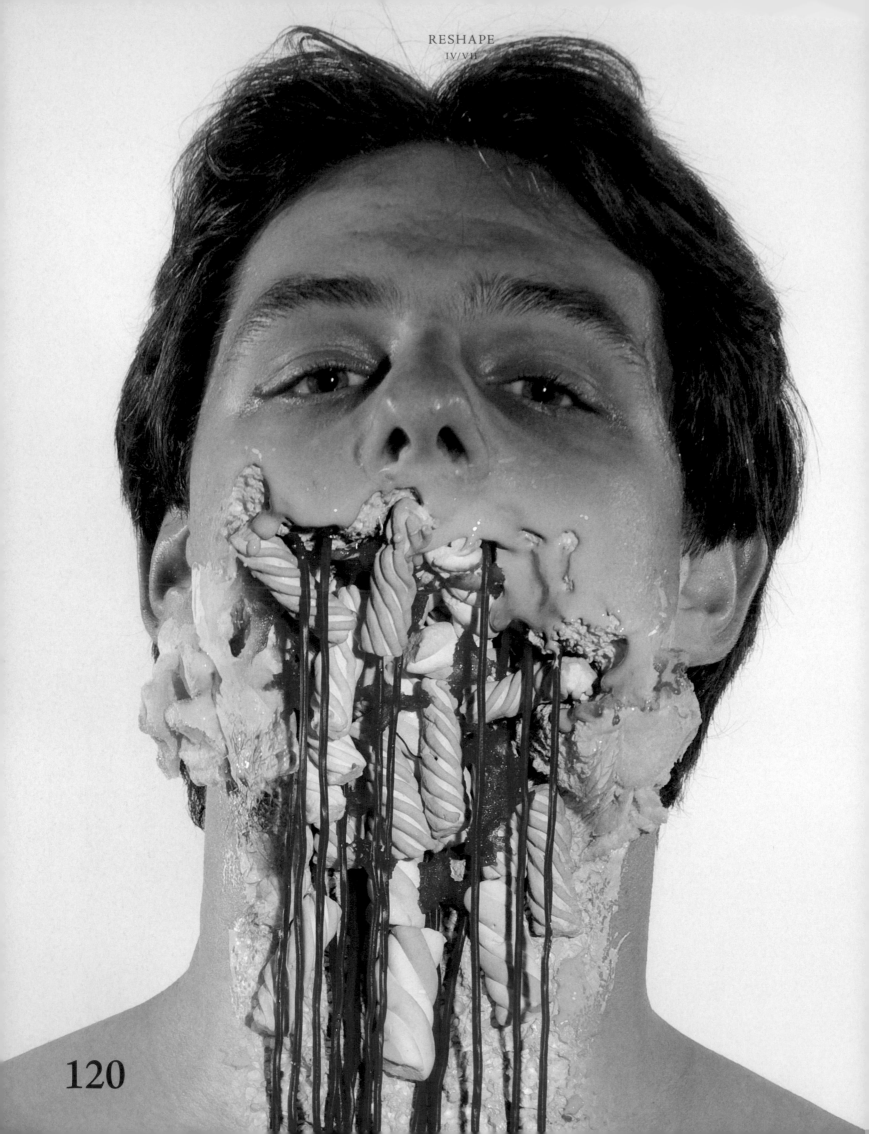

120

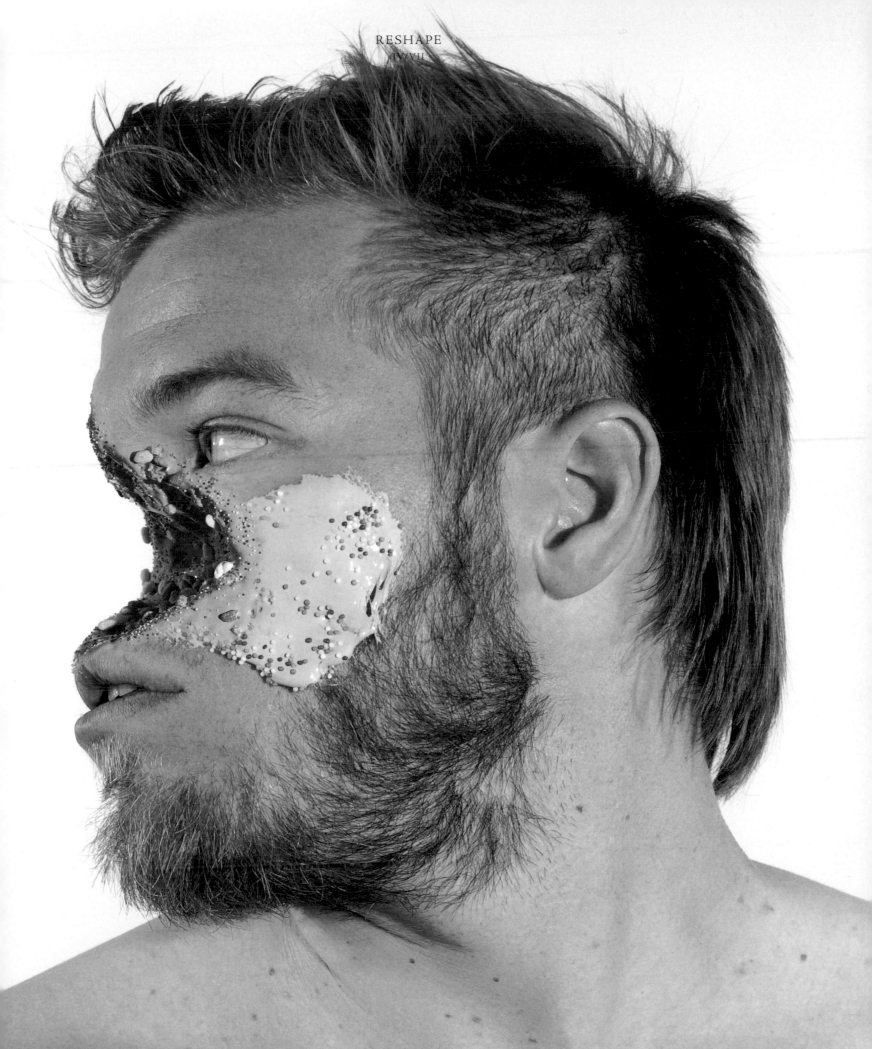

121 Ashkan Honarvar
*Faces-5*, 2010. Photography, digital manipulation.

Akatre
*Mains d'Œuvres, 2008.*

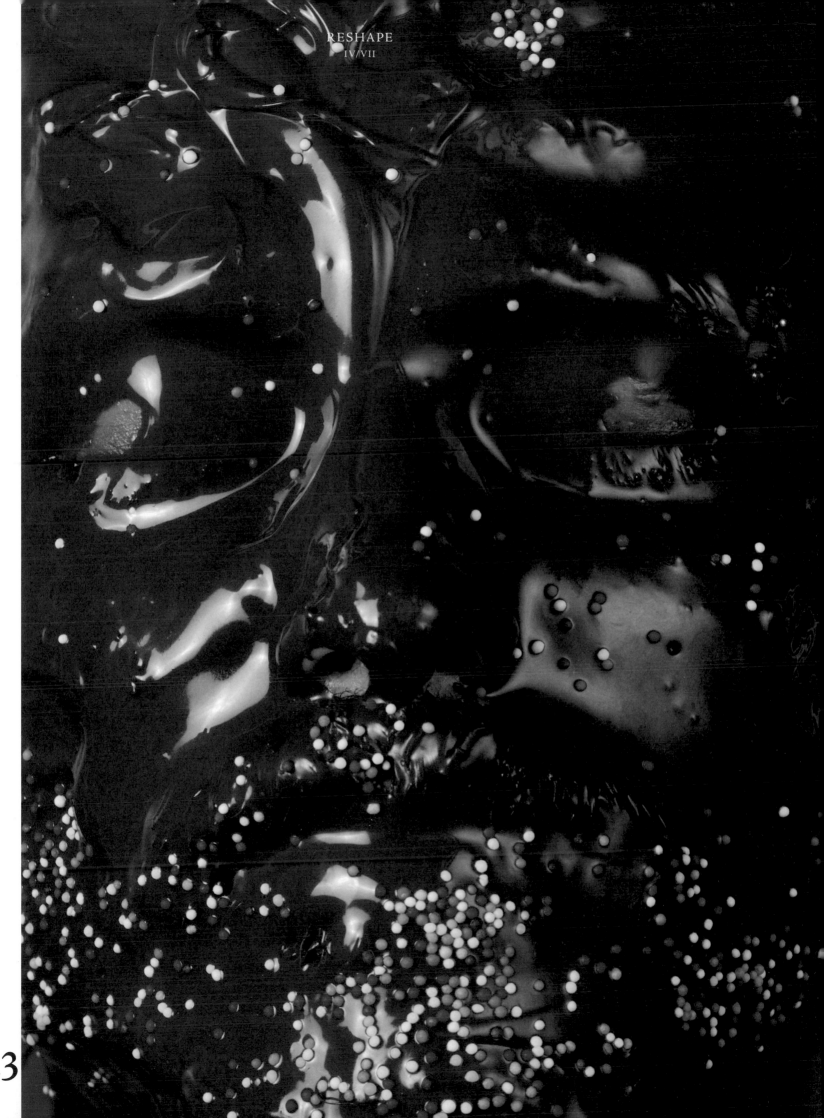

*Curated 2, 2010.*

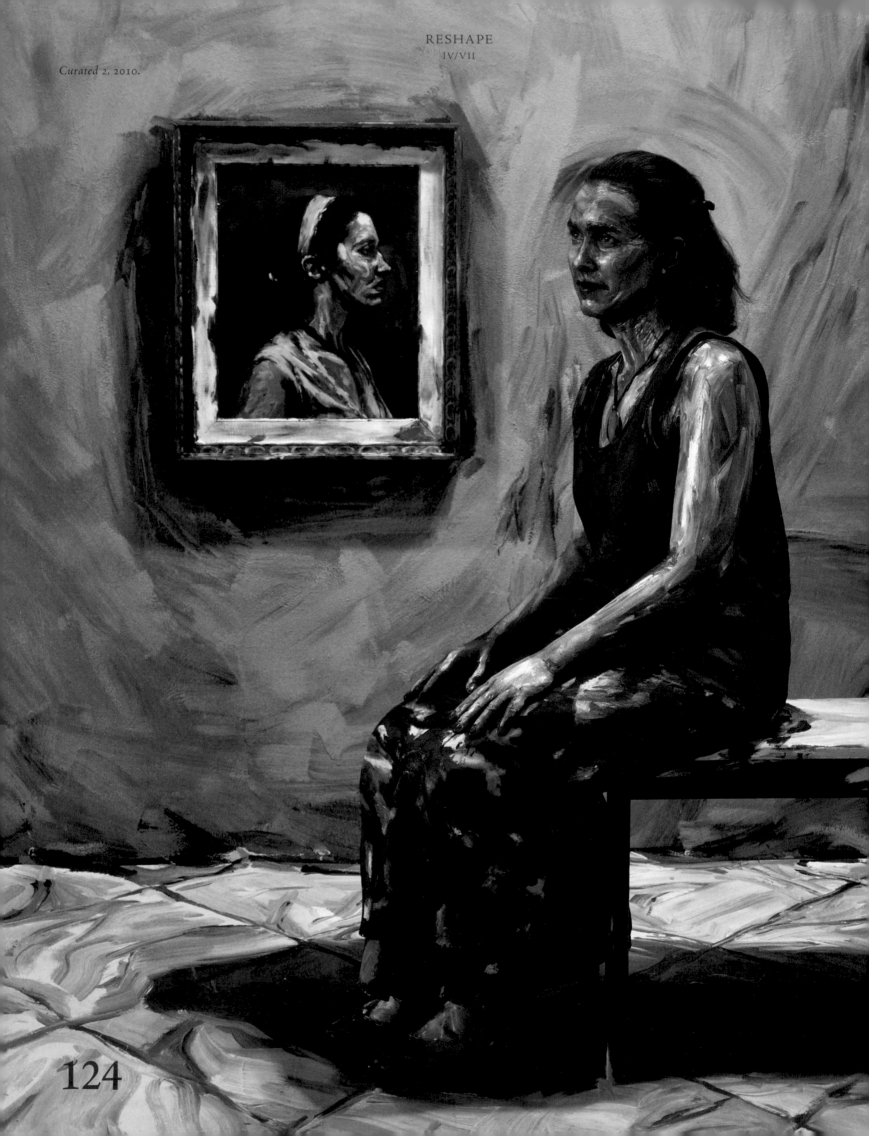

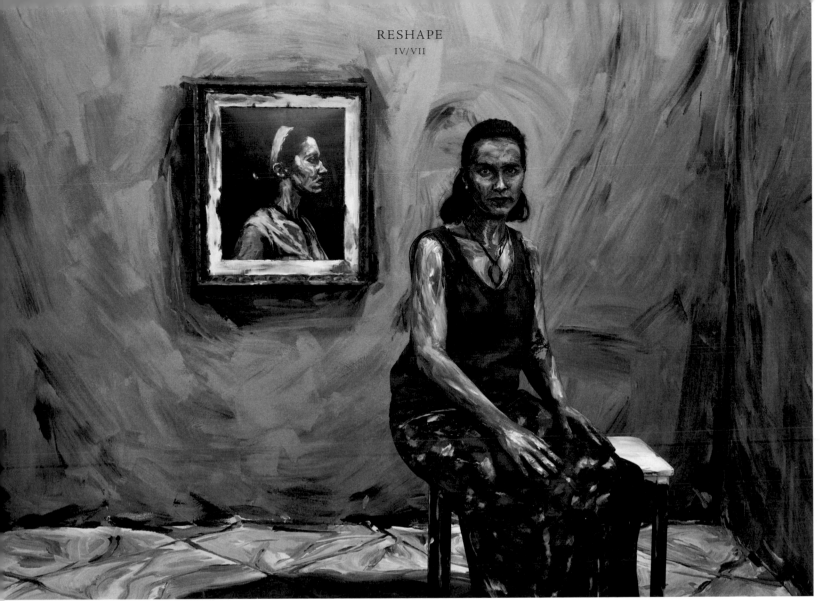

*Curated 1, 2010.*

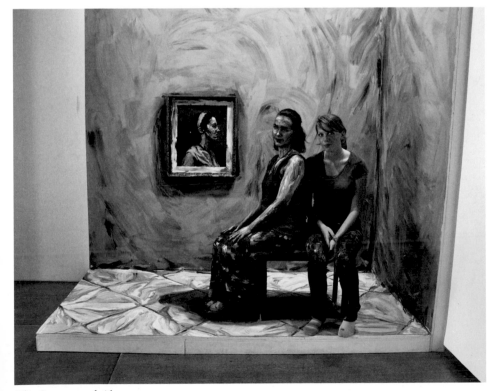

*The Curator and Alexa, 2010.*

## Alexa Meade

Alexa Meade painted directly on the three-dimensional form of the subject's body and clothes to render a portrait that seemingly exists in two-dimensional space.

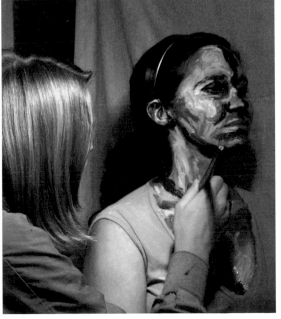

*Painting Jaimie, 2010.*

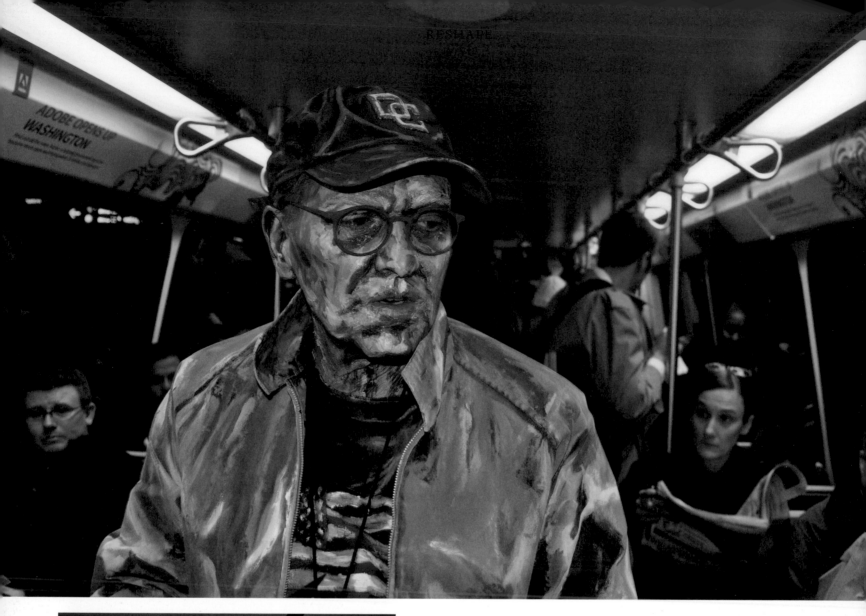

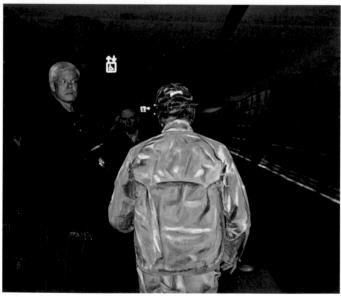

Alexa Meade, *Transit*, 2009, Washington, DC, USA.

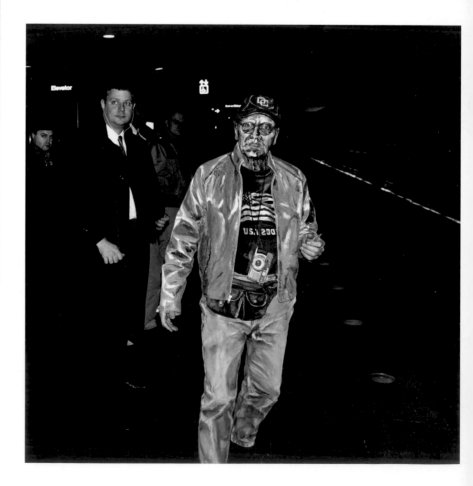

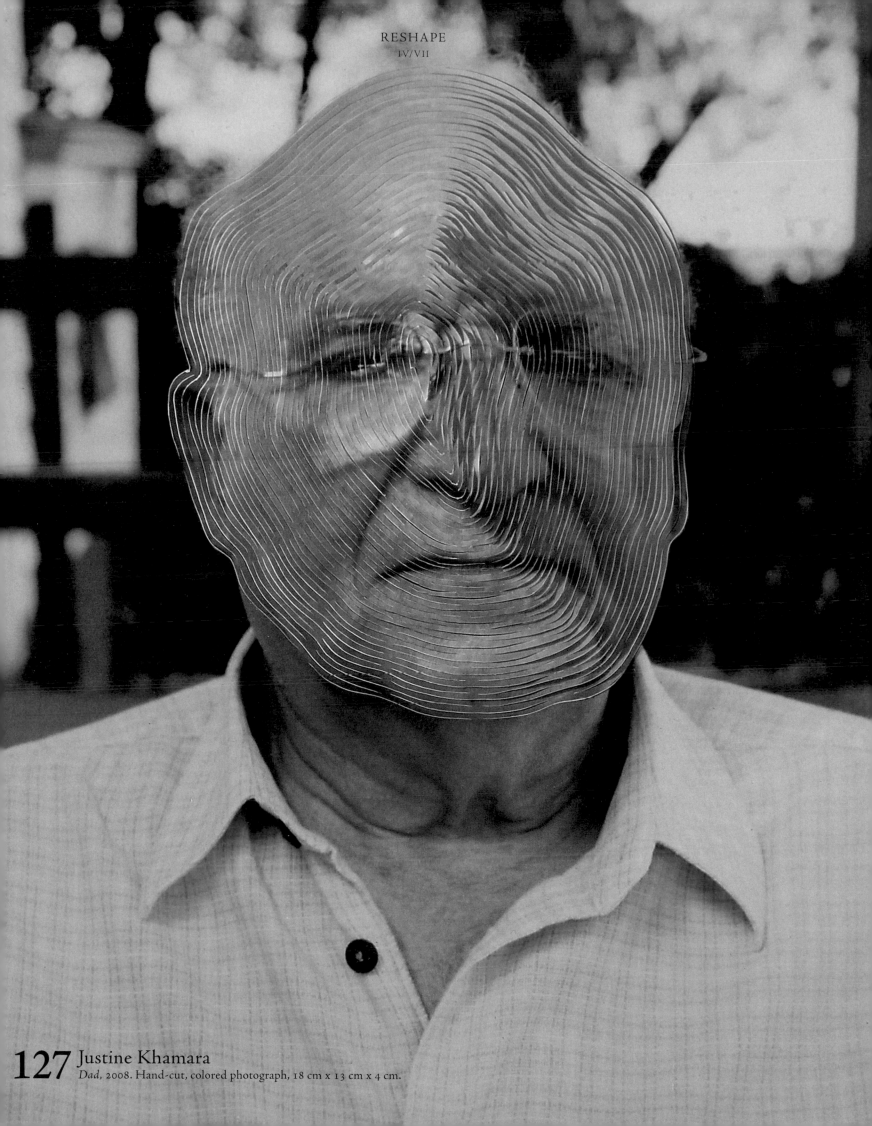

**127** Justine Khamara
*Dad*, 2008. Hand-cut, colored photograph, 18 cm x 13 cm x 4 cm.

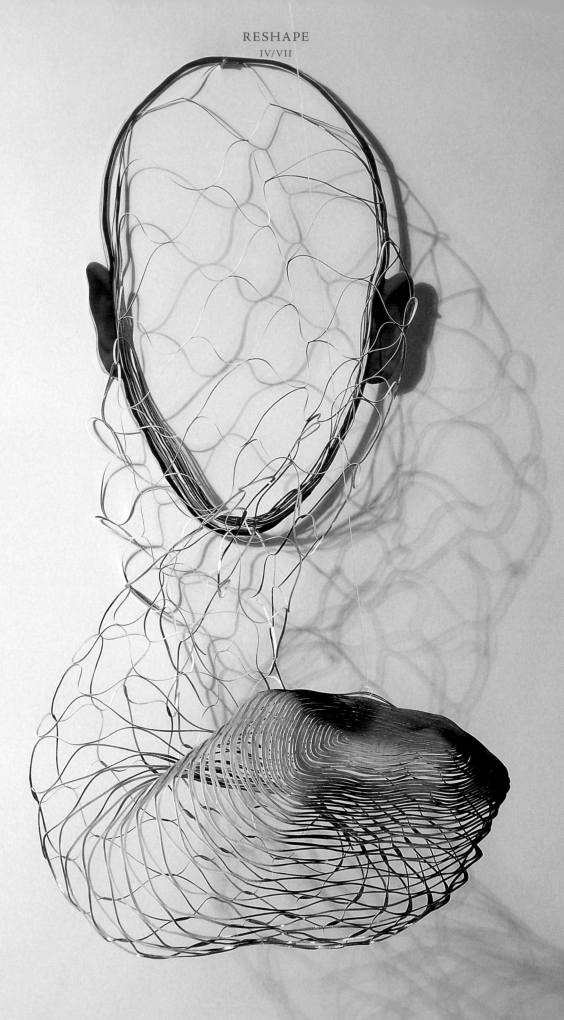

128 Justine Khamara, *Untitled*, 2008.
Hand-cut, colored photograph, dimensions variable.

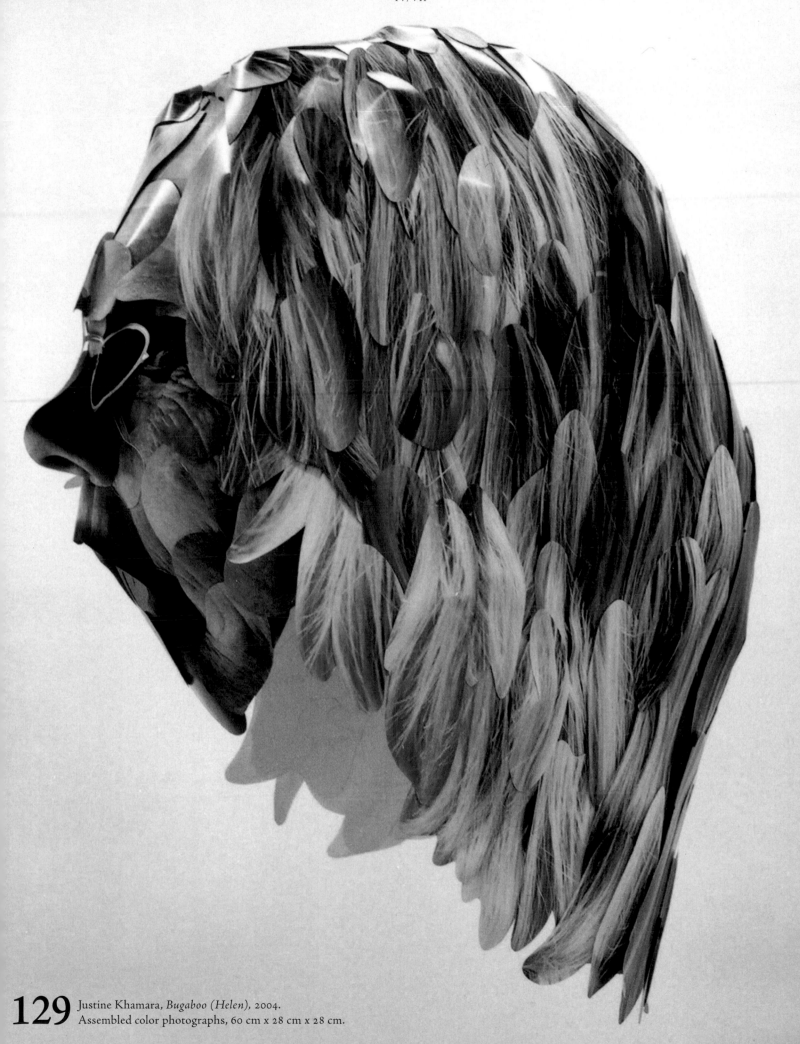

**129** Justine Khamara, *Bugaboo (Helen)*, 2004.
Assembled color photographs, 60 cm x 28 cm x 28 cm.

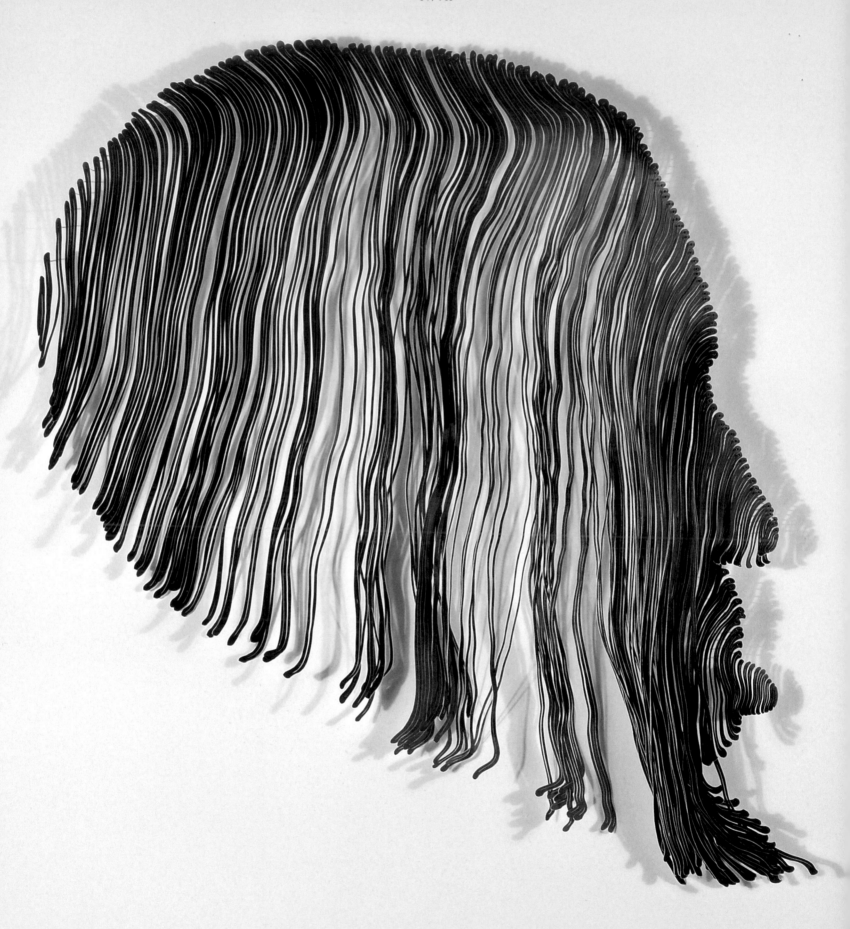

**130** Justine Khamara, *Untitled*, 2008.
Hand-cut, colored photograph, pins, 48 cm x 41 cm x 30 cm.

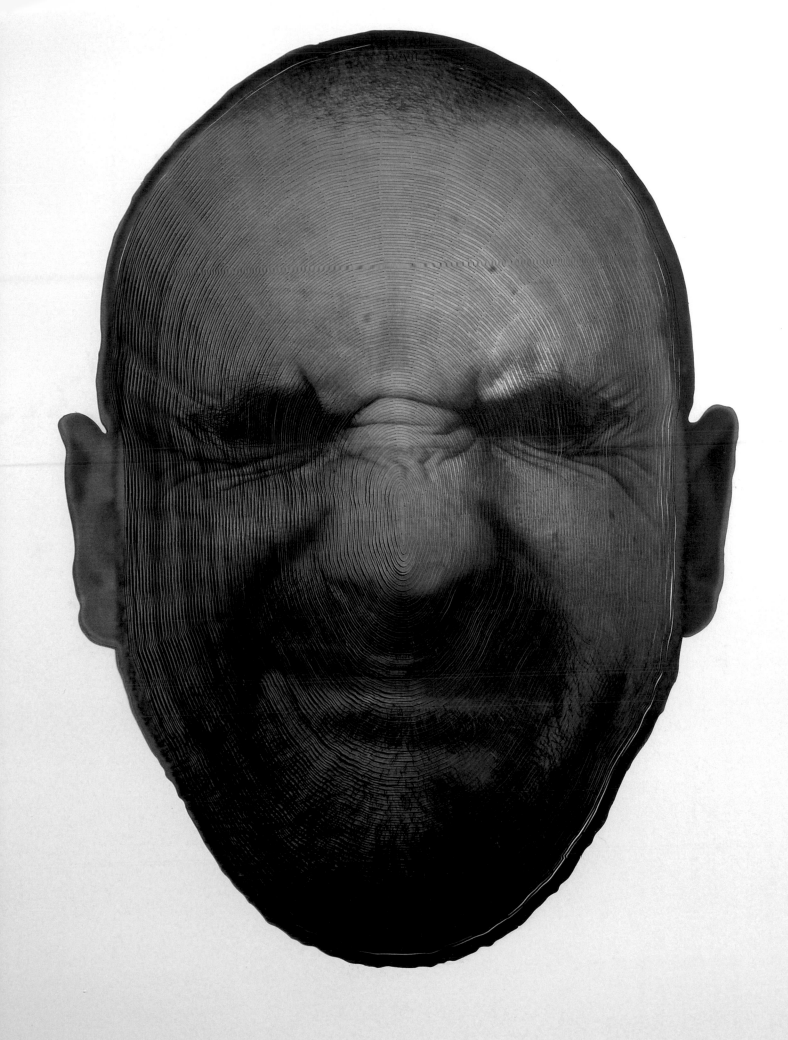

Justine Khamara, *Dilated Concentrations (Simon)*, 2009.
UV print on laser-cut stainless steel, 109 cm x 75 cm x 45 cm.

# 05

## DEFORM

(Construction/
Deconstruction)

●

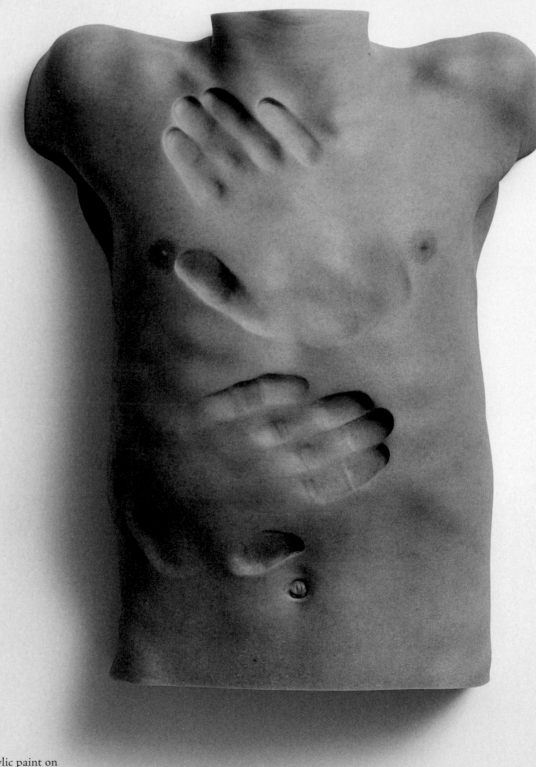

Anders Krisár

*The Birth of Us (Boy)*, 2006–2007. Acrylic paint on
polyester resin and fiberglass, oil paint, screw eye, steel
wire, and wire lock, 42 cm x 33 cm x 12 cm.

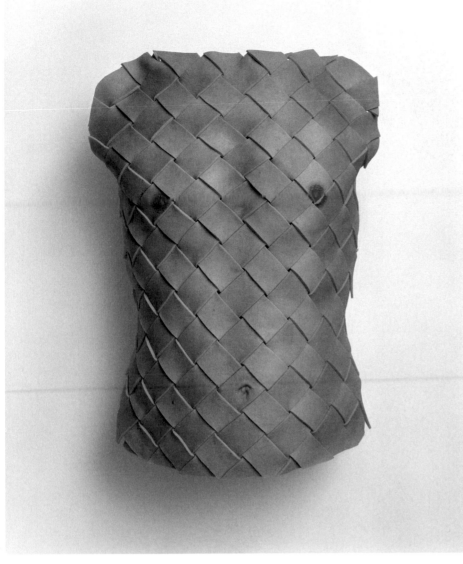

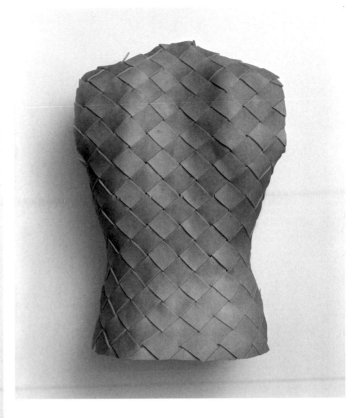

*Cuirass*, 2005. Silicone paint on silicone, mounted on fiberglass, with board, plastic padding, brass screws, screw eyes, steel wire, and metal hardware, two parts, 53 cm x 38 cm x 16 cm and 57 cm x 38 cm x 16 cm.

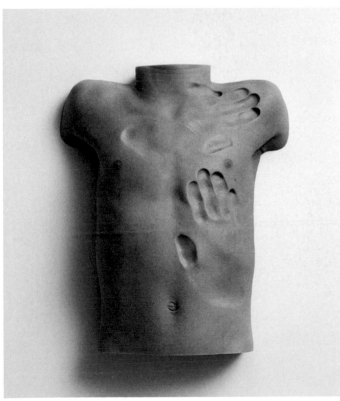

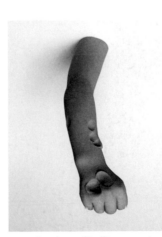

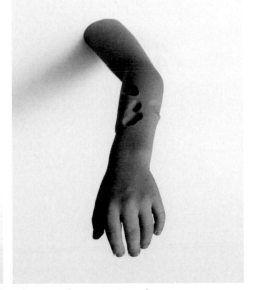

*Arm (Right andLeft)*, 2006. Acrylic paint on polyester resin, polyure-thane, and oil paint, 6 cm x 10 cm x 36 cm.

*The Birth of Us (Girl)*, 2006-2007. Acrylic paint on polyester resin and fiberglass, oil paint, screw eye, steel wire, and wire lock, 40 cm x 33 cm x 13 cm.

133

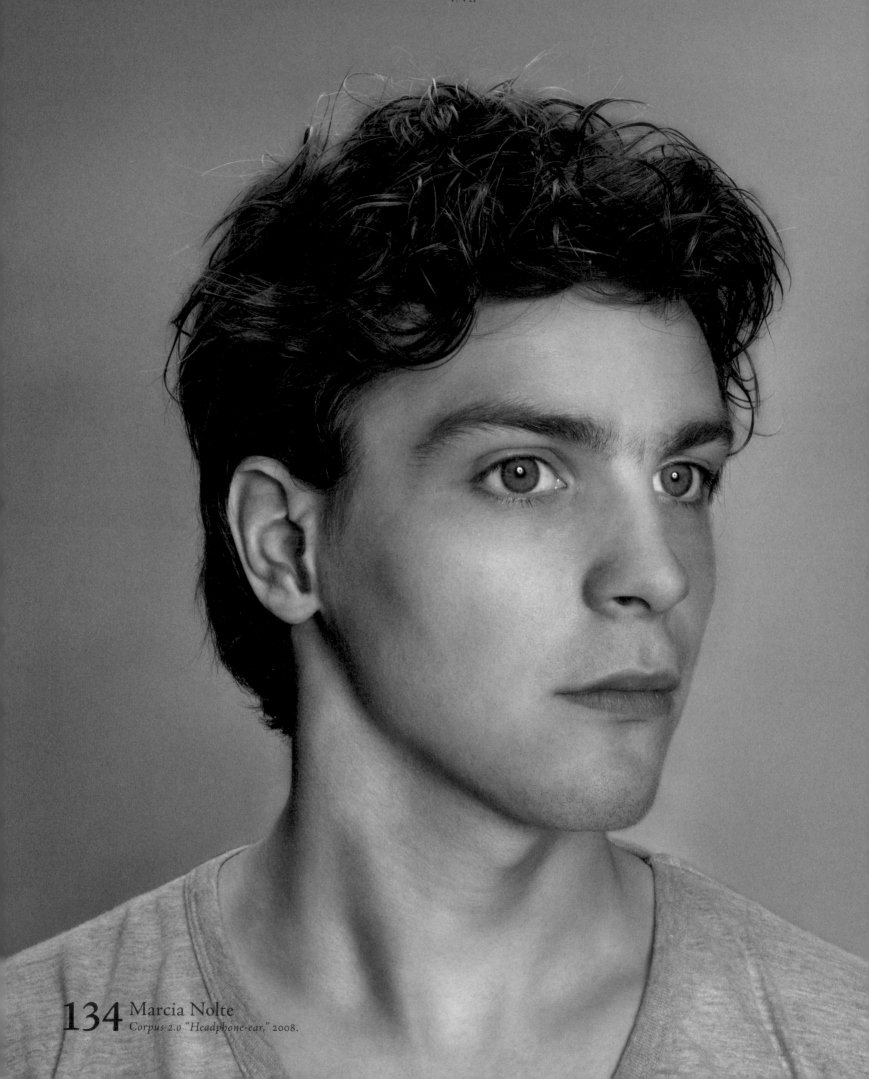

134 Marcia Nolte
*Corpus 2.0 "Headphone-ear,"* 2008.

*Corpus 2.0 "Noseslope," 2008.*

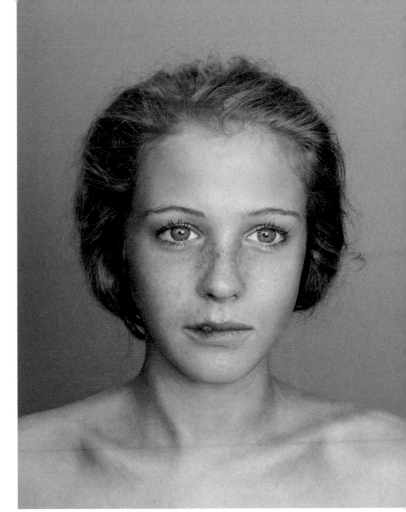

*Corpus 2.0 "Smokinghole," 2008.*

If we look into the history of evolution, we see that our body adapts to changing circumstances. Today we see that these circumstances also adapt to our body. In this case the design is usually reacting on the individual needs and less on surviving. Corpus 2.0 is a version of the human body, influenced by factors like developments in technology, but also fashion phenomenons, ways of living, and products. Corpus 2.0 is looking for the possibilities of the newly designed body and notices potential directions. The question remains if good design is still necessary, and how the human body will adapt to this.

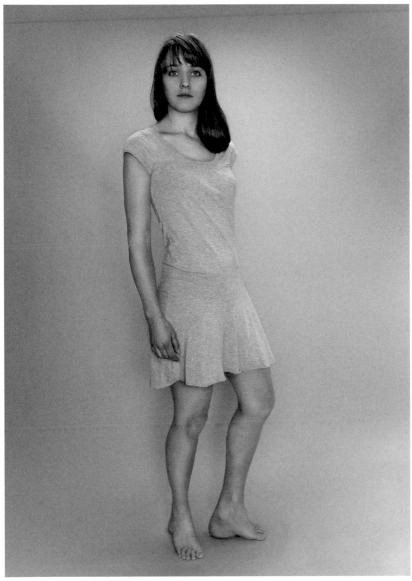

*Corpus 2.0 "High-heel foot," 2008.*

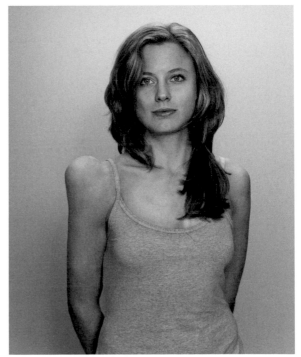

*Corpus 2.0 "Shoulderholder," 2008.*

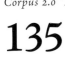

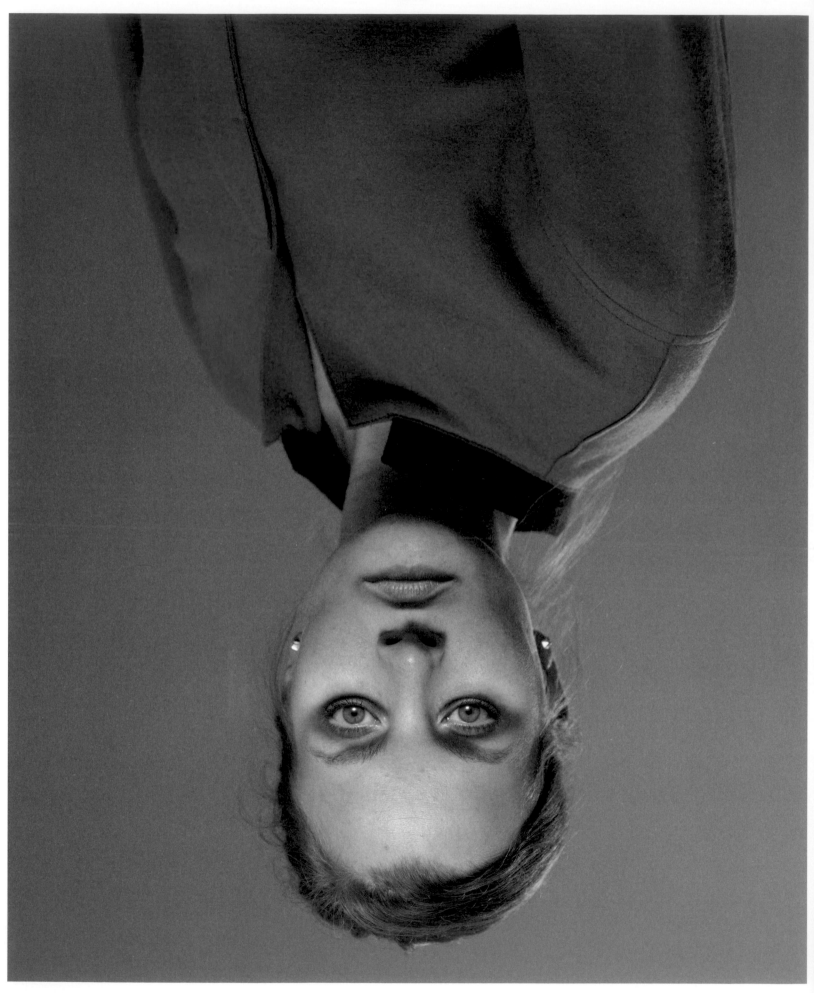

Blommers / Schumm
*Series YSL*, 2008. Pictures for Depeche Mode Magazine.

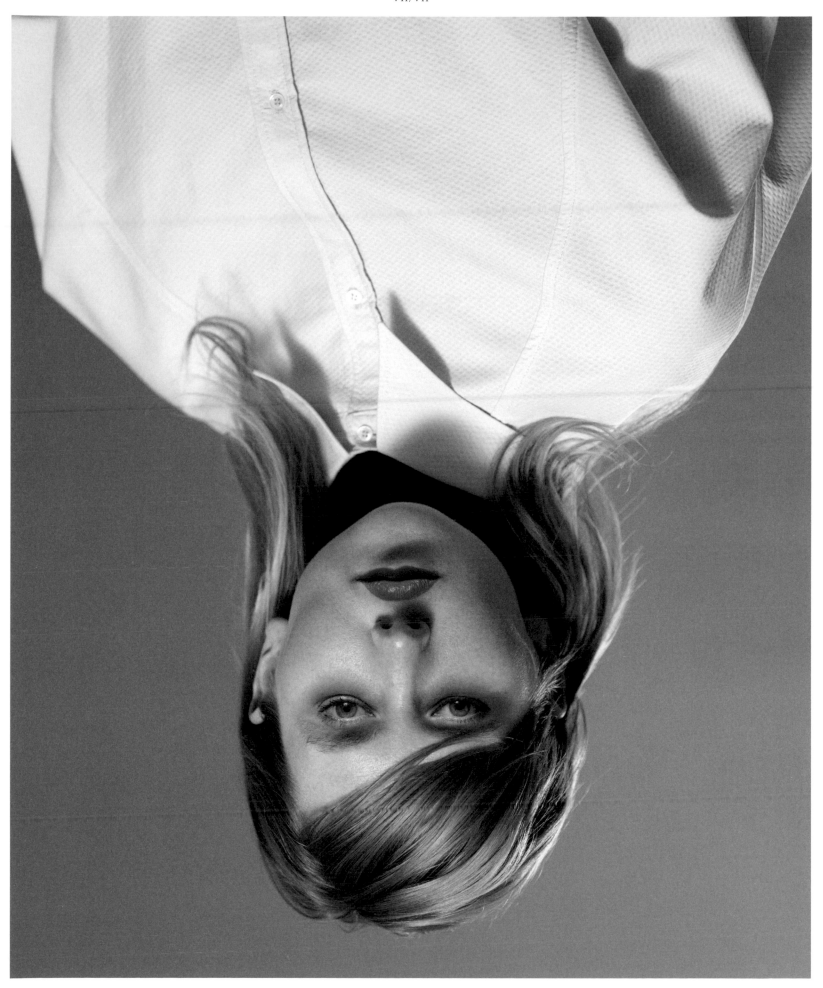

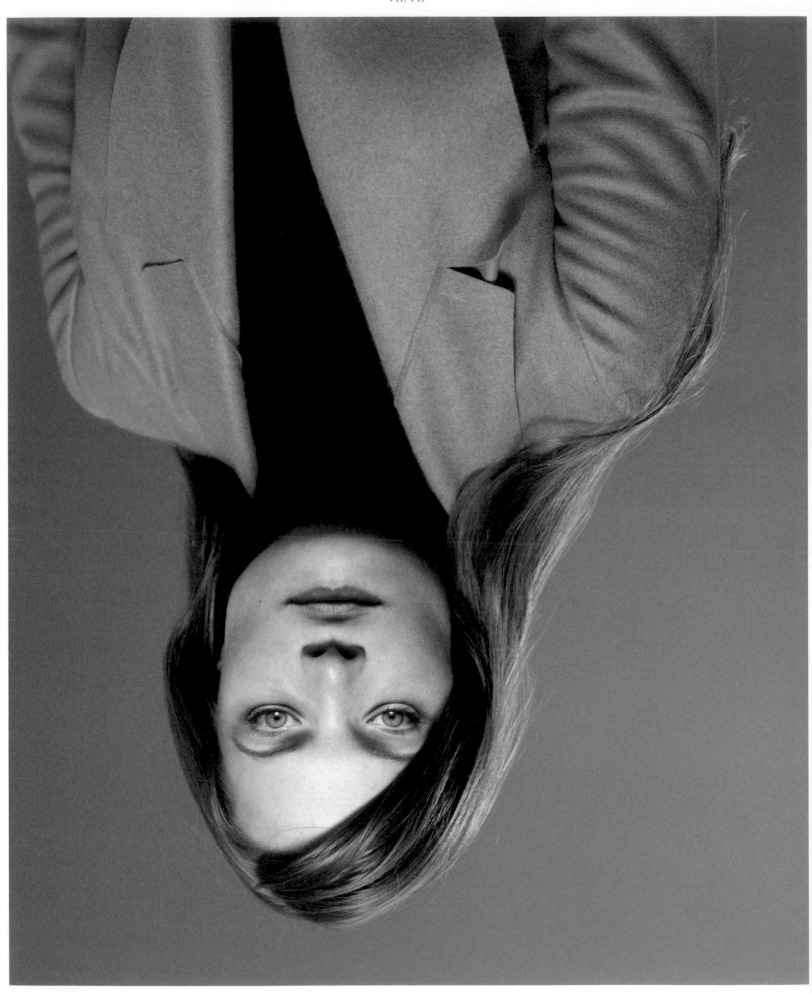

Blommers / Schumm, *Series YSL*, 2008.

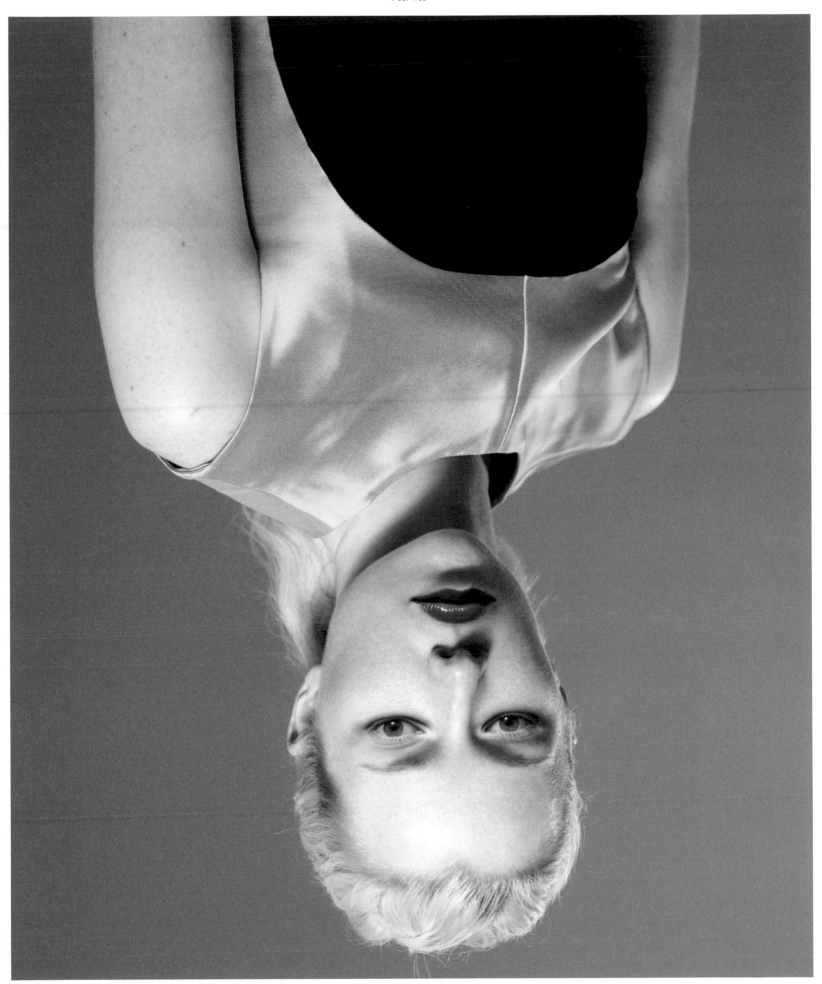

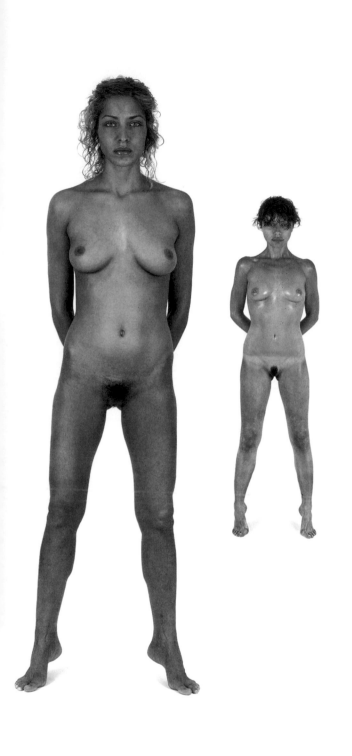
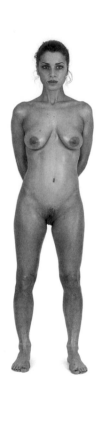
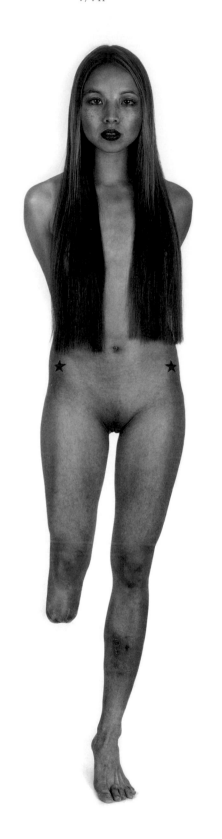
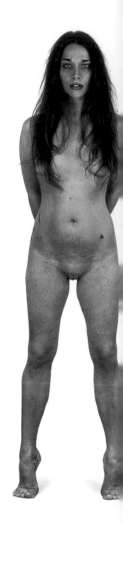

## Roger Weiss
*I am Flesh*, 2010.

35 naked female bodies meticulously photographed in their primeval condition to look as real as possible—and surprisingly so. This extraordinary resemblance to the truth is achieved by means of a special technique whereby each image is composed of

47,244 x 32,864 pixels per inch, equivalent to a 400 cm x 278 cm printable area at 300 dpi, while, for reasons of better perception, the final prints will be executed as 230 cm x 160 cm True Giclée Fine Art Prints, protected under plexiglass, and displayed all together. No

distraction is allowed in front of these bodies. In their presence, any feeling of attraction, repugnance, bewilderment, excitement, or banal initial curiosity fades away as one gets physically closer to the work, to its open essentiality.

140

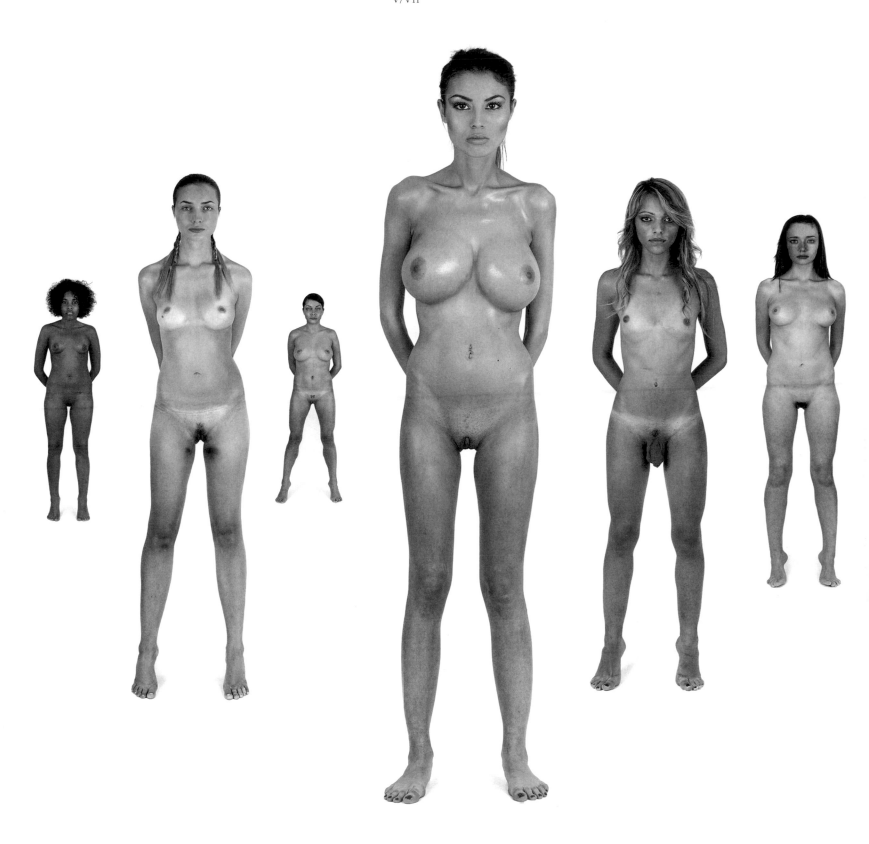

141

Retouch: Christophe Huet and Photography: Dimitri Daniloff
*Re-birth*, 2003.

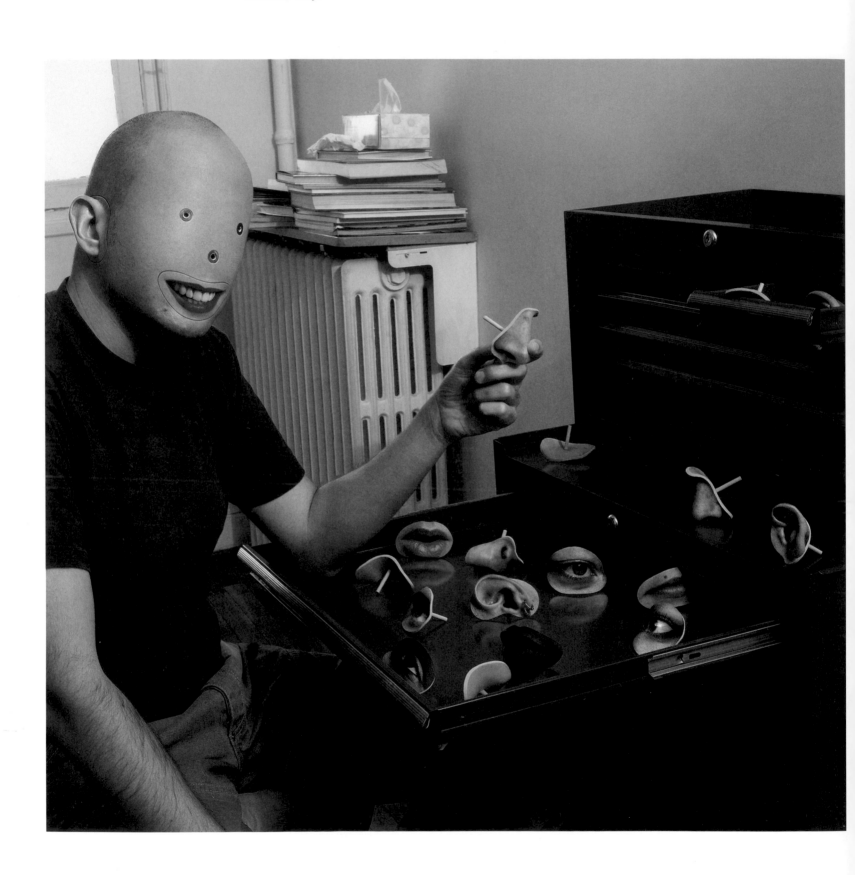

# Hugh Kretschmer
*Special Delivery*, 2006.

Part of a seven image, conceptual fashion series titled, 𝔄ssembly
𝔯equired, about two mannequins who, unwittingly, fall in love.

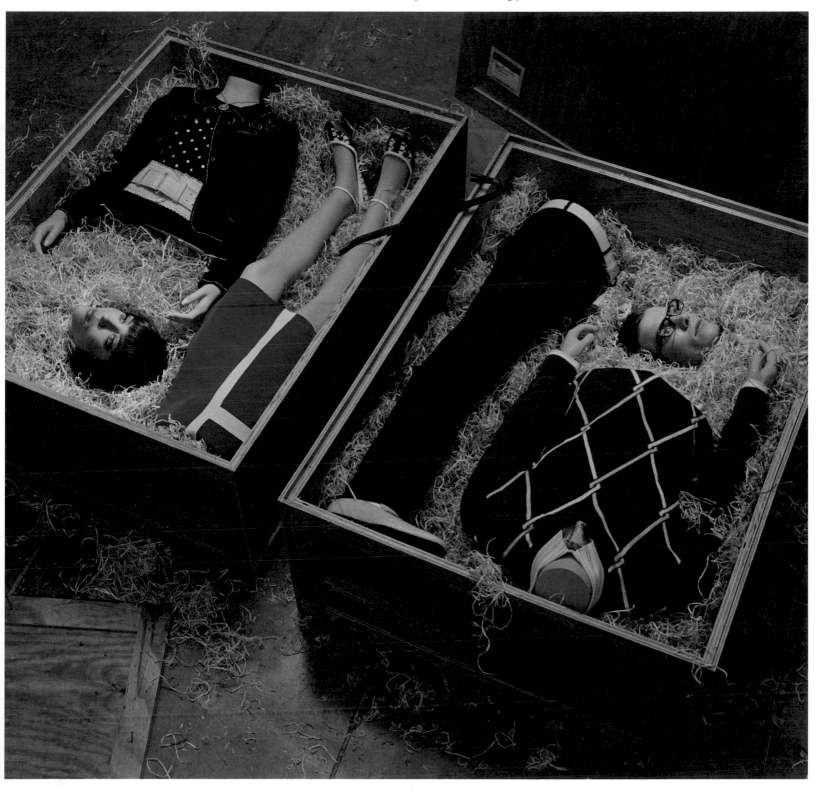

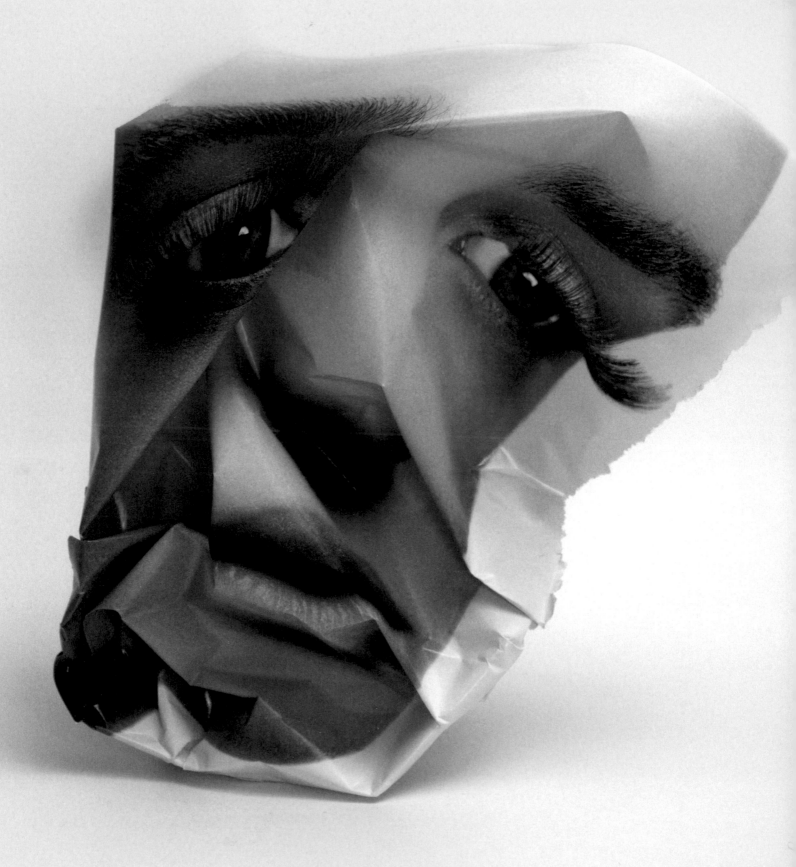

144 Christiane Feser
*Modelle 2, 2008.* Picture series made of folded ads from magazines.

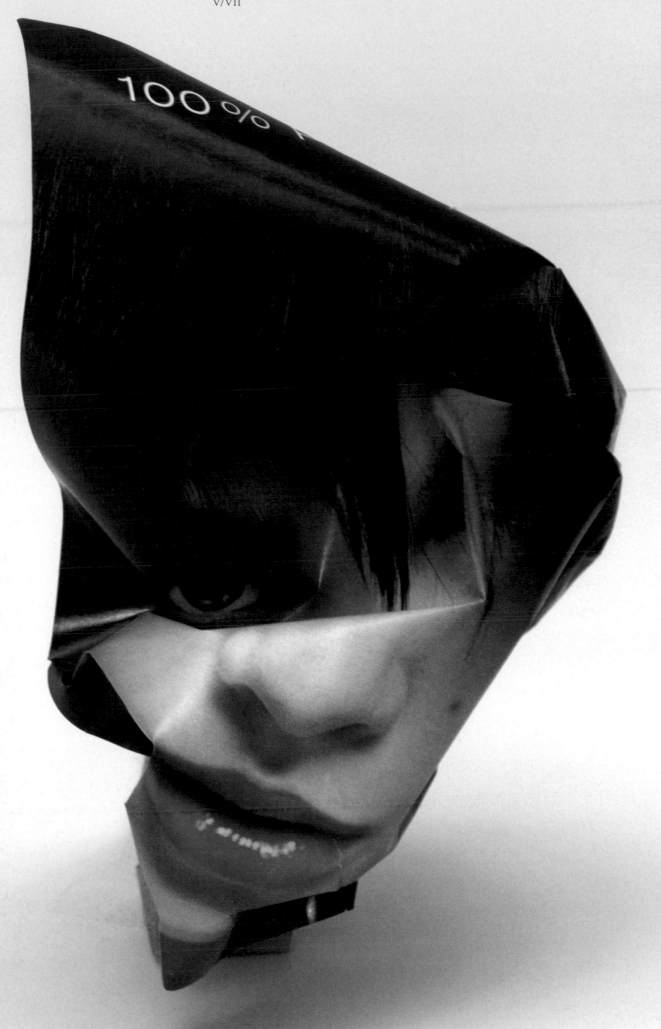

145

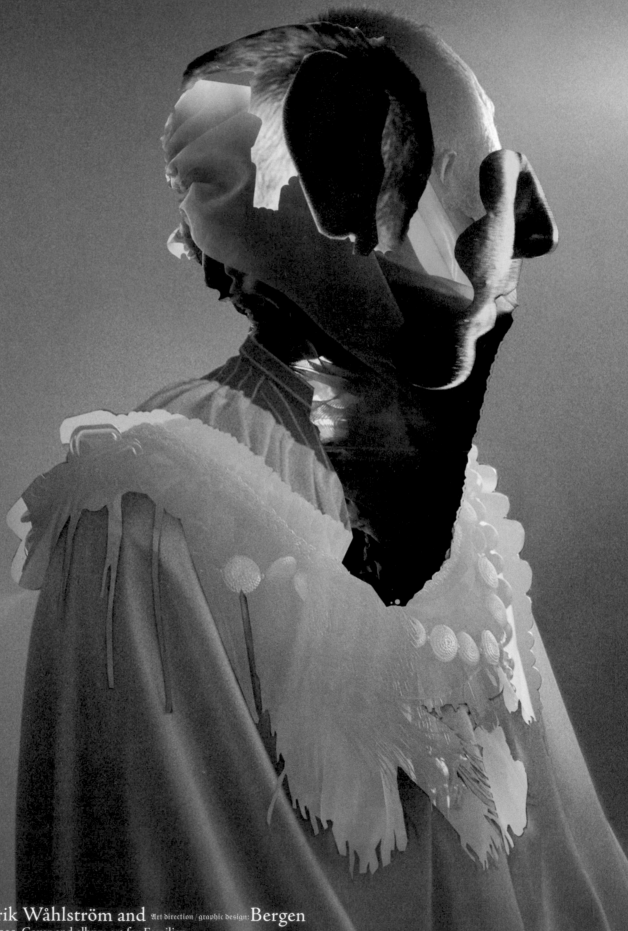

Photography: **Erik Wåhlström and** Art direction / graphic design: **Bergen**
*Familjen 1, 2010. Cover and album art for Familjen.*

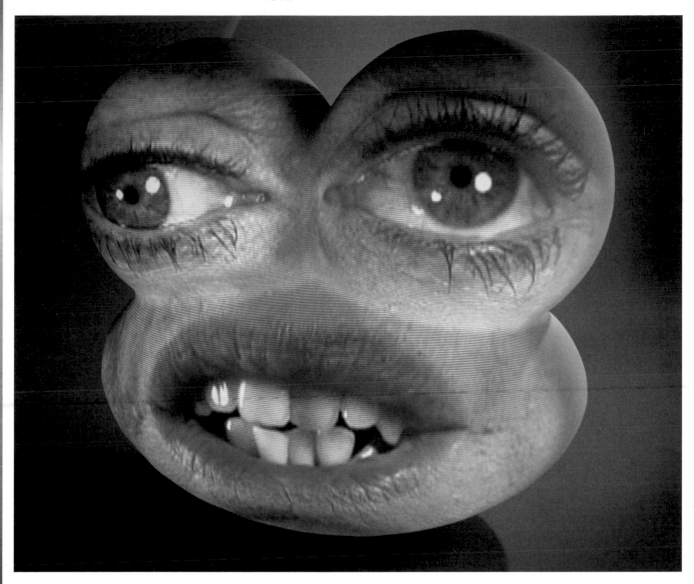

Tony Oursler
*Rubio*, 2003. Foam, resin, fiberglass, video projection. 104 cm x 89 cm x 51 cm.

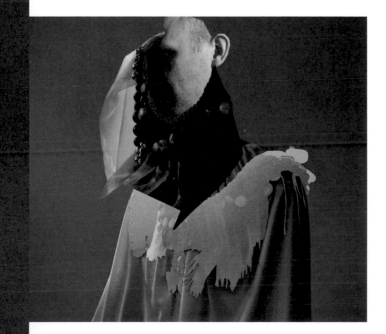

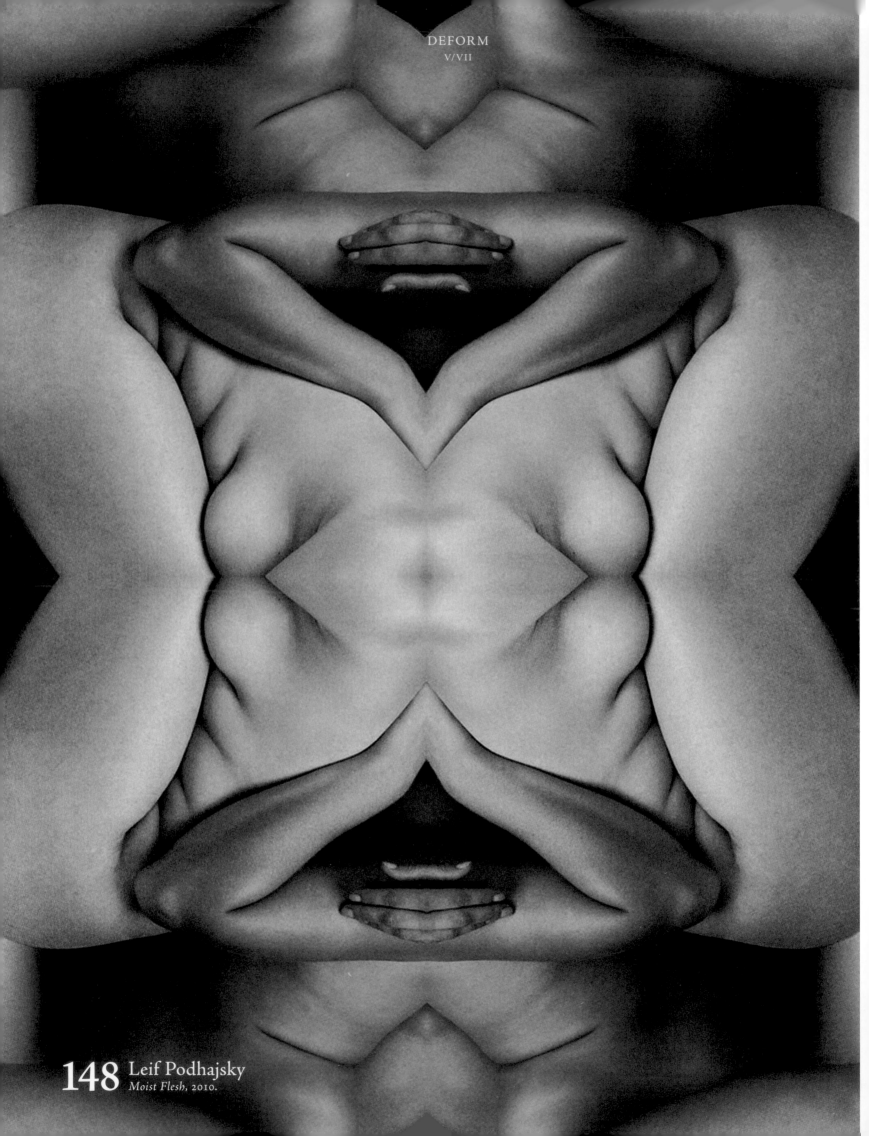

148  Leif Podhajsky
*Moist Flesh*, 2010.

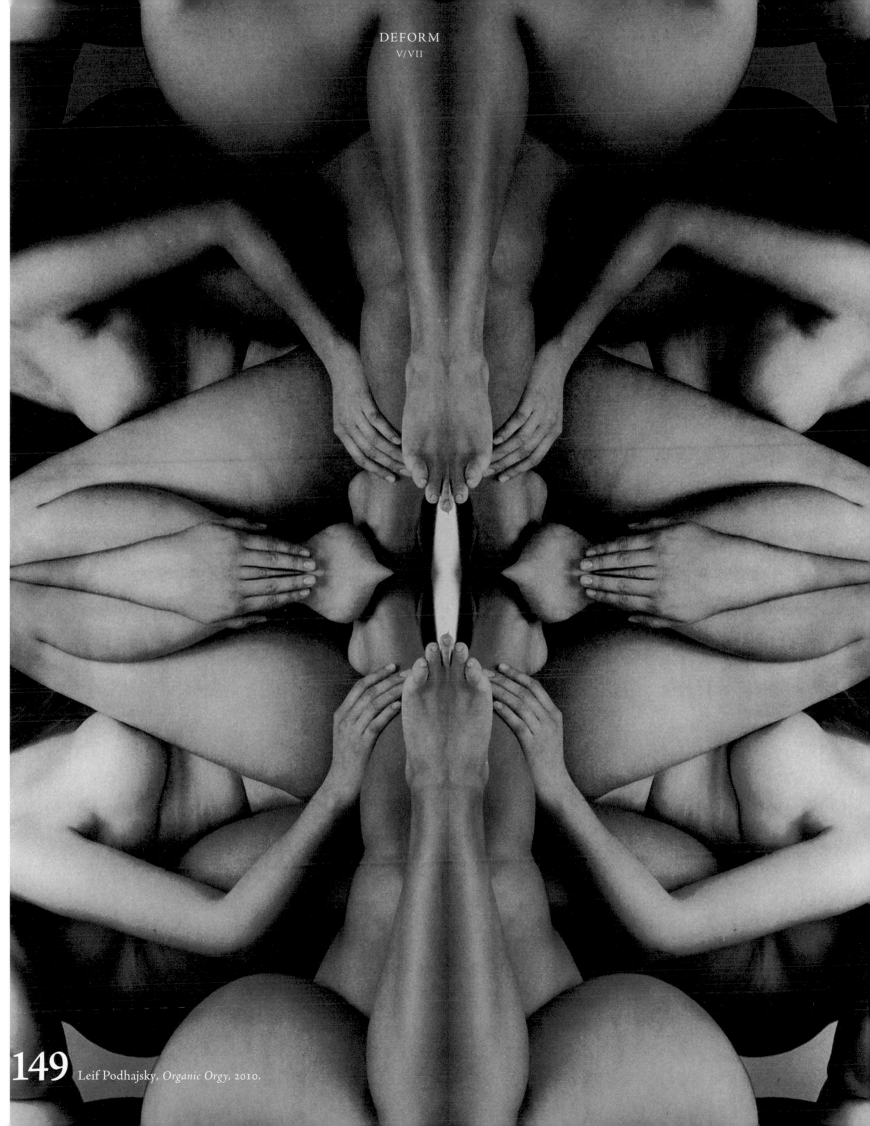

Leif Podhajsky, *Organic Orgy*, 2010.

*Temporal Form no. 5 (Uncertainty),* 2006.

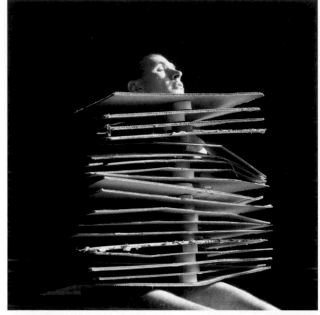

## Ansen Seale
*Temporal Form no. 10,* 2009.

Digital slit-scan photograph, created with a camera of
the artist's own invention. No photo manipulation.

No title, 2004.

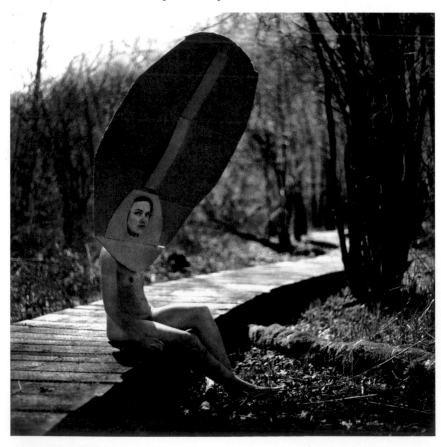

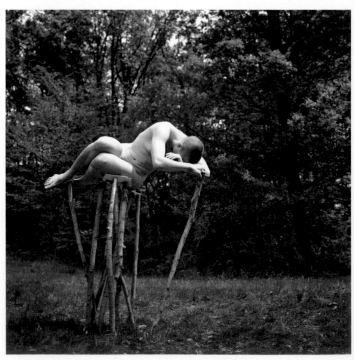

## Stéphane Fugier
No title, 2004.

No title, 2004.

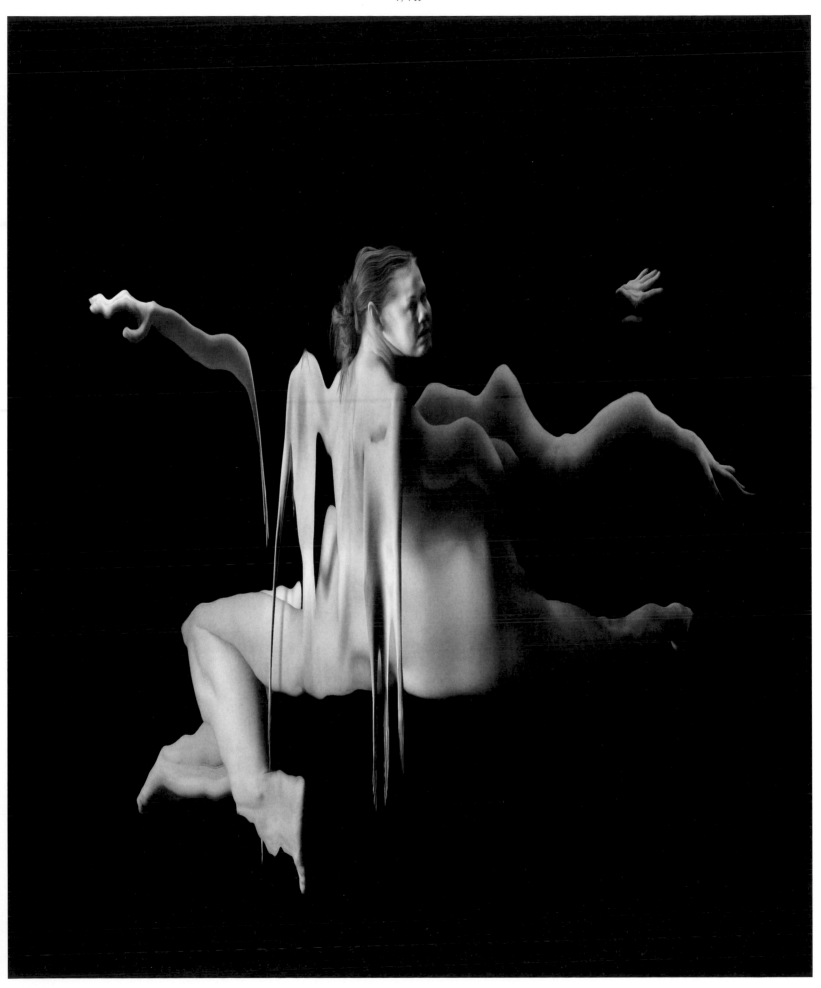

151 Ansen Seale, *Temporal Form no. 21, 2009.*

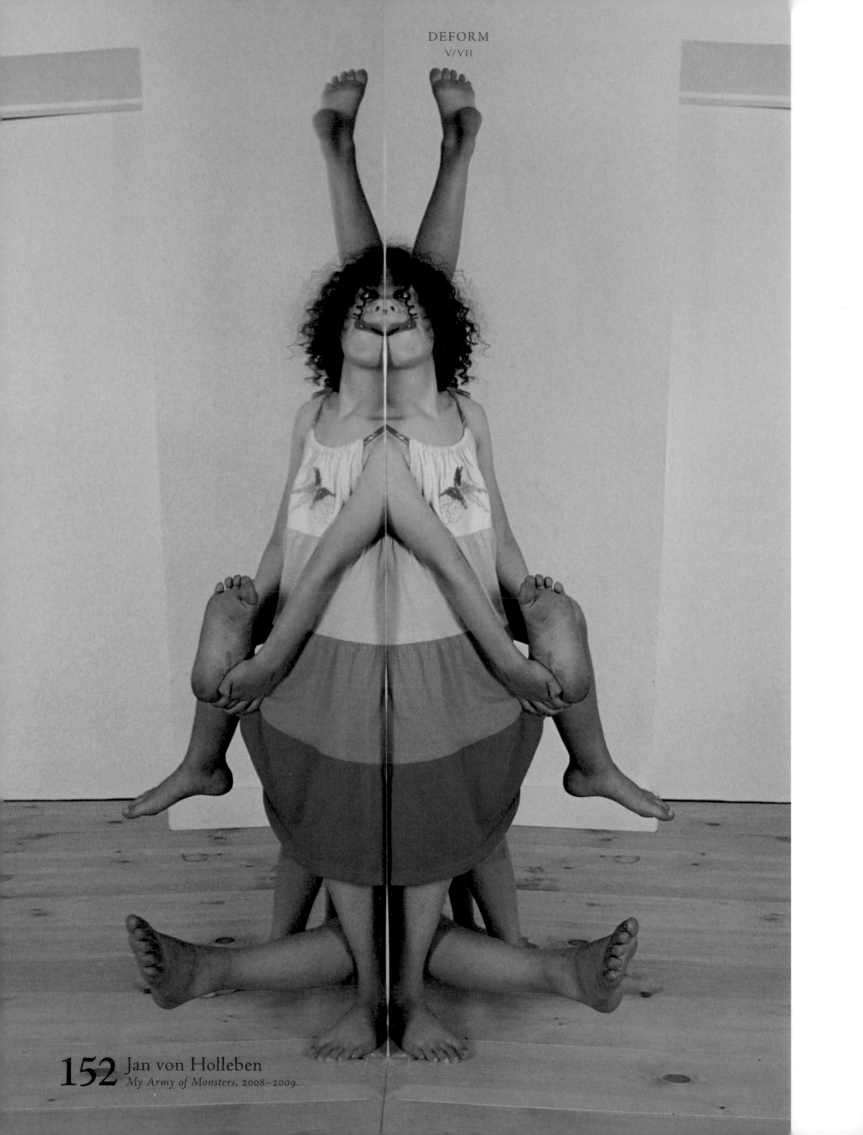

Jan von Holleben
*My Army of Monsters, 2008–2009.*

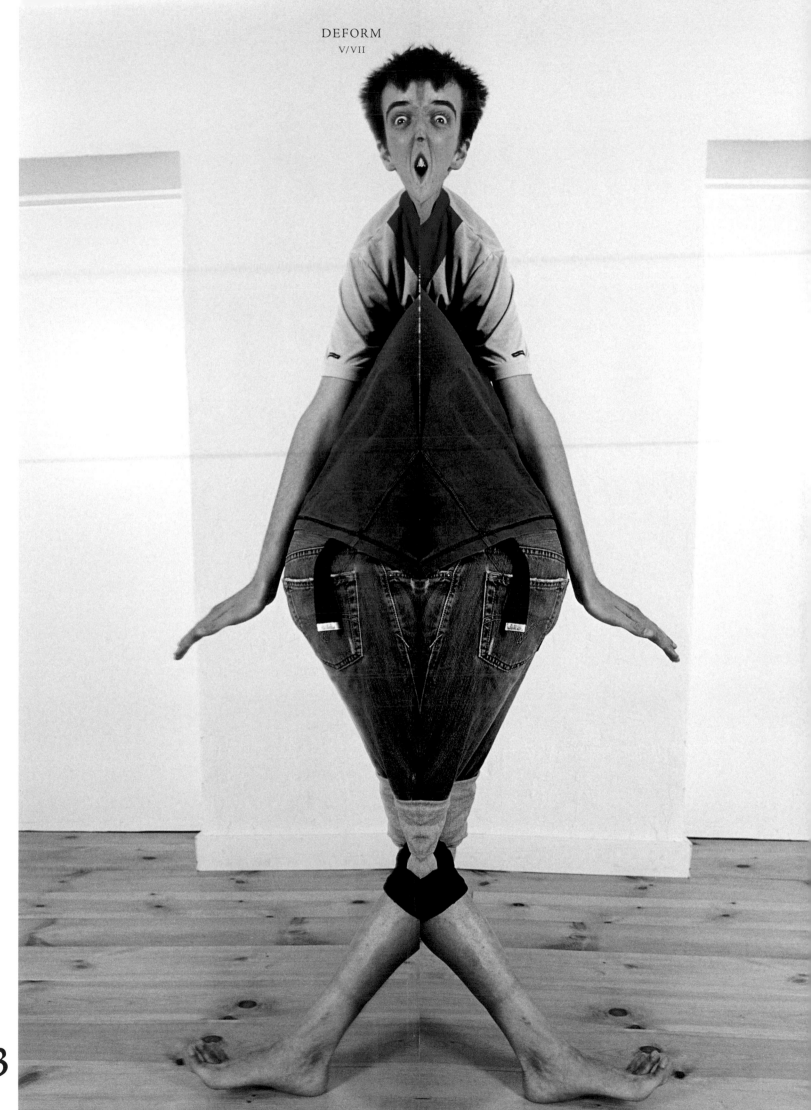

153

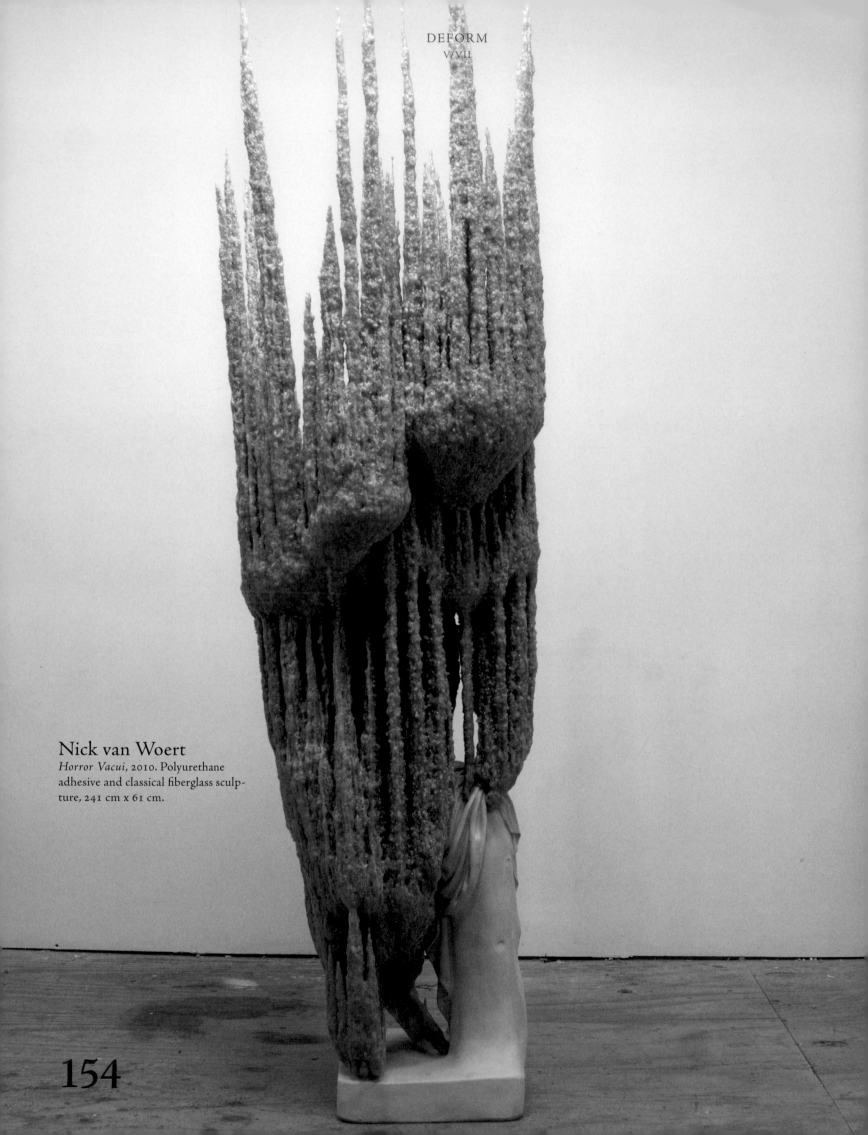

Nick van Woert

*Horror Vacui*, 2010. Polyurethane adhesive and classical fiberglass sculpture, 241 cm x 61 cm.

154

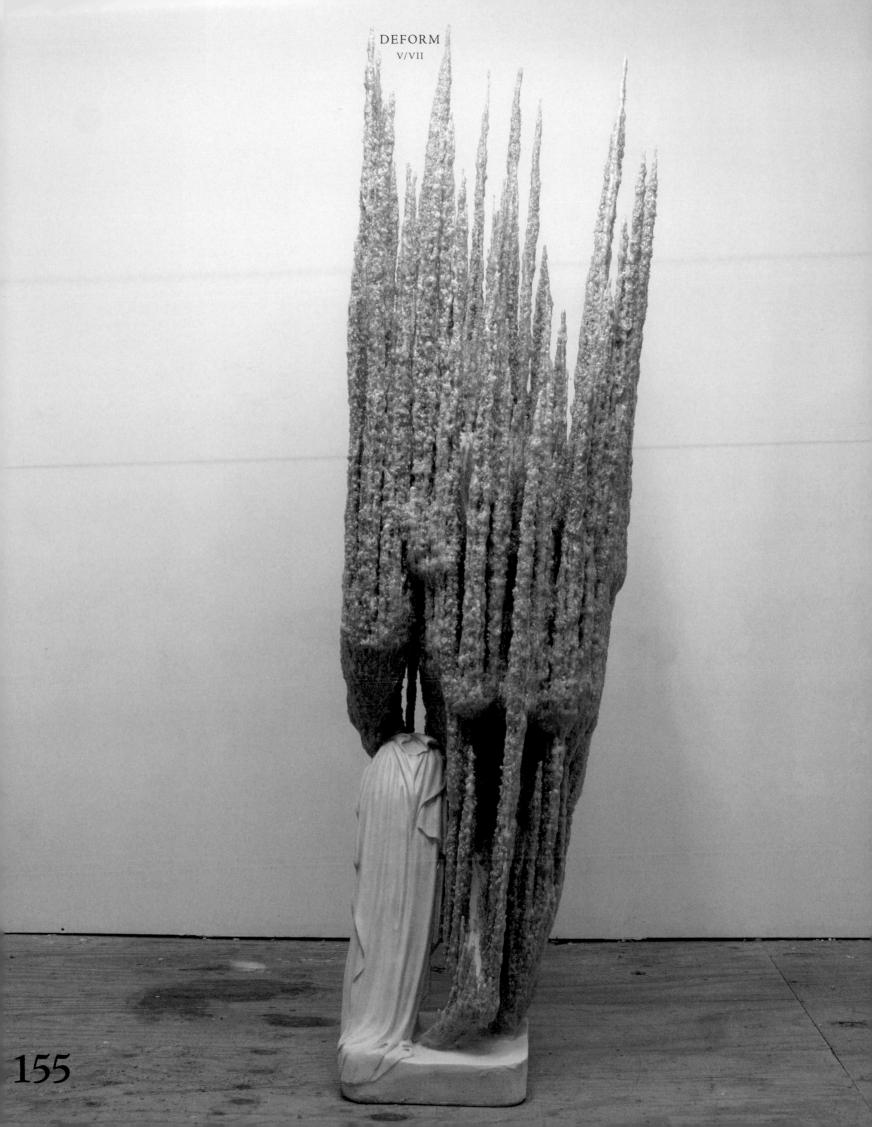

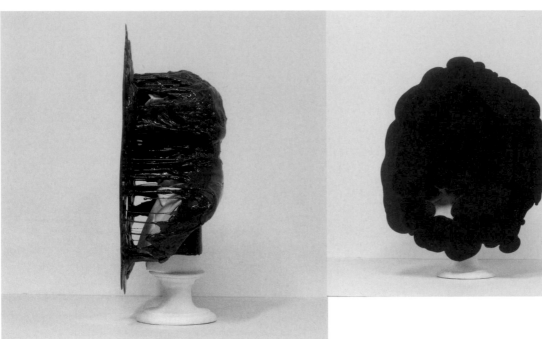

*Eclipse*, 2010. Plaster bust and polyurethane plastic, 61 cm x 51 cm x 20 cm.

*Untitled*, 2009. Plaster bust and polyurethane plastic, 36 cm x 36 cm x 20 cm.

*Haruspex*, 2010. Broken fiberglass statue, urethane, materials, and trash from an empty lot next to the studio, 155 cm x 37 cm x 37 cm.

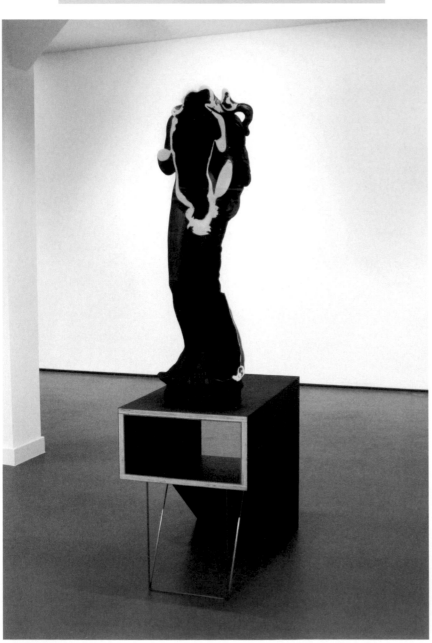

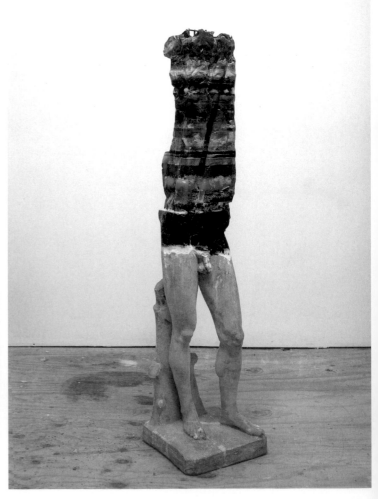

**156** Nick van Woert

*Untitled*, 2009. Plaster bust and polyurethane plastic, 36 cm x 36 cm x 20 cm.

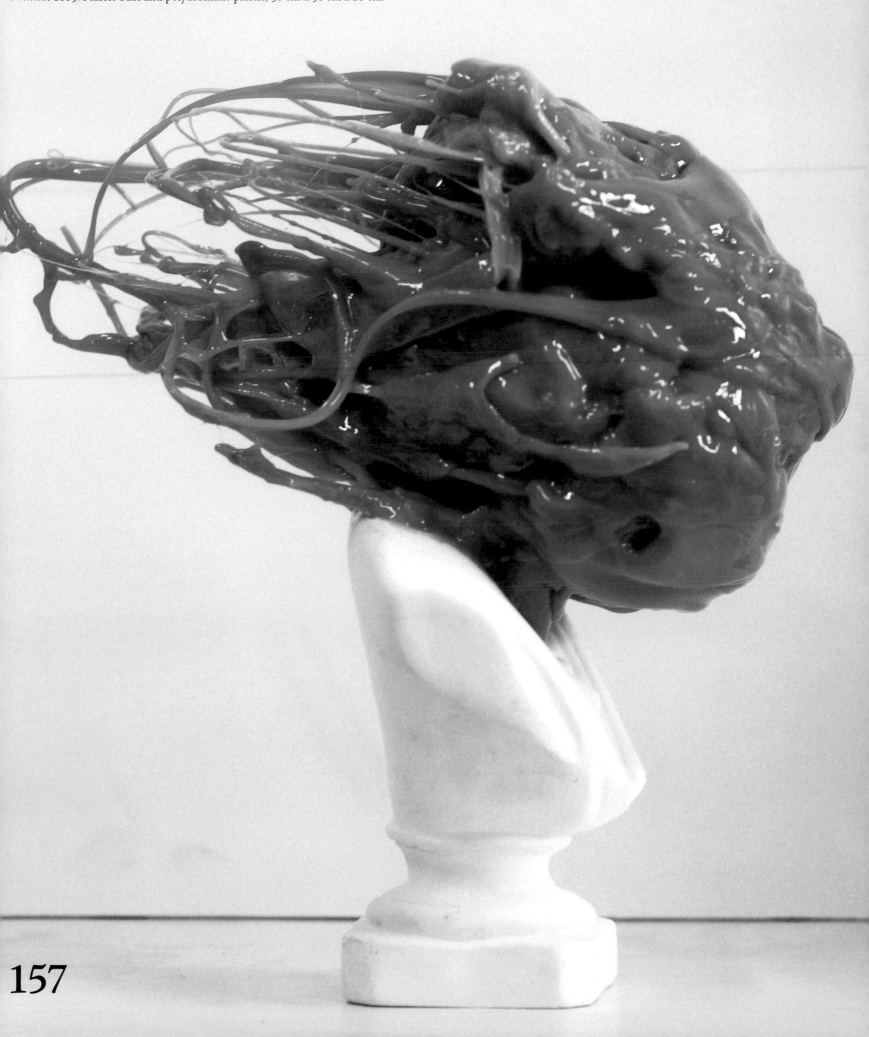

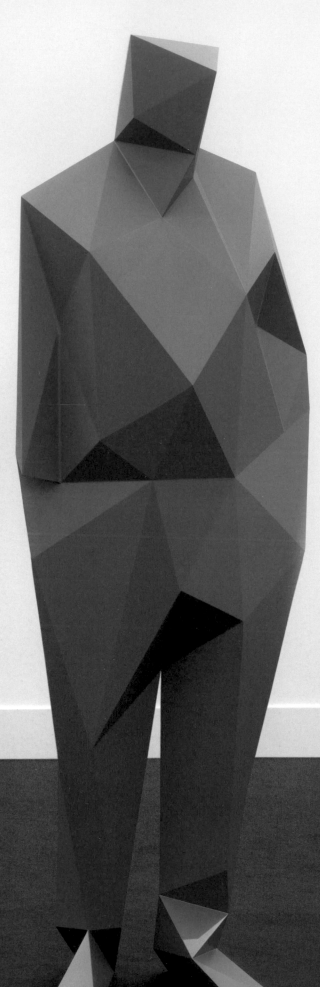

**158** Xavier Veilhan
*Richard Rogers*, 2009. Polyurethane, blue epoxy painting, 177 cm x 56 cm x 36 cm.

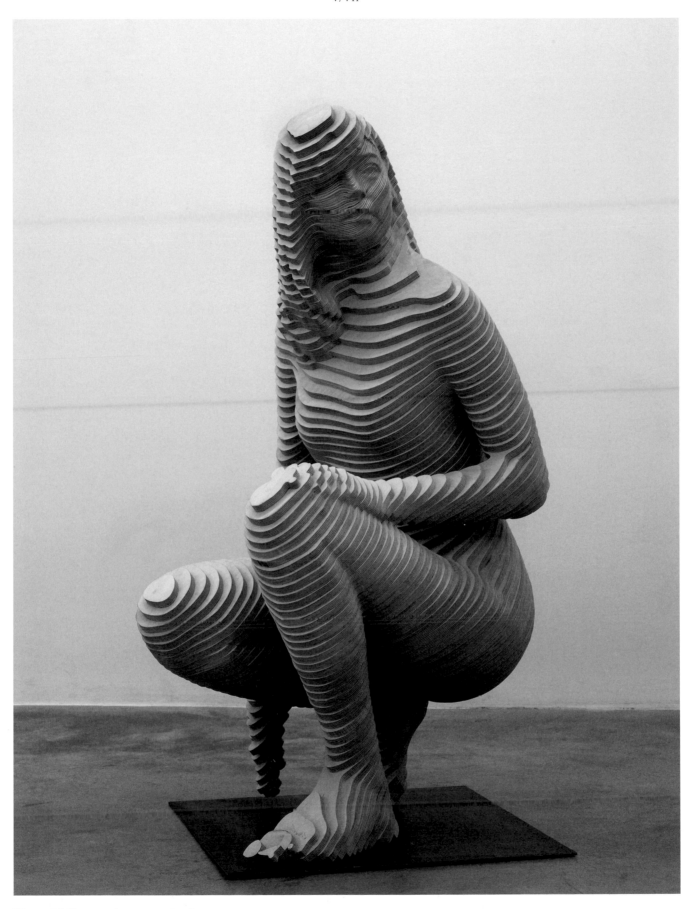

Xavier Veilhan, *Debora*, 2006. Birch, 135 cm x 86 cm x 73 cm,
exhibition view. Galerie Emmanuel Perrotin, Paris.

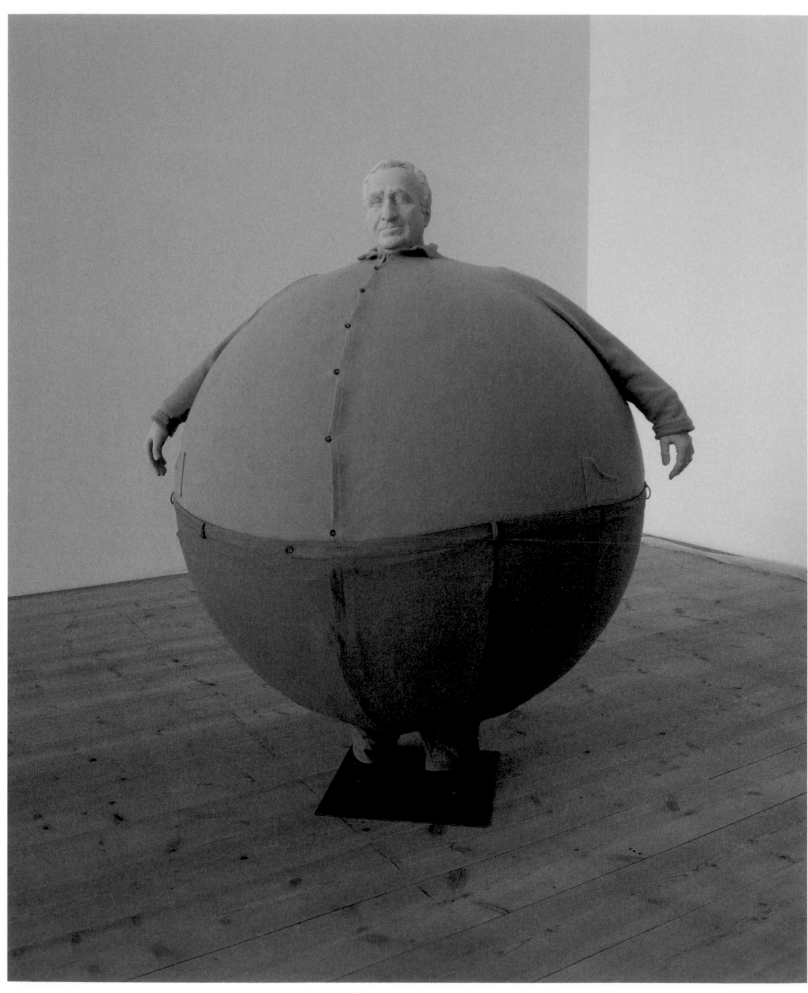

**160** Erwin Wurm
*The Artist Who Swallowed the World*, 2006. Mixed media sculpture, 190 cm x 140 cm x 140 cm.

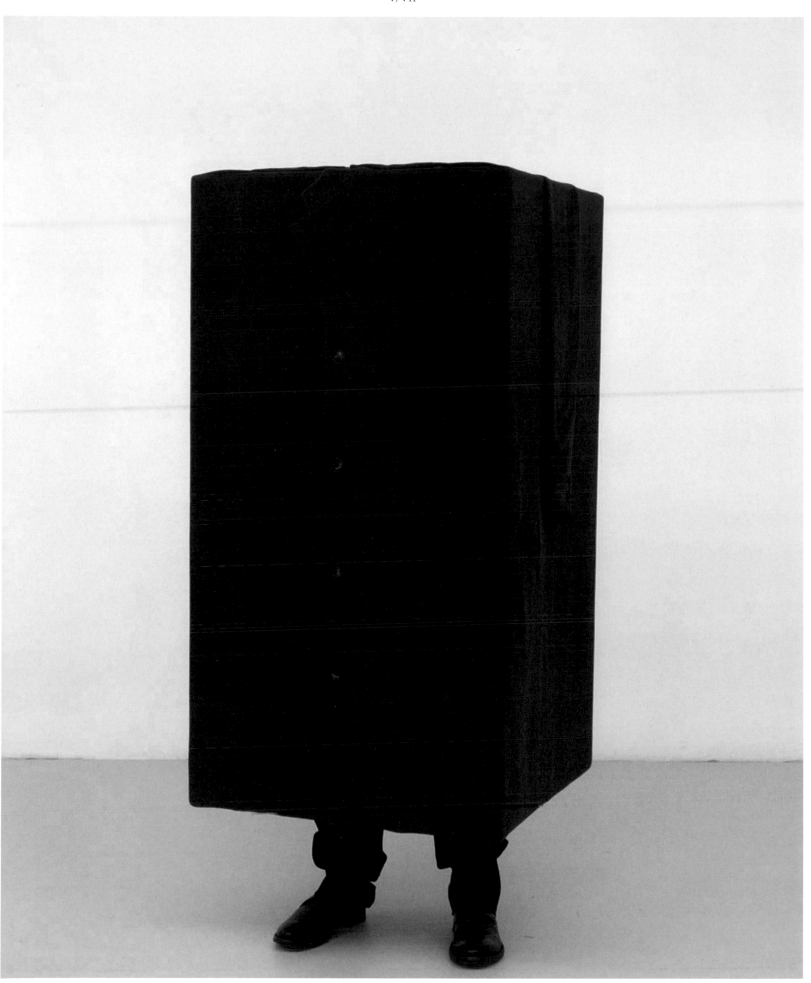

**161** Erwin Wurm, *Hypnose II*, 2008.
Acrylic, wood, clothes, 160 cm x 66 cm x 66 cm.

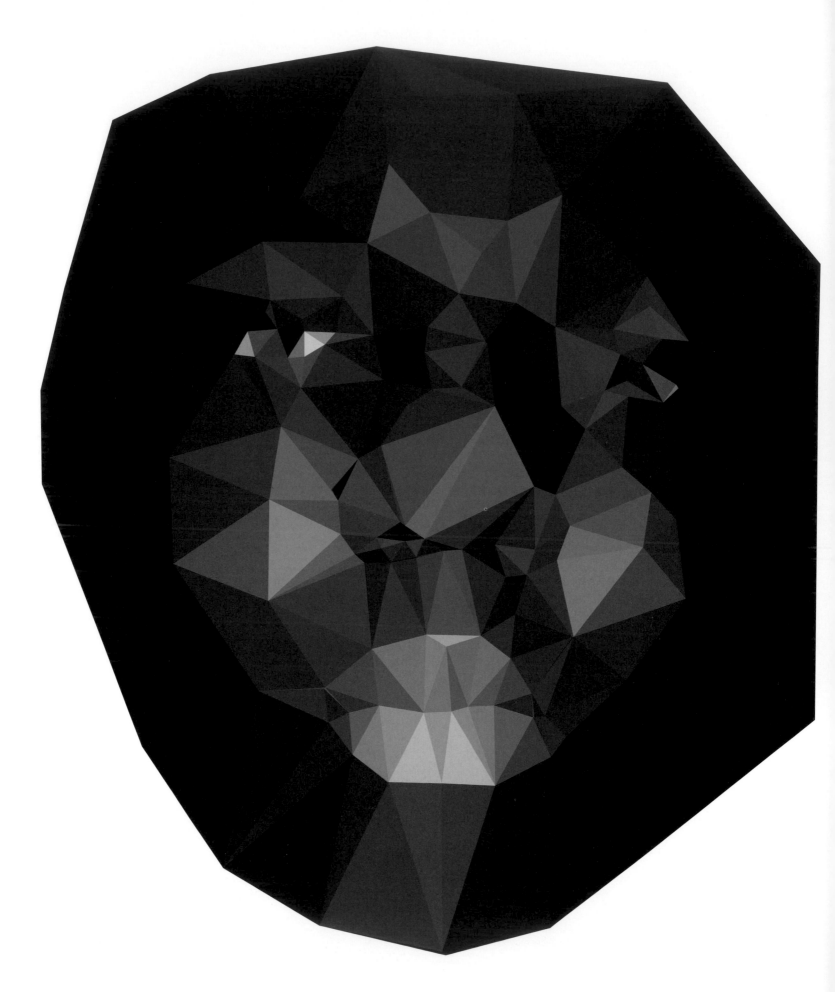

Jonathan Puckey
*The Notorious B.I.G.,* 2008.

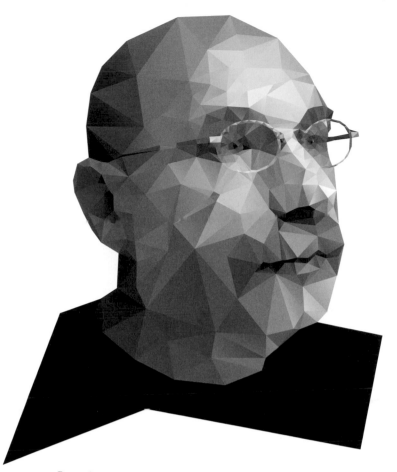

Portrait, 2009.

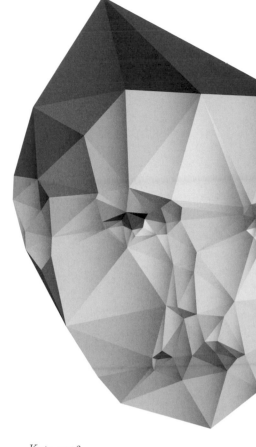

Kate, 2008.

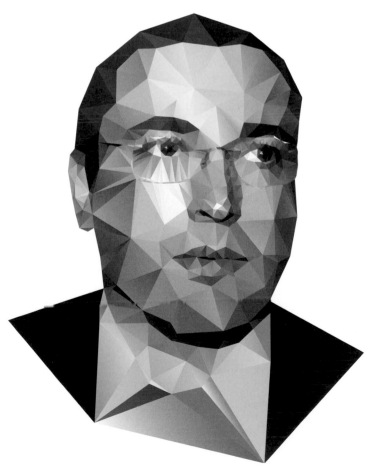

163 Portrait, 2009.

Jost Hochuli, 2009.

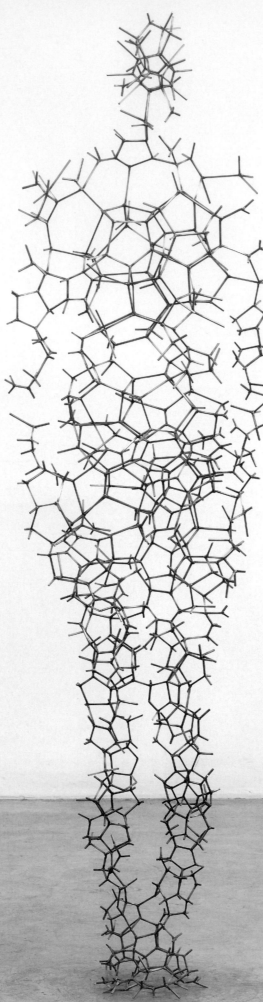

**164** Antony Gormley
*Aperture X*, 2010. 3 mm square section, mild steel bar, 189 cm x 54 cm x 29 cm.

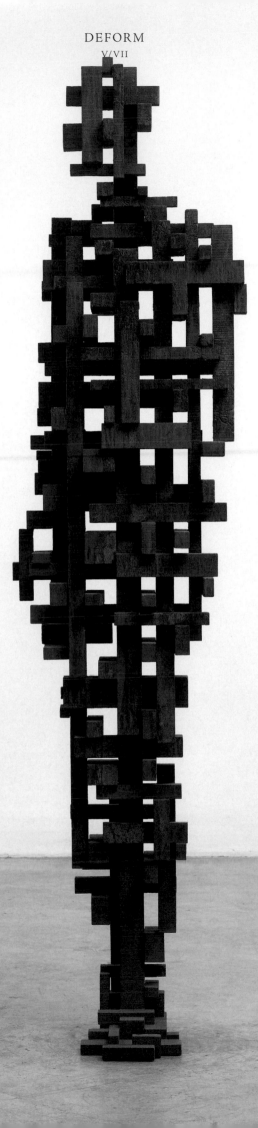

165 Antony Gormley, *Cast III*, 2009.
Cast iron, 193 cm x 45 cm x 37 cm.

# 06

___

## APPEAL

(Shining Bright)

●

Matthew Stone, 2010

*Love infectious.* Pigment print.

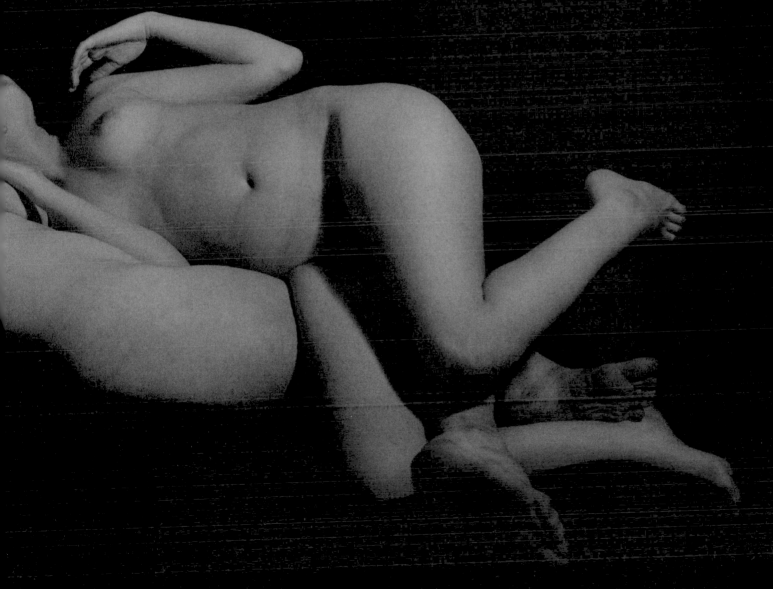

APPEAL

VI/VII

167

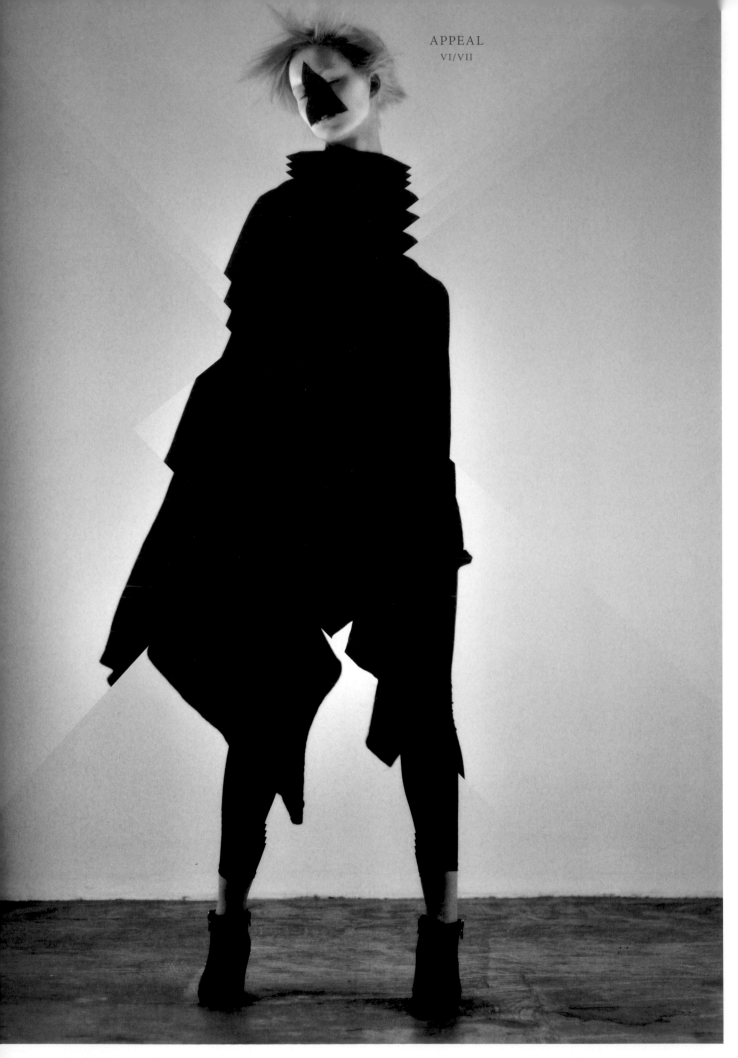

**168** Federico Cabrera
*One Day There Will Be a Place for Us - 02 / GILLES ET DADA, 2010.*

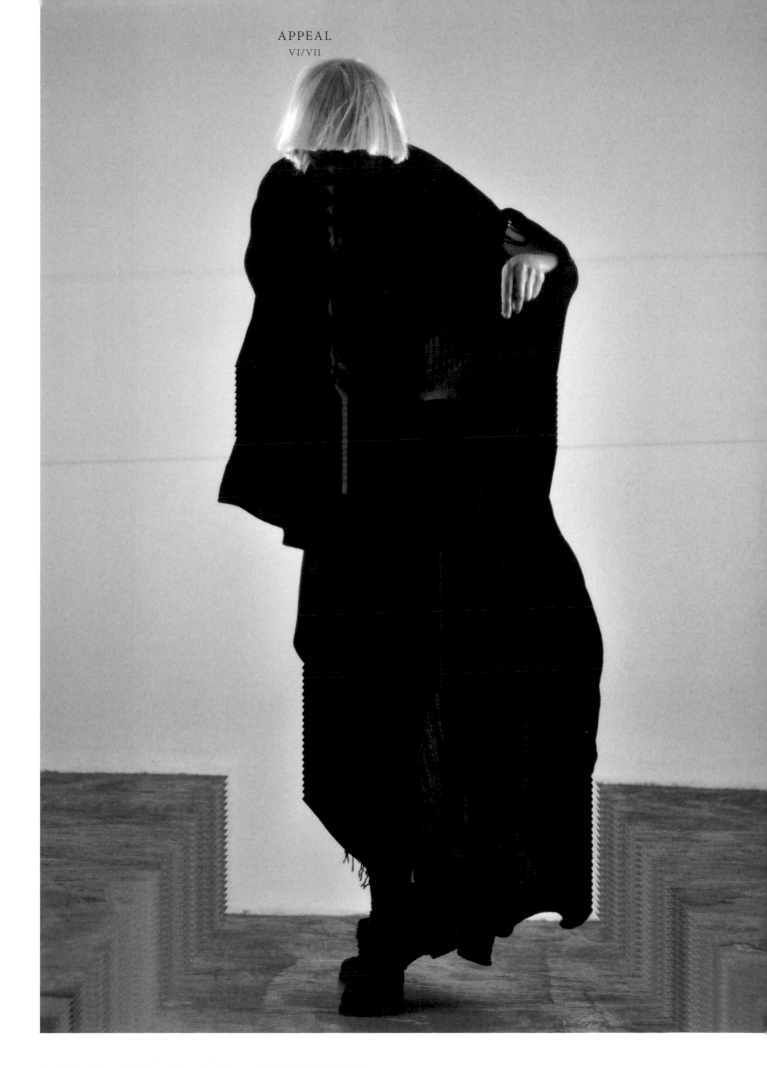

One Day There Will Be a Place for Us - 04 / GILLES ET DADA, 2010.

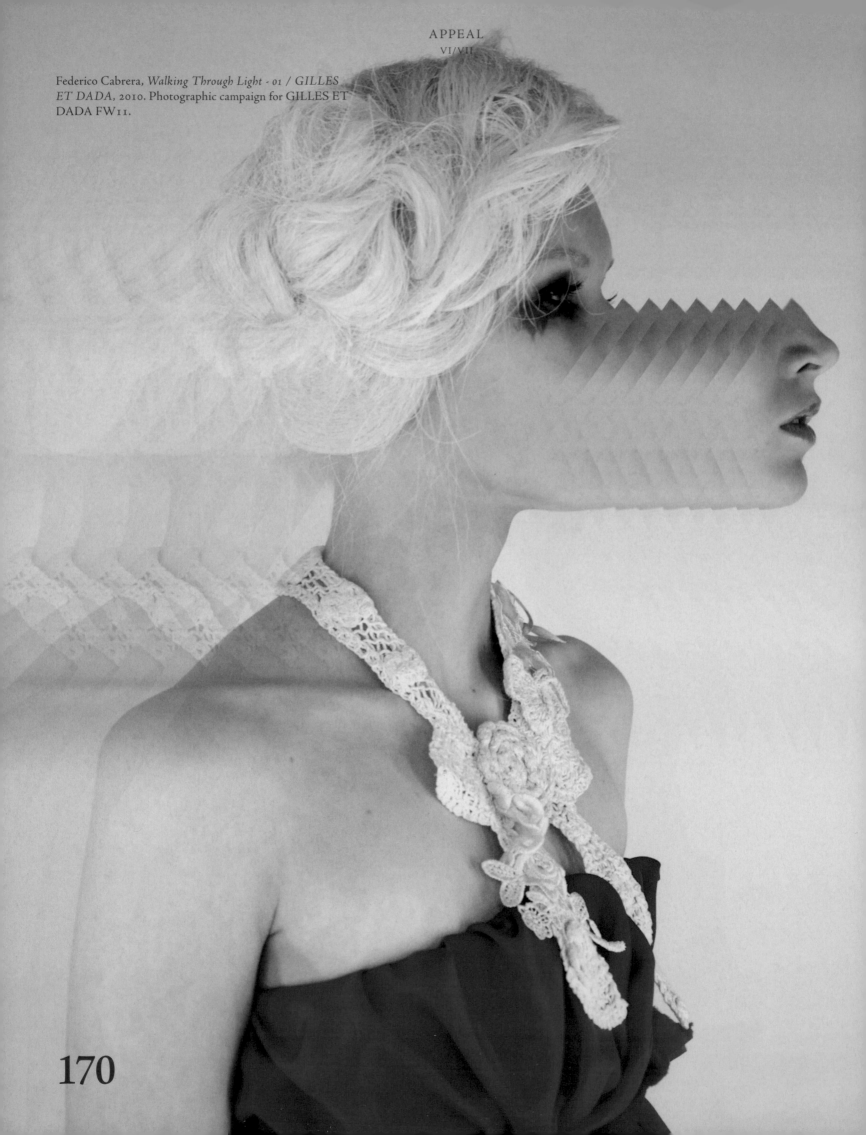

Federico Cabrera, *Walking Through Light - 01 / GILLES ET DADA*, 2010. Photographic campaign for GILLES ET DADA FW11.

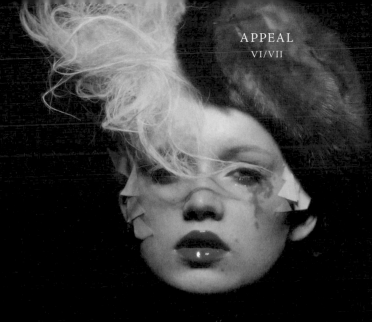

Federico Cabrera, *Crash-2* / *GILLES ET DADA FW*10, 2010.

1

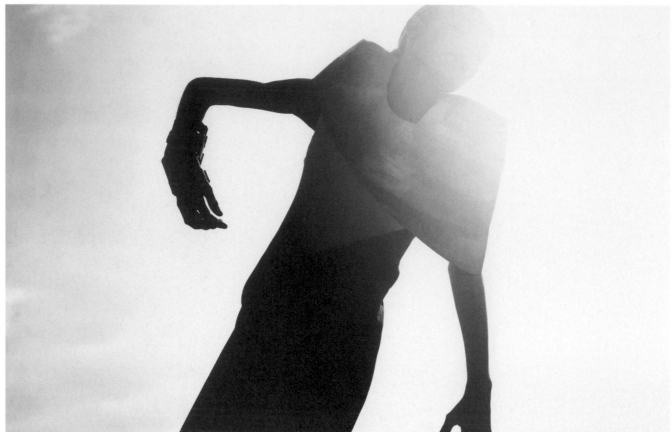

2

## Anders Lindén

**1**
*Repeat,* image shot for designer Sara Andersson, 2010

**2**
*NEW NEW,* portrait of NEW NEW founder Carl-Axel
Wahlström, 2010

**3** *OPPOSITE PAGE*
*Ways of Seeing,* a collaboration between Elena Becker and
Klara Sjons Nilsson. Beckmans College of Design, 2010.

172

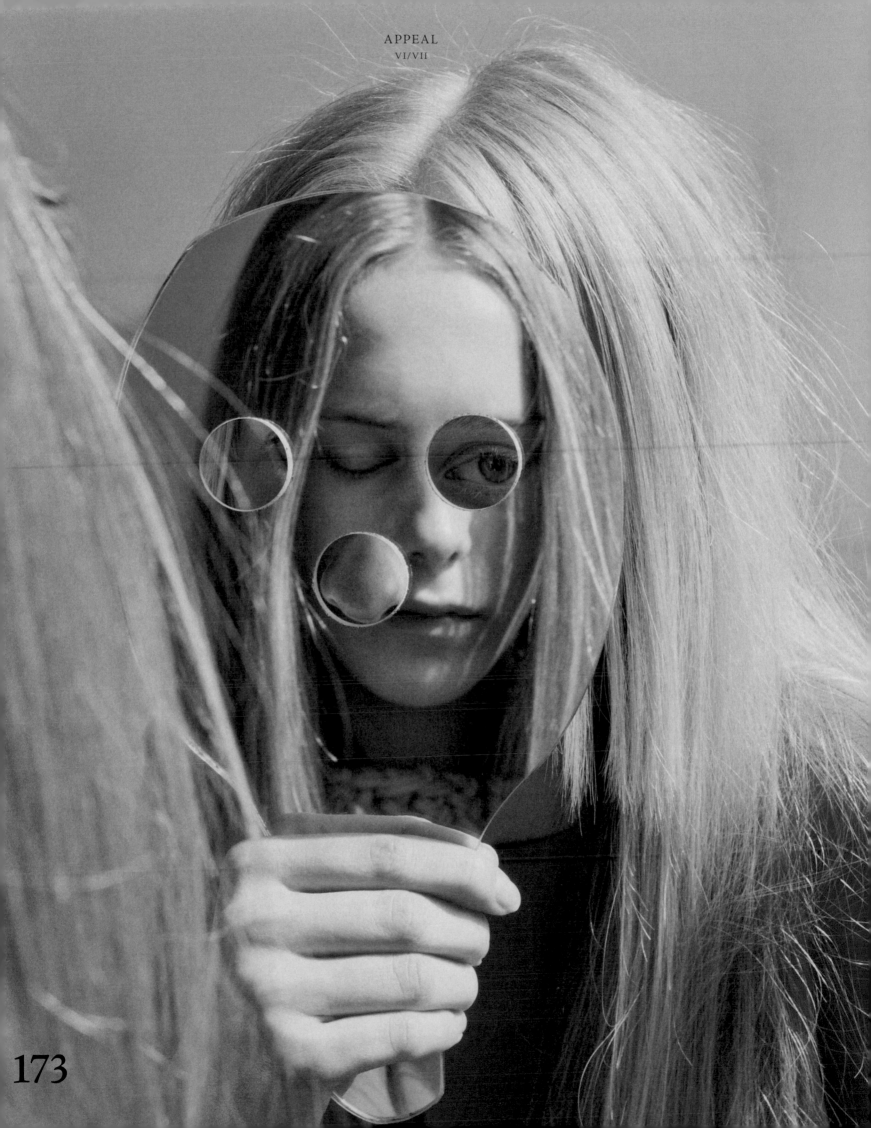

Kerstin zu Pan
*Untitled, 2009.*

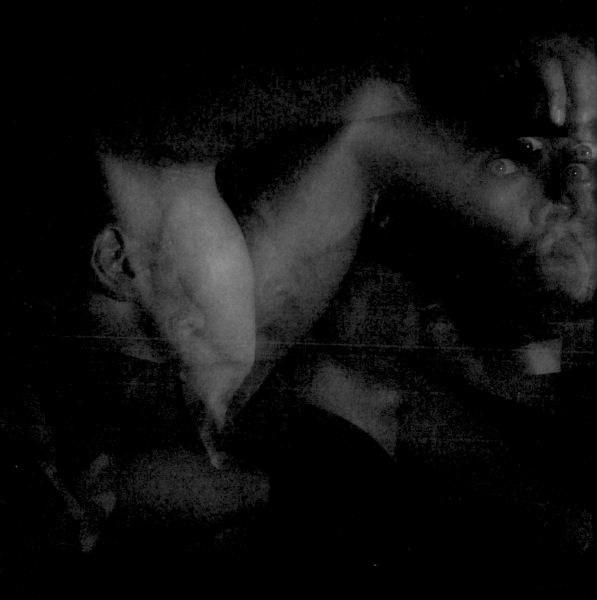

Kerstin zu Pan
*Untitled, 2009.*

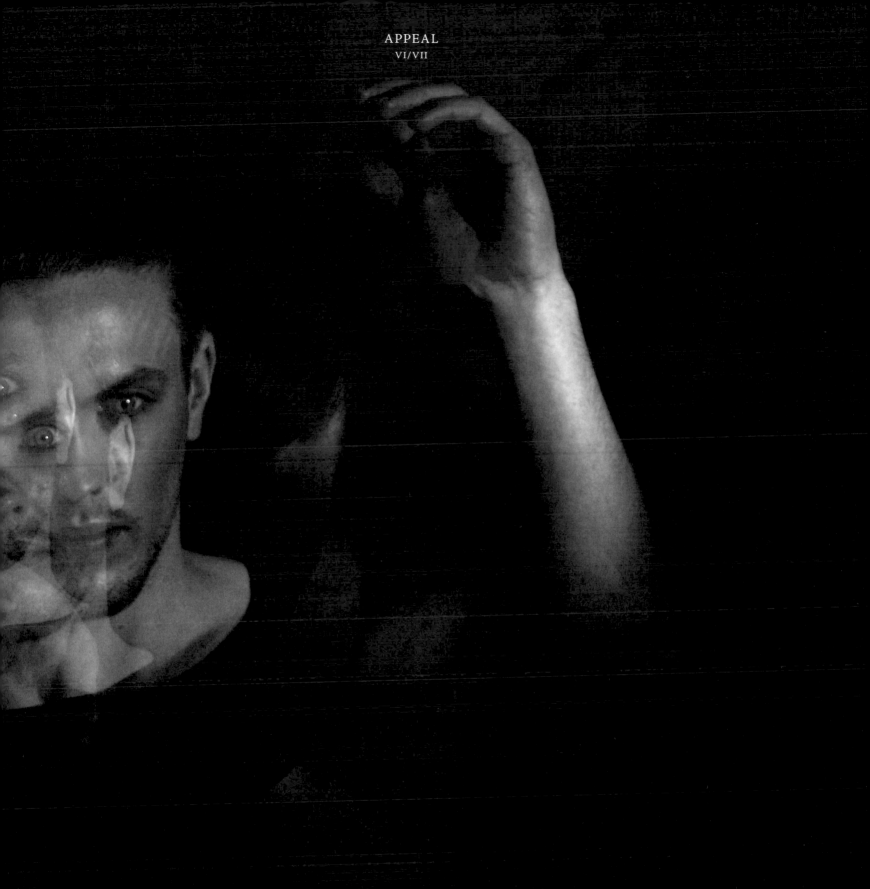

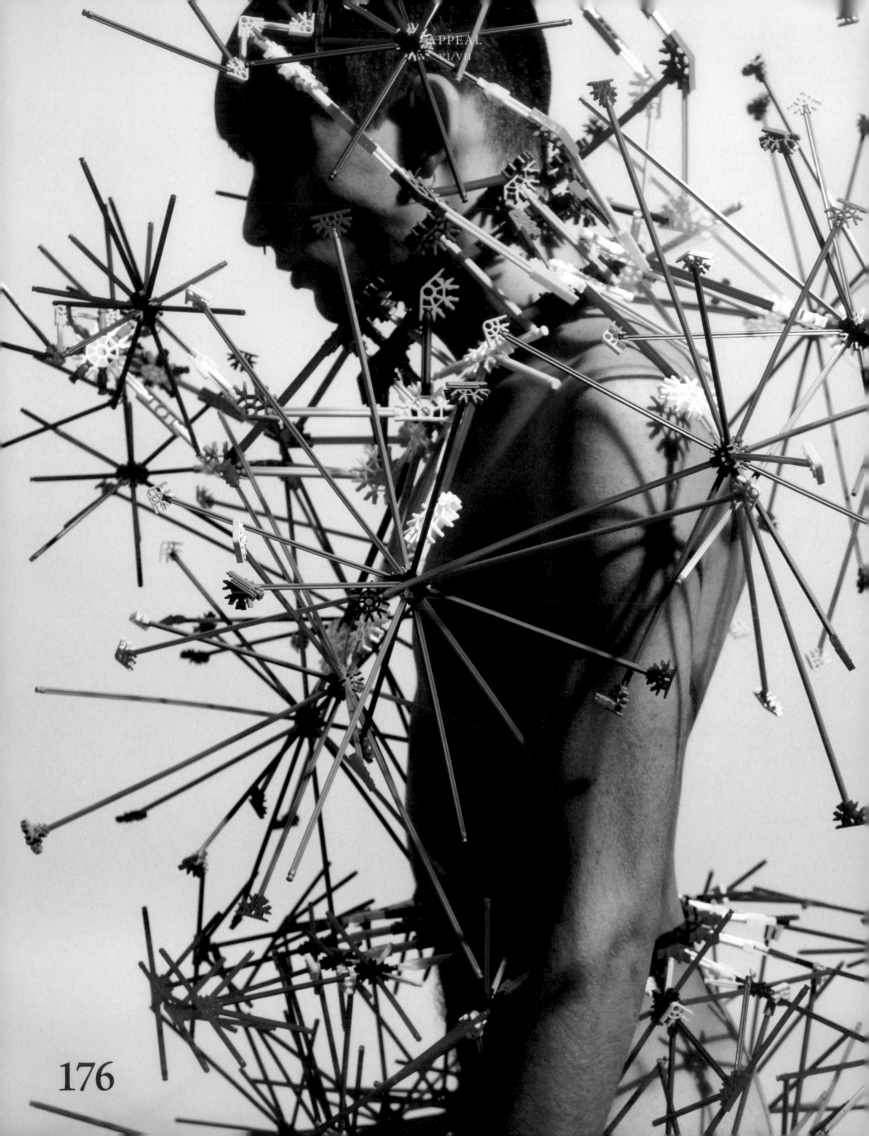

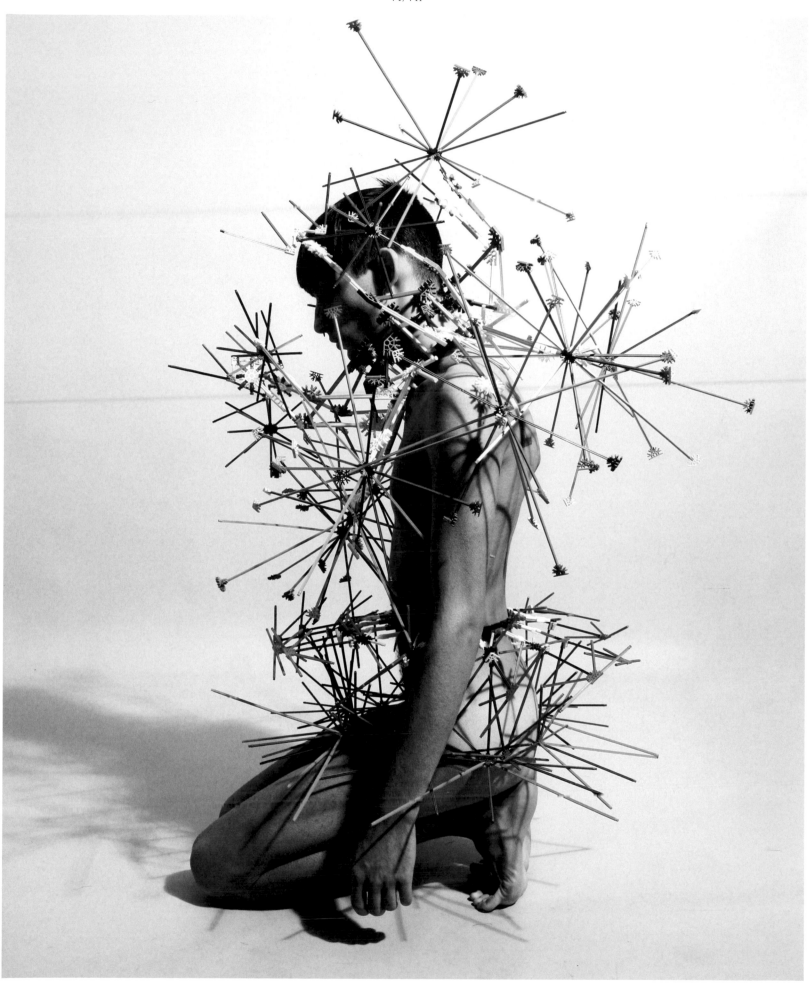

177 Ignacio Lozano
*Kaleidoscopic Second Skin*, 2010.

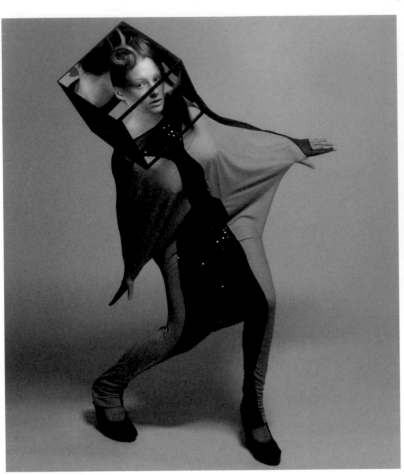

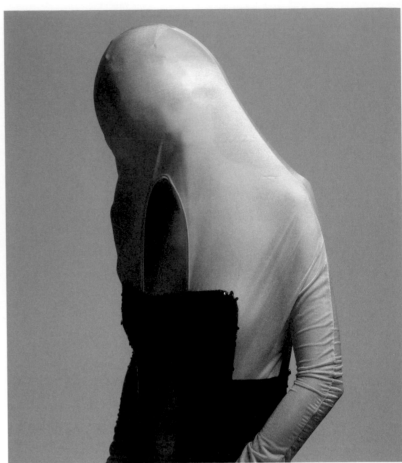

Ara Jo
*A/W Whitemare Collection, 2009.*

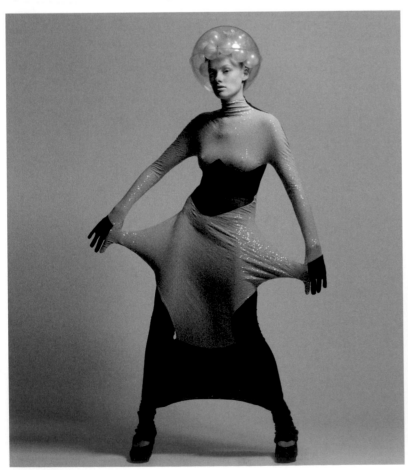

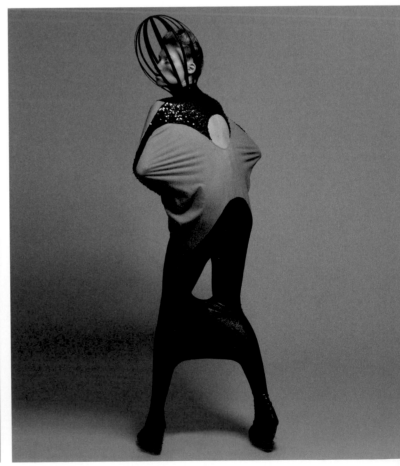

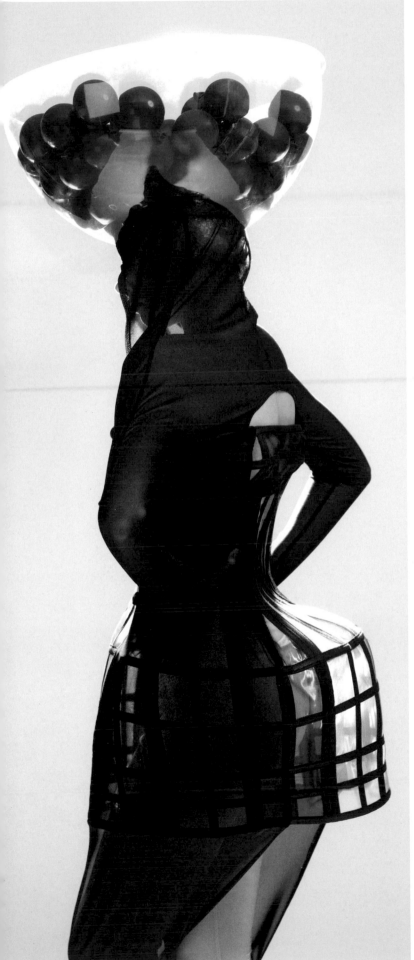

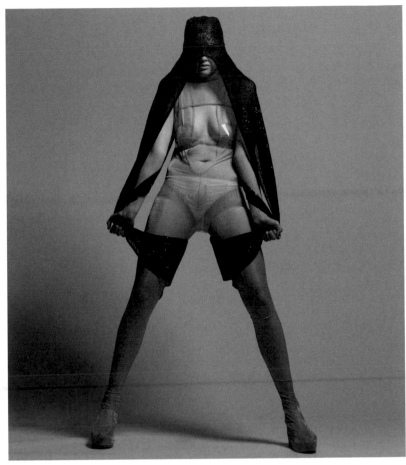

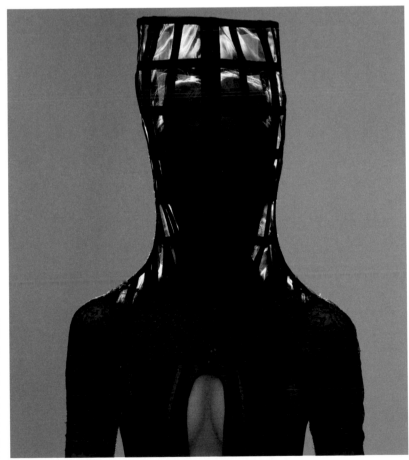

Zoren Gold & Minori
*Untitled.*

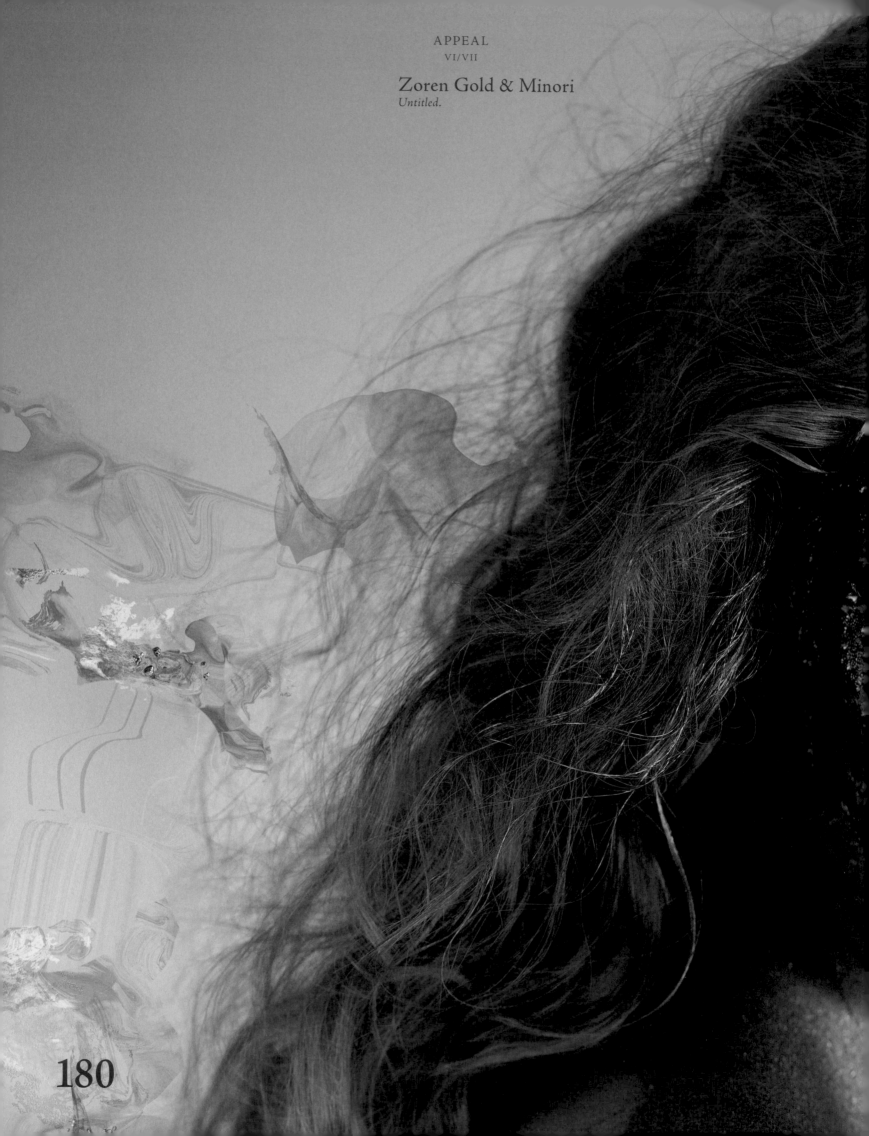

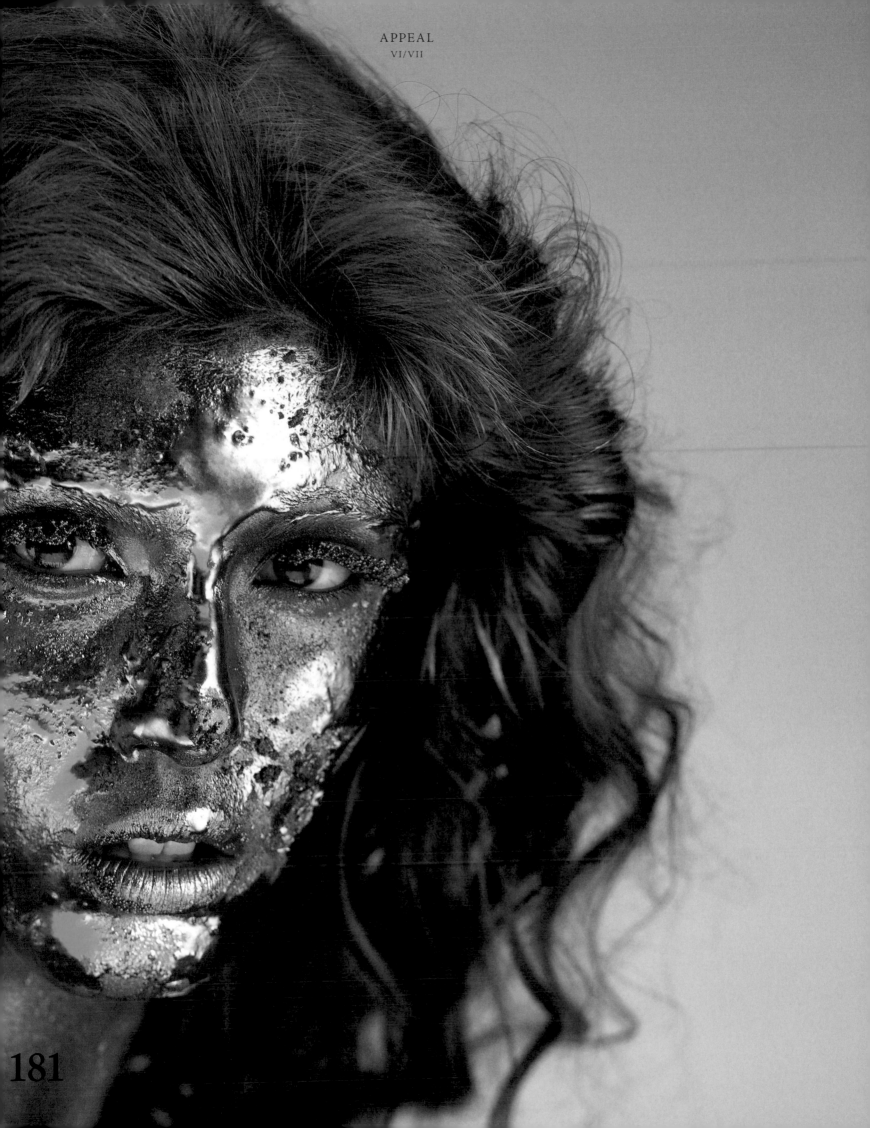

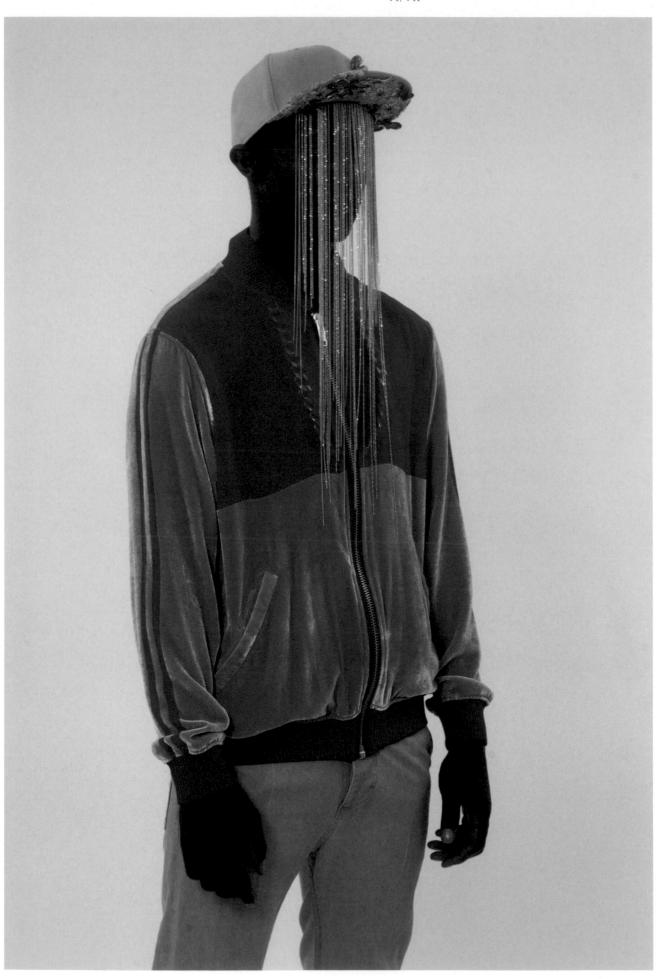

**182** Astrid Andersen
*RCA final MA Collection*, Devore Zip, Goldencap Piece, 2010.

Madame Peripetie
*Pughatory | Stewardess, 2010.*

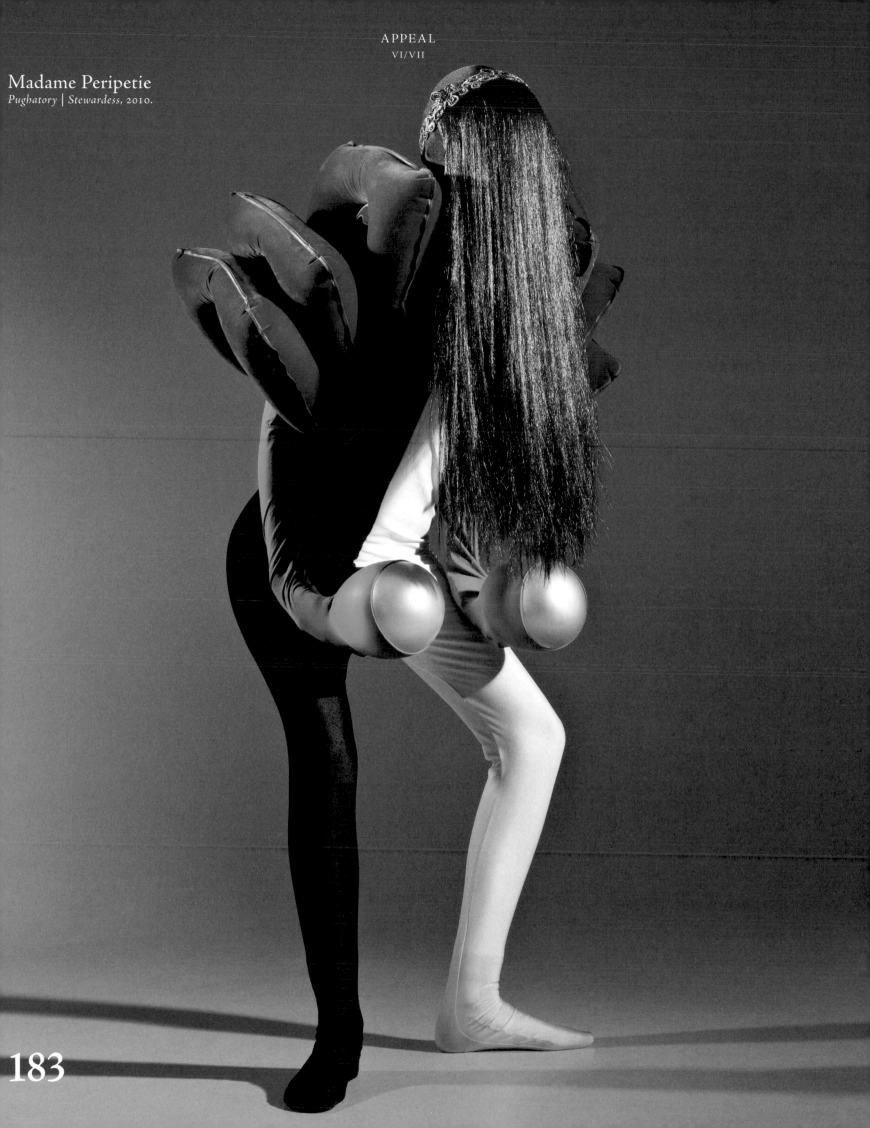

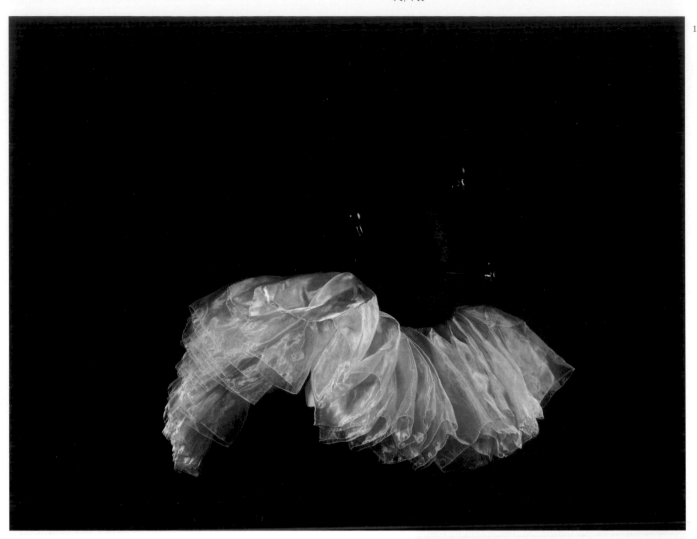

## Madame Peripeti

**1**
*Pughatory | Chimney Sweeper,* 2009.

**2**
*Pughatory | Diva,* 2010.

**3** OPPOSITE PAGE
*Pughatory | DJ,* 2009.

The things that we encounter in our everyday life—unspectacular objects that we don't perceive as being something special—are the main topic of Madame Peripeti's work. Like Dadaist "objets trouvés," which are not considered art or having a non-art function at all, these commonplace objects are being disintegrated from their original context and placed in a completely different one. These sculpturally extended anthropomorphic figures, combined with inanimate matter, create a new world of unexpected juxtapositions and Dantesque compositions—you don't know exactly where the object ends and the body begins. It's as "beautiful as the chance encounter of a sewing machine an umbrella on a dissecting table." The things maintain their original physical form/shape, but it is the surreal bizarre context that glamorizes them. The title comes from Gareth Pugh and purgatory, merging into a new world of limbo.

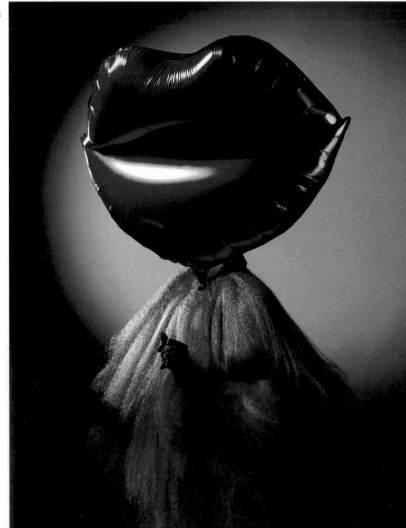

184

3

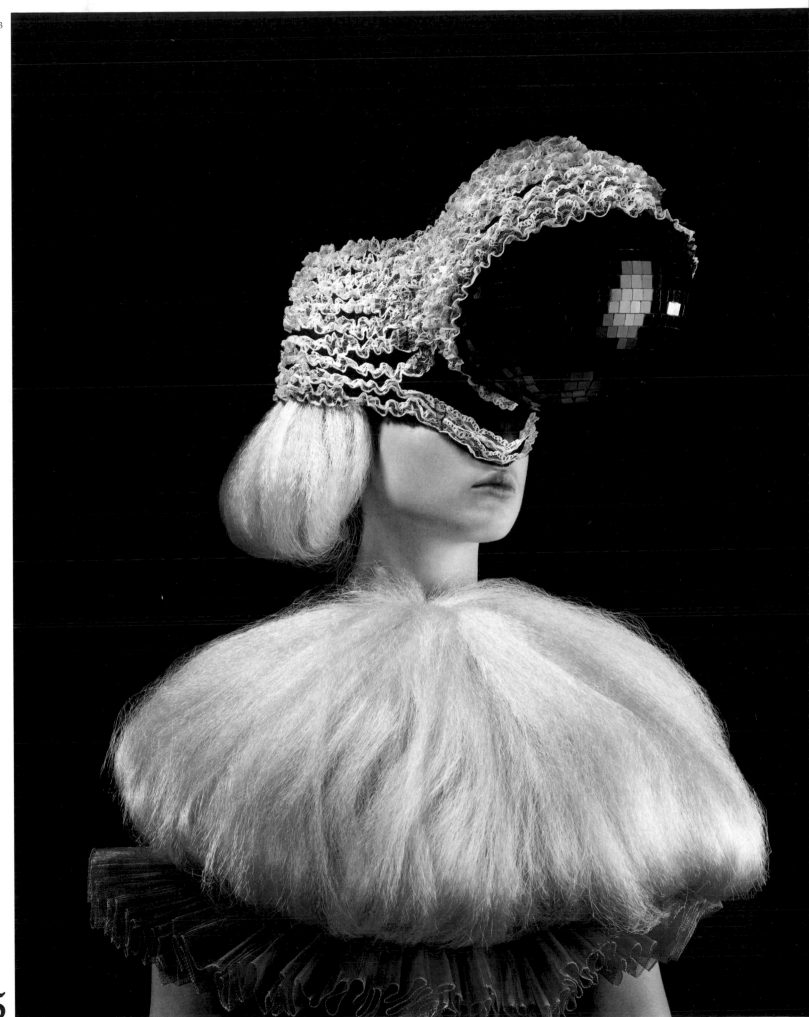

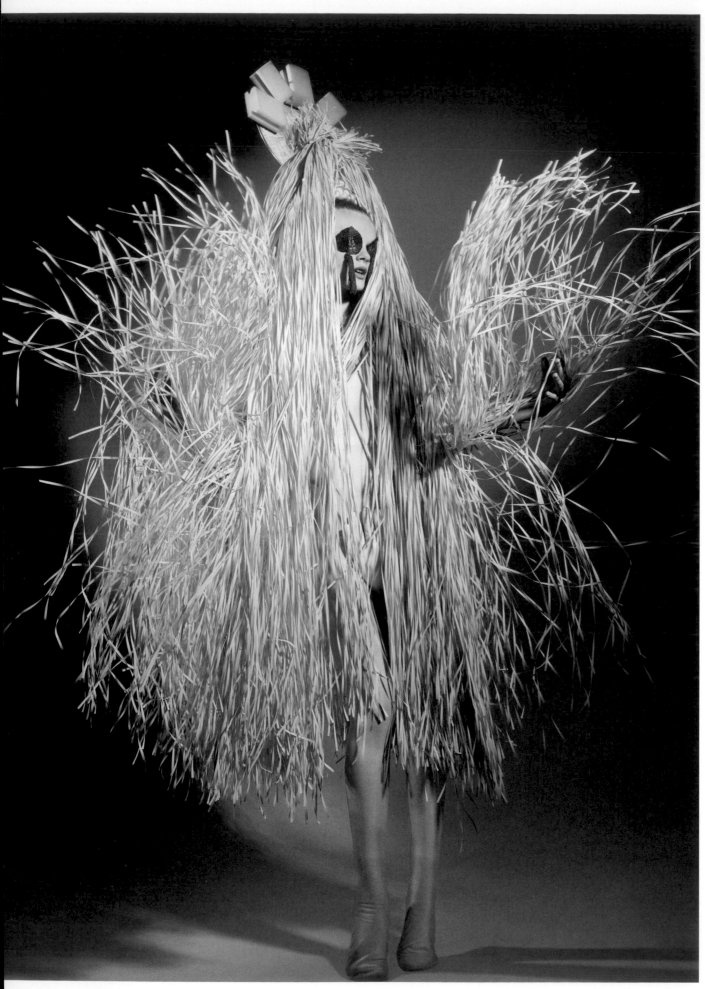

186 Madame Peripeti, *Pughatory | Cleaner,* 2010.

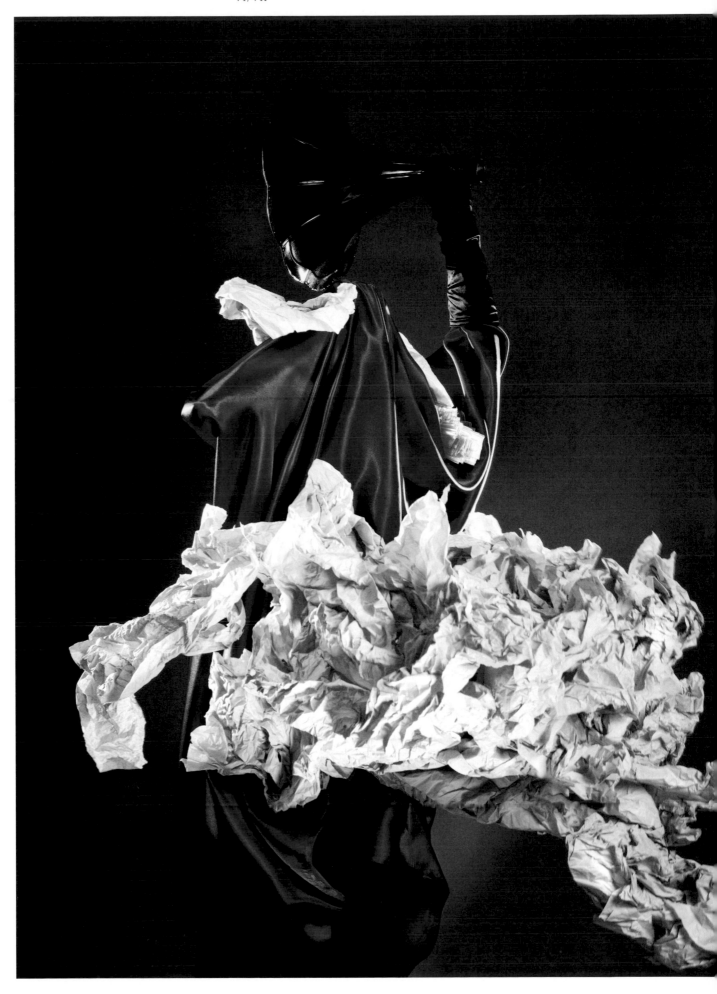

Madame Peripeti, *Pughatory* | *Conductor,* 2009.

# 07

## ESCAPE

(Surreal Staging)

●

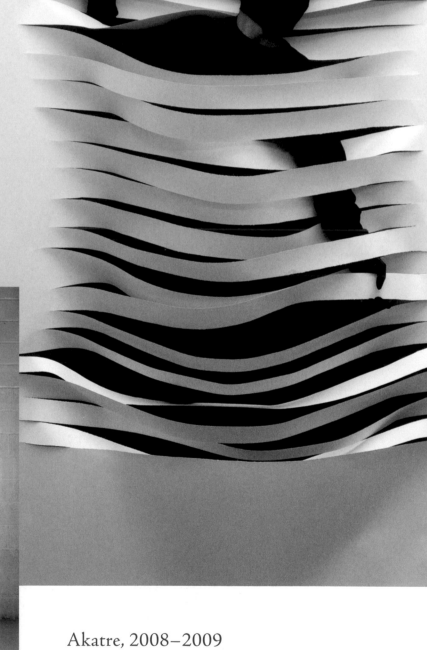

Akatre, 2008–2009

*Mains d'Œuvres.*

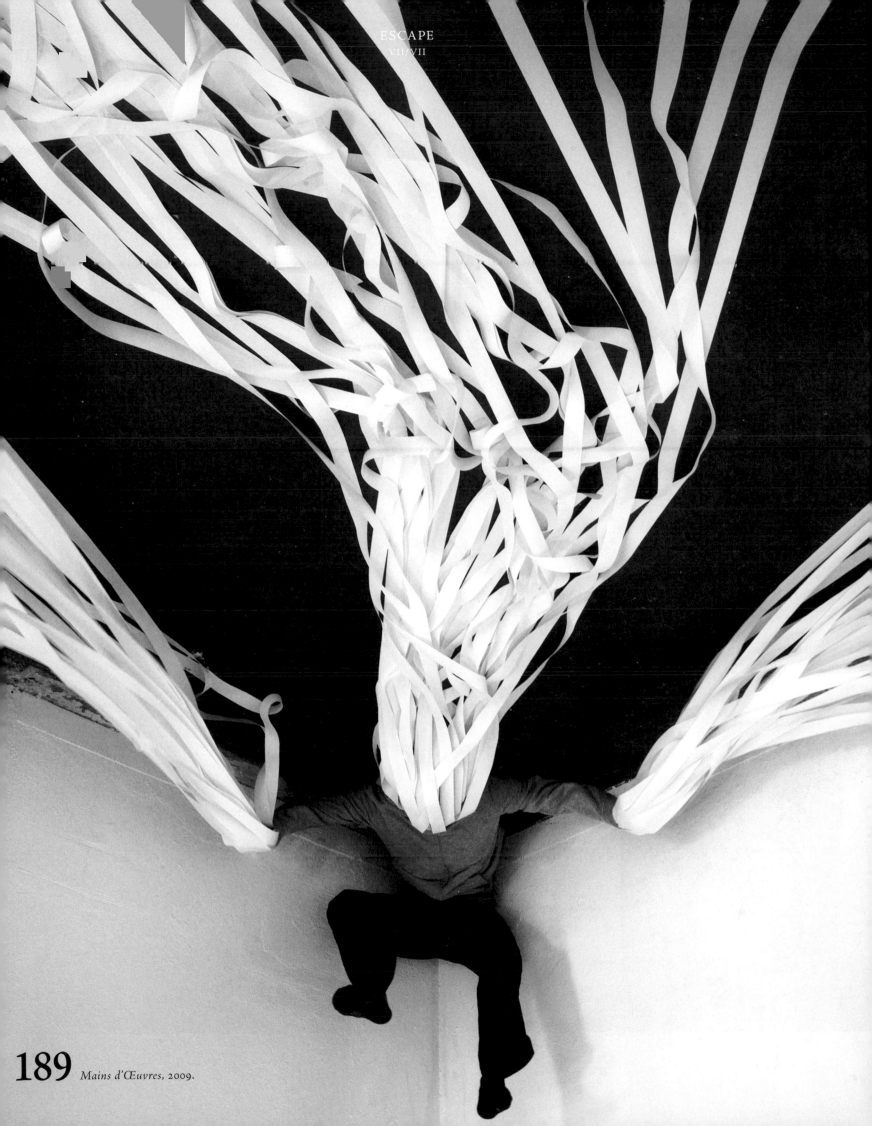

189 *Mains d'Œuvres*, 2009.

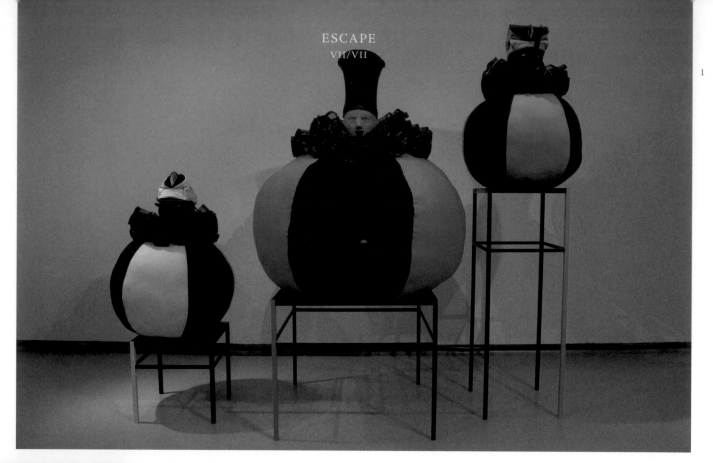

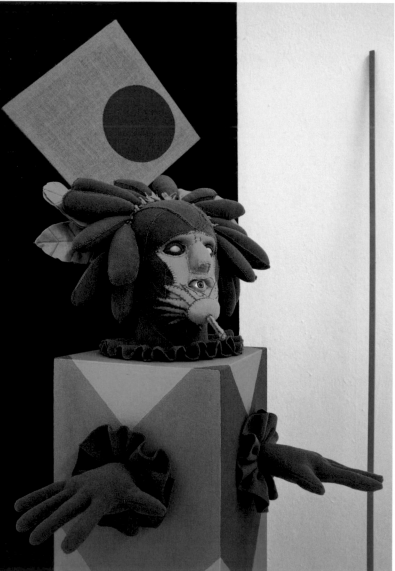

4

# Jonathan Baldock

**1**

*Feasts of Fools (Lords of Misrule). Mixed media, size variable.*

**2**

*Reflections of the Way Life Used to Be (detail), 2010.*
*Mixed media, 135 cm x 66 cm x 167 cm.*

**3**

*Asceticism & The Virtuous, 2008. Salt dough & mixed media,*
*each 50 cm x 45 cm x 45 cm.*

**4**

*Regality (The Fair), 2010. Mixed media, 182 cm x 23 cm x 30 cm.*

**5**

*Reclining Figure (detail), 2010. Mixed media, 135 cm x 66 cm x*
*167 cm.*

**6**

*Togetherness, 2010. Mixed media, 182 cm x 23 cm x 30 cm.*

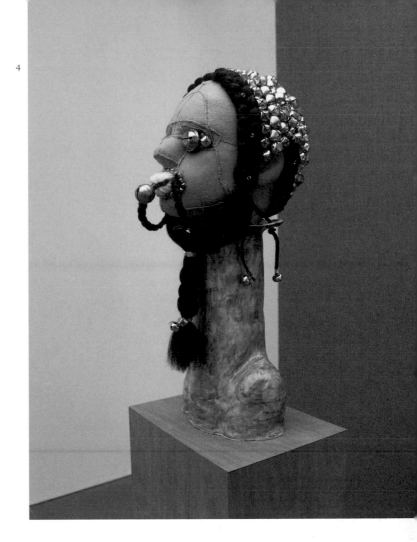

5

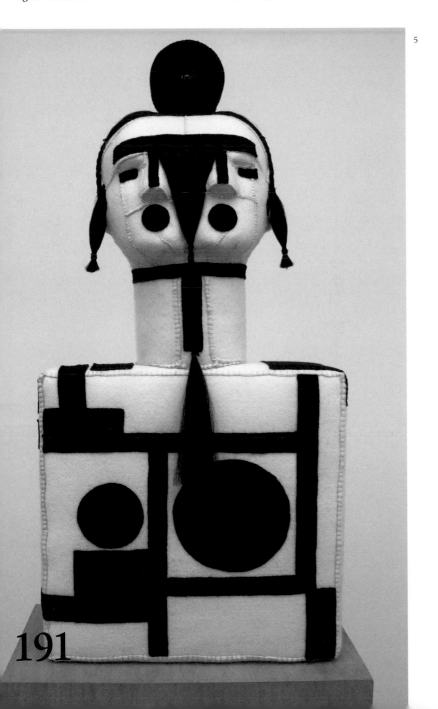

6

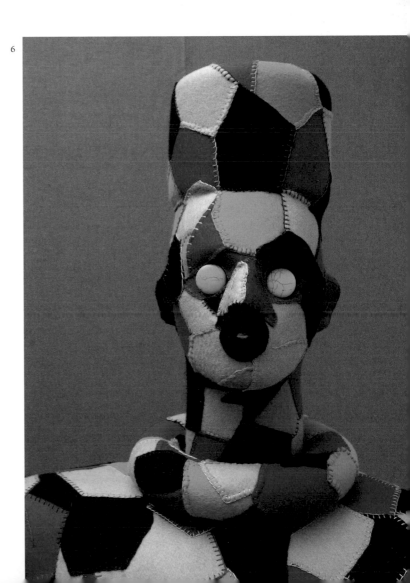

191

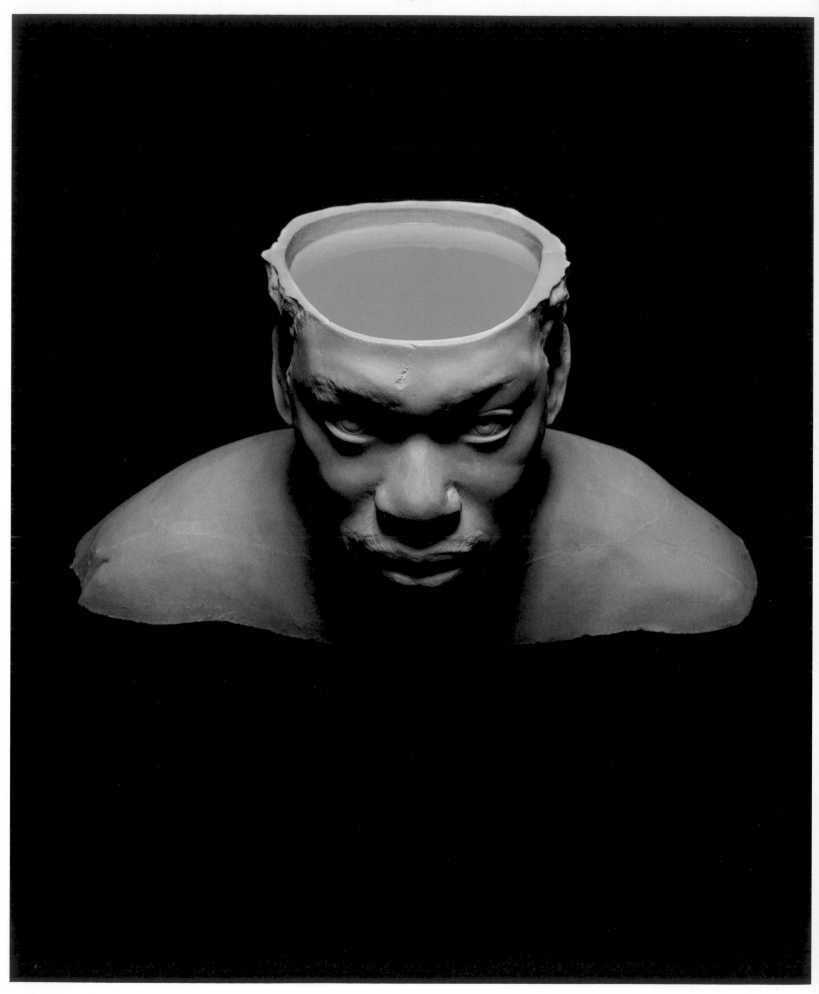

2

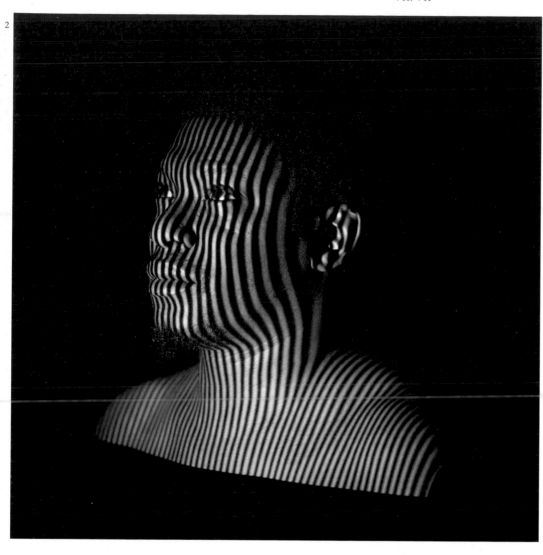

## Oscar & Ewan, 2008

**1**
*Roots Manuva: Slime and Reason,*
Big Dada Recordings, 2008.

**2**
3D scanning of Rodney Smith aka Roots Manuva.

**3**
Finished bust of Rodney.

**4**
*Roots Manuva: Do Nah Bodda Mi,* Big Dada
Recordings, 2008.

Taking a literal interpretation of the title, Oscar &
Ewan created a full-size plaster bust of Rodney Smith
aka Roots Manuva and filled his head with slime. The
bust was created by 3D scanning Rodney, rapid pro-
totyping the bust, and casting the result in plaster.
Different singles used the bust in different ways:
Dancehall-tinged 𝔇𝔬 𝔑𝔞𝔥 𝔅𝔬𝔡𝔡𝔞 𝔐𝔦 referenced Roots'
Banana Klan label with a banana crown, and 𝔏𝔢𝔱 𝔱𝔥𝔢
𝔖𝔭𝔦𝔯𝔦𝔱 bleached all the color out of the campaign.

3

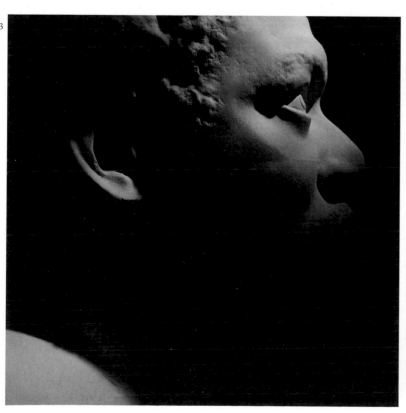

4

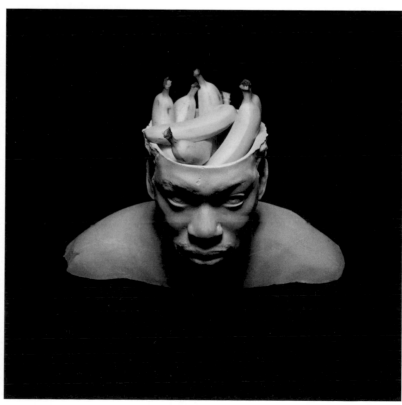

1

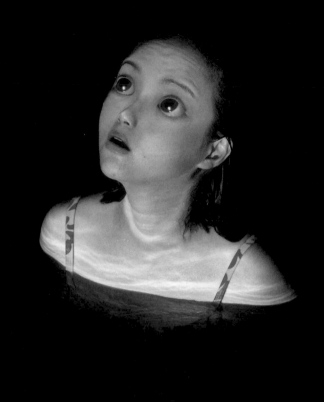

2

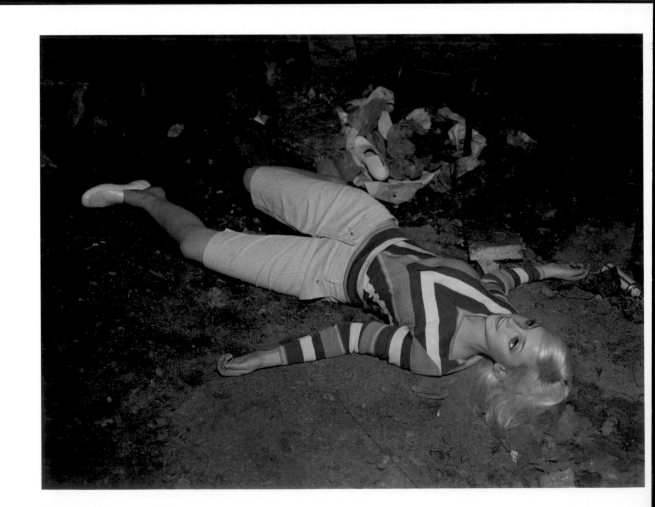

4

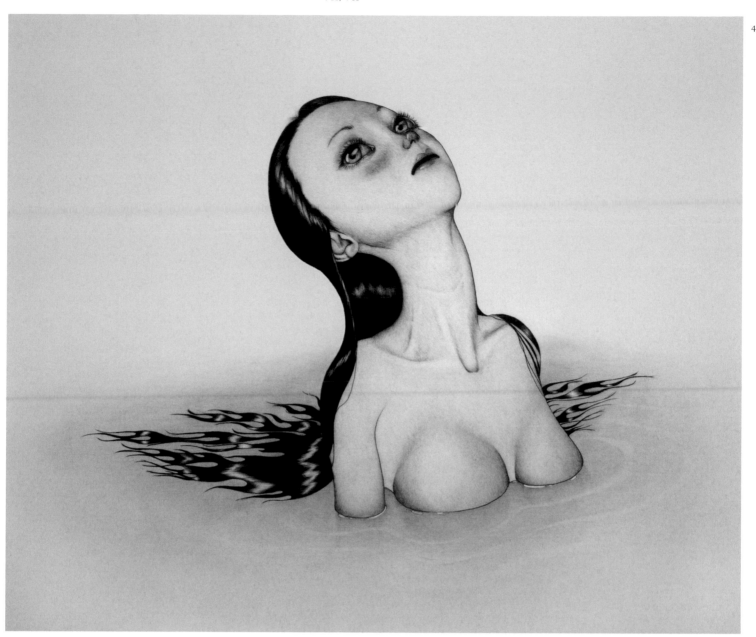

5

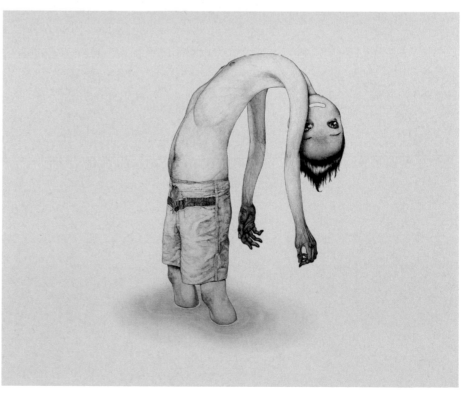

# Chris Scarborough

**1**

*Untitled,* 2005. Digital C-print, 51 cm x 76 cm.
Edition of 5.

**2**

*Untitled,* 2005. Digital C-print, 91 cm x 76 cm.
Edition of 7.

**3**

*Untitled,* 2006. Digital C-print, 76 cm x 102 cm.
Edition of 5.

**4**

*Untitled (Smolder),* 2006. Graphite on paper, 48 cm x 56 cm.

**5**

*Untitled (Bender),* 2006. Graphite on paper, 56 cm x 76 cm.

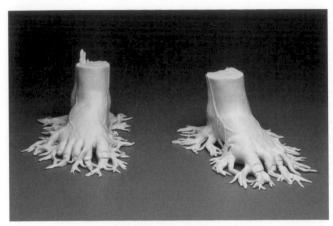

*Migrant*, 2009. Assembled, handcrafted porcelain,
41 cm x 51 cm x 18 cm.

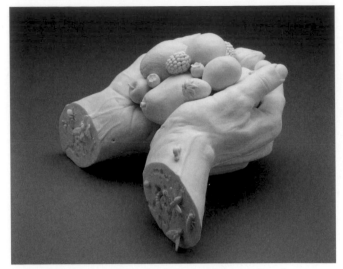

*Goblin Market*, 2008. Handcrafted porcelain, acrylic gel,
24 cm x 28 cm x 15 cm.

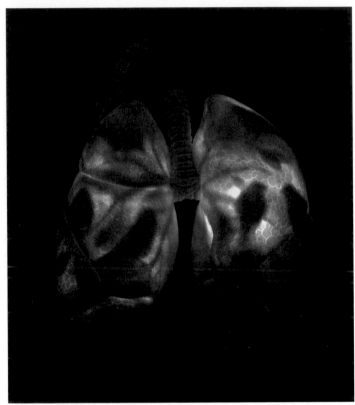

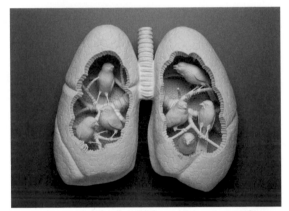

*Canary 3*, 2009. Handcrafted porcelain, cone 6 glaze,
34 cm x 32 cm x 15 cm.

*Canary*, 2008. Handcrafted porcelain, wooden wall pedestal,
compact fluorescent lights, wiring, 56 cm x 56 cm x 13 cm.

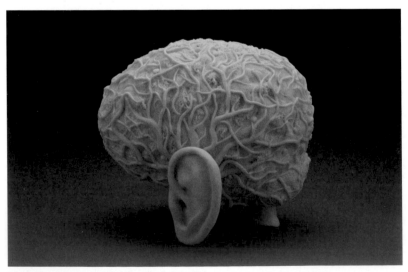

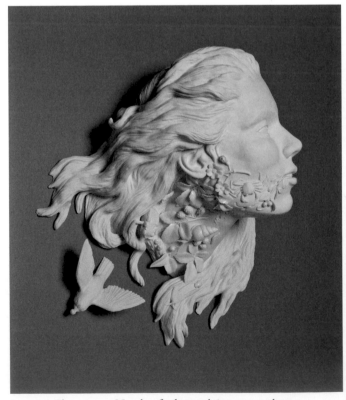

*Root Bound*, 2007. Handcrafted porcelain, 15 cm x 18 cm x 14 cm.

*Invasive Flora*, 2009. Handcrafted porcelain, cone 6 glaze,
41 cm x 43 cm x 20 cm.

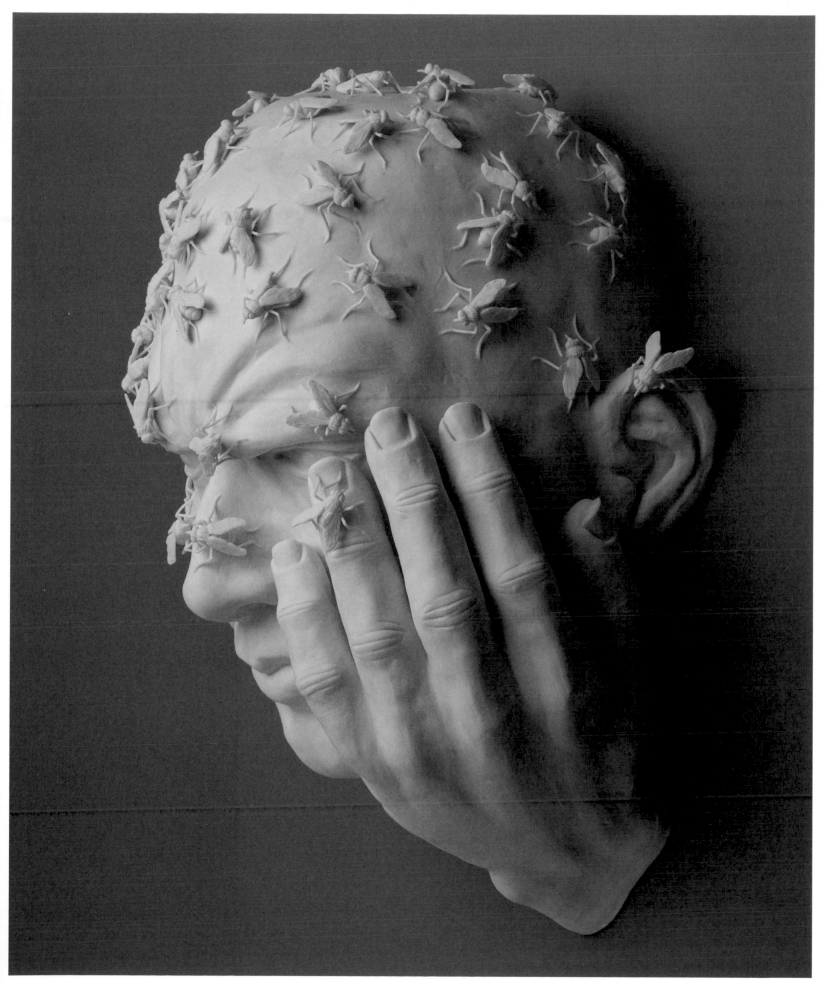

197 *Buzz*, 2008. Handcrafted porcelain, acrylic gel, 37 cm x 28 cm x 19 cm.

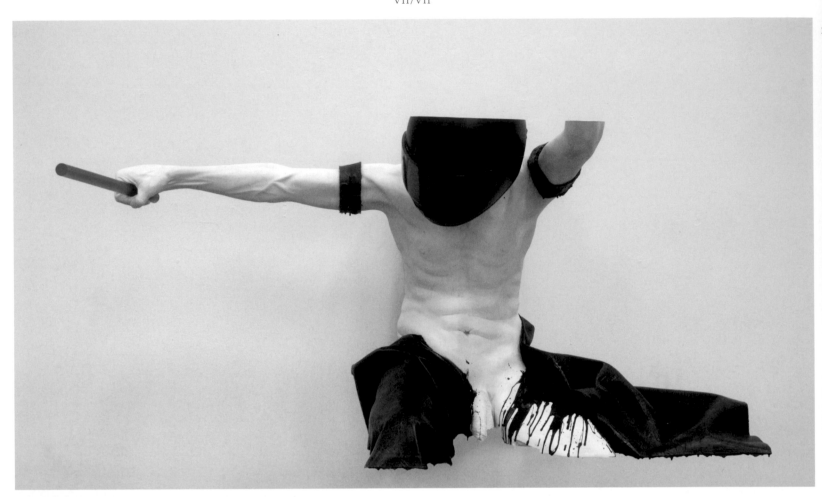

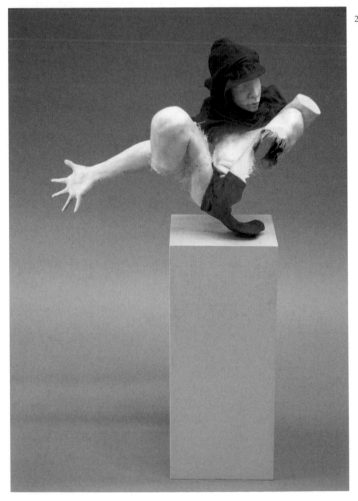

## Gregor Gaida

**1**
*Drummer II*, 2010. Painted wood, polyester resin, aluminium, 160 cm x 75 cm x 75 cm.

**2**
*Rest von F4*, 2008. Polyester resin, concrete base, 65 cm x 40 cm x 65 cm.

**3**
*Fragment*, 2008. Painted wood, polyester resin, 20 cm x 10 cm x 6 cm.

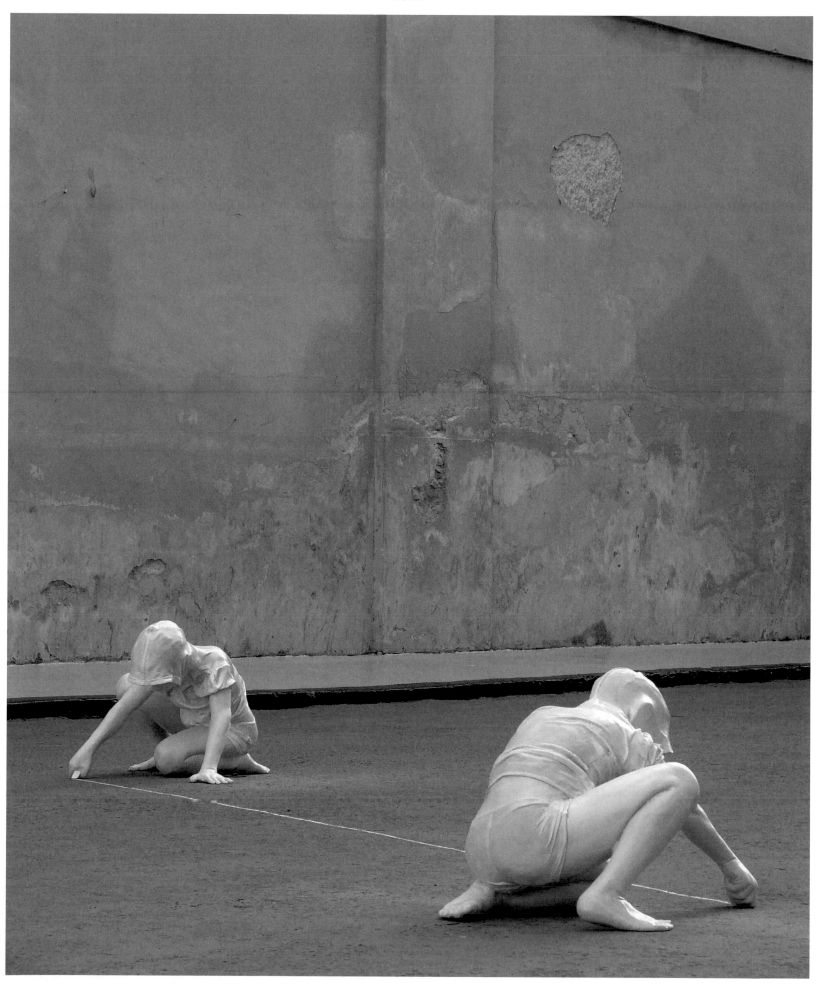

**199** Gregor Gaida, *Kind und Kreide III*, 2008, Collection Hangar-7, Salzburg, Austria.
Painted polyester resin, each 75 cm x 65 cm x 55 cm. Edition of 3.

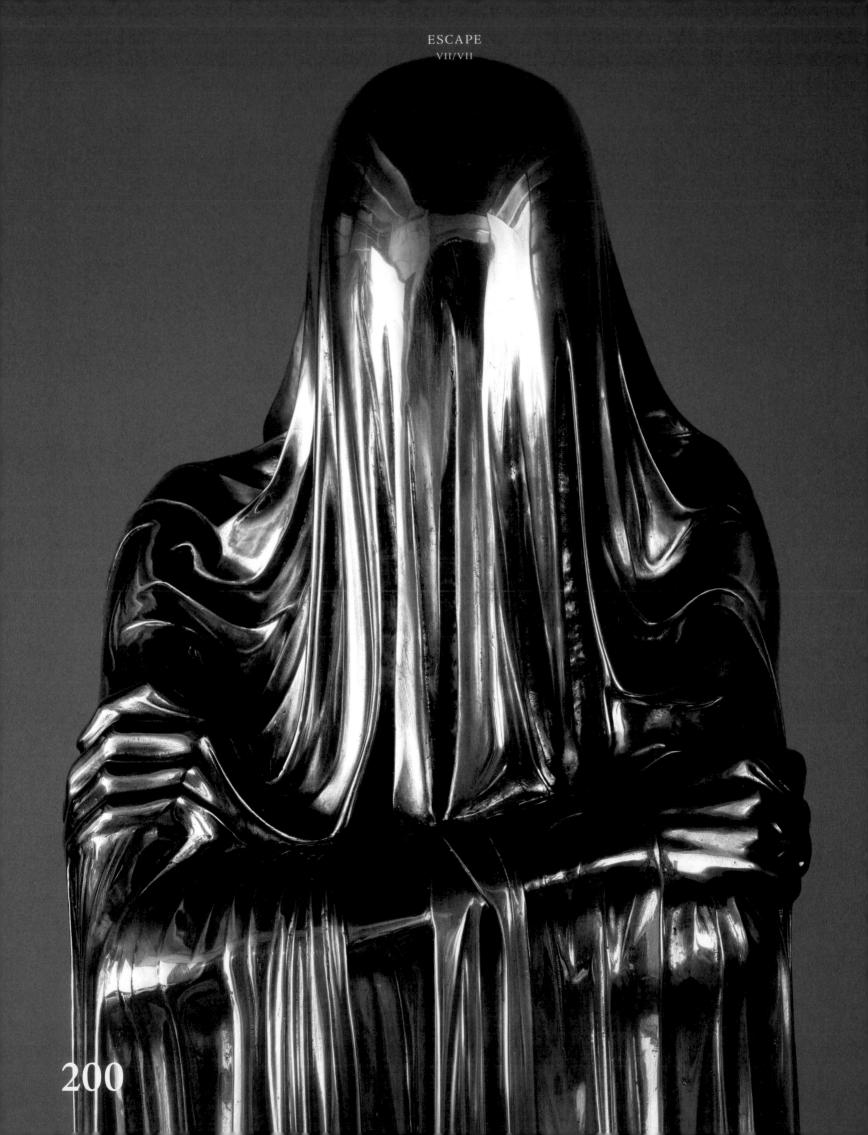

200

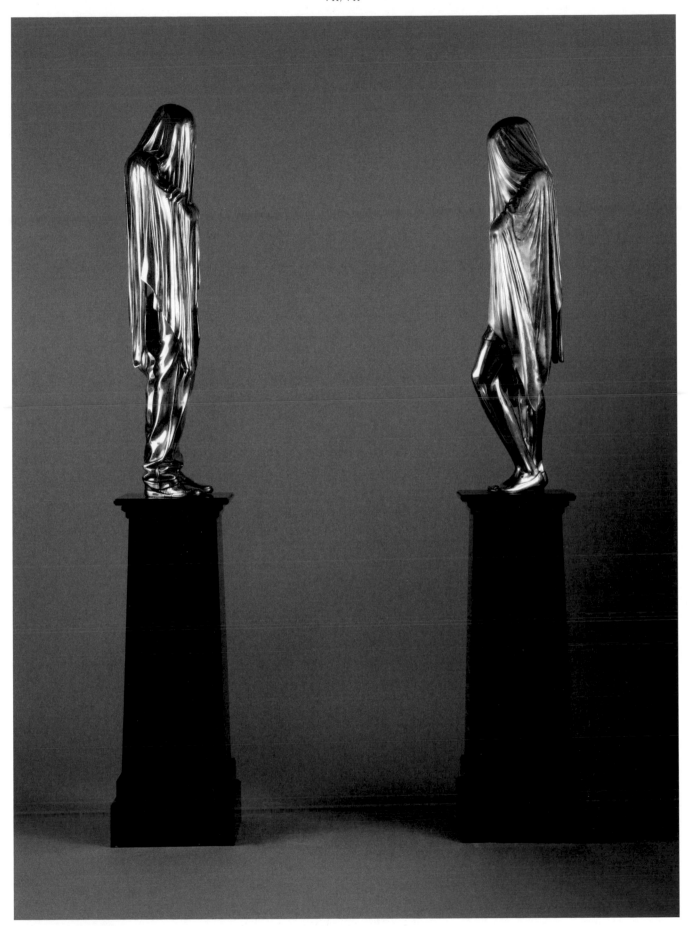

# Kevin Francis Gray

*Face-off*, 2007. Bronze, automotive paint. Wood boy: 106 cm x 40 cm x 30 cm.
Girl: 104 cm x 40 cm x 30 cm. Plinths: 91 cm x 30 cm x 30 cm. Edition of 4 + 1AP.

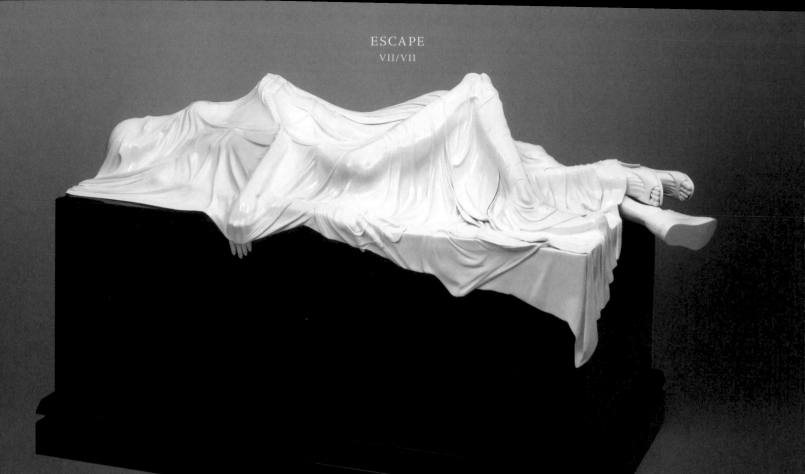

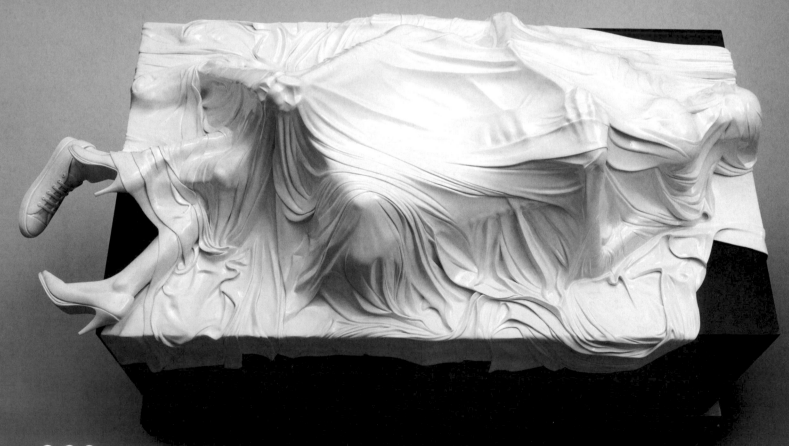

**202** Kevin Francis Gray, *Kids on a Tomb*, 2008. Fiberglass resin, automotive paint, wood, 165 cm x 110 cm x 100 cm. Edition of 4 + 1AP.

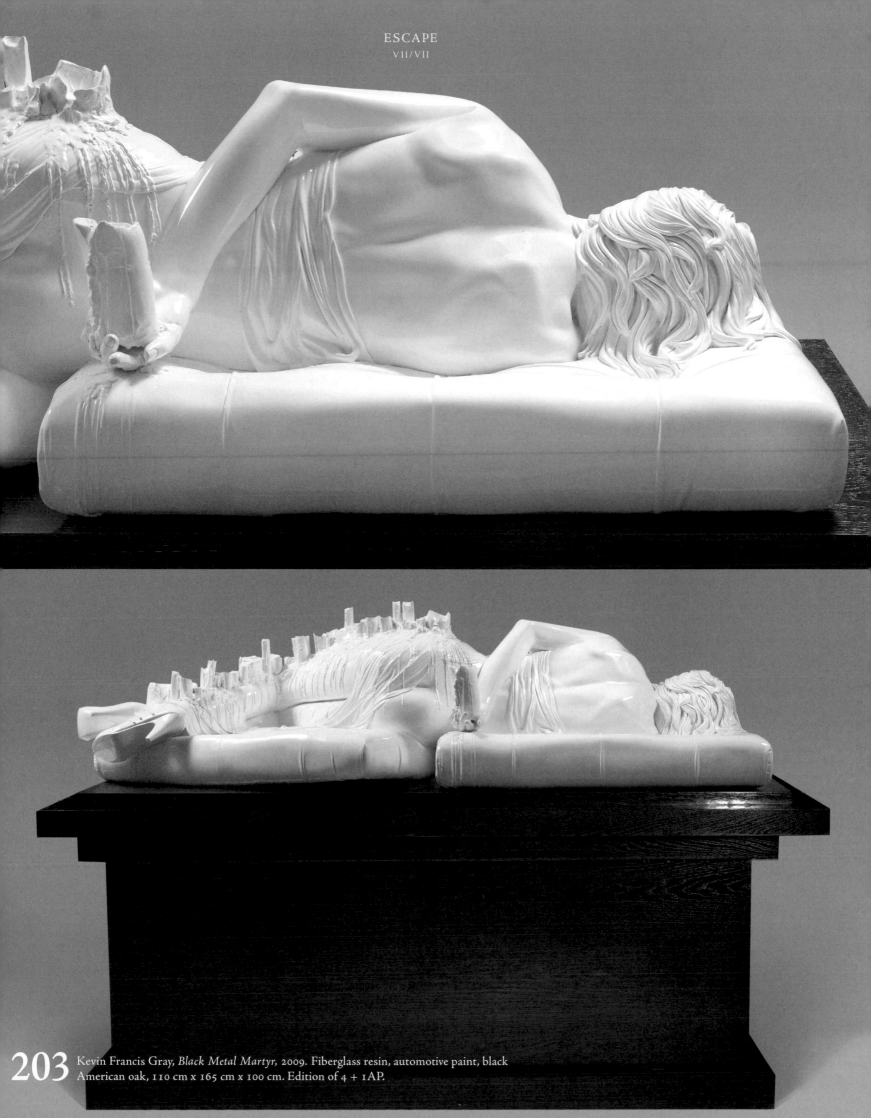

**203** Kevin Francis Gray, *Black Metal Martyr*, 2009. Fiberglass resin, automotive paint, black American oak, 110 cm x 165 cm x 100 cm. Edition of 4 + 1AP.

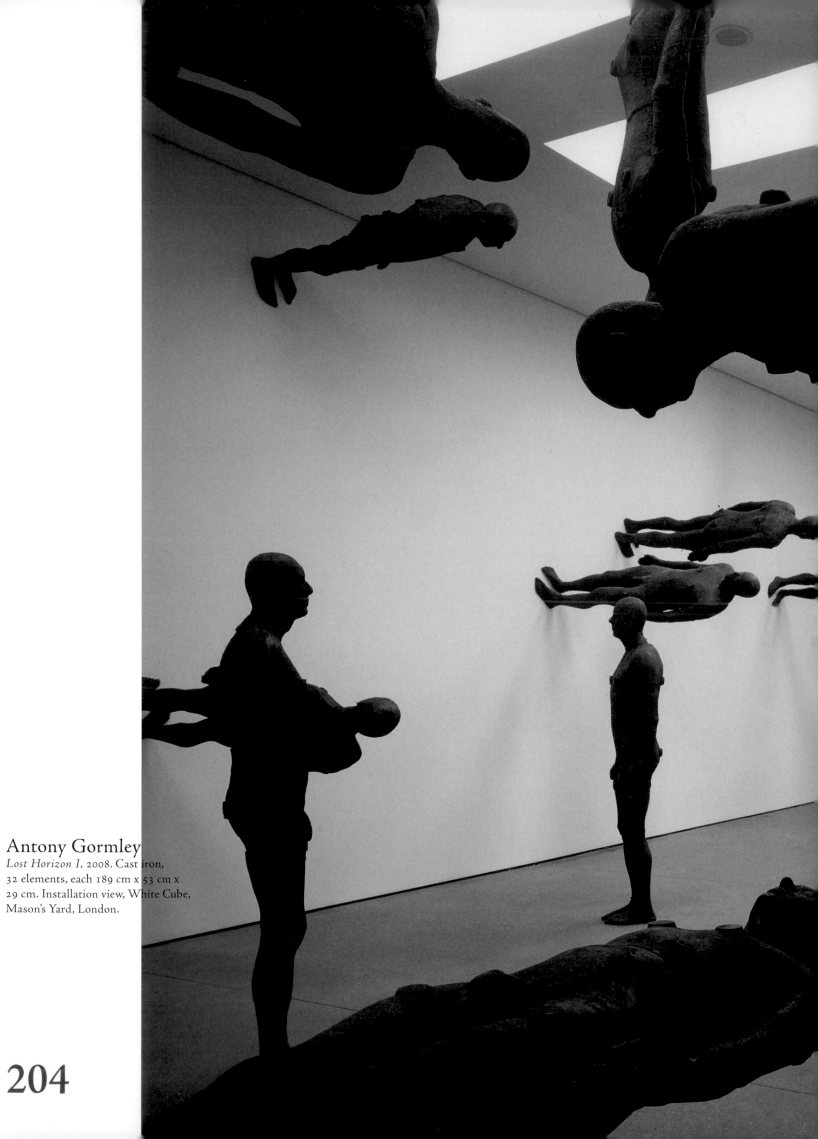

Antony Gormley
*Lost Horizon I*, 2008. Cast iron,
32 elements, each 189 cm x 53 cm x
29 cm. Installation view, White Cube,
Mason's Yard, London.

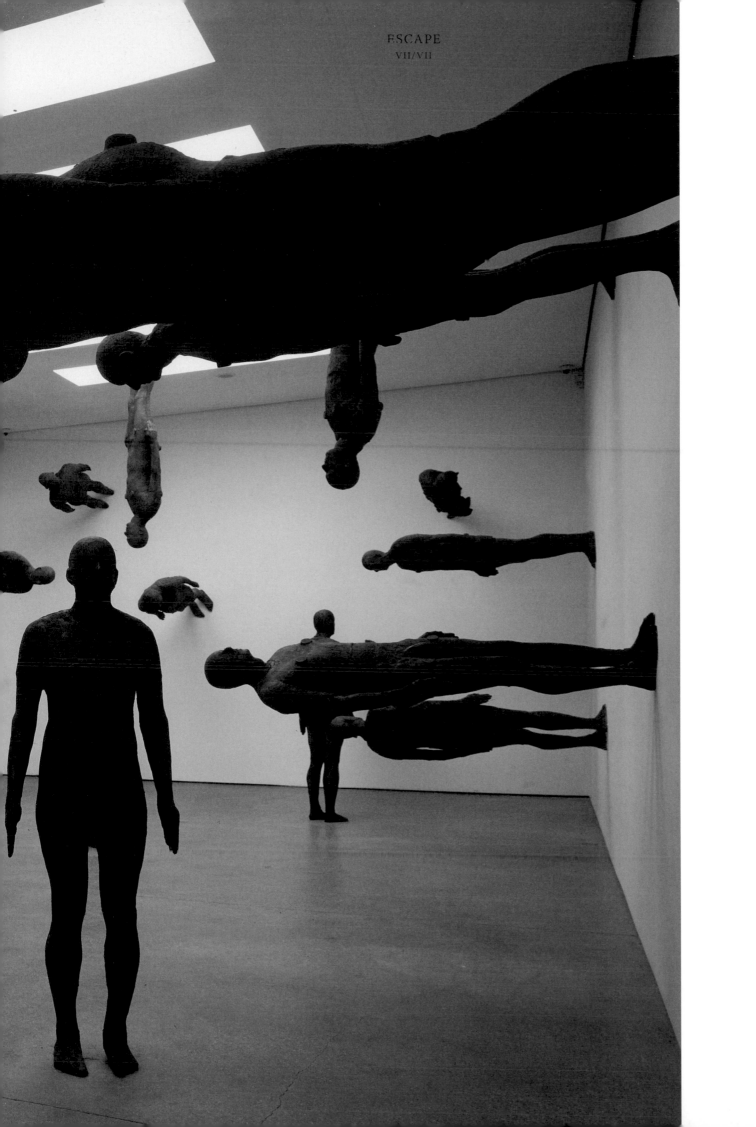

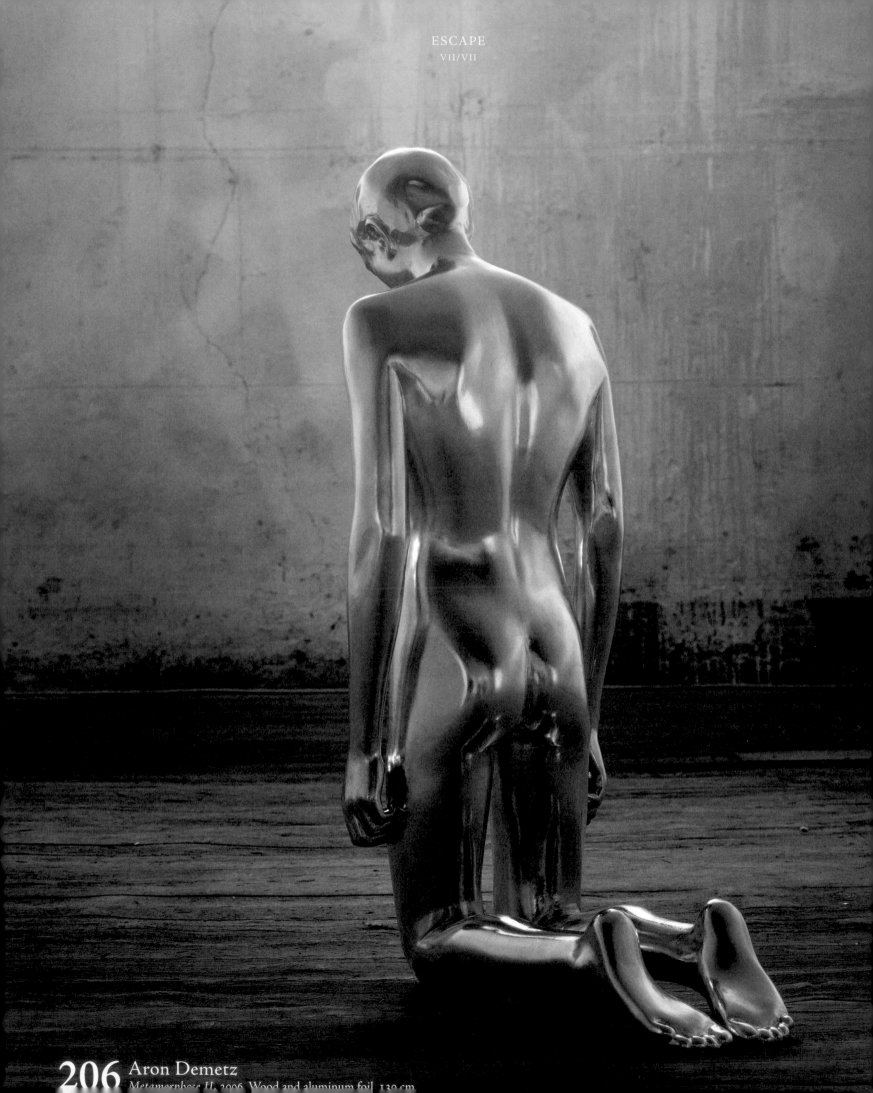

**206** Aron Demetz
*Metamorphose II, 2006, Wood and aluminum foil, 130 cm*

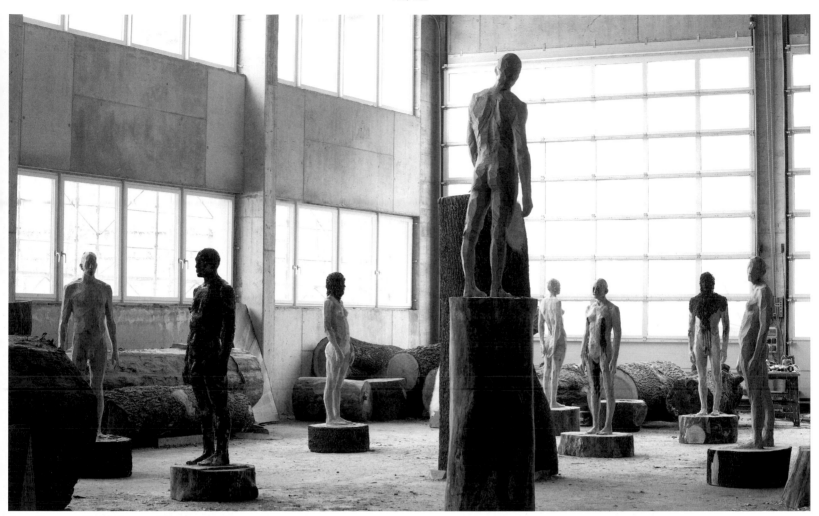

Aron Demetz, *Untitled*, 2009. Wood and galipot, 200 cm.

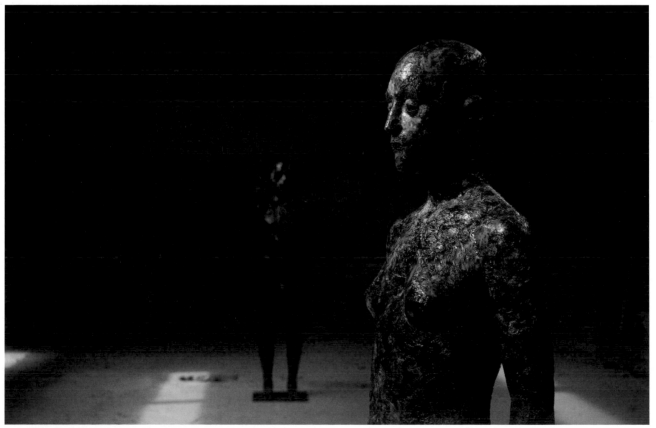

Aron Demetz, *Uomo Donna*, 2007. Wood and galipot, 175 cm.

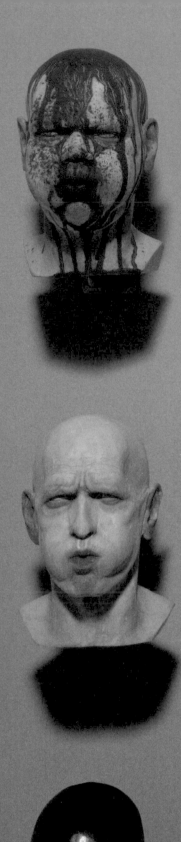
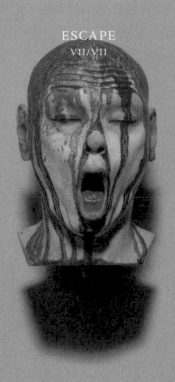
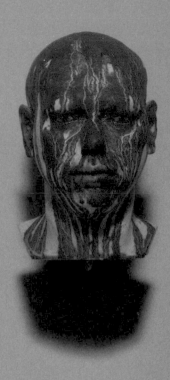
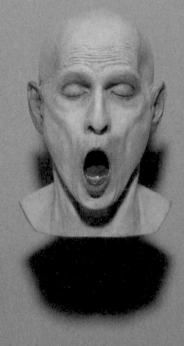
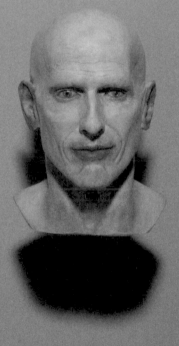
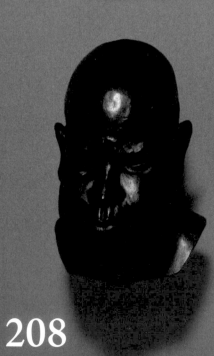
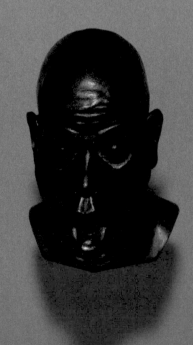

# Richard Stipl

## 1

*Breathe, You Fucker*, 2005, private collection. Resin, oil, 51 cm x 51 cm x 18 cm.

## 2

*A Futile Attempt at Getting to Know Oneself Better*, 2004, private collection. Wax, oil paint, 20 cm x 41 cm x 25 cm.

## 3

*A Futile Attempt to Get to Know Oneself Better III*, 2003, private collection. Wax, pigment, oil paint.

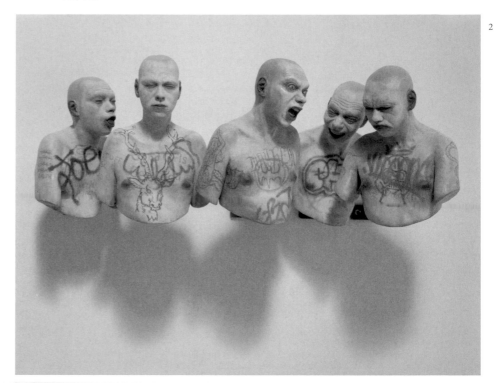

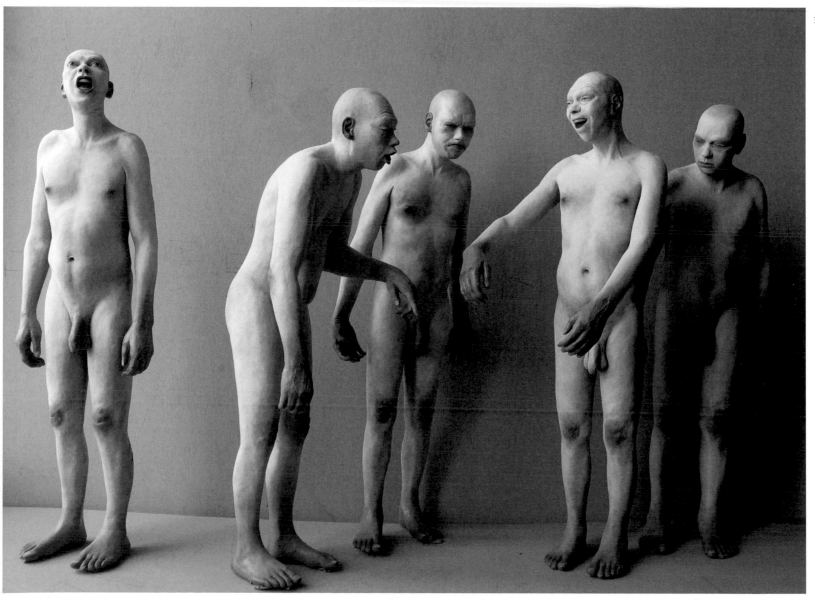

209

Richard Stipl, *Block Sabbath II*, 2005, private collection.
Resin, mixed media, 50 cm x 200 cm x 50 cm.

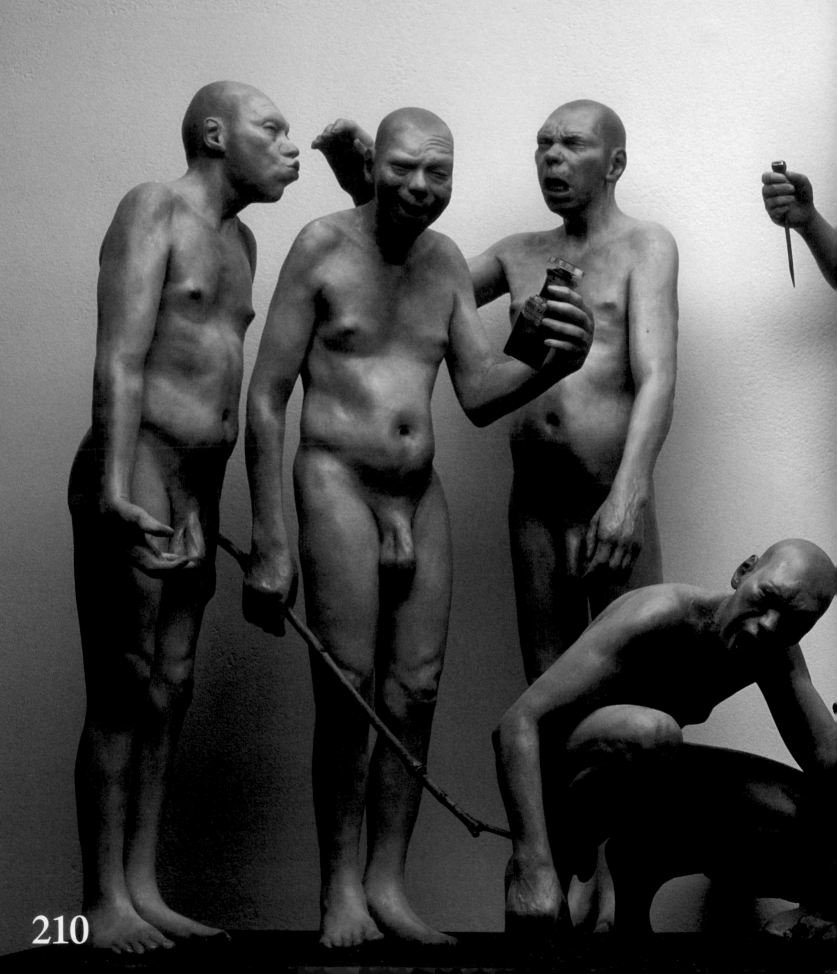

210

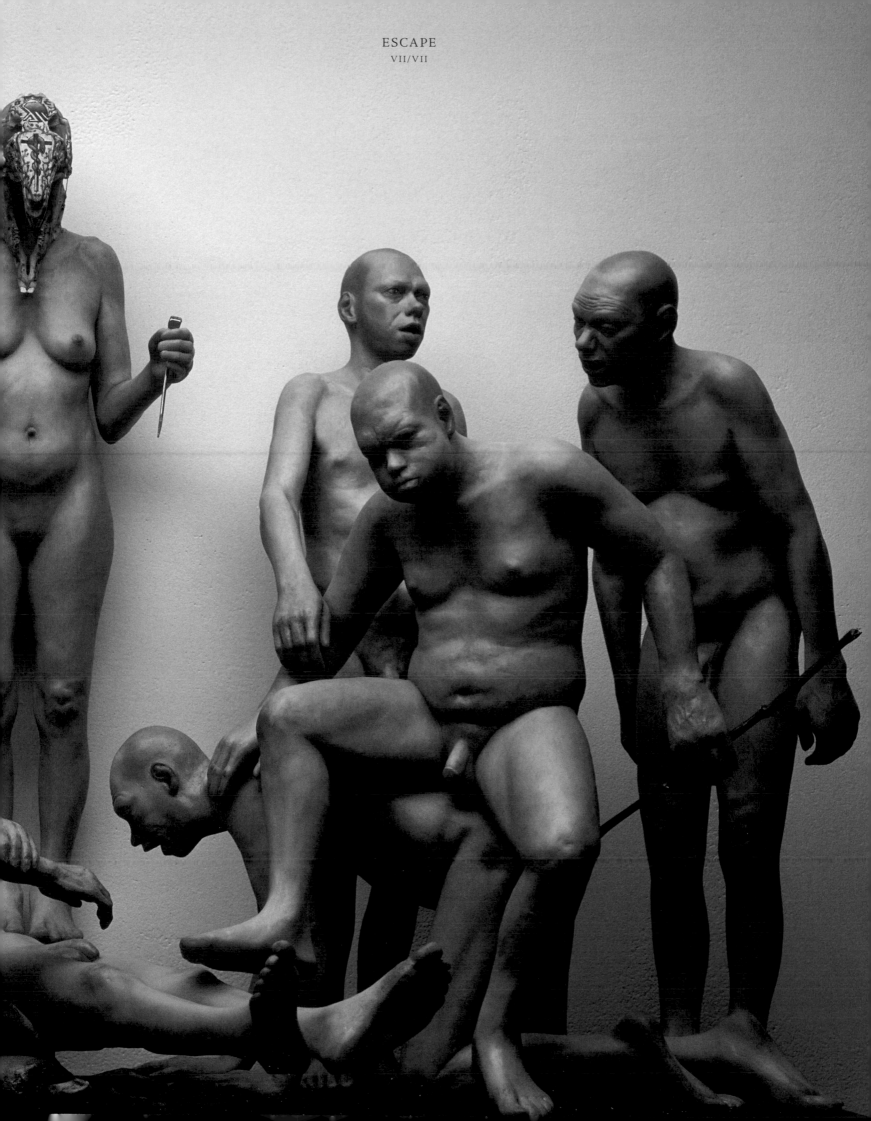

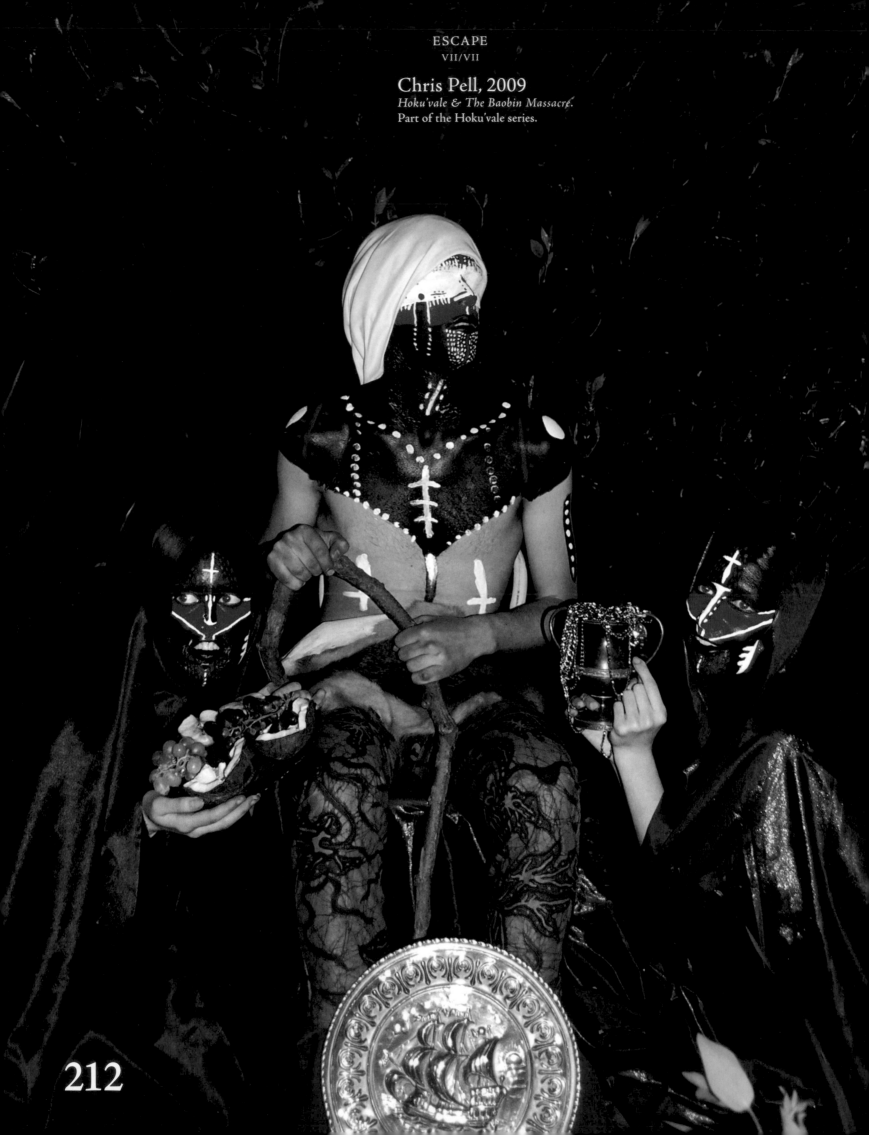

Chris Pell, 2009
*Hoku'vale & The Baobin Massacre.*
Part of the Hoku'vale series.

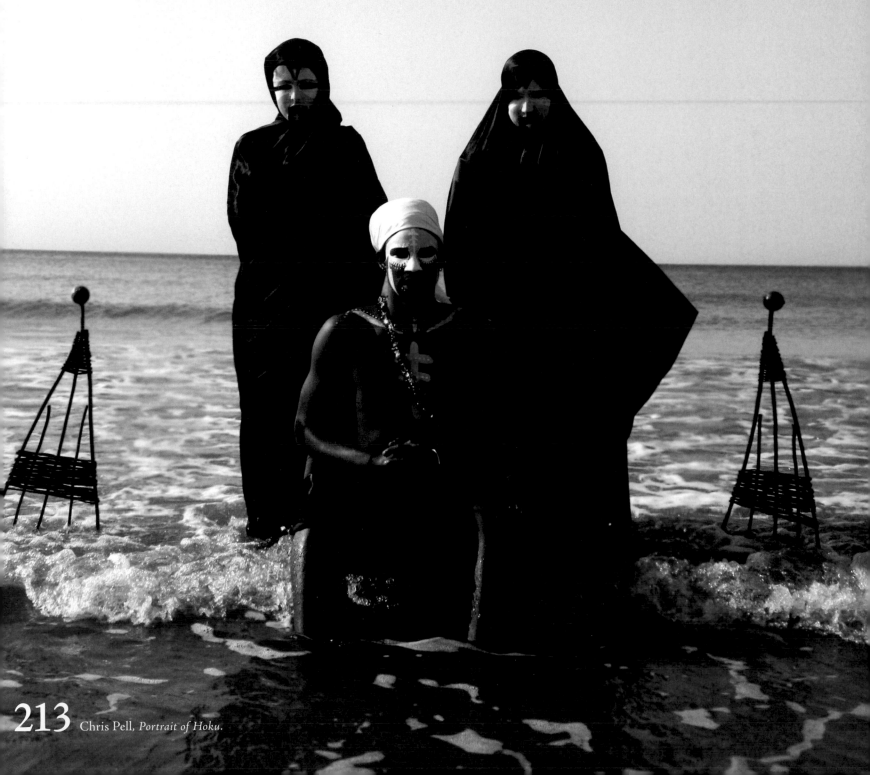

Chris Pell, *Portrait of Hoku.*

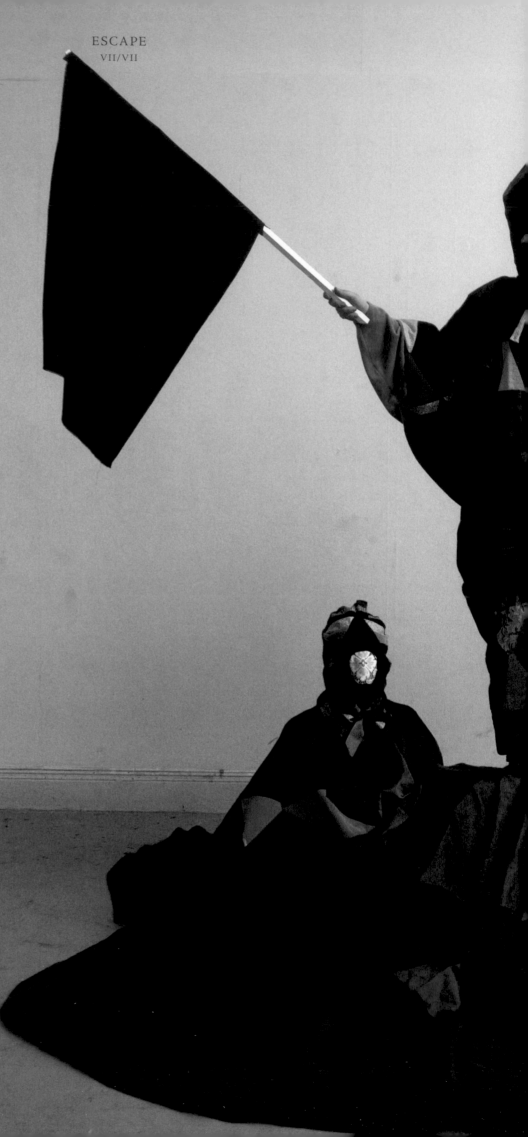

## Nadine Byrne
*The Shaman Suit*, 2008

The Shaman Suit and The Run  |→p.40|  are sprung from a fascination with mythology, ritual, and religion and the importance of the clothing in a religious experience. It shows how what we wear can signify what we believe, tell whole stories, and become an aid in the path towards an altered state.

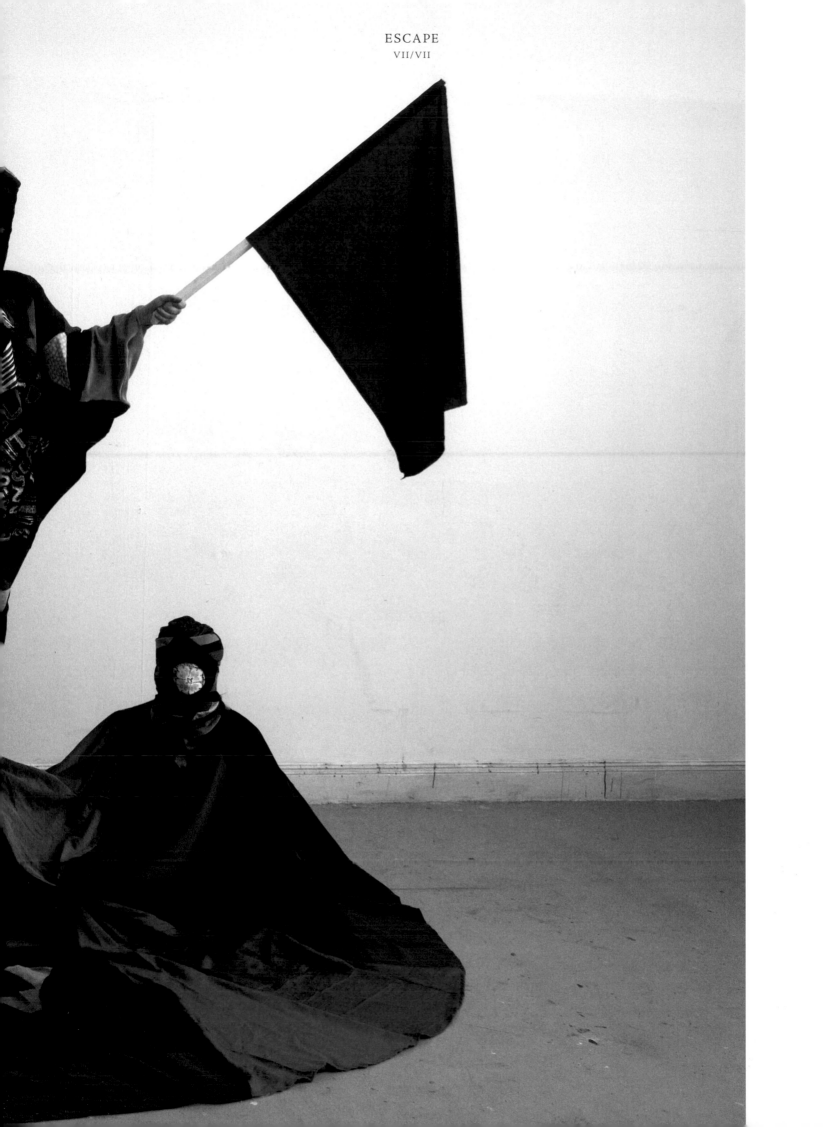

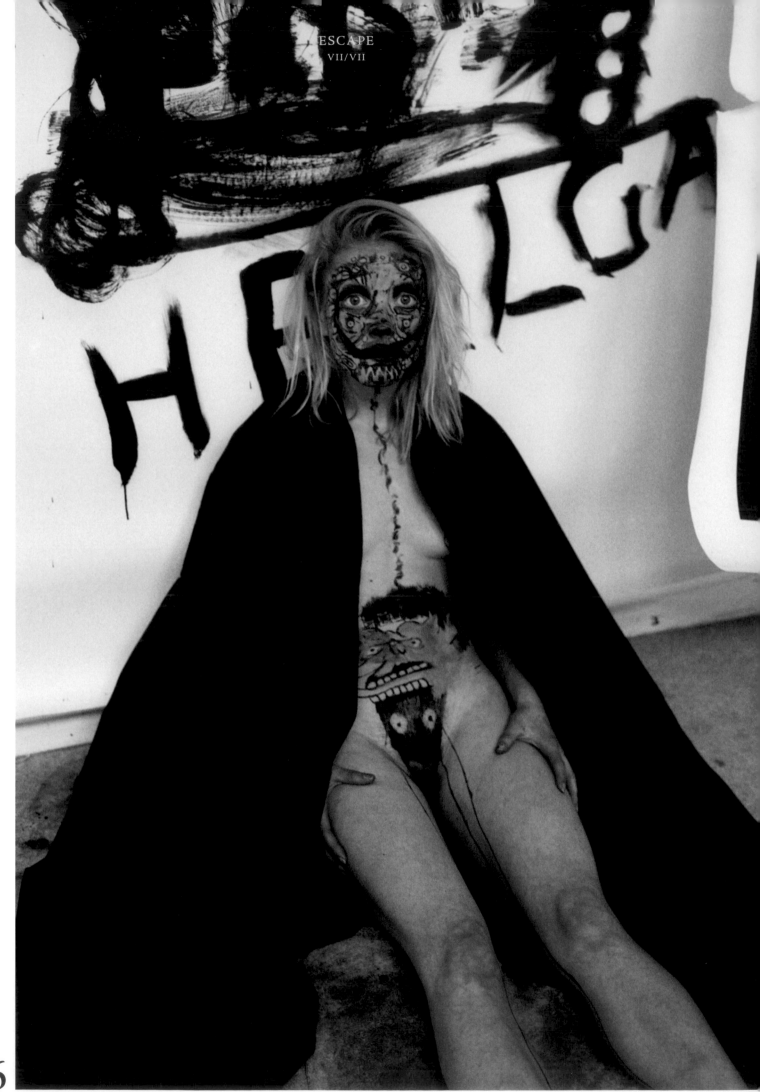

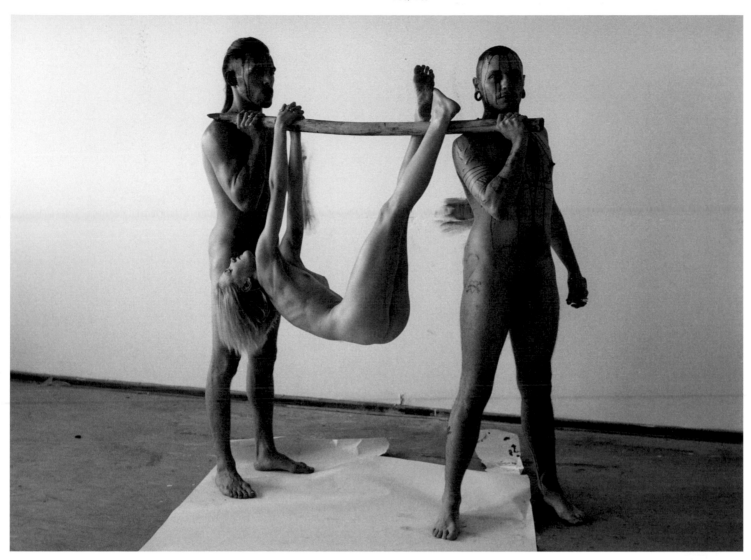

# Estelle Hanania

*OPPOSITE PAGE*
*Hellga*, 2009.
Collaboration with Christophe
Brunnquell and Helga Wretman.
*THIS PAGE*
*Black chalk*, 2008.

217

Estelle Hanania, *Black chalk*, 2008.

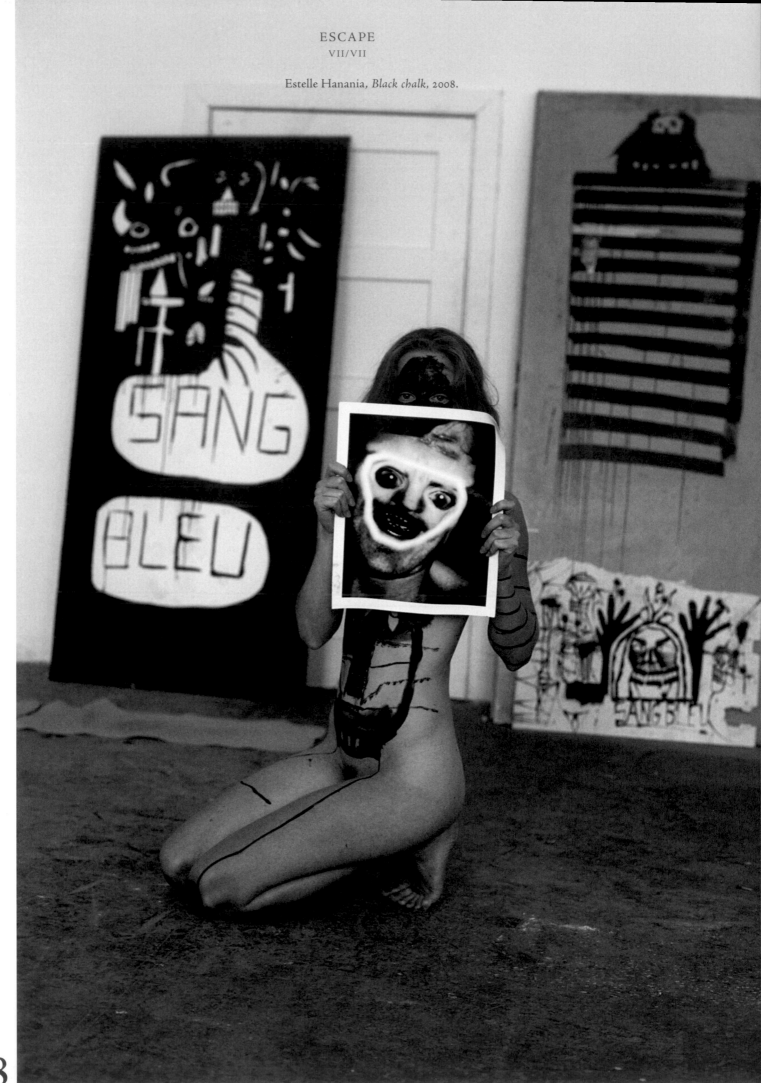

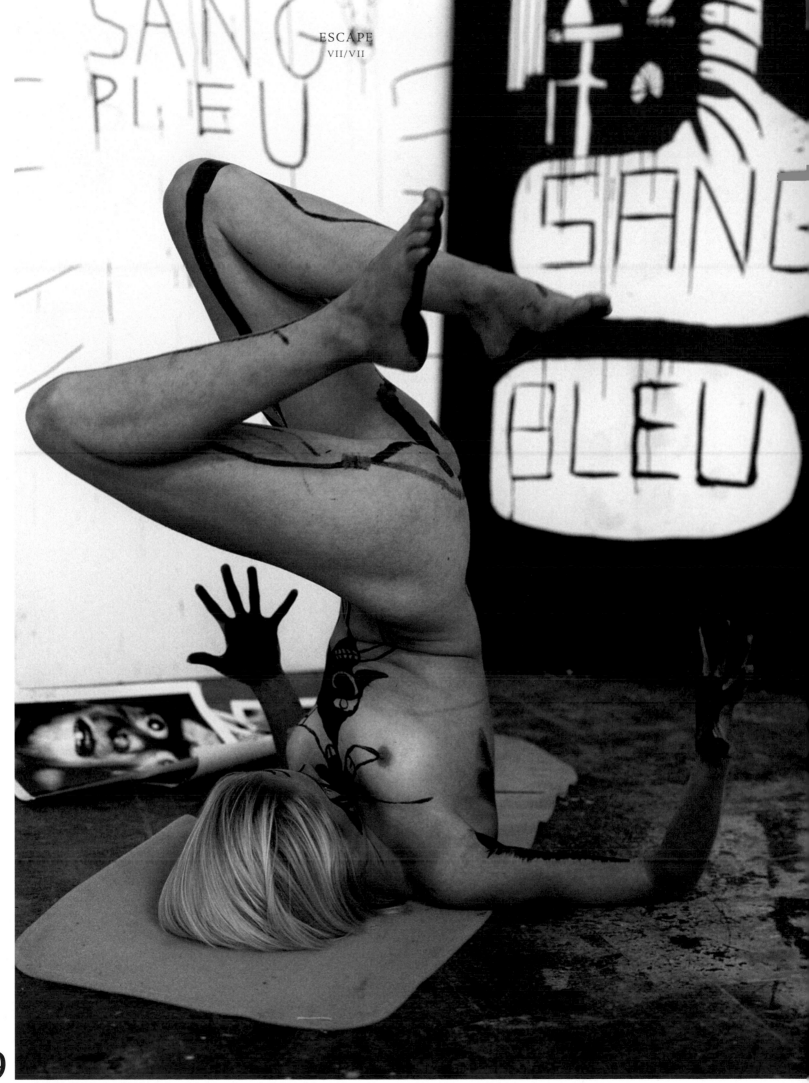

Dindi van der Hoek
*Carnaval les Animaux, 2010.*

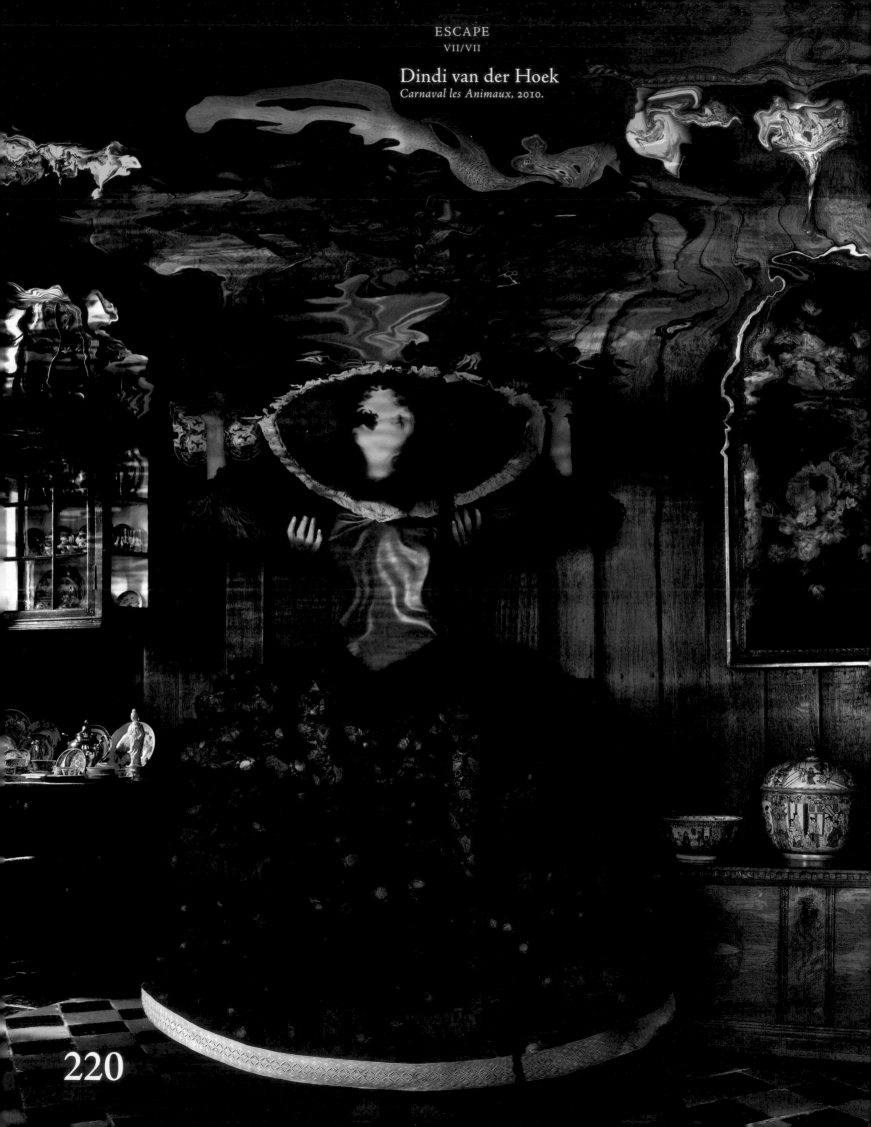

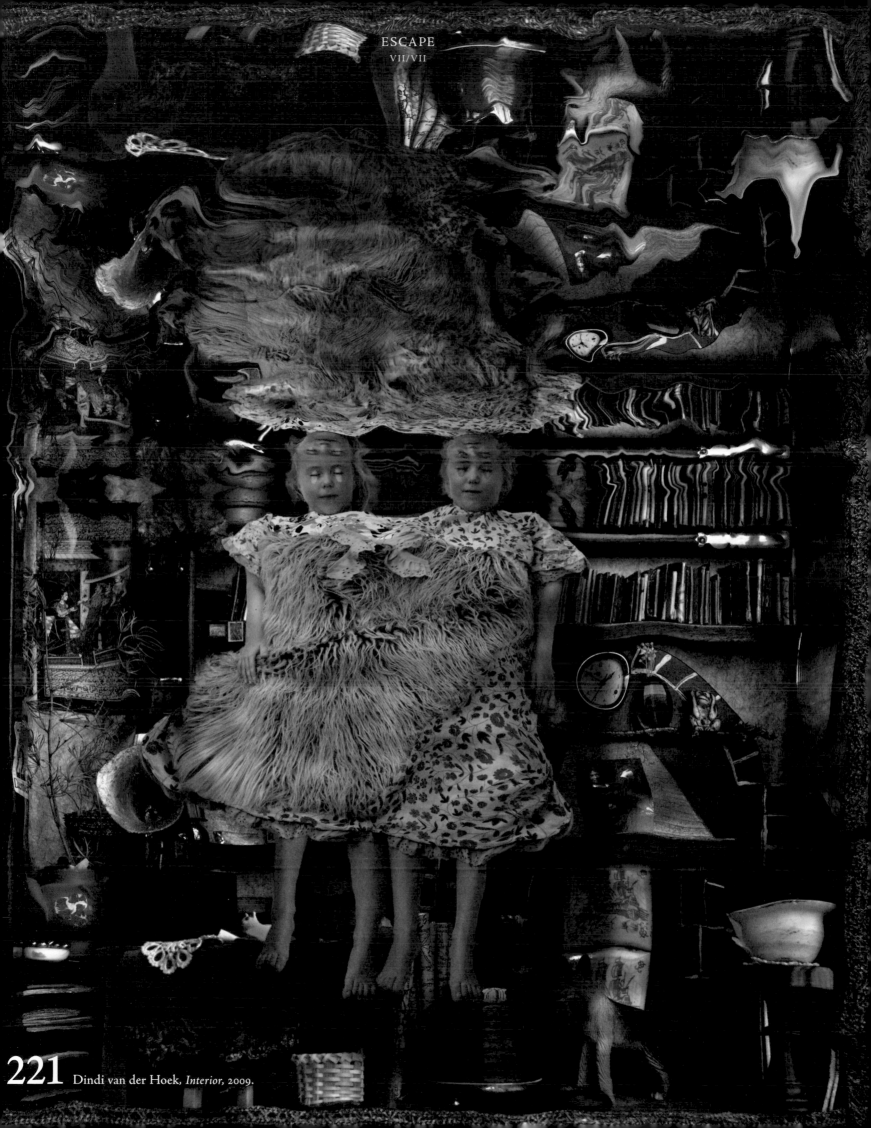

Dindi van der Hoek, *Interior*, 2009.

# Ted Sabarese

Ted Sabarese, *The Visualization of Sound #1*, 2010.

Part of an integrated ad campaign. The images visually represent sounds that people with hearing loss are not experiencing. All of the "sculptumes" were created by hand specifically for this project.

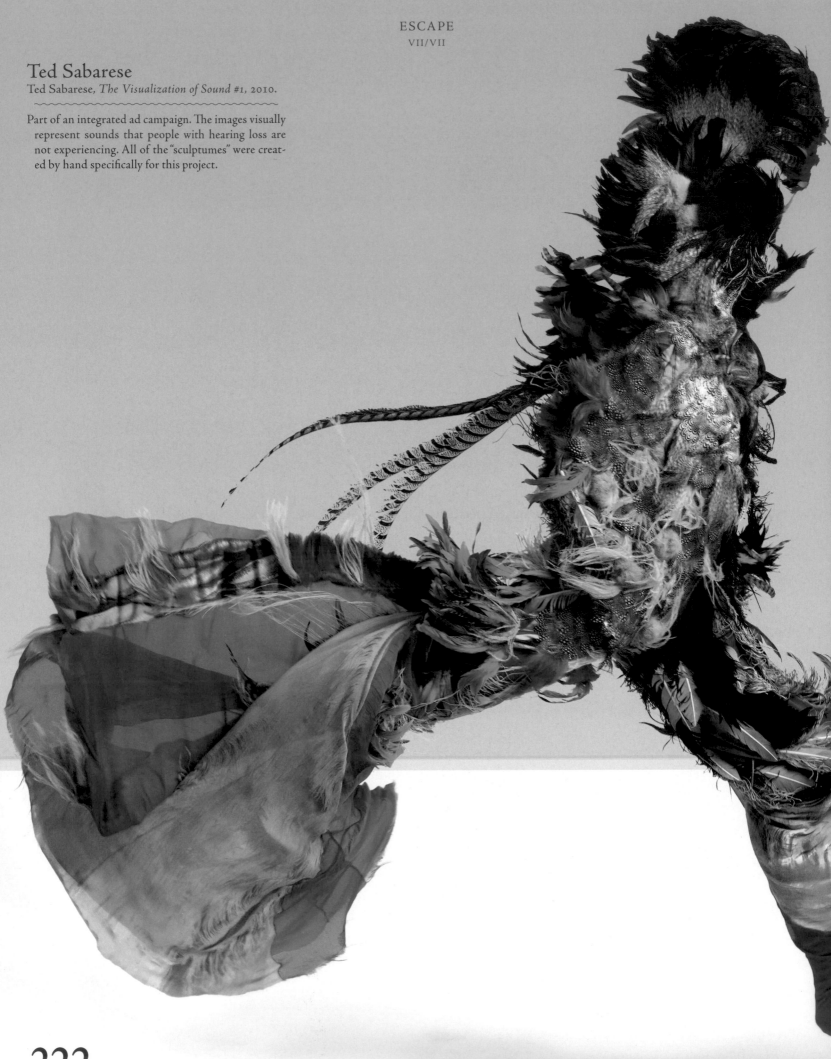

222

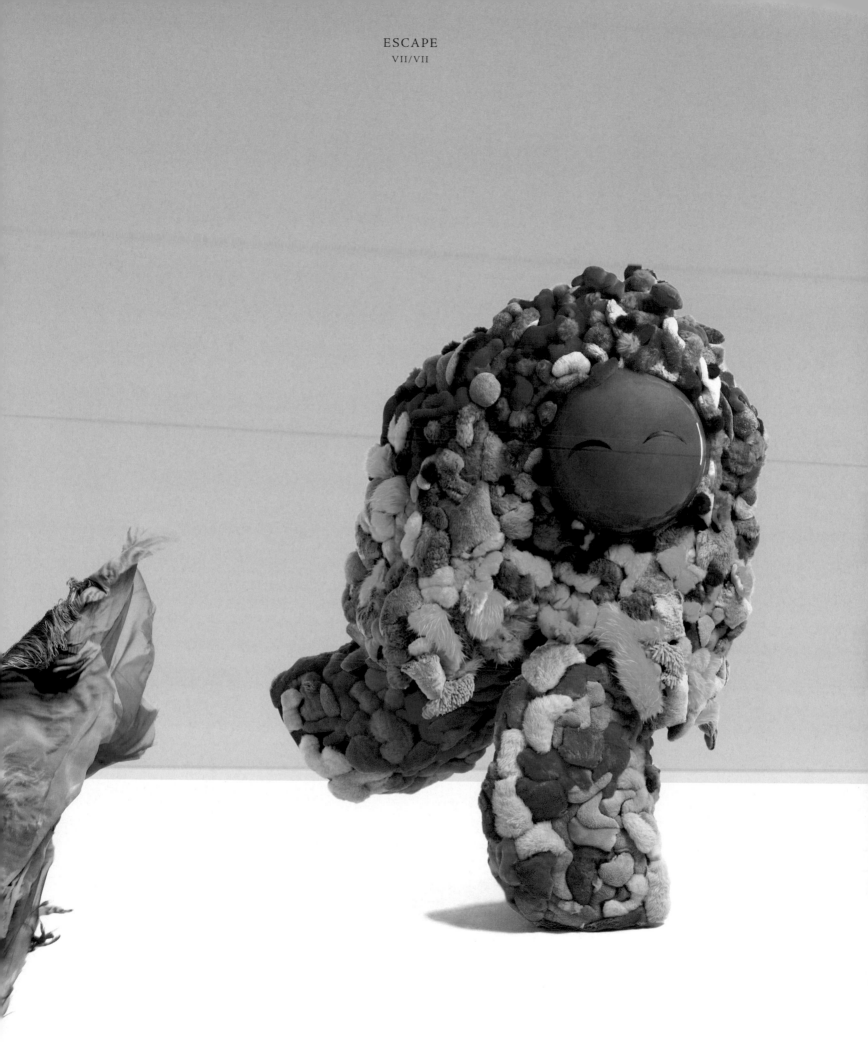

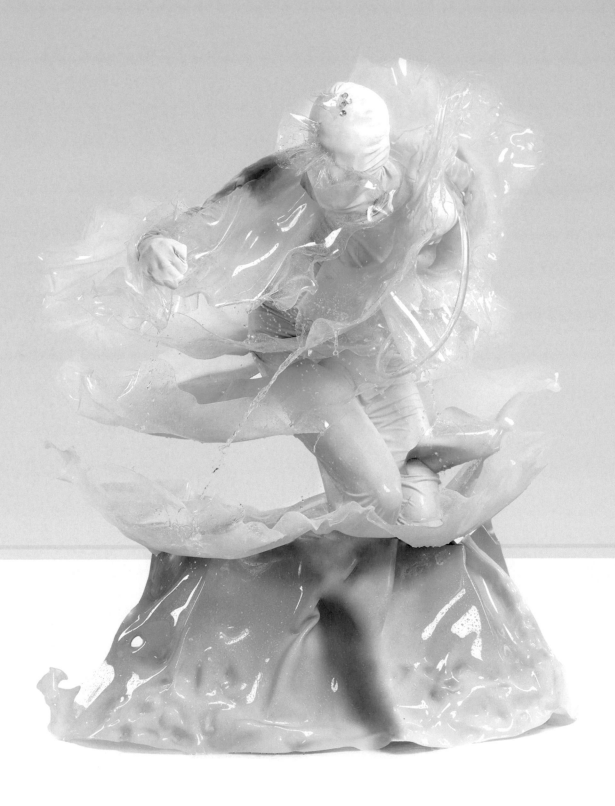

Ted Sabarese, *The Visualization of Sound #2*, 2010.

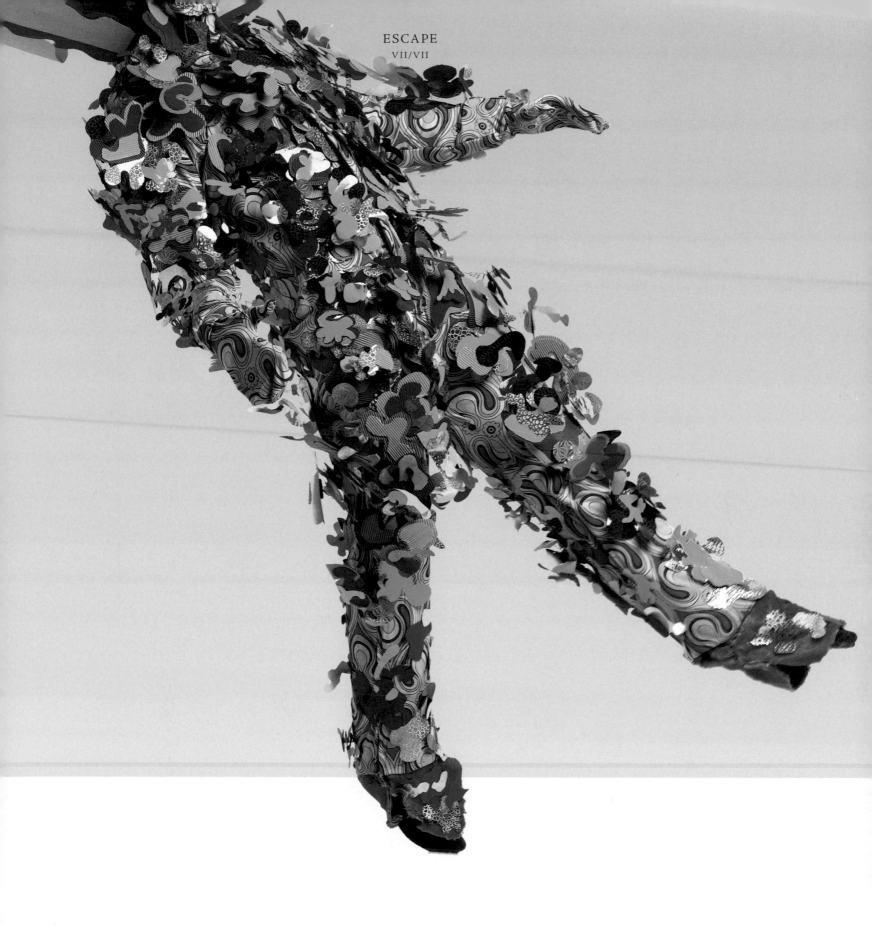

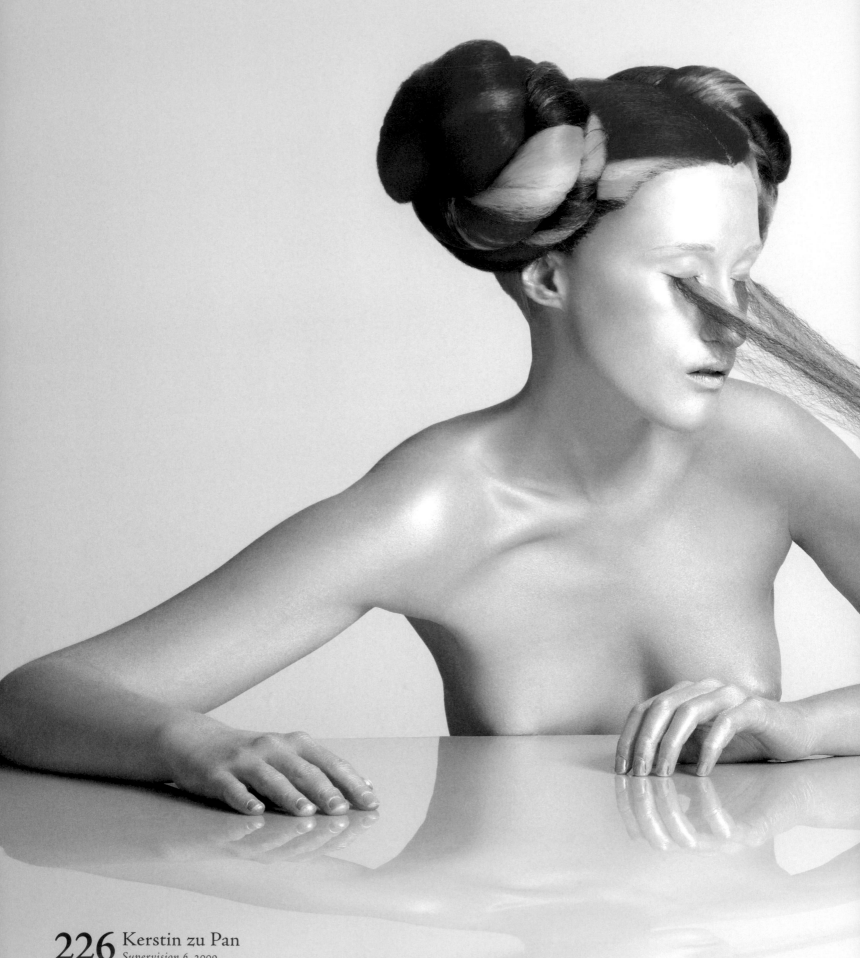

226 Kerstin zu Pan
*Supervision 6, 2009.*

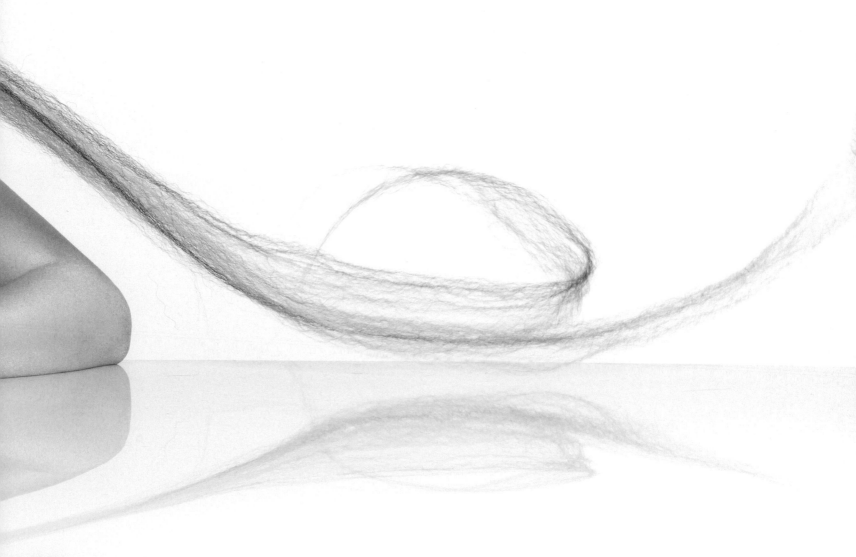

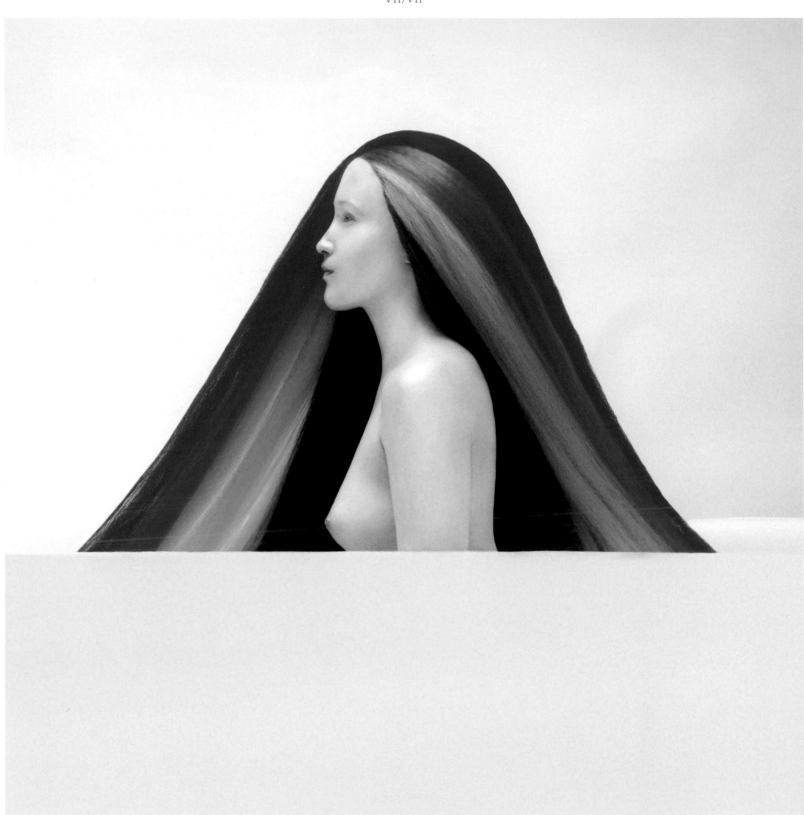

228 Kerstin zu Pan, *Supervision 9*, 2009.

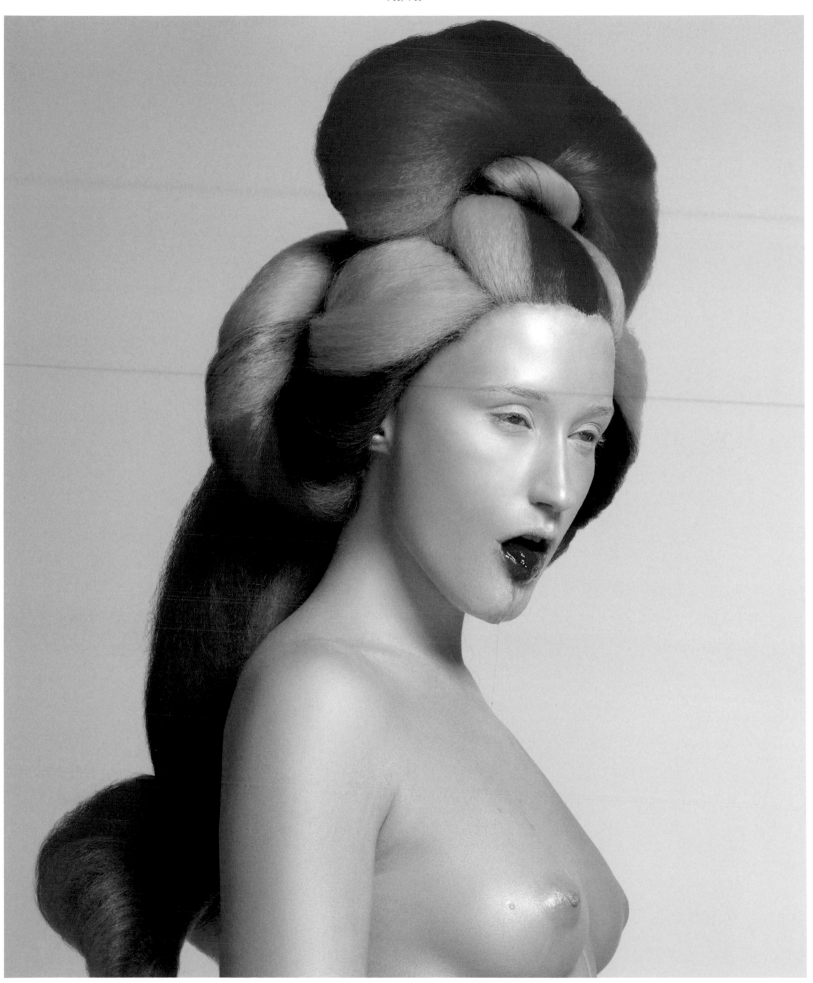

Kerstin zu Pan, *Supervision 4*, 2009.

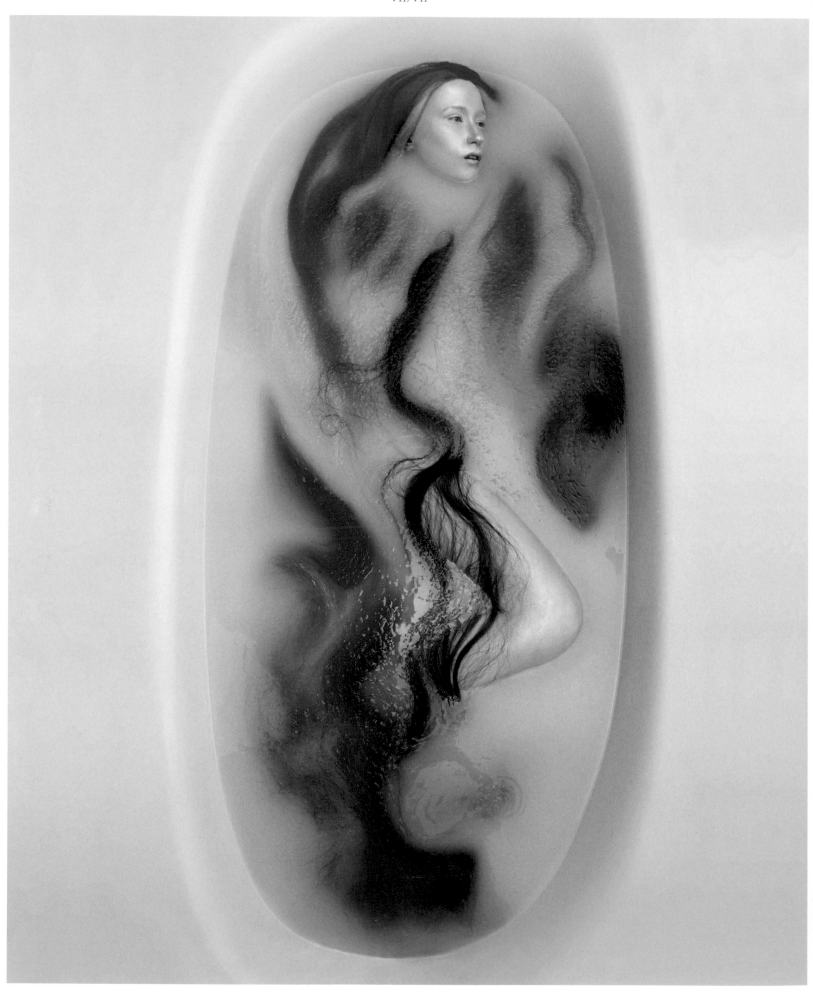

Kerstin zu Pan, *Supervision 12*, 2009.

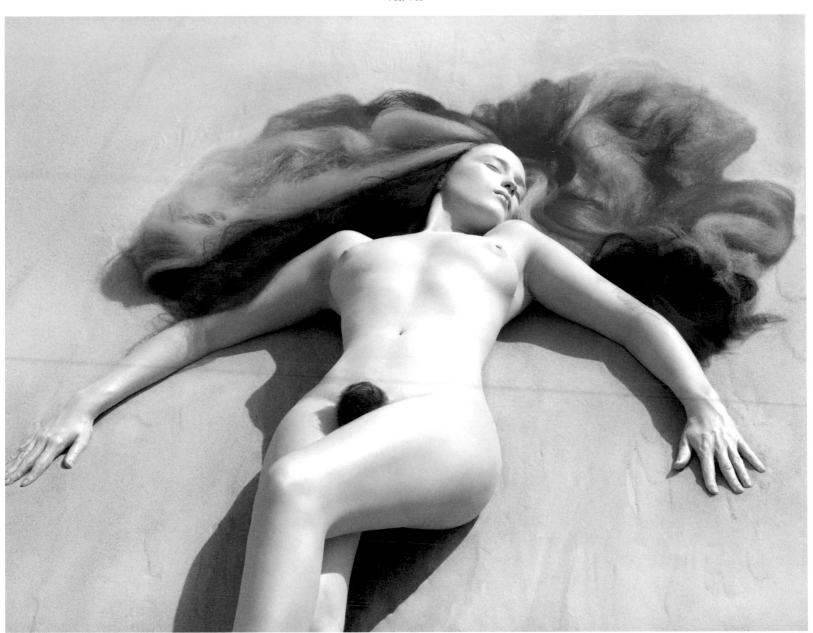

 Kerstin zu Pan, *Supervision 2,* 2009.

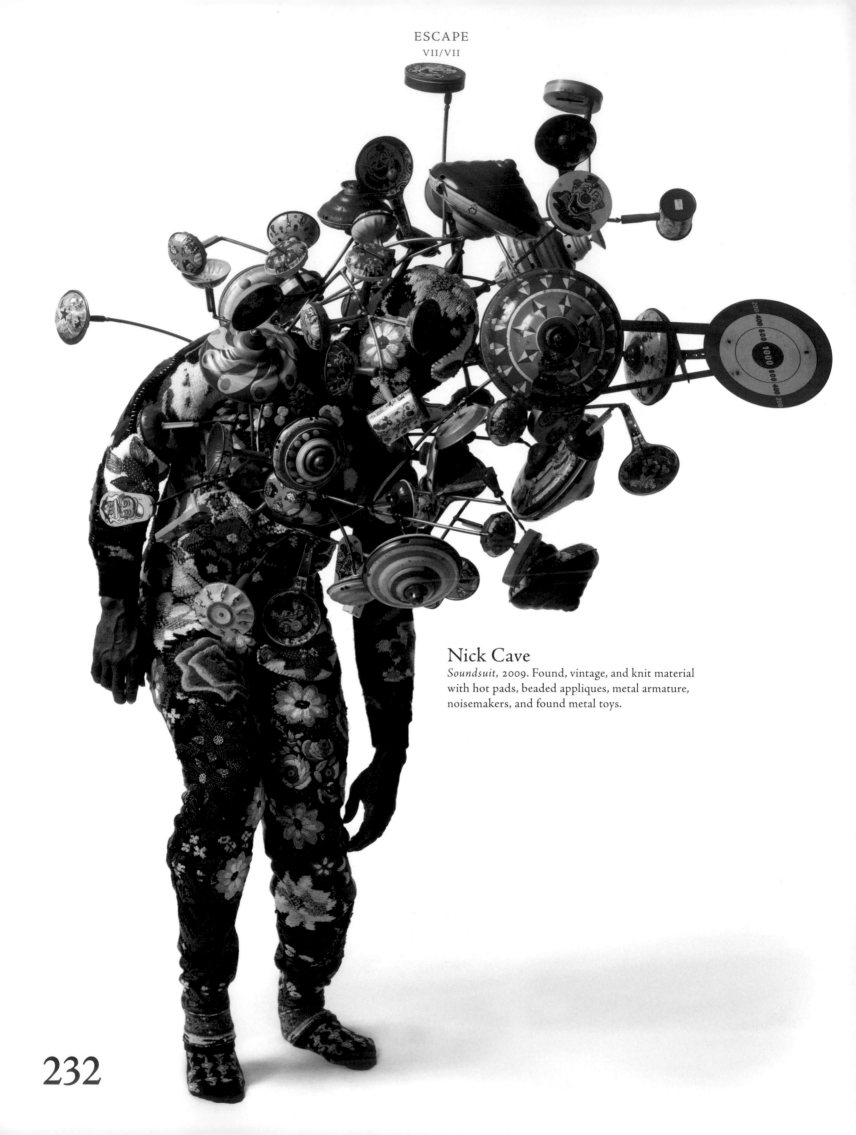

## Nick Cave

*Soundsuit*, 2009. Found, vintage, and knit material
with hot pads, beaded appliques, metal armature,
noisemakers, and found metal toys.

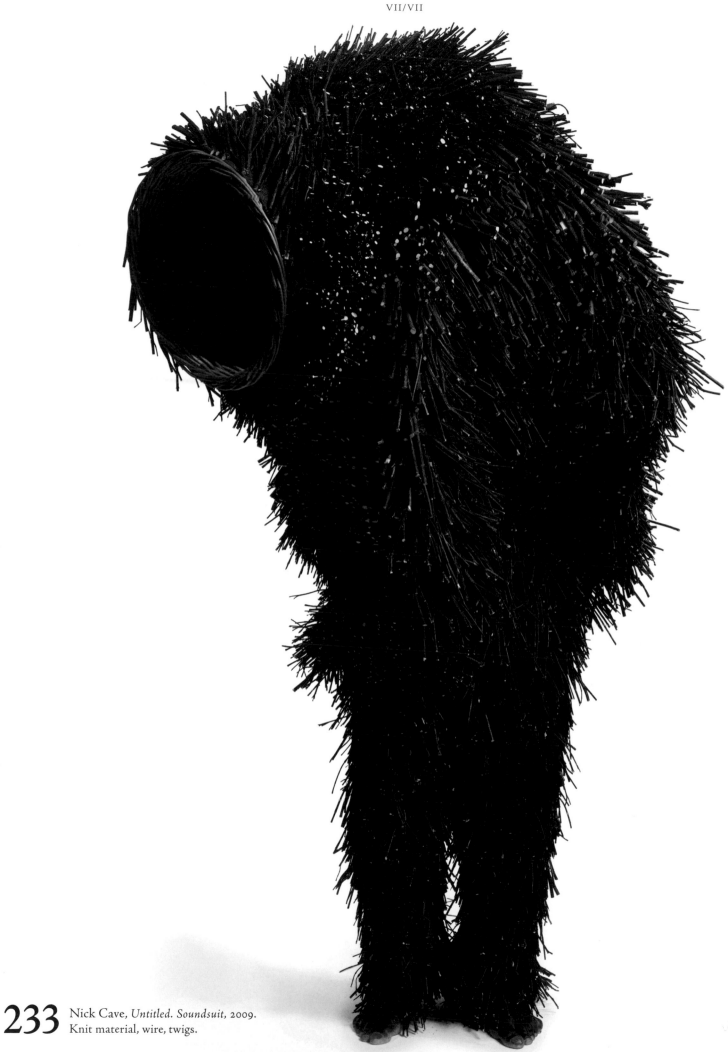

**233** Nick Cave, *Untitled. Soundsuit*, 2009.
Knit material, wire, twigs.

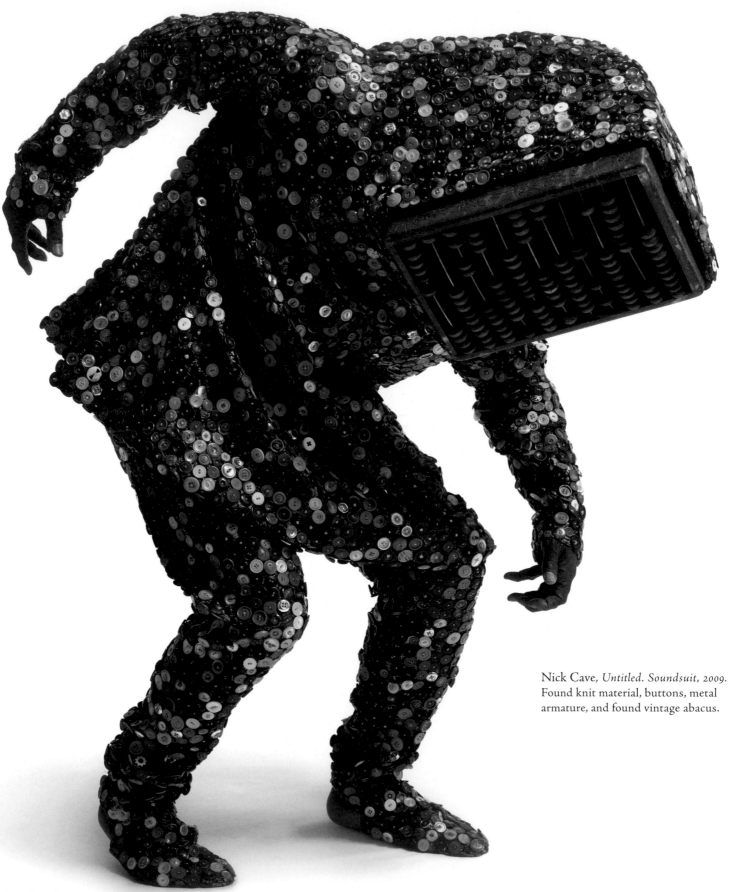

Nick Cave, *Untitled. Soundsuit*, 2009.
Found knit material, buttons, metal
armature, and found vintage abacus.

234

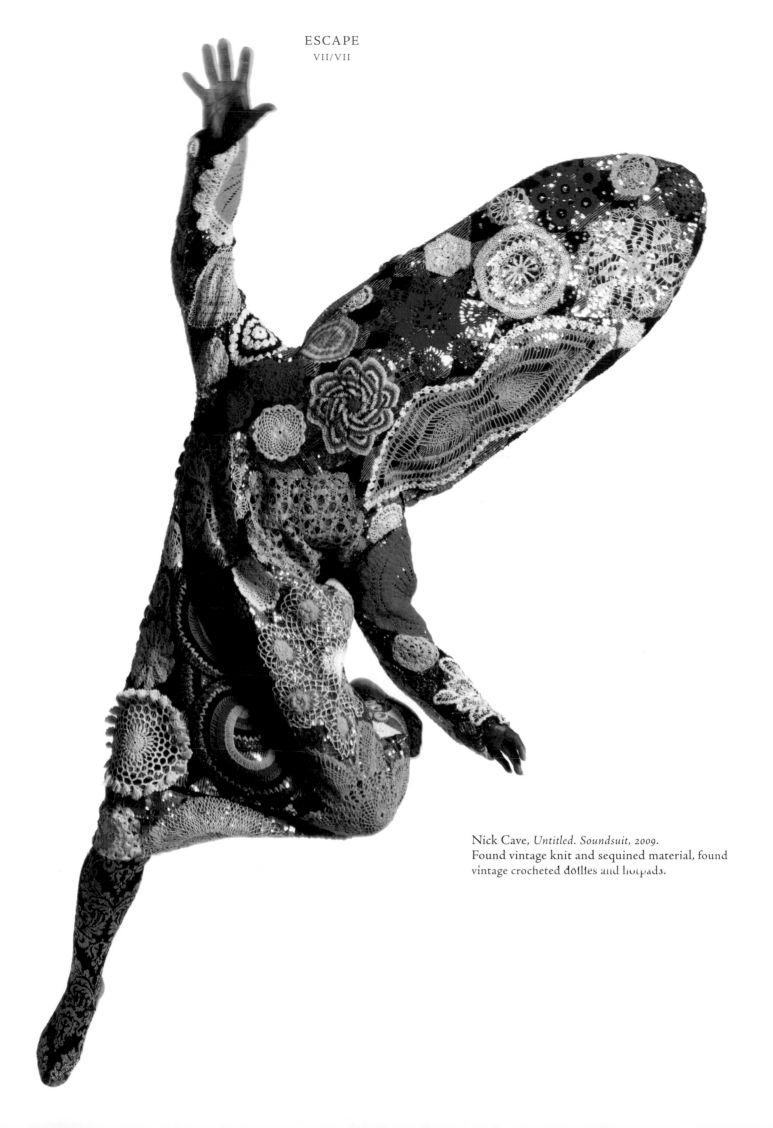

Nick Cave, *Untitled. Soundsuit*, 2009.
Found vintage knit and sequined material, found
vintage crocheted doilies and hotpads.

235

# DOPPELGANGER

## THE IMAGE OF THE HUMAN BEING

Edited by *Robert Klanten, Sven Ehmann, Floyd Schulze*
Preface by *Robert Klanten*

Cover image by *Sibling*
Cover and layout by *Floyd Schulze* for Gestalten
Typefaces: Adobe Jenson Pro by *Robert Slimbach*. Foundry: www.adobe.com/type
Wittenberger Fraktur by *Imre Reiner*. Foundry: www.linotype.com

Project management by *Elisabeth Honerla* for Gestalten
Project management assistance by *Vanessa Diehl* for Gestalten
Production management by *Janine Milstrey* for Gestalten
Proofreading by *Tammi L. Coles*
Printed by *Graphicom S.r.l.*, Vicenza
Made in Europe

Published by Gestalten, Berlin 2011
ISBN 978-3-89955-332-1

Bibliographic information published by the Deutsche Nationalbibliothek.
The Deutsche Nationalbibliothek lists this publication in the Deutsche Nationalbibliografie; detailed bibliographic data is available online at http://dnb.d-nb.de.

None of the content in this book was published in exchange for payment by commercial parties or designers; Gestalten selected all included work based solely on its artistic merit.

This book has been printed on FSC certified paper.

Gestalten is a climate-neutral company and so are our products. We collaborate with the non-profit carbon offset provider myclimate (www.myclimate.org) to neutralize the company's carbon footprint produced through our worldwide business activities by investing in projects that reduce $CO_2$ emissions (www.gestalten.com/myclimate).